P9-DCY-175

Acclaim for *Jackson Pollock: Energy Made Visible*

"Friedman's enduring biography of Pollock is essential reading for anyone interested in the artist's life and work."
—**Jeffrey Potter**, author of *To a Violent Grave: An Oral Biography of Jackson Pollock*

"A compelling biography of the one-time *enfant terrible* of modern abstract art, by an author who wisely lets his subject reveal himself as much as possible through his letters to his friends and family. . . . Artist and man, one as turbulent and tragic as the other, are superbly intertwined in this portrait as they were in Pollock's brief life."
—*Publishers Weekly*

"Friedman's Pollock is a close as one could have gotten to him. . . . His analysis of the paintings is, thank heaven, simple and unpretentious, and he doesn't try to fill in the unfillable with notions that appear scholarly but are in truth pure gas."
—*Los Angeles Times*

"Crammed with revelatory details."
—*Boston Globe*

"Only an artist with B.H. Friedman's skill and talent could have written about Jackson Pollock so that it is possible to see and hear him. The book is invaluable to me as a painter because of its perceptions."
—**Jim Dine**

"An important and authoritative book. . . . It will take its place as a keystone for any further studies of Pollock and his world and will be read for many years to come."
—*Chicago Sun-Times*

"Significant in substance and insights, [this book] is written in a vibrant style. . . . An important, multifaceted view of an American art innovator."
—*Booklist*

"[*Jackson Pollock*] is not likely to be superseded. . . . [Friedman] writes with ease and competence about the paintings and art in general. . . . Partisan but just and equally good as introduction or reference."

—*Kirkus*

"This biography, which successfully recreates the atmosphere surrounding both Pollock's career and the beginnings of the New York school of Abstract Expressionism, is moving and wholly engaging."

—*Library Journal*

"The book will be read—and should be read—for the valuable details it brings us about a period of American art that is only now beginning to acquire a serious historical literature."

—**Hilton Kramer**, *New York Times Book Review*

"For evaluation, interpretation, biography, quoted material from letters, reviews, interviews, art show catalogs; for analysis of the artist's work and human essence, Friedman's book will be difficult to surpass."

—*Detroit Sunday News*

Jackson Pollock

Energy Made Visible

By B.H. FRIEDMAN

Novels
CIRCLES
YARBOROUGH
WHISPERS
MUSEUM
ALMOST A LIFE
THE POLYGAMIST

Story Collections
COMING CLOSE
BETWEEN THE FLAGS

Biographies
JACKSON POLLOCK: ENERGY MADE VISIBLE
GERTRUDE VANDERBILT WHITNEY
(with Flora Biddle)

Monographs (in whole or in part)
SCHOOL OF NEW YORK: Some Younger Artists
ROBERT GOODNOUGH
LEE KRASNER
ALFONSO OSSORIO
SALVATORE SCARPITTA
MYRON STOUT
DAVID PORTER
CROSSCURRENTS: East Hampton and Provincetown
MICHAEL LEKAKIS
FRANZ KLINE

Plays
THE CRITIC
BEAUTY BUSINESS
CASE HISTORY
HEART OF A BOY
MIRRORS

JACK SON

Energy Made Visible

POLL OCK

by B. H. Friedman

DA CAPO PRESS • NEW YORK

Library of Congress Cataloging in Publication Data

Friedman, B. H. (Bernard Harper), 1926–
 Jackson Pollock: energy made visible / by B. H. Friedman.—1st Da
Capo Press ed.
 p. cm.
 Originally published: New York: McGraw-Hill, 1972.
 Includes bibliographical references.
 ISBN 0-306-80664-9
 1. Pollock, Jackson, 1912–1956. 2. Painters—United States—Biography.
3. Abstract expressionism—United States. I. Title.
ND237.P73F7 1995
759.13—dc20
[B] 95-21130
 CIP

First Da Capo Press edition 1995

This Da Capo Press paperback edition of *Jackson Pollock* is an
unabridged republication of the edition first published in New York
in 1972, with textual emendations, a new foreword by the author,
and new photos. It is reprinted by arrangement with the author.

Copyright © 1972 by B.H. Friedman
New foreword copyright © 1995 by B.H. Friedman

*The She-Wolf, Guardians of the Secret, No. 14A, Number 8, Lucifer,
No. 3, Convergence,* and *Search* are reprinted by permission of the
Pollock-Krasner Foundation/Artists Rights Society (ARS), New York.

PERMISSIONS
The author and publishers are grateful to the following for permission to include quoted extracts:

Art in America for "Who Was Jackson Pollock?" by Francine and Cleve Gray, May-June 1967

Art News for "The American Action Painters," by Harold Rosenberg

City Lights Books for "A Step Away from Them," by Frank O'Hara from *Lunch Poems* © 1964, City Lights Books

Horizon Press for "The American Action Painters," by Harold Rosenberg, from *Tradition of the New*, 1959 and "Foreword to the Second Edition," by Harold Rosenberg from *The Anxious Object*, 1959

Alfred A. Knopf, Inc., for "A Step Away from Them," by Frank O'Hara in *The Collected Poems of Frank O'Hara*, 1971

LIFE Magazine for "A LIFE Round Table on Modern Art," by Russell Davenport and Winthrop Sargent, October 11, 1948, © 1948 Time Inc.; "Jackson Pollock," August 8, 1949, © 1949 Time Inc.; "Rebel Artist's Tragic Ending," August 27, 1959, © 1956 Time Inc.

The Nation for reviews by Jean Connolly, May 1 and 29, 1943; reviews by Clement Greenberg, November 27, 1943; April 7, 1945; June 9, 1945; April 13, 1946; December 28, 1946; February 1, 1947; January 24, 1948; February 19, 1949

The New Republic for "Jackson Pollock," by Manny Farber, © 1945, Harrison-Blaine of New Jersey, Inc.

The New Yorker for reviews which appeared between 1943 and 1945; "Unframed Space," in "The Talk of the Town," August 5, 1950

Pantheon Books, a division of Random House, Inc., for an excerpt from *An Emotional Memoir of Franz Kline*, by Fielding Dawson, Copyright © 1967 by Fielding Dawson

Partisan Review for "Art Chronicle: Feeling Is All," by Clement Greenberg, January-February 1952, vol. 19, no 1, © 1952 by *Partisan Review;* "American-Type Painting" by Clement Greenberg, Spring 1955, vol. 22, no. 2, © 1955 by *Partisan Review*

Provincetown Review for "Daniel T. Miller" by James T. Valliere, no. 7, Fall 1968

TIME, The Weekly Newsmagazine for "The Best?," December 1, 1947, Copyright Time Inc.; "Words," February 7, 1949, Copyright Time Inc.; "Handful of Fire," December 26, 1949, Copyright Time Inc.; "Americans Abroad," August 21, 1950, Copyright Time Inc.; " Chaos, Damn It," November 20, 1950, Copyright Time Inc.; "The Champ," December 19, 1955, Copyright Time Inc.; "The Wild Ones," February 20, 1956, Copyright Time Inc.; "Milestones: Died," August 20, 1956, Copyright Time Inc.

University of Missouri Press, Columbia, Missouri, for excerpts from *An Artist in America* by Thomas Hart Benton, copyright 1968 by Thomas Hart Benton

Acknowledgments

For making various facts and/or documents available to me, I thank John I. H. Baur; Rita and Thomas Hart Benton; Peter Blake; Charlotte and James Brooks; Jeanne and Fritz Bultman; Peter Busa; Leo Castelli; Butler Coleman, Director of New York Area Office, Archives of American Art; Whitney Darrow, Jr.; Edward F. Dragon; Morton Feldman; Miss Inga Forslund, Associate Librarian, Museum of Modern Art; Lloyd Goodrich; Richard Governale; Philip Guston; Clement Greenberg; Stanley W. Hayter; Ben Heller; Dr. Joseph L. Henderson; Mrs. Sylvia Henry, Librarian, Long Island Collection, East Hampton Free Library; Thomas B. Hess; Axel Horn; Sam Hunter; Sidney Janis; Mervin Jules; Barbara and Reuben Kadish; Wolf Kahn; Stewart Klonis; Samuel M. Kootz; James Lechay; Julian Levi; Josephine and John Little; Anita and Conrad Marca-Relli; Mercedes and Herbert Matter; Patricia Maye; Mrs. Sanford McCoy; Donald McKinney; Robert Motherwell; Hans Namuth; Mrs. Barnett Newman; Reverend George Nicholson; Alfonso Ossorio; Betty Parsons; Phillip Pavia; Charles Pollock; Larry Rivers; Bernice Rose; May Natalie Tabak and Harold Rosenberg; William S. Rubin; Ludwig Sander; Irving Sandler; Jon Schueler; Springbok Editions, Division of Hallmark Cards; Tony Smith; Mrs. Patricia Westlake; and William Wright. However, any interpretations and conclusions drawn from these materials are entirely my responsibility.

Besides the writers among those names listed above, there are others

with whom I had no direct dealings but from whom I also quote factual and/or documentary material. I want to thank them too. Of particular value was the detailed chronology prepared by Francis V. O'Connor and his research assistants for the 1967 Pollock catalogue published by the Museum of Modern Art, the interviews of Francine du Plessix and Cleve Gray and those of James T. Valliere. Again, interpretations and conclusions are my responsibility.

I also want to thank Joyce Johnson for many valuable editorial suggestions, and Claire Mozel and her summer helpers Myra Hicks, Valerie Verdes, and Ruth Latta for a multitude of secretarial chores well done.

Finally, I want to thank the publishers, listed separately, who granted permission to reprint material from copyrighted articles and books.

B.H.F.

Contents

Foreword to the Da Capo Edition

He was the pure and barbaric new solipsist, who existed—even in performance, even in the part of a story that is beyond words—above and to one side and behind and below the words. He was pictures and text, a temporal animal, so clever that he seems demonic while remaining at least semi-irrestible—and not passively so. He was not an adorable self sitting still. He was as active and energetic as Puck.

HAROLD BRODKEY
Translating Brando

In 1968 Lee Krasner Pollock, the widow of Jackson Pollock, asked if I would be interested in writing a biography of her husband for Time-Life Books, and I entered into a contract with the publisher to do a short, tightly outlined book for their *World of . . .* art series. By coincidence, my editor was a friend and neighbor of Thomas Hart Benton, Pollock's most influential teacher, whom I presented, mostly in Benton's own words, as a hard-drinking reactionary. The editor wanted me to soften this characterization but, believing it was accurate as well as important to Pollock's story, I refused and we agreed to terminate our contract.

With the cooperation of Lee Krasner, who continued to answer my questions and provide documents and photographs, I was able to write a considerably longer and freer biography for McGraw-Hill. Early in the fall of 1970, when I had substantially finished, I asked Lee to check it. She explained, as I already knew, that she, like Pollock, disliked reading, and asked if I would read the book to her. I did this during a period of several days at her home in Springs, East Hampton, New York. She liked it very much, asked for a copy, and when we returned to the city, invited my wife and me to celebrate at a new restaurant in her neighborhood.

About two weeks later I received a letter, obviously written in consultation with her lawyer, requesting me not to publish the book. In sub-

sequent correspondence, phone conversations, and meetings with her and her lawyer, I realized that she, perhaps advised by someone else who had read the biography, had decided that it might hurt Pollock's reputation. I was willing to make factual corrections, if needed, but was unwilling to remove necessary references to Pollock's alcoholism and psychiatric history. Again and again I asked what, if anything, should be corrected. Each time Lee's lawyer replied that the problem was not specific but the general tone of the book. We got nowhere.

Inevitably, my long, close relationship with Lee was destroyed. We were now talking to each other only through lawyers. Hers wrote to McGraw-Hill threatening to withhold permission to quote from Pollock's letters. Mine took the position that Lee's having given me the letters was tantamount to permission to publish them. In addition, I agreed to indemnify McGraw-Hill against a lawsuit, and the publisher itself arranged to have three prominent art historians read the book to certify its reliability.

All of this took time. The book was finally published in New York in 1972, in London in 1973, and in a McGraw-Hill paperback in 1974. For the paperback I made some further revisions based on new information. But even before publication of the New York hardcover edition, and continuing through Lee Krasner's life, she did everything possible to undermine the book. For example, she often made the statement that she hadn't read it, which may have been technically true since I read it to her; and she emphasized to many reviewers that I was a "fiction writer," which was half true since by the time the book was written I had published about as much fiction as art criticism. However, she certainly knew about the criticism; it included several affirmative pieces about Krasner herself: a 1958 catalogue introduction, a 1959 magazine article, a 1965 monograph, and a 1969 interview.

Since my Pollock biography was first published in paperback more than twenty years ago, many books on him have been written, some biographical, some critical, some both. Of these, by far the most valuable is the four-volume *Catalogue Raisonné*, 1978, edited by Francis Valen-

tine O'Connor and Eugene Victor Thaw. I have relied on it for this new edition of my book, as does everyone now writing on Pollock. Other publications present a mixed bag. Ruth Kligman, who was in the car with Pollock when he died, has written a "memoir" of their brief affair. In his oral biography Jeffrey Potter, a close friend of Pollock's, has recorded many interviews. In *An American Saga* Steven Naifeh and Gregory White Smith have suggested that Pollock was gay and that his drip technique was inspired by watching his father piss—neither theory convincing. At the risk of seeming immodest, I am pleased that my biography has survived so many years—and the publication of so many other books.

B.H. FRIEDMAN
Wainscott, NY
May 1995

Introduction

I first met Lee and Jackson Pollock in the spring of 1955—that is, slightly over a year before his death. When we met he was forty-three and I was twenty-eight. I emphasize this discrepancy in age as I want also to emphasize the discrepancy in our situations. He was already an "old master" of Abstract Expressionism, then the most vital and original painting to have emerged in the history of American art. I was a real estate executive, still—after about six and a half years in business—torn between the excitement of New York's postwar building boom and a continuing desire to write. This I did nights and weekends, having published some articles, short stories, and poems, but none of the novels I had then written. So Pollock represented, for one side of my life anyway, a truly heroic figure: not only that of the committed artist, but one whose name was synonymous with the expression of freedom, a name as big, as charged for me then as was that of Dylan Thomas in the medium of words.

However, Thomas had died the year before, and there was Pollock suddenly in my living room. Or, I should say, Pollock and Mrs. Pollock. I was meeting her, too, for the first time. I did not know she painted under her maiden name, Lee Krasner, nor would I have recognized that name—she had had only a single one-person show; Pollock had had about a dozen. She was simply the great man's wife.

They were there in the apartment because a collector, Ben Heller,

was considering buying a painting by Pollock and wanted to bring him to "a friendly environment," one in which he knew a Pollock hung. In addition, I had that previous fall written an article for *Arts Digest* called "The New Baroque," dealing with Pollock among other Abstract Expressionists and illustrated with a painting by him next to one by Rubens (purposely reproduced upside-down).

Now, after a phone call from Heller telling me he had just returned with the Pollocks from East Hampton, they were there. Pollock, wearing a beige tweed sports jacket that looked too small for him, a dress shirt with collar open and knit tie pulled down, was bigger and bulkier than I would have guessed from photographs of only a few years before. The lean rugged face I knew from these pictures was rather bloated and covered with a stubble of beard he would grow somewhat fuller, though never very full, during the last months of his life. As we were introduced, I felt the size and power of his hand.

I hung Pollock's jacket in the hall closet and watched him lurch ahead of his wife and down the steps into the living room. From his awkward movements and the few words I had heard him mutter, it was clear that he was drunk. Mrs. Pollock whispered, "Don't offer him anything hard—nothing more than beer, if he wants that." The words were delivered with a tough clarity. They were neither desperate nor apologetic, but very direct. I felt already that there was considerable substance to this "shadow" of Jackson Pollock, this anonymous wife.

Pollock lumbered around the room, stopping only to look at the art: several pieces from Africa and the South Pacific, three Arp reliefs, a large collage by Laurens and two very small ones by Schwitters, a small painting by Feininger and a large one on burlap by Klee, and finally, on the wall nearest the window, a 1917 Mondrian gouache on paper hanging beside Pollock's four-by-four oil of 1949, the largest and most recent work in the collection: all in all, a sort of visual history of my own search for freedom.

The Mondrian was a work I was sure Pollock would appreciate, one of the very few done after his lyrical plus-minus image and before he

developed the more rigid grid of his typical late paintings. In this particular work, slightly irregular rectangles of color (yellow, red, and blue, but not quite primary, not quite "pure") move rhythmically across the white sheet in a way that anticipates such late masterpieces as his *Trafalgar Square* and *Broadway Boogie-Woogie.* It was this rhythmic quality and the suggestion, too, of continuous space extending beyond the frame that made me feel sure the work would appeal to Pollock.

For a moment he stood in front of the Mondrian with hands out as if he was about to seize it and fight it. His hands twitched in the air, seeming to want to touch or feel or somehow reproduce, remake, each element of the work before him. Then he turned to his own painting, a skein of silver and green and yellow and brown arabesques, drawn with spilled and splattered industrial enamels, and again I couldn't help but feel that, no matter how different the means, how different the apparent image, Pollock would respond to the Mondrian as to the work of a brother making a similar statement in a different way.

He looked at the painting again, turned toward me, and asked in a loud thick belligerent voice, "Who did that?"

"Mondrian."

"Shit. Why don't you have a Cavallon?"

At the time I hardly knew the work of the Italian-American, Giorgio Cavallon, had indeed dismissed it as being too derivative of Mondrian, a softer gentler version of the same thing. And I said something to that effect.

"Shit," Pollock repeated. "You're looking for tame art, familiar art."

"No. But I guess what's wild becomes tame and familiar." I was thinking of a recent exhibition of the Fauves in which this was the case.

Pollock looked at me very hard. There was an intensity in his eyes, perhaps a Westerner's distrust of an Easterner's glibness, a desire to test it.

"Shit," he said once more.

I didn't know what I was supposed to say or do. Shout "Shit" back at him? Everyone looked uncomfortable.

He staggered now in front of the window. With his back to it, he

faced the room, ready, I thought, to tear the art off the walls—all of it, including his own painting.

Finally Mrs. Pollock spoke: "Come off it, Jackson. You need some sleep." She turned to us. "We get up early to make our appointments in New York. With the stops on the way he gets like this. Is there any place he can take a nap?"

My wife said we had a spare room with a couch in it. She led the Pollocks to the back of the apartment. On the way, in the dining vestibule opposite the living room, he saw Arshile Gorky's *Table Landscape*. He stopped in front of it. Again he assumed something like a fighting stance, his hands moving in the air, tracing the configuration of the painting.

"That's better," he muttered, "much better."

After Pollock and the women had gone, Ben Heller said, "I'm sorry. I thought you'd like to meet him."

"You were right—but not like this."

"He wasn't this way in East Hampton. He was drinking a lot of beer and stopped for more on the way in, but he wasn't really tense until we got to the city. . . . Paul Brach took me to their place in Springs. We unrolled some of the big paintings, the nine-by-eighteens. Wow, they hit me in the gut. . . . He doesn't really want to sell, but— I guess I'll have to work that out. . . . I can't think of any better investment. The Impressionists have reached their peak. The Cubists are high. What's left? Miró? Giacometti? Dubuffet? The Americans are the most underpriced . . ."

He was still talking when my wife and Mrs. Pollock returned to the living room.

"He went right to sleep," Mrs. Pollock said. "He'll be all right. He gets like this when we come to New York—once a week, every week, until August. The doctors take their vacations in August. . . . Tomorrow we have our sessions. Then the real battle begins—to get him back out to Long Island. He's okay then, but when he's with those cronies of his at the Cedar, it's not easy. I never know when he's going to show up on Wednesday. One in the morning. Two. Three. Noon. Afternoon. Some-

times we stay an extra day. . . . Well, now *I* could stand a drink, a real drink."

The evening was laid out: we would drink until Pollock woke up, we would have dinner, we would deliver Mrs. Pollock to the Earle (a hotel on Waverly Place at which they stayed) and Pollock himself to the Cedar Tavern (two blocks away, on University Place). Ben Heller drank ginger ale while Lee Pollock, my wife Abby, and I finished a bottle of vodka. Lee talked more about the analytic sessions she and Jackson went to, his drinking problem, his working problem, and problems of her own as a painter married to a painter. She asked some questions about Abby and me and about Ben Heller and Judy (his wife, who had remained on Long Island), but mostly she talked about herself and Jackson. There was no doubt she considered him, not only the best painter in America, but in the world. Names kept coming up: Gorky, de Kooning, Tomlin, Kline, Newman, Brooks, Still . . . Though I knew their work, I didn't know any of them personally, and two of them, Gorky and Tomlin, were dead.

"You would have liked Tomlin," she said. "He was something like you—shy and aloof. He was just coming out to live near us when he had his heart attack. The move was too much for him."

I was digesting that "shy and aloof." I hardly heard the rest of what she said. "You'll see some of them at the Cedar."

Pollock came down the hall. "What are you all doing?" he asked. "I'm hungry."

He looked gentler than he had before—a big brown bear, rather than a grizzly. His eyes had receded with sleep, his face was not quite open.

"How would you like a shower before we go out to dinner?" Lee asked.

The answer was yes. Abby showed him where the shower was. In ten minutes he returned with his eyes and face wide open.

"That was great. Do you have a beer? Bud? Schlitz?"

"Only Heineken's."

"Oh . . . okay . . . in the bottle."

I gave it to him that way. He relaxed on the couch, lifting the bottle to his mouth in one big paw, holding a cigarette in the other. After the first swallow he said, "Good." He finished the beer. "Real good."

"Let's eat," Lee said.

We went around the corner to Billy's, an unpretentious steak place. There, with dinner, he had more beer—on draft. He was responsive now to my specific questions about his life and work. At one point he said something like: "A man's life *is* his work; his work *is* his life. That's what's bothering me— I'm not working much anymore. I go to my studio, but nothing happens. . . . I don't want to repeat myself."

I argued that by definition an artist's work could be only part of his life, though in another sense it might be bigger or—more accurately —stronger and surely more enduring than the life itself.

Pollock listened carefully to what I said, thought about it for a moment, then shook his head: "No. They're the same thing. They're inseparable." He locked the fingers of his hands to show me what he meant.

He asked many questions about my life and was surprised that I considered it to some degree separate from my work. "But what are you really *involved with?*"

This was a phrase I would hear again and again during the time I knew Pollock. "I'm involved with both—business *and* writing."

"You don't feel the need to choose?"

"Sometimes I have trouble juggling two lives, but I want to try it for a while. My folk heroes are Wallace Stevens and Charles Ives." I smiled.

There was no response from Pollock. I didn't know if he recognized the names of the poet and the composer or knew that they both had been insurance company executives. I started to explain——

"Why are you talking about other people's lives? I'm asking about *yours.*"

I told him about what I did in business and what I had written. In response to something I said about the difficulty of designing good-looking office buildings in New York under the existing zoning, he asked if I knew Tony Smith.

"No."

"He's a great architect. A student of Wright's. You should hear him recite Joyce. He knows whole hunks of *Finnegans Wake*."

"I read the architecture magazines. I don't remember seeing his name."

"He won't let them reproduce his work. He's done a studio for Fritz Bultman on the Cape, and a house for Stamos at Greenport, and one now in an abandoned rock quarry outside New Haven for Olsen, the man who bought *Blue Poles*. I've never seen the Olsen place, but it must be the best thing Tony has done. He's a great architect, he's my friend."

As earlier with Cavallon and then with Smith, so it was with writers. Pollock had faith in those he knew and felt committed to them, particularly Peter Matthiessen and Donald Braider, both of whom lived in the East Hampton area. When I mentioned something I had written, or was writing, or wanted to write, his questions were always about the same: What did it mean to *me*? What was *my* involvement with it? Why had *I* chosen a particular subject and not another?

Pollock was asking questions like these about my piece on "The New Baroque," when a truck on First Avenue backfired. At the restaurant, until then, he had been calm—probing and intense, but calm. Now he jumped from his seat and stared out the window, trying, through a film of air-conditioning condensation, to make out the cause of the noise. He shook his head, wiped his broad, bulging, sweating brow, and sat down. "I don't know," he said, "I don't know how you live here." He asked the waiter for another beer. When he finished that he said, "Let's leave."

It was fairly late, eleven or so. I don't remember—none of those present do—whether only I went with Pollock to the Cedar that night, or Abby and I did, or none of us did. I have a vague impression of Lee Pollock's wanting to get to the Earle to catch up on phone calls, an

equally vague one of Ben Heller's wanting to get a good night's sleep before an early conference. But whether I went there that first night or soon after is unimportant. What remains in my mind is the feeling of going there *with Pollock,* what it was like to enter the place with him. By coincidence I had been there before, but only during the day. Between the fall of '48 and '49, I was the manager of an apartment house at 1 University Place and had learned to go to the Cedar Tavern to retrieve the superintendent or a handyman. I don't think I knew the name of the bar. It was simply that place down the block where the maintenance crew went, an ugly, almost empty neighborhood bar where drinks were cheap and one wondered how the owner paid the rent.

But now, at night, almost seven years later, the place was mobbed. Even outside there was a crowd which greeted Jackson. And inside, guys —there were hardly any women—stood two- and three-deep at the bar. "Hi, Jackson," they yelled as we entered, "Hi, Jack." Several of them wanted to buy him a drink. Others created space at the bar. He picked an opening, led me to it, said the first drink was on him, and began introducing me to whoever was there on either side and behind us, an area which was filling up deeper than anyplace else at the bar. Again, I don't remember just who was there that first night, whenever it was. I do remember that within several visits, I met many near-contemporaries of Pollock's (Kline, Guston, de Kooning ...) and a lot of younger artists (Brach, Leslie, Rauschenberg, Rivers, Goldberg, Kanovitz ...) and Frank O'Hara, who was writing about them, and Morty Feldman, who had composed the music for the Namuth-Falkenberg documentary film on Pollock, and other photographers, dancers, critics, dealers ... In short, through Pollock, mostly at the Cedar, I met the art world.

Perhaps that drab bar deserves a book in itself. During the fifties it was the one place everyone went: students, established artists, artists from out-of-town and from abroad; there one could make contact with New York, with where it was happening and the men who were making it happen. And there I was listening to Jackson being greeted, watching

his back being slapped and his arms punched, and wondering what all these people wanted from him. To have bought him a drink? To have had a drink bought by him? To have touched him for luck? To have been touched by him? What? The more I watched and listened, the more convinced I became that for this crowd he was a kind of talisman. Young artists, many of them unknown to him, pressed in—touching, touching, touching for luck—because he had run so many of their risks for them, had, as de Kooning said, "broken the ice." Yes, that seemed to be it, there was a desire for some of his success to rub off (his success *as an artist*—there had been no appreciable monetary success), and a desire also to thank him for those risks he had run, the permissions he had granted. The greetings, the backslaps, the playful punching and nudging were all ways of expressing thanks. At least that was one side of it, the decent side. But there was an indecent voyeuristic side, too, among others who frequented the bar. For them Jackson was a freak, part of the entertainment, a notorious figure in the art world who had somehow succeeded in spite of himself, in spite, as they said, of his not being the draftsman de Kooning was. Some of these regulars bought Jackson drinks because they wanted him to act freakish, wanted to see what would happen this time.

Many, perhaps most of us there at the bar, and particularly those of my own generation, came from rather sheltered and constricting middle-class backgrounds. For us, surely for me, Pollock represented both the ability to have endured material poverty and to have found and expressed spiritual freedom—freedom as acceptance and affirmation of life's natural rhythms. Yes, that was the positive side—what he had done, the body of work he represented, the range in that work from the most tender lyricism to most violent images. And on the negative side was the desperation with which he was drinking (whiskey now, at the Cedar) and the inability he had spoken of to function as a painter, when for the first time in his life almost anything he put on canvas would have sold. Just as I felt he was being treated as a magical object by artists here at the

bar, I felt that he himself had a sense of having been turned into an object, not magical but commercial, by the larger and more peripheral art world of collectors, dealers, museum people, journalists. . . .

His voice became thicker, his vocabulary more obscene as he continued to drink, trying to kill whatever pain was gnawing at him and to relocate his own identity, the identity he may have felt he had given or sold to the world. It was painful to watch him, knowing that he would find nothing at the bottom of the bottle but anonymous oblivion, a blackout, censorship of himself; painful to see this man become sodden beside me when only an hour before he had been talking intelligibly and expressing interest in himself and others. He staggered now to the john, stumbling and rough-housing as he made his way through the crowd. This was the man who had "danced" *Autumn Rhythm* and *Lavender Mist* and *Blue Poles* and maybe a dozen more of the most graceful paintings ever made in America or anywhere else.

What had happened to him, that other man of whom hardly more than the aura remained? How had he lost contact with this other self? What had he done to himself? And what had been done to him? I don't know if I can answer these questions. I don't know if anyone can. But I hope that in what follows there are at least leads to the answers.

Jackson Pollock

Energy Made Visible

Chapter One

Growing Up in the West
(1912–1929)

There is at the back of every artist's mind something like a pattern or a type of architecture. The original quality in any man of imagination is imagery. It is a thing like the landscape of his dreams; the sort of world he would like to make or in which he would wish to wander; the strange flora and fauna of his own secret planet; the sort of thing he likes to think about. This general atmosphere, and pattern or structure of growth, governs all his creations, however varied.

G. K. CHESTERTON

On January 28, 1912, when Jackson Pollock was born in Cody, Wyoming, nothing could have seemed less likely to his parents than that this son, their fifth and last, would grow up to be the most famous painter of his generation—a generation destined, for the first time in the history of American art, to achieve international recognition, influence, and finally leadership. Nor, of course, could they have guessed that even the most external facts of his life would be oversimplified to create a popular myth as distorted as those concerning such nineteenth-century painters as Gauguin, Toulouse-Lautrec, and Van Gogh—artists who also died young.

Pollock has been described in European art journals as the leader of "the School of California," a hard-riding hard-drinking cowboy from the Wild West who came roaring, maybe even shooting, his way into New York where he took the art galleries by storm, and at forty-four, at the height of his powers, died in an automobile accident, perhaps drunkenly, perhaps suicidally (according to much unfounded gossip, denials which perpetuated it, and published statements,* including that of at least one fellow painter**)....

Jackson Pollock: what a perfect name; so strong, so tough, so

* Most recently, A. Alvarez in *The Savage God: a study of suicide,* 1971.
** See Robert Motherwell, Bibliography No. 127.

American. California: just the right state to have come from. Forty-four: the age at which Scott Fitzgerald died. An automobile accident, maybe a drunken one at that; with two girls in the car, one killed, one badly injured: again, so American. And yet, as with all myths about artists, the truths are fractional at best—the real adventures take place, not on the highways or at the roadside taverns, but in the loneliness of the studio. Although it may not make as good a movie, that's where the action is. There the artist has to face himself. And the outside world—its recognition or snub, its version of success or failure—don't these enter the studio, don't they intrude? Yes, all this is part of the story too, but hardly mythic; after all, success is as American as apple pie—even when, like Pollock, one chokes on it.

Jackson Pollock's parents, Stella May McClure and LeRoy Pollock, were both in their late thirties when he was born, the mother a year older than the father. They had been raised in Tingley, Iowa, and came from rather stern backgrounds, hers Irish, his Scotch-Irish, both Presbyterian. About 1890, the father, born McCoy, had taken the surname of his adoptive parents, neighbors of his natural parents, who had both died within a year. As a boy LeRoy Pollock learned frontier skills—mainly ranching, farming and, later, surveying—by which, with difficulty, he supported his wife and sons. There is nothing in his background or in the external facts of his life which would make one predict that all five of his sons would want early in life to become artists. Charles (Cecil) Pollock (1902–) is a painter who has also taught art; (Marvin) Jay Pollock (1904–) is a rotogravure etcher; Frank (Leslie) Pollock (1907–) studied writing, though he became a rose farmer; and Sanford (LeRoy) Pollock (1909–63), who changed his last name to McCoy, was a painter, rotogravure platemaker, serigrapher, and silk screen printer. Where did the strain of sensitivity and creativity come from?

Some members of the family trace it to Stella Pollock's interest in weaving, crocheting, and quilting. She was also an excellent seamstress and made shirts for the entire family. However, in all this work one sees

competence and craft, not necessarily sensitivity and creativity, and surely not originality. Stella, the "cottage weaver," stayed within a framework of folk conventions and given patterns. As one studies family pictures of her, the rigidity of a frame there, too, is what strikes one most forcefully: a large full-busted woman, always erect and stern. In contrast, pictures of LeRoy Pollock are typically relaxed and smiling. His face and body suggest a gentleness and sensitivity, a warmth rubbed a little raw, that may well have been the product of hard abrasive years. Before working at the sheep ranch in Cody, he had been a dishwasher at the Irma Hotel there, then a plasterer, then partner in a stone-crushing plant. When (Paul) Jackson was born, LeRoy's occupation was listed on the birth certificate as "stone mason and cement work."

Charles remembers his parents as "excellent craftsmen: they knew how to grow things, they knew how to make things. But neither of them had a sense for business or commercial profit." Stella Pollock worried, maybe even more than her husband, about the details of managing family affairs. However, Charles recalls that she liked beautiful things. One time he wanted fancy shirts instead of the plain blue work shirts she had been making. She took him to Goldwater's in Phoenix and let him buy some silk pongee. Though Stella shared LeRoy Pollock's life, his gentler qualities, if they existed in her, were hidden or repressed. Her outward mask was more contained, less subjective and expressive. Compositely, the two parents present much of the ambivalence—that mixture of tenderness and aggression, inwardness and outwardness—that would exist in Jackson and intensify throughout his life.

Perhaps because of LeRoy Pollock's lack of "business sense," perhaps because of a more profound and unconscious restlessness, the family was constantly on the move during Jackson's childhood. Before he was one they had left Cody to settle in San Diego. That didn't work out. The next year his father bought a small truck farm in Phoenix. Within four years it was auctioned and the Pollocks moved to a fruit farm in Chico, California, and then, within four more years, to yet another in Janesville,

California. From there, in 1922, they moved to Orland, California. Thus, by the age of ten, Jackson had lived in six homes in three states, and the moving wasn't over yet. By then, too, his eldest brother, Charles, had left home to work for the layout department of the Los Angeles *Times,* while studying at the Otis Art Institute. From Los Angeles during the next several years Charles sent his brothers copies of *The American Mercury* and *The Dial* which contained avant-garde art and literature. It is doubtful that these would have interested Jackson when he was between ten and twelve, but probable that they did later on.

Except for Charles, the family was on the move again in 1923. That fall they returned to Arizona, where LeRoy Pollock found a truck and dairy farm outside Phoenix. By now, ten years after their first stay here, Jackson was old enough to explore Indian ruins and visit reservations where ceremonial dances and sand paintings may have been tourist attractions and brightly colored dolls and blankets sold as souvenirs. However, his esthetic appreciation of American Indian art would come later, reinforcing childhood memories of bold abstract designs and "primitive" colors in sand and "war paint." This stay in Arizona was brief. In the spring they moved back to Chico; shortly thereafter to Riverside, just beyond Los Angeles and surrounded by citrus groves and vineyards. That is where they were, when in September of 1926, Charles registered at the Art Students League in New York.

By the following summer, though only fifteen and a half, Jackson was already almost five foot ten, the height he would reach as his body filled out during later years. Even at this age his build was strong and athletic, with particularly powerful capable-looking hands, despite the scarred gnarled tip of his right index finger which at eleven had been axed off either by himself while chopping wood or by a friend while killing a chicken on the farm outside Phoenix. (Whichever was true, he liked best to tell the story of how the chicken went for the tip of his finger and how he rescued it just in time to be sewn back on.) His face, too, was already almost that of a man, each feature—which would be-

come more pronounced as he grew older—clearly and characteristically there: the strong protruding line of the brow; the deep-set, intense, and, at the same time, vulnerable hazel eyes; the heavy bridge of the nose moving irregularly to the tip; the sensuous mouth; the rugged jaw line; the cleft chin—all topped by light brown hair. Yes, he would have been cast as a cowboy, even including that suggestion of vulnerability and shyness in his eyes.

From photographs as well as from the recollections of friends and family, we know that Jackson Pollock was a handsome young man. Until the last years of his life (and to a lesser extent, even then), the power, energy, and intensity of his face and body were magnetic, even charismatic, and as such must have affected his career. This was true, too, of the intensity of his moods and his projection of them. School friends remember this aspect of Pollock's personality, and years later his widow said, "Whatever Jackson felt, he felt more intensely than anyone I've known; when he was angry, he was angrier; when he was happy, he was happier; when he was quiet, he was quieter . . ."*

That summer of 1927 he and Sandy, the second youngest of the brothers, worked at surveying, which was by then their father's profession. For the job, along the north rim of Grand Canyon, they went to a site set up in much the same way as a lumber camp. The teams of surveyors would sleep in log cabins, eat enormous breakfasts in the messhall, take lunch with them on horseback, and return at night for dinner—and drinking. We can only guess about young Jackson (he began using his middle name about now and dropped Paul completely when he moved to New York three years later) in this environment, working with an experienced surveyor, perhaps as a linesman or at clearing brush; returning to camp, exhausted but exhilarated by the scenery, wild life, and sense of space (he would identify with these aspects of nature throughout his life); putting away his meat and potatoes, maybe having seconds; and

* See Bibliography No. 14.

then drinking with the older men, trying to compensate for his youth by being aggressively "manly." Yes, within this context, the name "Jackson" would have had the right ring, with its echoes of General Andrew Jackson and General "Stonewall" Jackson. Even when shortened to "Jack," which old friends and family would call him, the name still sounded right—terse, tough, and, again, manly—very different from the biblical saintly "Paul."

During this summer Jackson discovered that alcohol—mostly, at this time, wine and beer, rarely hard liquor—seemed somehow to resolve the conflicts within him between tenderness and aggression, made him feel calm and more at ease in a society which was neither calm nor easy. This early, he was on his way to becoming an alcoholic. While others close to him shared the intense inner conflicts which made Jackson drink, he would be the only one to accept "alcoholism" as a diagnosis, to seek its cure (mostly in psychiatric therapy—Freudian, Jungian, Sullivanian, group—but also in homeopathy, hypnosis, and biochemistry), and finally to overcome drinking during a brief but very productive period late in his career. However, though Jackson's desire for alcohol was great, his tolerance was low, as if his system were allergic to it. Many of his friends remember how wildly drunk he became on comparatively small amounts of wine and beer and, of course, even smaller amounts of whiskey. When he drank a lot—and he could hold a bottle of whiskey, even though high from almost the first sip—he just got that much drunker before passing out. Finally, to distinguish between Jackson's case and that of the more ordinary tippler, when he drank he didn't just become Jackson happy or Jackson sad or Jackson uninhibited; there was personality change. He, like Dr. Jekyll, became someone else, though his potion was alcohol. In short, Jackson's problem was clearly physiological as well as psychological.

However, again given the example of his older brothers, Jackson had discovered a more positive way than alcohol to deal with his active—

passive ambivalence and the resulting tension. He had found that he liked to draw and that in doing so he could, at least temporarily, *act out,* put on paper, the resolution of anxieties that liquor only dulled. To our knowledge, no work from this early period survives—we can only imagine the sense of excitement the sensitive and rather introverted boy in his mid-teens must have experienced as, there on paper, his greatest hopes and worst fears were able to exist together and become suddenly, magically, as compatible as dark line against light ground. And we can only *imagine*—as we will later be able actually to *see*—the images of father and mother, male and female, the whole dichotomy of active and passive principles being resolved in art. Life's discrepancies must have fallen more comfortably on the sketch pad than on Jackson's shoulders; life there, under his pencil or pen or whatever, must have seemed calmer.

After his first summer of surveying, Jackson went to Riverside High School. There he met the painter-sculptor Reuben Kadish with whom he would remain in intermittent contact for the rest of his life. In March, when the Pollock family moved into Los Angeles, Jackson left Riverside High and wanted to enroll at Manual Arts High School. However, he had to wait until the following fall, at which time he met Philip Guston and Manuel Tolegian, two more artists to whom he would be close for a while and with whom he would continue to have contact throughout his life. But, at the time, his most important relationship was with an art teacher named Frederick Schwankovsky who introduced him to Far Eastern religions, particularly Buddhism, and to the contemporary teachings of Krishnamurti. Pollock went to several camp-meetings of this Hindu poet and mystic at Ojai, north of Los Angeles. One can get a sense of what Jackson heard there from *Life in Freedom,* a 1928 collection of Krishnamurti's "Camp-Fire addresses." Here is a brief but typical passage from "the Search": "I have painted my picture on the canvas and I want you to examine it critically, not blindly. I want you to create because of that picture a new picture for yourself. I want you to fall in love with the picture, not with the

painter, to fall in love with the Truth and not with him who brings the Truth. Fall in love with yourself and then you will fall in love with everyone."

Schwankovsky, known as "Schwanie" at school, believed in complete openness to all kinds of experience—religious, esthetic, political. Besides the camp meetings, he took his students to a Theosophy church. He lectured to them on the ethics of vegetarianism. He performed experiments in extrasensory perception, especially as this related to a Universal Consciousness. For example, he would have his students and students in other parts of the country write letters simultaneously in order to prove that they had concerns in common. Rather than offering a focus of youthful rebellion, these teachings and experiments must have satisfied a need in Jackson. Although his parents were nominal Presbyterians, they were not churchgoers; their creed was closer to pantheism than to any Christian sect. And for Jackson, too, a mystical and contemplative identification with the natural flow of life was already more meaningful than any formal church.

Rebellion and protest, as such, were expressed in another way, also encouraged by Schwankovsky. During this 1928–29 academic year Pollock was expelled from Manual Arts for having taken part, along with Guston and Tolegian, in the preparation and distribution of the *Journal of Liberty,* two printed attacks on the high-school faculty, particularly the English Department, and its overemphasis on athletics. When Jackson learned that at the same time Kadish had independently organized similar protests at Riverside, which the newspapers had described as part of a Communist conspiracy, he phoned Kadish and reestablished contact with him. From then until the end of the year these two, as well as Guston, Tolegian, and Donald Brown, a writer particularly interested in Joyce and Cummings, were very close. Though drawn together as "political trouble-makers," their real interest was in art. Kadish recalls that they were already reading *transition*, the avant-garde literary magazine which had begun publication in April 1927. "We were living a European fan-

tasy," Kadish says. "We knew we didn't belong in the Los Angeles Water Color Club or the Art Association. Siqueiros coming to L. A. meant as much then as did the Surrealists coming to New York in the forties."

Pollock was not readmitted to Manual Arts until the following fall —after another summer of surveying, this time with his father in Santa Ynez, California—and he was soon in trouble again, as indicated by the following long letter, one of the few which survives from this period of Jackson's life. (Note: Frank was in New York studying literature at Columbia, while Charles was still there at the Art Students League.)

Los Angeles
Oct. 22 1929

Dear Charles and Frank:

I am sorry for having been so slow with my correspondence to you. I have been very busy getting adjusted in school, but another climax has arisen. I have been ousted from school again. The head of the Physical Ed. Dept. and I came to blows the other day. We saw the principal about it but he was too thick to see my side. He told me to get out and find another school. I have a number of teachers backing me so there is some possibility of my getting back. If I can not get back I am not sure what I will do. I have thought of going to Mexico city if there is any means of making a livelihood there.

Another fellow and I are in some more very serious trouble. We loaned two girls some money to run a way. We were ignorant of the law at the time. We did it merely through friend ship. But now they have us, I am not sure what the outcomes will be. The penalty is from six to twelve months in jail. We are both minors so it would probably be some kind of a reform school. They found the girls today in Phoenix and are bringing them back.

If I get back in school I will have to be very careful about my actions. The whole outfit think I am a rotten rebel from Russia. I will have to go about very quietly for a long period until I win a good reputation. I find it useless to try and fight an army with a spit ball.

I have read and re-read your letter with clearer understanding each time. Altho I am some better this year I am far from knowing the meaning of real work. I have subscribed for the "Creative Art", and "The Arts". From the Creative Art I am able to under stand you better and it gives me a new outlook on life.

I have dropped religion for the present. Should I follow the Occult Mysticism it wouldn't be for commercial purposes. I am doubtful of my talent, so what ever I choose to be, will be accomplished only by long study and work. I fear it will be forced and mechanical. Architecture interests me but not in the sense painting and sculptoring does. I became accquainted with Rivera's work through a number of Communist meetings I attended after being ousted from school last year. He has a painting in the Museum now. Perhaps you have seen it, Dia de Flores. I found the Creative Art January 1929 on Rivera. I certainly admire his work. The other magizines I could not find.

As to what I would like to be. It is difficult to say. An Artist of some kind. If nothing else I shall always study the Arts. People have always frightened and bored me consequently I have been within my own shell and have not accomplished anything materially. In fact to talk in a group I was so frightened that I could not think logically. I am gradually overcoming it now. I am taking American Literature, Contemporary Literature, Clay Modeling and the life class. We are very fortunate in that this is the only school in the city that have models. Altho it is difficult to have a nude and get by the board, Schwankovsky is brave enough to have them.

Frank I am sorry I have not sent you the typewriter sooner I got a box for it but it is too small I will get another and send it immediately. How is school going? Are you in any activity? Is Mart still in the city? We have not heard for a long time in fact the letters have slacked from all of you.

Sande is doing quite well now. He has an office and handles all the advertising. He continues to make his weekend trip to Riverside.

Affectionately
Jack

In this letter we have a summary of the seventeen-year-old boy's confusions and gropings, a portrait of the artist as a young man. He knew only that he wanted to be "an Artist of some kind." The capitalization is touching, especially within the context of his attraction to radical politics, for it was only an attraction, not a distraction. Jackson never confused art and politics and never joined a political party. From his teens on he remained faithful to Art, with a capital A, absolutely single-minded in his desire to be "an Artist of some kind."

For the spring term, with Schwankovsky's help, Jackson was once

again admitted to Manual Arts, but now as a part-time student, on partial probation. He stayed there until summer. However, early in the term (three days after his eighteenth birthday), he described his new routine and current state of mind:

los angeles
jan 31 1930

dear charles

i am continually having new experiences and am going through a wavering evolution which leave my mind in an unsettled state. too i am a bit lazy and careless with my crrespondance i am sorry i seem so uniterested in your helping me but from now on there will be more interest and a hastier reply to your letters. my letters are undoubtedly egotistical but it is myself that i am interested in now. i suppose mother keeps you posted on family matter

school is still boresome but i have settled myself to its rules and the ringing bells so i have not been in trouble lately. this term i am going to go but one half day the rest i will spend reading and working here at home. i am quite shure i will be able to accomplish a lot more. in school i will take life drawing and clay modeling. i have started doing some thing with clay and have found a bit of encouragement from my teacher. my drawing i will tell you frankly is rotten it seems to lack freedom and rythem it is cold and lifeless. it isn't worth the postage to send it. i think there should be a advancement soon if it is ever to come and then i will send you some drawings. the truth of it is i have never really gotten down to real work and finish a piece i usually get disgusted with it and lose interest. water color i like but have never worked with it much. altho i feel i will make an artist of some kind i have never proven to myself nor any body else that i have it in me.

this

so called happy part of one's life youth to me is a bit of damnable hell if i could come to some conclusion about my self and life perhaps then i could see something to work for. my mind blazes up with some illusion for a couple of weeks then it smoalters down to a bit of nothing the more i read and the more i think i am thinking the darker things become. i am still interested in theosophy and am studing a book light on the path every thing it has to say seems to be contrary to the essence of modern life but after it is under stood and lived up to i think it is a very helpful guide. i wish you would get one and tell me what you think of it. they only cost thirty cents if you can not find one i will send you one.

> we have
> gotten up a group and have arranged for a furnace where we can have our stuff
> fired. we will give the owner a commission for the firing and glazing. there is
> chance of my making a little book money.
>
> i am
> hoping you will flow freely with criticism and advice and book lists i no longer
> dream as i used to perhaps i can derive some good from it.
>
> i met geritz at a lecture on wood block cutting he asked about you and sends
> his regards the fellow you mentioned of coming
> here has not arrived
>
> Jack

Written only about three months after the October letter, this one is surprising in several ways: the lower case throughout, the eccentric punctuation and paragraphing, the use of the fancy nonword "boresome." Jackson had indeed been reading—perhaps e. e. cummings, in one of the more avant-garde literary magazines such as *The Dial.* It may seem a mechanical thing for an author using a typewriter not to shift to capitals or to indent paragraphs in the conventional way. However, even these affectations are small rebellious gestures, indicating a fight against what one has been taught. The words *compulsive* and *obsessive* are as applicable to such typing as to Pollock's typically cramped handwriting (which was to open up only much later—and then on canvas, not on stationery). Even more remarkable is this eighteen-year-old boy's judgment of his drawing: "it seems to lack freedom and rythem it is cold and lifeless." No painter was to become more involved with freedom and rhythm as a means of conveying warmth and life to his art. But, again, that will take time and effort, mostly in the studio. There this shy, emotionally disturbed and conflicted, incipiently alcoholic young man will come as close as he can to finding the roots he never had as a child.

American Scene, New York Scene, Personal Scene (1930–1941)

Modernity is that which is ephemeral, fugitive, contingent upon the occasion; it is half of art, whose other half is the eternal and unchangeable.
CHARLES BAUDELAIRE
The Painter of Modern Life

Until now Jackson Pollock's story has been his own, a private one based on a few facts, a few documents. From here on it becomes more public, a part of art history. To understand it one needs to know at least a little about what had happened up to this point, not only in American art but in modern European art. No matter how radical an artist may seem he is never born of a vacuum; there is always a dialogue between his present and the past, his search for new forms and already existing traditions.

There is no need to trace in detail the ever-accelerating discoveries in painting, from the great Impressionists of the nineteenth century, through turn-of-the-century Post-Impressionism, to Matisse, Picasso, Kandinsky, Mondrian. . . . It is necessary only to emphasize that during this brief period of about fifty years—from, say, Manet's masterpieces of the early 1860s until about the beginning of World War I and the Synthetic Cubism of Picasso and Braque, as well as the pure abstractions of Kandinsky and Mondrian—almost every major art discovery of roughly the first half of the twentieth century had already been made, if not fully developed. Even Surrealism had been anticipated in work outside the mainstream by such artists as Redon, Rousseau, and Ensor. In short, circa 1860 to 1910 represents a sort of Second Renaissance, during which the Impressionists and Post-Impressionists discovered new ways in which to convey greater optical reality by fragmenting (and/or simplifying) color and form and by using these for their own sake, for their sensory and emotional impact, for their expressiveness.

Picasso followed the structural leads suggested by Cézanne, who "wished to make out of Impressionism something solid and durable." Matisse looked more to Gauguin and Lautrec for his less intellectualized, more organic, plastic values: a delight in sensuous color and flowing line. It is ironic that he was pejoratively labeled a "Fauve" (literally, a wild beast) just as, a few years later, Picasso was labeled a "Cubist." Through the early years of this century, these two, more than any others, continued and led the revolution against pictorial realism and beyond it, toward pure abstraction. Indeed for another forty years—that is, up to about the middle of the twentieth century—the two most powerful art currents will remain Cubism and Expressionism: Cubism, leading to Dutch de Stijl (particularly Mondrian), Russian Constructivism, Italian Futurism, the German Bauhaus, Hard-Edge, Minimalism, etc.; and Expressionism, of which Matisse and other so-called Fauves represent the most joyous flowing line and flamboyant happy color, as opposed to the more tortured line and typically muddier color associated with North European Expressionists. However, we will see these two main currents converge, not only in Surrealism and later in Abstract Expressionism, but in the work of Picasso and Matisse themselves. Picasso may at one moment be classified an Expressionist and at another a Surrealist; and Matisse, similarly, an Expressionist and then a near-Cubist and/or Formalist. But one of the things this book is about, especially in relation to Pollock, is the meaninglessness of such labels. They work only up to a point, the same point as such seeming oppositions as Classicism and Romanticism. Then one has to face the content of unclassifiable work, that not only of a Picasso or a Matisse but of any artist big enough to contain both an objective and a subjective world.

While these various discoveries were being made in Europe—most of them by the time of Jackson Pollock's birth, just a year before the Armory Show—little by way of really adventurous esthetic discovery had taken place here. The main line of American painting had been and continued to be realistic. Except for an underground avant garde, working in

abstract modes deriving mostly from European contact and examples, the revolution here was in subject matter rather than in form.

Remember that then there was no network of fast mass visual communication. Even techniques for reproducing pictures were crude and expensive. When contemporary avant-garde art was reproduced, it got into such comparatively highbrow magazines as those which Charles Pollock had been sending to his brothers or even smaller, more specialized periodicals. There were no well-printed, wide-ranging large-circulation magazines. What existed—*Street and Smith, Saturday Evening Post, Collier's*—was not aimed at a public with an international cultural orientation. That audience did not exist. On the contrary, the popular audience expected its art to be as illustrative, topical, and immediate as that day's big-city newspaper photographs. Many of the American artists who satisfied these requirements were excellent draftsmen and even powerful painters, but, obviously, within this context, not one was an originator or esthetic revolutionary; not one changed the history of art as had the Impressionists, Post-Impressionists, Fauves, and Cubists.

The Americans who had learned from the newest traditions, Cubism and Expressionism, and had practiced them throughout the 'teens, twenties, and thirties—Marin, Maurer, Russell, Macdonald-Wright, Hartley, Joseph Stella, Weber, Dove, Covert, O'Keeffe, Davis, etc.—were all in a sense artists' artists, appealing to each other and to a specialized audience. It was the Realists, along with the Academicians, who continued to have broad appeal, receive mural commissions, illustrate books and periodicals, make posters, have articles written about them in popular publications. Only after World War II, with Jackson Pollock and his generation and with the advent of more efficient and knowledgeable mass media, is the avant garde given attention and publicity even as the work is being produced. What we will then observe is technology in mass media eliminating the time lag.

It is not surprising that in 1926, when Charles Pollock went to New York to continue his art education, he enrolled at the Art Students

League. Despite its French Renaissance–style building (at 215 West 57th Street, between Broadway and Seventh Avenue), the League was, some fifty years after its establishment, by far the most vital, as well as the largest, art school in the United States. Nor is it surprising that Charles selected a semi-Academic, semi-Realistic teacher. This kind of work— "visible" and therefore "successful"—was typically what was being taught. Nor, finally, is it surprising that, when Jackson joined his brother at the League four years later, he would—after sculpting for a few weeks at the tuition-free Greenwich House—enroll with the same man. His name was Thomas Hart Benton.

At the time of the Armory Show Benton had just returned from Europe and was working in the abstract Cubist style of his friend Macdonald-Wright. However, although he lost interest in these particular experiments with form and color and the optical theories that went with them, he never stopped seeking new theories and rules for the perfect painting. Increasingly he applied such Renaissance principles as foreshortening, perspective, and chiaroscuro to American subject matter—an attempt to pull native Realism back into the Academy. His friend and apologist Thomas Craven, with whom he had shared a studio, quotes him as saying of this period, "I wallowed in every cockeyed ism that came along and it took me ten years to get all the modernist dirt out of my system." The "modernist dirt" came from the big cities, particularly Paris and New York. Benton preached a return to the purer dirt of Renaissance Italy as well as that of his native Missouri. In his autobiography he speaks of the Stieglitz group (Marin, Hartley, O'Keeffe, Dove) as "an intellectually diseased lot, victims of sickly rationalization, psychic inversions, and God-awful self-cultivations." Again and again he baits city people, whom he equates with foreigners, socialists, intellectuals, degenerates; and conversely embraces rural hairy-chested hard-drinking masculinity. All of this he does with such great energy and enthusiasm that one is almost distracted from his limitations and crudities as a thinker.

Perhaps it was Benton's exaggeratedly tough masculine stance which

appealed to Charles and Jackson Pollock; perhaps, too, it was his success. Like their father, Benton had come from a small Midwestern town (Neosho, Mo.). Unlike him, Benton had managed, against the same great odds, to gain recognition and to "show" the city people. By the twenties he was already planning *My American Epic in Paint,* a series of sixty-four historical panels (of which sixteen were completed), and doing rural landscapes and portraits of "American types." In this last category, even such a comparatively small work as the Whitney Museum's *The Lord is My Shepherd* (1926) illustrates very well Benton's strengths and weaknesses. The idea of the painting is obvious, even crude. In front of a sampler bearing the title legend, a humbly dressed old couple sit with heads downcast finishing a sparse meal. They look past each other in silence. They have nothing to say, nowhere to go; no shepherd can lead them anywhere but to death. Compared with realistic portraits of the elderly by Rembrandt and Hals or the American Eakins, Benton's old man and woman are not seen in depth or with any large degree of compassion. They are stylized props used to illustrate a message. What virtues the painting has are formal, as though part of a preconceived layout rather than emerging from the subjects themselves: the strong colors, the line of the man's slightly stooped silhouette against the simple curve of the chairback, the rhythm of folds in his sleeve and his wife's dress and the knuckles of both their hands, the placement of objects on the table and the couple's own placement in the overall composition. Indeed the power of the couple's hands, and particularly the exaggerated size of the man's, seems to contradict the sentiment of the painting. Benton's own energy and power are inconsistent with that of his subject. This inconsistency, this continuing interest in stylized abstraction (while publicly denying it) and, particularly, in rhythmic composition, may also explain in part Jackson Pollock's admiration for an artist who in retrospect stands for values mostly opposed to those which eventually became Pollock's own.

Through the late twenties and the thirties Benton's work became more and more satirical, even grotesque. Just as his "straight" portraits

lack depth and compassion, his satire lacks the steady penetrating gaze and implicit positive values of a Goya or a Daumier. On one hand, Benton was in love with the energy and scale of America (its revivalist meetings, dance halls, movie houses, sporting events, and other subjects which interested the Realists); on the other hand and at the same time, he was revolted by these phenomena. His satire is often as ambivalent as Sinclair Lewis's writing of the period. For a while Benton scoffs equally at the "effete" and "radical" city (*e.g., City Scenes*) and the rural South and wild West (*Susanna and the Elders*), at the reformer and the racketeer, at popular and highbrow entertainment. Revealingly he writes: ". . . when I take stock of myself, apart from alcoholic drinks and the equally intoxicating effects of words, I find that I don't believe anything very much."* The Man from Missouri barely believes what he sees: in his eyes regional subject matter will not become transcendently universal, it will be reduced to local color.

During the first year Jackson Pollock was in Benton's Life Drawing, Painting, and Composition class, working five evenings a week and subjecting his work to criticism as much as twice a week, it is unlikely that the student would have been as aware of his teacher's inadequacies and prejudices as of his vitality. Benton was ingratiating. He didn't criticize unless he was asked to. Many nights he ran up the five flights of stairs to Studio 9—stinking, even out in the corridor, of the sulfur from egg tempera, a favorite medium of his—and shouted from the doorway, "Anybody want criticism?" If no one answered, he'd turn around and leave without going into the studio.

In answer to a questionnaire published a dozen years later, Pollock said, "My work with Benton was important as something against which to react very strongly, later on; in this, it was better to have worked with him than with a less resistant personality who would have provided a much less strong opposition. At the same time, Benton introduced me to Renaissance art."** Notice the phrase "later on": at first Pollock was a

* See Bibliography No. 16.
** See Bibliography No. 1.

devoted student of Benton, not, as is often stated, a rebel against him. As we look at Pollock's sketchbooks of the thirties—probably done subsequent to his classes with Benton, but nevertheless related to them— sheet after sheet is filled with copies of High Renaissance and Baroque studies of stylized drapery and the human body, many by Rubens, Rembrandt, late Michelangelo, Tintoretto, and mostly El Greco, all favorites of Benton, particularly the last three. These studies are sometimes reduced to cubes and simplified outlines in accordance with Benton's use of exercises by Dürer, Schön, and Cambiaso. Whether the drawings are of drapery, a single figure, or a group, typically they emphasize the rhythmic energy of the subject, frequently by the use of strong diagonals. On some sheets freer, rougher, more personal and expressionistic drawing appears along with the studies. On others, recognizable self-portraits are incorporated in the compositions. Either way, whether by introducing his emotional self or his literal self, it is clear that however accomplished Pollock's draftsmanship had become under Benton's tutelage, he wanted also to express something more personal than was possible within the framework of drawings based upon Renaissance or even Baroque masters.

Few of Pollock's oils survive from the middle thirties. In those that do, such as *The Covered Wagon* and *Going West,* Benton's influence is clear. So is that of El Greco, a Baroque forerunner of Expressionistic distortion on whose work so many of the drawings in Pollock's sketchbook are based. And so, finally, is that of Albert P. Ryder, that native Expressionistic sport whose work is intensely personal and compressed, yet swirling and exploding out into some larger world beyond the self. Pollock later described Ryder as "the only American master who interests me."* The title *Landscape with Rider,* of about the same period, might have been intended as a verbal and visual pun. As in Ryder's work, Pollock's subject matter is not literal and the painting values are extremely plastic.

These early sketches with their personal intrusions, these oils with their groping for the self within American subject matter, came—whether

* See Bibliography No. 1.

directly or indirectly—from Benton's classes. Throughout this work we see Benton's emphasis on Renaissance draftsmanship and composition, echoes of Michelangelo in the use of foreshortening, perspective, and chiaroscuro. But beyond classroom studies and formal lectures, perhaps during coffee breaks (even when Pollock was clearing tables in the cafeteria to earn part of his tuition), perhaps during visits by the students to Benton's home, more must have rubbed off—Benton's own "Americanness."

After Jackson's first year at the League, he wrote Charles a postcard from Fulton, Missouri, on June 10, 1931, while on a hitchhiking trip to Los Angeles with Manuel Tolegian, now also enrolled at the League:

Seeing swell country and interesting people—haven't done much sketching— experienced the most marvelous lightning storm (in Indiana) I was ready to die any moment. This Missouri state is most impossible to catch a ride in—and there's four thousand bums on the highway. Tried to catch a freight in Indianapolis and got thrown out of sight the damned thing was going too fast— spent one night in jail—haven't seen Tolegian in five days—think he's ahead of me.

Before the end of June, in a letter to Charles and Frank he wrote:

My trip was a peach. I got a number of kicks in the but and put in jail twice with days of hunger—but what a worthwhile experience. I would be on the road yet if my money had lasted. I got in Monday afternoon exactly three weeks after starting. The country began getting interesting in Kansas—the wheat was just beginning to turn and the farmers were making preparation for harvest. I saw the negroes playing poker, shooting craps and dancing along the Mississippi in St. Louis. The miners and prostitutes in Terre Haute Indiana gave swell color—their both starving—working for a quarter—digging their graves.

I quit the highway in southern Kansas and grabbed a freight—went through Oklahoma and the Panhandle of Texas—met a lot of interesting bums —cutthroats and the average American looking for work—the freights are full, men going west men going east and as many going north and south a million of them. I rode trains through to San Bernardino and caught a ride into Los Angeles. Tolegian made the trip in 11 days he got a thru ride from Pueblo to L.A. I guess he had a fine trip—neither of us did much drawing.

The "swell color"—local, no doubt—of the miners and prostitutes in Terre Haute, and the "interesting bums" in the Texas Panhandle are recognizable as responses that may well have been inspired by Benton. The excitement of being "on the road" would have come more probably from Jackson himself. He loved the feel of moving fast through the countryside in a car or truck and was to do a lot of driving, some of it restless and reckless, right up to the moment of his death.

That summer after Jackson got home he and Tolegian worked as lumberjacks at Big Pines, Calif. Before returning to New York, Jackson wrote Charles again:

> *The folks have probably told you that I have been cutting wood—I have finished up the job today—and after figuring things out there is damned little left—barely enough to pay for my salt—at any rate I'm built up again and feel fine. I wish you and Frank could have gotten out for the summer—its quite a relief. I guess the short stay in the country helped. I haven't done any drawing to speak of. Some more study with Benton and a lot of work is lacking—the old bunch out here are quite haywire—they think worse of me tho. Sande and Loie [Sanford's fiancée] were in San Francisco to see Rivera's mural but found it impossible, it being in a private meeting room for the Stock Exchange members. . . .*
>
> *I don't know what to try and do—more and more I realize I'm sadly in need of some method of making a living—and its beginning to look as tho I'll have to take time off if I'm ever to get started. To make matters worse, I haven't any particular interest in that kind of stuff. There is little difficulty in getting back there—and I suppose I can find something to do—what is your opinion? The trip through the country is worthwhile regardless of how I might have to make it. I landed here with a dime but could have made the trip easily on ten dollars. . . .*
>
> *Dad still has difficulties in losing money—and thinks I'm just a bum—while mother still holds the old love.*

The last short paragraph—a single compressed sentence—is the knottiest in this letter to his eldest brother, who along with Benton is at this time one of the two surrogate father figures in his life. After wondering, earlier in the letter, about what he is going to do, how he will make a

living, Jackson writes in a confused spirit of self-justification and self-accusation, as well as father-justification and father-accusation: "Dad still has difficulties in losing money." The syntax is sloppy, but the intention is clear. Jackson is really saying, *Even though* my father loses money, he "thinks I'm just a bum." All this intense compression of the eighteen-year-old boy's conflicted feelings precedes the final ellipsis: "while mother still holds the old love." One wants to ask if she holds it for Jackson or from him, or for or from Jackson's father.

Charles Pollock has said that his mother encouraged him and his brothers to do, to become what they wanted. However, with that encouragement and love went, one suspects, the condition that her sons be successful, able to support themselves and their families better than their father had supported his. This condition—maybe explicit, but more likely implicit—was both crippling and motivating. With Jackson, as with some of his brothers, it may well have been a contributory factor in his need to drink, to be "manly" at such an early age. And very early on it must also have contributed to Jackson's desire to be a great painter—not just a good one, but a great one, one who would change the history of art. This ambition grew steadily from Jackson's late teens until his thirties, when it was realized. It is important to remember, though, that during these years it is always there, however ambiguously presented. The need to *show* mother, father (for only a short time longer), brothers, friends, the world, by means of his painting is one aspect of his ambition; the need to *shock* them by behavior is another.

After the return trip to New York—filled with as much of the local color Benton had taught him to look for as with his own response to landscape and space—Jackson registered once more at the League, now in Benton's class in Mural Painting, on a tuition loan arranged by his teacher and partially paid for by cafeteria work.

This year, from nine to twelve-thirty, six mornings a week—with two of criticism by Benton—Jackson again faced the Renaissance, trying to absorb the laws of composition in the work of the masters and yet

struggling still to express himself, to resolve the conflict between given laws and personal necessities. Thus, except for Pollock's introduction to greater scale, the second year was pretty much a repetition and extension of the first. However, an understanding of scale was extremely important to his later development. For laymen—and indeed for too many so-called "muralists"—scale is simply a matter of size, a sketch is too often blown up to fit a space. But for a true artist, scale is part of the conception of a work, one of the factors which determines its nature. Such an artist understands that forms, colors, textures, all the elements of composition, change qualitatively as they change quantitatively; that what is exciting or appealing on a small surface may not be so when simply enlarged. Pollock was beginning to learn these lessons, to face the problems inherent in keeping all of a large surface—or one, anyway, of a *particular* size—alive and interesting.

A friend of Jackson's at the League, Whitney Darrow, Jr., now a *New Yorker* cartoonist, remembers: "Jackson drew with a real Benton-esque hollow-and-bump muscularity—always with frenzy, concentration, wild direct energy. His work was rough—but direct, again—never polished or graceful. His approach was very much Benton's: clay models of a scene painted black and white to study light on figures made from live models. Exploring muscles of model—on stand in class—by touching the model. (The ticklish ones didn't sign up for Benton's classes.)"

Another classmate, Axel Horn, amplifies: "The 'hollow and the bump' had a symbolic significance like 'yin and yang.' It expressed for us the polarity from negative, recessive softness to positive, solid, projecting forcefulness." Horn even speaks of Jackson's personality transformation when drunk as the "hollow" becoming the "bump."

Darrow continues: "There was that pride in being a Westerner. Like Benton, Jackson looked down then on the East and Europe. He was made monitor of our class in the fall. He was a very gentle man, considerate, thoughtful, humorous—unless drunk, when he was often violent and quarrelsome. One time he got into some kind of fight with a policeman.

I was going to be a character witness, but I was never called to appear before the judge. Also I heard from our mutual friend Tolegian that he woke up one night and found Pollock, who had entered his apartment, standing over him with a drawn knife. Well, that's hearsay."

If this is hearsay, there are other first-hand stories of Jackson's violence. He tried to throw Guston off a roof. He tried to push Baziotes out a window. He tried to strangle Siqueiros.... The operative word is "tried," but he never tried very hard. He never killed anyone, never badly hurt anyone until the time of his own death. Rather he shocked and scared friends to provoke a response, to provoke punishment of himself. Again and again we hear of Pollock hitting friends or strangers only until he is hit back.

Again, in his autobiography (the third revised edition, 1968, which contains much more material on Pollock than earlier editions), Benton shows us still more of Pollock's complex personality. He describes how, first in New York and later in Martha's Vineyard:

> *Jack's appealing nature made him a sort of family intimate. Rita, my wife, took to him immediately as did our son T.P., then just coming out of babyhood. Jack became the boy's idol and through that our chief baby sitter. He was too proud to take money, so Rita paid him for his guardianship sessions by feeding him. He became our most frequent dinner guest....*
>
> *In the summers of the thirties Jack was a frequent and long-staying visitor at our place in Martha's Vineyard, where he helped me with the chores, gardening, painting trim, cutting firewood, and the like. We fixed up a little house where he could live and paint ["Jack's shack" is still there]. He was treated as one of the family and encouraged to participate in all gatherings.... Jack never spoke at these gatherings and, though drinks were occasionally available, rarely touched them. Though plainly intelligent, he seemed to have no intellectual curiosity. He was not a reader. In all the time of our Vineyard intimacy, I never saw him with a book in his hands, not even a whodunit. He was mostly a silent, inwardly turned boy and even in gay company carried something of an aura of unhappiness about him. But everybody liked him just the same. The appeal he had for us was generally shared.*
>
> *Although in our company Jack was quiet and reticent, rumors would oc-*

casionally reach us that he was not always so. Tales, emanating from student parties in New York, revealed a quite different person. Give him sufficient alcohol, it was said, and he became loud, boisterous, combative, and sometimes completely unmanageable.

A rather lengthy anecdote follows concerning a visit to the Vineyard during which Jackson was arrested for disturbing the peace after buying a bottle of gin (intended as a gift for Benton), drinking it, renting a bike, and then chasing girls until he fell off. He was fined $10, paid by Benton.

A year after the publication of Benton's revised autobiography, he was interviewed by a reporter and spoke more brusquely: " 'I don't like to go into the private lives of my pupils. And I don't like to talk about artists, in general. I'll talk about a man's work, but not about him personally. But I guess I can tell you that Jackson was a sweet boy who became a violent alcoholic. He had talent. And I'll tell you another thing. Jackson Pollock was the best colorist America ever had. That's never mentioned about him. His later work? I guess it was all right for *him.*' "*

The differences between Benton's official autobiography and his off-the-cuff statements are more than tonal. There is little doubt in the minds of those who watched Pollock identify more and more closely with Benton that, along with everything else, the older man's heavy drinking influenced his protégé, or at least could be justified as part of the example to be followed. Pollock may well have connected the drinking with Benton's comparative freedom as a painter and his seemingly relaxed, but really driving, relationship with dealers, collectors, and the commissioners of murals. For Pollock, Benton's drinking may indeed have appeared to be a necessary ingredient of the formula for success which Pollock himself wanted so desperately.

In May, when his second year at the League was completed, he again made a cross-country trip. This time going West to see his family he traveled in comparative style—in an old touring car—with his brother

* See Bibliography No. 113.

Charles, a girl named Laura, and Whitney Darrow. Although there had been some talk of a "sketching trip" (which is the way it is usually described in biographical writing on Pollock), Darrow remembers it not as an artistic ramble but as a way to get to California; he himself was included as a paying passenger to help defray expenses. Jackson did, however, bring along a box of hard colored crayons which had to be dipped in water before use. On the return trip, when Darrow drove through the desert, Jackson, lacking extra water for crayon-dipping, would spit on the crayons and then sketch enthusiastically. Some of the time he chewed cut plug tobacco, and both Benton classmates rolled and smoked Bull Durham, lighting the hand-rolled cigarettes with a flick of the thumbnail across a large "kitchen" match. Such Americana was a substantial part of the return in a $100 Ford Darrow bought in L.A. And Darrow remembers Jackson's somewhat ecstatic appreciation of desert earth colors, the detours to see plantations in Alabama and Tennessee and stevedores loading bales of cotton in New Orleans, the hillbilly songs Jackson played on the Jew's harp, the cowboy boots he wore.

While in Los Angeles, Jackson saw little of his father, who was by then a County Road Supervisor, laying out new roads and in charge of some two or three hundred prison laborers. The work was steady but hard, and kept him away from home a great deal. Those who remember LeRoy Pollock from this period say he was a no-nonsense type, very quiet and generally respected. Perhaps the father was too tired to respond much to Jackson's talk about art in general and Benton in particular. Surely at this time his mother was more patient with her youngest son, her last baby. She doted upon his every word concerning art and, more particularly, Benton and other famous teachers at the League.

Before returning East, Pollock and Darrow went to see the Duco murals sprayed by Siqueiros on the cement exterior of the Chouinard Art School. This was at least Pollock's fourth direct contact with work of the Mexican muralists. There had been the references to Rivera in Jackson's long letter of October 22, 1929, to Charles and Frank. The following

year, just before his first trip to New York, Charles had taken him to Pomona College to see Orozco's recently completed *Prometheus* fresco, which Jackson then thought the most important twentieth-century painting. And that same fall, in New York, when Benton and Orozco began murals at the New School for Social Research, Pollock helped support himself by doing "action posing" for Benton, at which time he must also have seen Orozco and his work. A few years later he would watch Rivera paint at the New Workers School on West 14th Street, and then Pollock would join Siqueiros nearby in his "experimental workshop" on the west side of Union Square. Among living artists, this group of Mexican muralists was second only to Benton in profound influence on Pollock's work of the thirties. As Peter Busa, a friend of Pollock's at the League, has observed: "Benton taught Pollock about ideals of beauty; these Mexicans taught him that art could be 'ugly.' "

The relationship of the Mexican muralists to their audience could not have been more different from that of Benton to his. Politically, they moved to the left with their revolution, producing works conceived as propaganda; Benton moved to the right as his country moved to the left during the Depression. Esthetically, the Mexican artists communicated with a tradition of semiabstraction and stylization—reflecting a cultural heritage dating back to the Mayans, Olmecs, and Aztecs. Benton, having embraced abstraction, was turning right once more—towards the Academy.

However, the politically revolutionary content of work by the Mexican muralists ultimately influenced Pollock no more than the politically reactionary content of Benton's work. Though Pollock had seen comparative poverty in his own home and a more generally grinding poverty in his trips across the country, and though he, like so many during the Depression, was attracted to various leftist groups, he never did paintings that were specifically social in orientation and resisted concepts of art as sociology or politics or propaganda. As he said, "painting is not illustration."

Pollock's debt to Siqueiros is obvious in the small highly Expressionistic painting *Woman* (of the late thirties) and to Orozco in the angularly rhythmic paintings and crayon drawings of the same period. However, more important than what Pollock borrowed for a while from any of the Mexicans is the reinforcement of more general ideas about the mural itself, about painting as a wall, an environment. Like Benton, the Mexicans extended Pollock's still-formative ideas as to the possibility of handling a large space in a way that was continuous and lively; like him, they contributed to Pollock's stylistic development. As to the content of Pollock's work, he was still discovering that this could not be learned or borrowed from outside examples but would have to be found within himself.

When Pollock returned from Los Angeles, he registered for the second time in Mural Painting. This was to be his fifth and last term with Benton. As Darrow mentioned, Pollock was made monitor of his class, and was thus exempted from tuition. This arrangement lasted through the fall term. In December Benton stopped teaching to do a commission for the State of Indiana, and in January Pollock registered for painting classes with John Sloan.

Pollock may have respected Sloan as a great Realist, a founder of the Eight, an organizer of the Armory Show, a militant illustrator; but all this was history. We know from Sloan's work of the thirties that, although he had lost none of his proficiency as a draftsman, his style and choice of subject matter had become tamer, more gentle and impressionistic than in the early years of his career. Pollock missed the vitality and ambitiousness of Benton's work, however often that vitality was misplaced and that ambition excessive. Sloan—at the time over sixty, twenty years older than Benton—did not challenge Pollock; he is not mentioned in Pollock's public statements or correspondence, and we know that in February and March Pollock registered for other classes with Robert Laurent in sculpture. This, along with making pottery, would remain an

interest of Pollock's throughout his life—a clue perhaps to his longing for a different, more solid, three-dimensional reality than that which he was to create in his later work. Still more peripheral was an interest in lithography, but, although Pollock made lithographs during the thirties, this was a medium in which he was not comfortable. Typically his lithographs are influenced by Benton's style and subject matter, and to pull them he needed the help of a professional printmaker, usually Theodore Wahl at the League.

Though the relationship with Benton would remain by far the most profound of those Pollock established at the League, he would, before leaving there and later when visiting, meet many other artists whose paths would cross his own in future years. For example, there was a group known as "the Armenians"—the painter Arshile Gorky, the sculptors Raoul Hague and Reuben Nakian—who used to hang around the cafeteria, sometimes joined by their countryman, Pollock's friend Tolegian. Of this group, Gorky, despite some difficulty with English, was particularly eloquent; he liked to match his "poetry" against the tougher, more direct verbal style of his friend Stuart Davis, who taught at the League during 1931–32. Another unusually eloquent talker was the sculptor John Flannagan, whose Irish brogue was a strong contrast to the voices of "the Armenians." One more contrasting voice—hoarse and slightly Italian-accented—came from the young sculptor Phillip Pavia, who would years later found The Club* and include on its panels such other young artists formerly at the League as Harry Holtzman and Will Barnet. But besides those who were around the League as teachers, students, or regular visitors, there were also guest speakers: some, like Lewis Mumford, who dealt with broad cultural themes; others, more specialized, who lectured on artists outside the curriculum (*e.g.,* Mondrian) or on topics of practical interest such as the emerging art program for Rockefeller Center. There was even a reading of "Anna Livia Plurabelle" in 1932 when that sec-

* See Chapter Five.

tion of *Finnegans Wake* was separately published. Some of all this, however difficult to measure, must have rubbed off on Pollock.

Early in 1933, those Pollock brothers in New York (Charles, with his wife Elizabeth; Frank; and Jackson—all struggling to make ends meet in Greenwich Village) received word that their father, only fifty-six, was dying, that there was no hope. On March 6 he died of malignant endocarditis, but they couldn't afford to go to Los Angeles for the funeral. Less than two weeks after his death, Stella Pollock wrote a long touching letter to "My Dear Sons and daughter/Charles and Elizabeth Frank and Jack." In it she mentions having moved her husband's bed across the east windows in the dining room so he could see the snow-capped mountains with green hills below and flowers—in short, the outdoors he loved. She says he never complained despite drenching night sweats and running a temperature all the time. His last pleasures were, as always, simple. Saturday morning he listened to a speech by President Roosevelt and thought it was wonderful, and he listened to the news and music at various other times. Sunday morning he heard the Tabernacle Choir from Salt Lake City, but by about noon he could hardly get his breath, and by evening Marvin (as his mother still called him, though the rest of the family called him Jay) went for the doctor. As he returned with the doctor, his father died in his mother's arms.

Sanford was then nearby visiting his fiancée Arloie Connaway, who had been his Riverside High School sweetheart since 1927. When Marvin called him, both the news and the fact that he had not been at home left him "paralyzed with grief." He expressd his deep sorrow in a letter to his brothers and sister-in-law written about the same time as his mother's but much shorter. He writes that their father's "absence will leave a gap in our lives which can only be filled by our untiring efforts toward those cultural things which he, as a sensitive man, found so sordidly lacking in our civilization. Our beautiful mother is bearing up in a strong courageous manner— She is a most inspiring person. The emotional strain is tre-

mendous—she found tears and consolation in your telegram and seems to find strength in her indomitable love for her sons. . . ."

Though Benton returned to the League in the fall of 1933, Pollock took no more classes with him—or with anyone else. However, along with other students, he did quite regularly join Tom Benton and his wife, Rita, for their "musical Monday evenings" of folk-singing and guitar-playing, with Jackson still doing his best—never very good—on the Jew's harp. And later, when the Bentons settled in Kansas City, Pollock remained in touch with them and continued to visit them during the summer on the Vineyard. A letter from Benton before he left New York indicates his affection for Pollock and encouragement of the young painter:

> *Before I get started on my own stuff and forget everything else I want to tell you I think the little sketches you left around here are magnificent. Your color is rich and beautiful. You've the stuff old kid—all you have to do is keep it up. You ought to give some time to drawing—but I do not somehow or other feel the lack of drawing in the stuff left here. It seems to go without it. Rita has framed your little lithograph and it carries well. See you around the tenth with the others.*

After LeRoy Pollock's death Jackson shared an apartment with Charles and his wife, and in the summer of 1934 he and Charles were on the road again. They covered 8,000 miles in a second-hand Model T Ford, first visiting coal-mining areas in Pennsylvania, West Virginia, and Kentucky; then traveling through the South; then going cross-country to their mother in Los Angeles, and visiting her sister in Iowa on the way back. There was no more talk of local color. The color was the same everywhere—the dismal gray of Depression poverty.

In Los Angeles, Jackson once again showed his interest in sculpture. The old county courthouse had been demolished to make way for a new one, and the sandstone from the old building had been dumped in the Los Angeles River (a "river" only during and just after the heavy winter

rains). Jackson got his friend Reuben Kadish to help him fish a block of sandstone from the river bed. Pollock did some preliminary carving, but, as far as we know, never completed the sculpture.

When Charles and Jackson got back to New York, Sandy joined them. He and Jackson got a small unheated apartment above a lumberyard at 76 West Houston Street and Charles, who had been teaching part-time at the City and Country School, found them a shared job there as janitors at $10 per week. Caroline Pratt, the school's director, and Helen Marot, a teacher there, were extremely sensitive to Jackson's alcoholism and the emotional problems underlying it. Miss Marot had been a social crusader earlier in her life, but now, almost seventy and somewhat disillusioned with mass movements, she had become more interested in psychology, more hopeful for the particular individual than for a general class or group. Both women, but particularly Helen Marot, helped and encouraged Jackson throughout the thirties, one of the most difficult periods of his life aggravated for him, as for almost everyone, by the terrible economic condition of the country, and for artists in particular, by the death of the art market. Janitorial work must have been demeaning enough for men of Sandy's and Jackson's sensitivity, but in addition they had to go on relief and sometimes were even forced to steal fuel and food. Rita and Tom Benton helped by urging Jackson to paint ceramic plates and bowls which she sold in the basement of Frederic Newlin Price's Feragil Gallery. (Price was Benton's dealer and the author of a book on Ryder.) In February 1935 when Pollock exhibited a watercolor called *Threshers* at the Brooklyn Museum, he listed this gallery as handling his work. For a time Jackson worked, too, for the city's Emergency Relief Bureau, as a "stonecutter," cleaning the Saint-Gaudens statue of Peter Cooper in Cooper Square.

By summer, as part of Roosevelt's National Recovery program, the Federal Art Project (like the Writer's Project, Theater Project, etc.) of the Works Projects Administration had been formed. As with other recovery programs, the idea was to create employment. Specifically, the

federal government envisaged as much art as possible in public locations: administrative buildings, post offices, courthouses, schools, hospitals, and so forth. The Project was divided into parts: sculpture, graphics, mural painting, and easel painting. Typically, mural painting attracted mostly artists in the Realistic tradition, including Regionalists and Social Realists, who could fulfill commissions of a given size on a given theme, usually historical or regional. The easel project offered more freedom as to size and subject matter as well as to working hours and conditions. Where muralists were supervised on a daily basis by a senior artist in his studio or in one rented for a specific project, easel painters were permitted to work in their own studios pretty much at their own pace. It is not surprising therefore that artists tending toward greater abstraction, which still meant mostly toward aspects of Cubism and Expressionism, were attracted to the easel project. However, there was much overlapping, and it must be emphasized that the underlying attraction to both painting projects was very simply the need for economic help.

Pollock was fortunate in joining the easel project, where his principal supervisor was Burgoyne Diller. Diller's style, profoundly influenced by that of Mondrian, had, like his master's, emerged from Cubism to pure hard-edged Abstraction. Nevertheless he was tolerant of Pollock's Expressionistic explorations—and also of his rather "romantic" working methods, based usually on waiting for inspiration which sometimes had to be stimulated by alcohol. Pollock was supposed to turn out one painting every four to eight weeks, depending on size, for allocation to public buildings. When these paintings were late or unsuitable, Diller "covered" for Pollock. Somehow, with only brief interruptions, Pollock remained on the Project until the beginning of 1943, when it was discontinued.

Not many paintings of the mid- to late thirties can be located, if they have survived. Charles Pollock owns Jackson's sketch for two murals at Greenwich House, done in oil on wrapping paper in 1933 or 1934. The lower sketch of five musicians is energetically Bentonesque in style as in instrumentation (a banjo or guitar, an accordion, a clarinet, and possibly

two mouth instruments such as an harmonica or a Jew's harp). Then, if one wants to count them as paintings, there are several bowls and plates done under Benton's influence and in his collection along with landscapes done on Martha's Vineyard. The Archives of American Art has a photograph of *Night Pasture,* about which we know neither whereabouts nor dimensions but only that it was done before 1937. It too is Bentonesque in the stylized angularity of the man behind horse and plow, set against a turbulent landscape and sky. Ryder's influence is apparent in the previously mentioned *Landscape with Rider* and in a self-portrait. Finally, there is *The Flame,* dated 1937, and an untitled undated abstraction of about the same time. However, all of these works, indebted as they are to Benton and then Ryder, are consistent in their Expressionistic contours, free brushwork, and movement toward abstraction.

For such work Pollock was paid roughly $100 a month. Over the period from 1935 to 1943 he averaged less than $1,000 a year. But at least he was able to keep on painting. He was able, also, to keep on drinking. Painters who were on the Project remember "check-cashing sprees" not unlike payday binges in the army or navy. Jackson, still only in his early twenties, was once again part of a hard-drinking community, curbed by lack of funds.

Soon after Jackson joined the Project, Charles and his wife, Elizabeth, left New York to go to Washington where Charles would work for the Resettlement Administration. Thereafter he had little contact with Jackson, and Sandy became increasingly close to him. In September they moved into Charles's 8th Street apartment, anticipating Sandy's marriage to Arloie Connaway.

Charles's apartment, where Jackson had lived for about a year after their father's death, was on the top floor of a five-story building owned and well maintained by Sailors' Snug Harbor, a charitable trust for the benefit of needy sailors. It was luxurious compared with cold-water flats the younger brothers had previously shared. The big front room facing north became Jackson's studio (though not closed off until two years

later) and a very small room beside it, his bedroom. Sandy's studio, in the center of the floor-through, was smaller and darker. However, the bedroom he and Arloie had was much larger than Jackson's and in closer proximity to the bath and the kitchen where all of them ate their meals. For almost seven years—from early 1936 until late 1942—Sandy and Arloie remained with Jackson in this apartment, somehow surviving the inevitable friction of close quarters (made even closer when friends, including Philip Guston and Reuben Kadish, came to New York and stayed with Jackson). The problems presented by Jackson's drinking made the situation still more difficult. As will be seen in Sandy's letters, the relationship of the McCoys to Jackson was to become more like that of ideally sympathetic parents than of a brother and sister-in-law.

In the spring of 1936 Siqueiros started a workshop at Union Square. Jackson, his brother Sandy, and at least two of his former classmates from the League, Axel Horn and Mervin Jules, worked there. Horn says* it was

for the express purpose of experimentation with new technological developments in materials and tools. Paints including the then new nitro-cellulose lacquers and silicones, surfaces such as plywoods and asbestos panels, and paint applicators including airbrushes and sprayguns, were some of the materials and techniques to be explored and applied. We were going to put out to pasture the "stick with hairs on its end" as Siqueiros called the brush.

New art forms for the use and exposure to large masses of people were to be initiated. Our stated aim was to perfect such new media even though they might be comparatively impermanent, since they would be seen by hundreds of thousands of people in the form of floats, posters, changeable murals in subways, multi-reproduced graphics, etc.

Spurred on by Siqueiros, whose energy and torrential flow of ideas and new projects stimulated us all to a high pitch of activity, everything became material for our investigations. For instance, lacquer opened up enormous possibilities in the application of color. We sprayed through stencils and friskets, embedded wood, metal, sand and paper. We used it in thin glazes or built it up into thick globs. We poured it, dripped it, spattered it, hurled it at the picture

* See Bibliography No. 122.

surface. It dried quickly, almost instantly, and could be removed at will even though thoroughly dry and hard. What emerged was an endless variety of accidental effects. Siqueiros soon constructed a theory and system of "controlled accidents." ...

Of course, we used all of these devices to enhance paintings with literary content. No one thought of them as ends in themselves. The genesis of Pollock's mature art began to be discernible only when he began to exploit these techniques as final statement.

In addition to Horn's recollections, Mervin Jules recalls Siqueiros's practice of preparing panels by splattering and dripping on them so that this abstractly patterned underpainting would stimulate the figurative imagery to follow. This preparatory technique, and the experiments with "controlled accidents," and the use of "Duco" and other enamels— Siqueiros was, according to the critic Harold Rosenberg, "known locally as 'Il Duco' "—all must have influenced Pollock. However, these new techniques, as well as the dream of making mural-sized paintings, would be repressed until Pollock needed them to express the subject matter he would some ten years later discover in himself. Meanwhile, his parting with Siqueiros was violent. Siqueiros was about to leave for Spain to join the Loyalists, and, according to Horn, a farewell party was given for him in a loft. When someone proposed a toast, he was missing and so was Pollock. Eventually they were found under a table. "Each had his hands around the other's throat and was silently attempting to choke the other into unconsciousness, Jack in a wild exhilarated effort and Siqueiros in a desperate attempt to save himself. Sandy McCoy moved in and with a deft right to the jaw unlocked Jack's fingers. ..."

Toward the end of 1936, while living for a short time in a $5-per-month farm house near French Town, New Jersey, Jackson wrecked a Ford which Charles had given him before leaving New York and did $80 worth of damage to the car he hit. By early the following year, at the urging of Caroline Pratt and Helen Marot as well as Sandy, he began psychiatric treatment for alcoholism.

In February, soon after beginning this therapy, Jackson—along with

Sandy, Philip Guston, and Manuel Tolegian, among others—exhibited at the Temporary Galleries of the Municipal Art Committee. At this short-lived gallery, run without commission for the benefit of artists working in the city, Jackson showed a Bentonesque tempera painting called *Cotton Pickers*. Sometime between this exhibition and the following summer Charles Pollock moved to Detroit to do layouts and political cartoons for the United Automobile Workers newspaper. In July, Jackson, visiting the Bentons on Martha's Vineyard, was arrested for drunkenness and disturbing the peace. On July 27, 1937, less than a week after this incident and apparently without knowledge of it, Sandy wrote Charles in Detroit explaining why he couldn't accept a job opening on the newspaper there:

Jack has been having a very difficult time with himself. This past year has been a succession of periods of emotional instability for him which is usually expressed by a complete loss of responsibility both to himself and to us. Accompanied, of course, with drinking. It came to the point where it was obvious that the man needed help. He was mentally sick. So I took him to a well recommended Doctor, a Psychiatrist, who has been trying to help the man find himself. As you know, troubles such as his are very deep-rooted, in childhood usually, and it takes a long while to get them ironed out. He has been going some six months now and I feel there is a slight improvement in his point of view. So without giving the impression that I am trying to be a wet nurse to Jack, honestly I would be fearful of the results if he were left alone with no one to keep him in check. . . . There is no cause for alarm, he simply must be watched and guided intelligently. . . . Jack is at the Vineyard for a three week vacation. I am sure it will do him much good.

In October, Jackson again exhibited a single painting, a watercolor, at the opening of the new WPA Federal Art Gallery. The following February Sandy wrote Charles, whom Jackson had stopped to see in Detroit after a Christmas visit to the Bentons in Missouri:

Our plans for the summer are very indefinite except for one important thing which is to get Jack out of New York. It has only been with a very commendable and courageous effort on his part that he has held himself in check. I

don't remember whether I told you but in the first part of the winter he was in serious mental shape and I was worried as hell about him. He's in pretty good condition now, doing some fine work but needs relief badly from New York.

However, Jackson's alcoholism became worse. On June 9, 1938, he was dropped from the Project for "continued absence," and two days later, with the help of his psychiatrist and Helen Marot, he became a patient at the Westchester Division of N.Y. Hospital, known as Bloomingdale's. There, during the summer, as part of his therapy, he drew and made some hammered copper bowls and plaques.

The Bentons had hoped Jackson would be able to spend part of the summer with them. They wrote him from Kansas City in the fall:

I saw your stuff in N.Y. and later a picture that my brother has. I am very strongly for you as an artist. You're a damn fool if you don't cut out the monkey business and get to work.

Tom

I was worried about you for 4 months, and can't tell you how relieved I was to hear from you.

We all hope & pray that you settle down & work—& we mean work hard paint hard— So few have the ability to say something interesting thru their work— You have— Tom & I & many others believe in you. . . .

Tom gave up drinking last July and this summer he had a most productive one and greatly improved. . . .

Do let us hear from you. Remember our house is always opened for you. . . .

Rita

Despite Benton's example at this time, Pollock continued to drink, even after being readmitted to the Project in late November. Early in 1939 Helen Marot, by now approaching her mid-seventies, persuaded him to reenter psychiatric therapy and, through Mrs. Cary Baynes, a mutual friend, she persuaded Dr. Joseph L. Henderson, a Jungian who had recently set up practice in New York, to take him on as a patient. The doctor writes from memory (i.e., without having taken notes at the time

and without having either numbered or dated the drawings which will be referred to) in his unpublished lecture "Jackson Pollock: A Psychological Commentary" (1968):

Early in my psychiatric career, a friend asked me to see a young artist professionally while he was convalescing from a mental breakdown. Since he was extremely unverbal, we had great trouble in finding a common language and I doubted I could do much to help him. Communication was, however, made possible by his bringing me a series of drawings illustrating the experience he had been through. They seemed to demonstrate phases of his sickness and they were followed by others showing a gradual development during therapy into a healthier condition, a psychological reintegration, which allowed him to recover to a considerable extent during the next two years. In contrast to these there were a number of sketches which reflected the influence of Picasso in his "Guernica" period, or of Orozco, and would have to be classified as experimental works....

Dr. Henderson wrote* about this introduction:

...It sounded as if I had set Pollock the task of portraying the unconscious in these drawings. This was not the case. He was already drawing them, and when I found it out, I asked for them. He brought me a few of the drawings each time in the first year of his treatment, and I commented upon them spontaneously, without establishing any psychotherapeutic rules. He did not have free associations, nor did he wish to discuss his own reactions to my comments. He was much too close to the symbolism of the drawings to tolerate any real objectivity toward them. I had to be content with saying only what he could assimilate at any given time, and that was not much. There were long silences. Most of my comments centered around the nature of the archetypal symbolism in his drawings. I never could get onto a more personal level with him, until after he stopped bringing the drawings. So you see my role was mainly to empathize with his feeling about the drawings and share his experience without trying to "interpret" them in the ordinary sense. They provided a bridge to communication, and it gave him the assurance that at least one other person understood something of their abstruse language.

* Letter of Nov. 11, 1969, to the author.

Pollock saw Henderson once a week regularly and, as necessary, the doctor "fitted in some extra appointments." In the section of the lecture devoted to slides of individual drawings, Dr. Henderson starts with three representing (1) "violent agitation," (2) "paralysis or withdrawal of vital energy," and (3) "pathological form of introversion." Henderson comments:

Following a prolonged period of representing human figures and animals in an anguished, dismembered or lamed condition, there came a new development in the drawings Pollock made during therapy. This was not merely the dissociation of schizophrenia, though he was frequently close to it. It has seemed to me a parallel with similar states of mind ritually induced among tribal societies or in shamanistic trance states. In this light the patient appears to have been in a state similar to the novice in a tribal initiation rite during which he is ritually dismembered at the onset of an ordeal whose goal is to change him from a boy into a man.

This passage in Henderson's paper is the only one where the word "schizophrenia" occurs and then only in this qualified context. The widely publicized statement of art historian C. L. Wysuph that "Henderson diagnosed Pollock's illness as schizophrenia" is therefore inaccurate, as it has been labeled by Henderson himself. Furthermore, the title of the monograph in which the statement appears, *Jackson Pollock: Psychoanalytic Drawings* (1970), is misleading, since the drawings in it were not done specifically for Henderson but relate to others done both before and after this time, including some periods when Pollock was also in therapy.

Perhaps Dr. Henderson himself should have been reminded of this. In the remaining drawings discussed in his lecture—drawings, it must again be emphasized, neither numbered nor dated—he sees a movement towards relative health: new ordering symbols (the cross, the circle, the square, the mandala, the *axis mundi*), opposing elements brought increasingly into a harmonious whole, including Jung's archetypal dominants of square and circle. Of one image Dr. Henderson remarks, "Those pathetic upper limbs reaching upward toward an unfeeling purely schematic

female torso must denote a problem left unsolved and perhaps insoluble, a frustrated longing for the all-giving Mother."

Whether or not one agrees with Dr. Henderson's interpretations, one can at least substantially accept the biographical information which emerges toward the end of the lecture:

> *...I shared his transference with an older woman friend of his.... I never met Miss Marot, but I talked to her occasionally by telephone when there was some question as to whether the artist was being adequately cared for, especially during the times when he was drinking heavily. We invariably found that his frequently missing attention to reality was admirably being supplied by his brother (Sanford Pollock) near whom he lived and with whom he shared a studio [apartment]. If his brother carried much of his reality function, it became clear to me as time went on that he relied upon his woman friend for his need to give and receive feeling, while he relied upon me mainly to help him structure ego-consciousness and his thinking function toward achieving a more rational and objective view of his life and his art. His own highly developed function of intuition needed no help from anyone, but did need to be rescued from time to time from a crucifying sense of isolation....*

Dr. Henderson goes on to quote a phone call from Helen Marot: " '... I saw Jackson Pollock last night and he talked for hours in a stormy but fascinating way about himself and his painting. I don't know but it seems to me we may have a genius on our hands.' " The doctor comments:

> *I was inclined to minimize this possibility because of my anxious concern with the strongly pathological elements I saw in his material, but I thanked her and I agreed to discuss with her some practical ways in which she or I could help him with his career. Only a week or so later, Pollock told me she had died suddenly. The effect of this loss was to push him back again into some of his old troubles, with an alcoholic binge as the outward symptom. This was not, however, entirely regressive in as much as a truly glorious wake seemed justified for such a special friend. Pollock saw the humor of this himself and I knew that he would come out of this period without any lasting damage to his psychic health. Not long after this, I had to tell him that I would be leaving New York in four months and would have to refer him to another analyst at that time. I greatly*

feared this would throw him into another regressive phase, but it did not, so far as I know. He was no longer bringing me his drawings at this time, and our attention from thence forward dwelt upon his personal conscious problems, rather than upon the imagery of the unconscious. . . .

One questions the theory of "a truly glorious wake" and, even more, the possibility of Pollock's having seen "the humor" in it. However, again, whether or not one agrees with Dr. Henderson's interpretations, one can acknowledge some positive contribution from his therapy for Pollock—disturbed as he had been and would be again—to have survived both Helen Marot's death and the doctor's departure for the West Coast. Henderson may have increased Pollock's awareness that since young manhood he had been using art to resolve the conflicts within himself—not only to confirm his sanity but to save his life. However, from here on Pollock would more and more profoundly equate his work with his life, and periods of nonproductivity with death.

The one gouache painting and sixty-nine sheets of drawings in various media (twelve done on both sides of the sheet) which Pollock showed Henderson are, of course, interesting esthetically as well as clinically, interesting not only image by image—animal figures, totems, swastikas, mandalas, yin–yangs—but sheet by sheet in the way the images are laid out on the page. In this work, as in the paintings of a year or two before (*e.g., Masked Image* and *Birth*) Pollock is extremely inventive, endlessly improvising on the bull, the horse, the serpent, the bird, dancing figures, and "primitive" designs from the North American and Mexican Indian. Many of the sheets seem to have been worked in a circular way—or, if not actually turned by the artist, can be read from more than one side. The Benton influence is no longer apparent, that of the Mexican muralists (particularly Orozco) is strong, as is that of Picasso: the Picasso of the *Minotauromachy,* and *The Dream and Lie of Franco* and particularly *Guernica* (including the studies for it); Picasso at his most passionate and powerful; Picasso closest to his own dreams and nightmares; a Picasso who has learned from Surrealism; a Picasso who will at

first dominate and then liberate Pollock. Yes, in Pollock's continuing dialogue with art history, the time lag is shortening, he is moving closer to himself. Whether helped by Picasso's example, or by analysis, or by the admittedly destructive and temporary but nevertheless freeing use of alcohol, or all three, Pollock—now only in his late twenties—is already close to making the final step toward the creation of his own image as an artist, the presentation of himself on canvas.

While in therapy with Dr. Henderson, the external pressures affecting Jackson were as great as the internal ones. For example, in March of 1939 Sanford wrote to Charles:

We have been investigated on the project. Don't know yet what the result of it will be. Should they ever catch up with my pack of lies they'll probably put us in jail and throw the key away! They are mighty clever at keeping the employees in a constant state of jitters. Jack is still struggling with the problems of painting and living.

In July the Project was reorganized as the WPA Art Program, with a proviso that artists employed for more than eighteen months be dismissed. Sandy was dropped in August and collected relief until he was readmitted at the end of the year. Jackson hung on until May 22, 1940. In June, Sanford wrote to Charles:

We on the project have been forced to sign an affidavit to the effect that we belonged to neither the Communist or Nazi parties. A wholly illegal procedure. And now I understand the army is snooping around the Project finding out how the artists could fit into the "Defense Program."

Jack is still off the Project. It would be necessary for him to get on relief before he could get his job back. And the relief bureau is making it as miserable as possible for single men. Trying such tricks as suggesting that the Army has openings for healthy young men.... I would just as soon that Jack doesn't get tangled up in the Relief mess and instead have a good healthy summer in the country. It makes any one nervous to have to go through such an humiliating experience and Jack is especially sensitive to that sort of nasty business.

During the summer Jackson wrote to Charles:

I haven't much to say about my work and things—only that I have been going through violent changes the past couple of years. God knows what will come out of it all—it's pretty negative stuff so far.... I haven't been up to any of those competitions. Will try when my work clears up a little more. Phil Guston and his wife have been winning some of the smaller jobs. I'm still trying to get back on the project and it doesn't look any too damned good. At best it will be another four or five weeks, and then it may be the army instead.

Jackson got back on the Project in October and during the same month registered for the draft. Sanford wrote to Charles:

They are dropping people like flies on the pretense that they are Reds, for having signed a petition about a year ago to have the C.P. put on the ballot. We remember signing it so we are nervously awaiting the axe. They got 20 in my department in one day last week. There is no redress. The irony of it is that the real Party People I know didn't sign the damn thing and it is suckers like us who are getting it. I could kick myself in the ass for being a damn fool—but who would of thought they could ever pull one as raw as that. Further more, when they get us in the Army with the notion that we are Reds you can bet they will burn our hides. Needless to say we are rigid with fright.

The tensions surrounding the Project and the draft were compounded by Jackson's having to adjust to a new doctor, Violet Staub de Laszlo, another Jungian, to whom Henderson had referred him, having very consciously chosen a woman. Dr. de Laszlo had ideas about the army making a man of Jackson, making him face his responsibilities, and so forth. Despite the history of alcoholism, psychiatric therapy, and brief institutionalization, it was only with great reluctance that she wrote his draft board the letter that, in April, would assure his being classified IV-F.

The previous May, in yet another letter to Charles, Sanford had written: "Jack is doing very good work. After years of trying to work along lines completely unsympathetic to his nature, he has finally dropped the Benton nonsense and is coming out with an honest creative act." Then the good work must have been mainly what he had done while with Dr.

Henderson. But now in July 1941, more than a year later, Sanford would again write to Charles, giving him for the first time detailed information regarding Jackson's psychiatric problems and esthetic progress:

> ... *In the summer of* [1938] *he was hospitalized for six months in a psychiatric institution. This was done at his own request for help and upon the advice of Doctors and with the help and influence of Helen Marot. For a few months after his release he showed improvement. But it didn't last and we had to get help again. He has been seeing a Doctor more or less steadily ever since. He needs help and is getting it. He is afflicted with a definite neurosis. Whether he comes through to normalcy and self-dependency depends on many subtle factors and some obvious ones. Since part of his trouble (perhaps a large part) lies in his childhood relationships with his Mother in particular and family in general, it would be extremely trying and might be disastrous for him to see her at this time. No one could predict accurately his reaction but there is reason to feel it might be unfavorable. I won't go into details or attempt an analysis of his case for the reason that it is infinitely too complex and though I comprehend it in part I am not equipped to write clearly of the subject. To mention some of the symptoms will give you an idea of the nature of the problem, irresponsibility, depressive mania (Dad), overintensity and alcohol are some of the more obvious ones. Self-destruction, too. On the credit side we have his art which, if he allows it to grow, will, I am convinced, come to great importance. As I have inferred in other letters, he has thrown off the yoke of Benton completely and is doing work which is creative in the most genuine sense of the word. Here again, although I "feel" its meaning and implication, I am not qualified to present it in terms of words. His thinking is, I think, related to that of men like Beckmann, Orozco and Picasso. We are sure that if he is able to hold himself together his work will become of real significance. His painting is abstract, intense, evocative in quality. . . .*

Sandy's description of Jackson's latest work suggests his assimilation of the Cubist tradition (particularly the recognition of a flat picture plane) and that of Expressionistic distortion. Though Beckmann's work was not nearly as well known as Picasso's, Pollock would surely have seen it in art publications and probably also at Curt Valentin's Bucholz Gallery and at the Museum of Modern Art. As with Picasso, Pollock would have been moved by Beckmann's intensely personal response to public events.

Neither Beckmann nor Picasso is at all literal or topical in presenting his subject matter. Each uses timeless images. For example, in Beckmann's *Departure* triptych, the trussed and mutilated figures, the man in a garbage can (whom we see now as Beckett-like), the blindfolded messenger (bell-boy), the executioner, the drummer—all in modern dress—are as eternal as the fisher-king, oarsman, and mother and child who appear in the bright center panel. With Beckmann, just as Sandy said about Jackson's own work, we "feel" it. We cannot "read" it and paraphrase its meaning, but we can get a general sense *from the entire painting* of hope within the flanking context of dark horror and despair. Similarly, with *Guernica* it would be impossible to state the exact meaning of the decapitated warrior still holding a broken sword or of the flower growing beside it, or the speared horse, or the bird with beak upturned as though feeding, or the dispassionate bull, or the shrieking women, one holding a dead child, another a kerosene lamp toward the center of the action where an electric light already shines without casting much light. However, again *from the entire painting,* from its style, its fragmentation, raw living line, lack of color (only black, white, and gray), as well as its subject matter, we get a sense of animalism gone wild, of horses and humans brutalized while the bull (usually associated with brute force) remains calm and aloof, a presence as mysterious as the eye-shaped glow from the electric bulb which sheds as little light on all of this as the more primitive kerosene lamp thrust into the picture (or, in earlier studies, the candle or the match).

There is no doubt that the widely reproduced images in *Guernica,* with their strong despairing blacks—probably the most powerful and best known of the twentieth century, if we exclude photographic images —influenced Pollock's paintings of the late thirties, early forties, and later. But there again the point is not so much the specific influence of Cubism and Expressionism but rather the movement away from literal realism toward more universal, mythic, archetypal symbolism: a plunge into the depths of the unconscious.

Surrealists Come to New York
(1941–1946)

*I make one image—though "make" is not the word, I let, perhaps, an image be "made" emotionally in me and then apply to it what intellectual and critical forces I possess—let it breed another, let that image contradict the first, make of the third image bred out of the other two together a fourth contradictory image, and let them all, within my imposed formal limits conflict.**

DYLAN THOMAS

In November 1941 John Graham began arranging a show for the Mc-Millen Gallery** called "American and French Painting." Several then-unknown Americans were to be in it, including Jackson Pollock, Lee Krasner, and Willem de Kooning.

Graham was already an underground legend. Born Ivan Dabrowsky in Kiev, he studied law, served as a cavalry officer during World War I on the Rumanian front, was imprisoned and then released after the Russian Revolution, fled to Warsaw, joined the counterrevolutionaries in the Crimea, and, when their resistance fell, came to the Art Students League where he remained until 1924. For the next two decades or so he painted in a Cubist style. But even by 1937, when his *System and Dialectics of Art* was published, he was beginning to move through Cubism (and a devotion particularly to the earlier work of Picasso) to something like Surrealism. More than in his paintings, this was evidenced by his interest in occult and mystical systems—yoga, astrology, numerology, and later alchemy, cabalism, and black magic—a body of thought which interested Jung as well as the antecedents and living practitioners of Surrealism.

Here is a quotation from Graham's book (roman emphasis is his):

* In connection with Pollock, this quotation was used first by Thomas B. Hess. See Bibliography No. 259.

** Actually McMillen, Inc. was an interior decorating firm which showed art.

Art is the authentic reaction of the artist to a phenomenon observed, set authoritatively to the operating plane. *No technical perfection or elegance can produce a work of art.* A work of art *is neither the faithful nor distorted representation,* it is the immediate, unadorned record of an authentic intellecto-emotional *REACTION* of the artist set in space. *Artist's reaction to a breast differs from his reaction to an iron rail or to hair or to a brick wall.* This authentic reaction recorded within the measurable space immediately and automatically in terms of brush pressure, saturation, velocity, caress or repulsion, anger or desire which changes and varies in unison with the flow of feeling at the moment, constitutes a work of art. . . .

The difficulty in producing a work of art lies in the fact that artist has to unite at one and the same time three elements: thought, feeling, and automatic "écriture."

Probably Pollock read or at least looked at *System and Dialectics of Art* almost as soon as it was published, since he had read an article of Graham's—"Primitive Art and Picasso," which appeared in *Magazine of Art* the same year—and admired it sufficiently to write Graham. This led to friendship and mutual admiration. Graham intended to add Pollock's name to his list of promising young American artists, had his book gone into a second edition.* Besides Pollock, Krasner, and de Kooning, Graham knew, encouraged, and influenced the thinking of Gorky and David Smith —all of whom were beginning to feel stifled by European Cubism.

What, then, was the Surrealist alternative to Cubism? Surrealism is difficult to define. Many books have been written about it, and even its foremost exponents disagree about its meaning. To complicate matters more, as the term became popular, it was used so all-inclusively that by World War II it was almost synonymous with "modern art."

The word was invented in 1917 by the French avant-garde poet Guillaume Apollinaire. Close to the Cubists, about whom he wrote a major appreciation, he needed a word to describe the related but more fantastic art of such painters as Chagall and de Chirico, as well as certain

* It was finally republished by Johns Hopkins Press in 1971, thirty-four years after its initial publication by Delphic Studios in New York, ten years after Graham's death in London.

of his own writings. He used the word *surréaliste* to indicate something above or beyond realism. However, after his death at the end of World War I, Dada was the term applied to the most avant-garde work being done by such artists as Duchamp, Arp, Schwitters, and the expatriate American Man Ray, all of whom, in the spirit of disillusionment following the war, were practicing a sort of anti-art or, for them, anti-Cubism, which was in fact much closer to a love-hate relationship. Like the Cubists, the Dadaists used a layout that was typically flat and they expropriated and expanded the use of collage incorporating printed, photographic, and other "real" or "found" material, including three-dimensional objects. Unlike the Cubists, who believed in analysis, synthesis, and other rational processes, the Dadaists put their faith—or lack of it—in "gratuitous acts," arbitrary gestures, chance, and other manifestations of the irrational, based mostly on the will of the subconscious.

The poet André Breton, who had been a medical student primarily interested in mental diseases, was attracted to Dadaism, with its emphasis on the importance of the irrational. However, unlike the Dadaists themselves, who were becoming more and more negative in their work, he became convinced that subconscious irrationality might become the basis for a positive program, a philosophy of life. No propagandist for any art movement has ever been more articulate or more aware of the politics of art. In 1924, at the age of twenty-eight, with his first *Surrealist Manifesto* he gathered most of the Dadaists around him by defining the movement in this way:

Surrealism. n. masc. *pure psychic automatism, by which an attempt is made to express, either verbally, in writing or in any other manner, the true process of thought. Thought's dictation, in the absence of all control by the reason and every esthetic or moral preoccupation being absent.*

Philos. Encycl. *Surrealism rests on the belief in the higher reality of certain hitherto neglected forms of association, in the omnipotence of the dream, in the disinterested play of thought. It tends to destroy the other physical mechanisms and to substitute itself for them in the solution of life's principal problems....*

Except for its emphasis upon the verbal and written, this 1924 "definition" was one to which Pollock might well have subscribed by the late thirties. But why the time lag? Why the slow filtering of the message through Picasso and even John Graham? After all, Pollock and other artists of his generation had been generally exposed to Surrealism by the middle thirties. Two explanations seem pertinent. First, much of the best Surrealist material was literary (written in French by such poets as Eluard, Aragon, and Breton himself—and difficult to translate). Second, the activities of the Surrealists must have seemed frivolous and irresponsible in the context of the Depression and political upheaval here and abroad. Though Picasso supported Republican Spain, Surrealism's first "ambassador" to the United States was the much less serious Salvador Dali. He lectured at the Museum of Modern Art in 1935 and was by 1939 the best known of all the Surrealists, enjoying a broad public reputation gained less by his brilliant draftsmanship and haunting images than by window displays for Bonwit Teller and his *Dream of Venus* exhibit at the New York World's Fair. In fact Dali became so commercial, such a chic commodity, that in 1941 Breton, as "the Pope of Surrealism," excommunicated him and dubbed him Avida Dollars (an anagram). By then, a year after the fall of France, Breton himself was in New York, as well as Ernst, Masson, Tanguy, and Matta—almost everyone except such less doctrinaire sometimes-Surrealists as Picasso, Miró, and Arp.

With the more readily labeled Surrealists came Peggy Guggenheim, a wealthy American whose family had made its money chiefly in copper. The niece of Solomon R. Guggenheim, founder of the museum now bearing his name, she had been collecting (mostly abroad) since 1938, with the help of the Dadaist Duchamp; the Surrealists Breton and Ernst; and the critics Herbert Read, Alfred H. Barr, Jr., and James Johnson Sweeney (the last two of whom were associated with the Museum of Modern Art). She knew virtually all the major Surrealists and had bought work by many of them. Soon after her return to the States she married Max Ernst and in 1942 opened a museum-gallery called Art of This Cen-

tury where she could both show her acquisitions and encourage younger artists. Art of This Century would, she said, "serve its purpose only if it succeeds in serving the future instead of recording the past." It did serve the future, though probably not in the way Miss Guggenheim, with her commitment to Surrealism, expected it to. For just as, in a sense, Benton did much to destroy the validity of the American realistic tradition, the young American Surrealists discovered by her, her advisers, and her perceptive assistant Howard Putzel did much to destroy the validity of European Surrealism and to shift the art center of the world from Paris to New York.

Pollock's *Birth* was exhibited at the McMillen Gallery in early 1942, along with works by very well-known School of Paris painters (*e.g.*, Picasso, Matisse, Braque, Bonnard, Modigliani) and by those Americans then as anonymous as himself (Lee Krasner and Willem de Kooning) and others who were comparatively established (Stuart Davis and Walt Kuhn). The show received some attention—particularly from American artists who were pleased to see their countrymen treated on the same basis as the famous Europeans—and Pollock was for the first time reviewed in the art press, by James Lane, writing for *Art News:* "... resembles Hayter in general whirling figures, while Purdy is more restful. But a tight-rope walker, Virginia Diaz, walks off with the show in a brace of thoughtful little canvasses." Where, we wonder, did she walk? True, Pollock's *Birth* is not a "restful" work; nor is it a "thoughtful little canvas"; it fairly bursts from its roughly two-by-four frame and is very different in feeling from the elegantly contained and finished work of Hayter. Though an indebtedness to Picasso (and Surrealism) is still here, at this time Pollock has already moved farther from Picasso than Graham himself, Krasner, or de Kooning.

For Pollock the show was particularly important. Not only had he for the first time exhibited a painting that was, even if somewhat derivative of Picasso, still largely his own, but because of the show, he was

looked up by Lee Krasner. She lived around the corner from 46 East 8th Street and could hardly believe that there was an artist powerful enough to have painted *Birth* whom she had not seen somewhere, sometime in the comparatively small New York art world. It turned out they had met briefly at an Artists' Union loft party some five years before. He was that tall, ruggedly handsome Western fellow, at once shy and aggressive, perhaps drunk, whose dancing she remembered as impossible to follow. ("He stepped all over me.") However, she was to fall in love with Pollock through his work, to equate the man with the work which she immediately respected. As for Pollock's reaction to her, Clement Greenberg wrote years later:* ". . . even before their marriage her eye and judgment had become important in his art, and continued to remain so." No doubt, as Pollock responded to Lee Krasner as a woman and an artist, he had also a profound need for her response to him. She must have felt that need— she began looking after him in various concrete ways. In May, following the McMillen show, they signed a petition to President Roosevelt protesting the decline of the easel project. In the summer she had Pollock assigned to a War Services window display project which she supervised. And throughout this period, she introduced Pollock to people in the art world with whom he was not yet acquainted.

Besides Lee Krasner, Willem de Kooning first met Pollock and saw his work at the time of the McMillen show. When asked if Graham discovered Pollock, de Kooning said: "Of course he did. Who the hell picked him out? The other critics came later—much later. Graham was a painter as well as a critic. It was hard for other artists to see what Pollock was doing—their work was so different from his. It's hard to see something that's different from your work. But Graham could see it."**

Much bigger shows that season were those of Miró and Dali, which closed at the Museum of Modern Art just before the opening of the McMillen "American and French Painting"; then, in March, "Artists in

* See Bibliography No. 109.
** See Bibliography No. 218a.

Exile" at the Pierre Matisse Gallery, including work by Breton, Chagall, Ernst, Léger, Masson, Matta, Mondrian, and Tanguy; and finally, in October, the most elaborate and fashionable exhibition of Surrealism ever put on in America, "First Papers of Surrealism," a title intended to suggest first citizenship papers. This show, installed in the vacant Whitelaw Reid mansion on Madison Avenue, sponsored by French Relief Societies, hung by Breton, decorated by Duchamp with a maze of twine, received enormous publicity. It included some Americans—Alexander Calder, Robert Motherwell, David Hare, William Baziotes—along with their European colleagues. Indeed, Motherwell (who had met Pollock through Pollock's fellow-worker on the Project, Baziotes) had asked him to exhibit something, but Pollock refused because he was a "loner" who did not like "group activity." And Matta has described Pollock as, even more egregiously, ". . . fermé. A closed man." However, though Pollock was certainly not a joiner, he and Lee Krasner did at about this time collaborate with the Baziotes and the Motherwells in writing automatic Surrealist poetry as an after-dinner game, and Pollock did soon after join Peggy Guggenheim's Surrealist-oriented Art of This Century gallery.

For part of 1942, through Lee Krasner's influence, Jackson had been assisting her in the special program of window displays showing available war-training courses. When that program was completed, he became a "Vocation Trainee in Aviation Sheet Metal" in Brooklyn. And after the Project itself ended in January of 1943, he took any job he could get. One was painting neckties; another, decorating lipsticks. In the spring he got a job at the Museum of Non-Objective Painting on East 54th Street (now the Solomon R. Guggenheim Museum, at 89th and Fifth). There he helped with installing and dismantling shows, making frames and bases, cleaning up. He was doing these various custodial and janitorial jobs when, through Baziotes and Motherwell, he met Peggy Guggenheim. She asked all three young artists to participate in an exhibition of collages she was planning for her gallery in mid-April. Neither Pollock nor Motherwell had previously made collages. They worked together at Pol-

lock's studio, where Motherwell remembers Pollock's intense concentration and the physicality of his attack on the medium (savagely ripping paper and once burning the edges of a piece).

Art of This Century had opened in October 1942, the same month as "First Papers of Surrealism." Located at 30 West 57th Street, it became the most important link between the European Surrealists in exile and the avant-garde younger American painters. The physical gallery itself was a Surrealistic environment. Frederick Kiesler had designed an illusionistic womblike space, with curved outer walls from which paintings (some perpendicular, some not) extended from brackets, and in which equally ambiguous free-form furniture functioned as chairs, pedestals, and easels. The gallery was the last word in chic, or what at the time was also being called "modernistic." To Pollock, the gallery, the wealthy lady who ran it, the coterie of cosmopolitan artists and advisers who surrounded her, the elegant customers and glib critics who visited there . . . all must have seemed strange, surreal, perhaps altogether unreal, another manifestation of the larger world out there insanely blowing itself apart in war.

As to his private world, that too was coming apart. Arloie and Sandy had had their first child and would be moving that fall to Deep River, Conn. There, at a salary way beyond that paid by the Project—where, for the past two and a half years, Sandy had been working with James Brooks on Brooks' mural, *Flight,* for the Marine Terminal of La Guardia Airport—Sandy had gotten a defense job in a piano factory converted to the manufacture of gliders. There, in Connecticut, he—with Arloie and (soon) his mother and then a second child—would remain until his death in 1963.

Before the move to Connecticut Stella Pollock made a visit to New York. Jackson prepared for it in a revealing and typical manner; he drank for several days. Lee Krasner Pollock recalls: "One morning, before Jackson and I were married, Sandy knocked on my door and asked, 'Did Jackson spend the night here, last night?' I answered, 'No, why?' 'Because he's in Bellevue Hospital and our mother has arrived in New York. Will

you go with me and get him?' We went and there he was in the Bellevue ward. He looked awful. He had been drinking for days. I said to him, 'Is this the best hotel you can find?' At Sandy's suggestion I took him back to my place and fed him milk and eggs to be in shape for dinner that night with Mother. We went together. It was my first meeting with Mother. I was overpowered by her cooking. I had never seen such a spread as she put on. She had cooked all the dinner, baked the bread—the abundance of it was fabulous. . . ."*

Pollock's collages for Art of This Century are seemingly lost, but whatever he and Motherwell did must have had merit. Both of them, as well as Baziotes, were asked to exhibit paintings in the next show, a "Spring Salon for Young Artists." For this Pollock contributed *Stenographic Figure,* an oil painting of the previous year, in which, superimposed on a Matissean ground and a Picassoesque headlike image at the left and an armlike one at the right, is freely scrawled calligraphy containing letters, numbers, ticktacktoe: a sort of private shorthand, once again intended not to be read, symbol by symbol, but felt in more general terms as a presentation (rather than a re-presentation) of life and energy as, act by act and gesture by gesture, they are being experienced by the artist. In this—as, even more successfully, in later work—the question "What is Pollock abstracting?" can be answered: He is abstracting creativity itself; the painting *is* that process.

In *The Nation* (May 1, 1943), Jean Connolly—a friend of Peggy Guggenheim's, who would later marry Peggy's first husband, Lawrence Vail—had called attention to Vail's, Ernst's, and Picasso's collages as well as those of "Baziotes, Pollack, and Reinhard" (thus misspelling the last two of three unknown names). At the end of the month, she wrote in the same publication regarding the Spring Salon, "This is a show of artists under thirty-five years old. [Pollock was thirty-one.] It is a good one, and for once the future reveals a gleam of hope . . . there is a large painting 40″ × 55¾″ by Jackson Pollack [misspelled again now—and

* See Bibliography No. 172.

so many times over the years] which, I am told, made the jury starry-eyed." The jury consisted of Barr, Duchamp, Jimmy and Max Ernst, Mondrian, Soby, Sweeney, with Peggy Guggenheim and Howard Putzel representing the gallery. This jury, with the exception of Mondrian, was looking for "Surrealism" and "automatic writing," and Jean Connolly must have been influenced by her closeness to Peggy Guggenheim. However, Robert Coates, writing more objectively for *The New Yorker* (May 29), was at least as enthusiastic. The show was the first he had "known to devote itself strictly to those twin branches of advanced modern painting, abstractionism and surrealism, and as such it has attracted a lot of new talent in Jackson Pollock's abstract 'Painting' [later titled *Stenographic Figure*], with its curious reminiscenses of Matisse and Miró, we have a real discovery."

Despite Connolly and Coates singling out Pollock's *Stenographic Figure,* it was still for sale the following fall. However, Howard Putzel and Matta urged Peggy Guggenheim to give Pollock a one-man show and a year's contract. She agreed to do both. The contract was for $150 a month against sales, after a one-third commission to the gallery. If $2,700 (gross) worth of work was not sold, she was to get paintings to make up the difference.

In July, Jackson wrote Charles:

> *Things really broke with the showing of that painting. I had a pretty good mention in the* Nation—*I have a year's contract with The Art of This Century and a large painting to do for Peggy Guggenheim's house, 8'11½" x 19'9". With no strings as to what or how I paint it. I am going to paint it in oil on canvas. They are giving me a show Nov. 16 and I want to have the painting finished for the show. I've had to tear out the partition between the front and middle room [i.e., between his own studio and the one which had been Sandy's] to get the damned thing up. I have it stretched now. It looks pretty big, but exciting as all hell.*

As soon as the contract was set, Jackson quit his job at the museum and began concentrating on the November show. Except for thinking

about the mural and feeling its size, the space it would fill, Jackson did no work on it until after the show (actually one week earlier than the date mentioned in his letter). By then, besides the unsold *Stenographic Figure,* there were fourteen other new paintings, plus gouaches and drawings. Typically the paintings were very much in the spirit and style of *Stenographic Figure,* all containing some figurative elements increasingly obliterated by his improvised "doodling," as he himself called it.

In *Male and Female* (1942) there are already passages of the dripping and splattering that were to become Pollock's trademark. In the related *Stenographic Figure* he was both dictating and taking dictation, and now, too, he is both acting on and reacting to paint, saying with the medium, "I am male and female. My psyche contains elements of both. See these active and passive principles at play." Surely this is closer to his statement than any reference to parents or another specific man and woman. Indeed the totemic "figures" (still somewhat reminiscent of Picasso) function principally to divide the canvas into three vertical panels. Within these "panels" Pollock is most original—i.e., most himself —just as in *Guardians of the Secret* (1943), even more obliterated totemic and animalistic images frame a central horizontal panel which is entirely nonfigurative; there "the secret" is again Pollock himself.

James Johnson Sweeney's introduction to the catalogue for the show is the first extended critical appreciation of Pollock:

> *"Talent, will, genius," as George Sand wrote Flaubert, "are natural phenomena like the lake, the volcano, the mountain, the wind, the star, the cloud." Pollock's talent is volcanic. It has fire. It is unpredictable. It is undisciplined. It spills itself out in a mineral prodigality not yet crystalized. It is lavish, explosive, untidy.*
>
> *But young painters, particularly Americans, tend to be too careful of opinion. Too often the dish is allowed to chill in the serving. What we need is more young men who paint from inner impulsion without an ear to what the critic or spectator may feel—painters who will risk spoiling a canvas to say something in their own way. Pollock is one.*
>
> *It is true that Pollock needs self-discipline. But to profit from pruning, a*

plant must have vitality. In art we are only too familiar with the application of self-discipline where liberation would have been more profitable. Pollock can stand it. In his early work as a student of Thomas Benton he showed a conventional academic competence. Today his creed is evidently that of Hugo, "Ballast yourself with reality and throw yourself into the sea. The sea is inspiration."

Among young painters, Jackson Pollock offers unusual promise in his exuberance, independence, and native sensibility. If he continues to exploit these qualities with the courage and conscience he has shown so far, he will fulfill that promise.

Pollock replied in a note postmarked November 3, 1943:

Dear Sweeney—

I have read your forward to the catalogue, and I am excited. I am happy—The self-discipline you speak of will come, I think, as a natural growth of a deeper, more integrated, experience. Many thanks—he will fulfill that promise—

Sinecerely
Pollock

Though Pollock wrote this polite note, the word "undisciplined" in the introduction had actually made him furious, smolderingly mad. In time to add it to the show, Pollock painted *Male and Female in Search for a Symbol* (later called simply *Search for a Symbol*). He brought the wet painting to Sweeney at the gallery and said, "I want you to see a really disciplined painting."

Robert Coates of *The New Yorker* was sympathetic again, and fair in describing Pollock's style as "a curious mixture of the abstract and symbolic . . . almost wholly individual . . . the effect of his one noticeable influence, Picasso, is a healthy one, for it imposes a certain symmetry on his work without detracting from its force and vigor."

The *Times* critic Edward Alden Jewell found Pollock's abstractions "not without precipitate violence . . . extravagantly, not to say savagely, romantic. Here is obscurantism indeed, though it may become resolved and classified as the artist proceeds." Not to say is always *to say*.

Maude Riley's review in *Art Digest* began enthusiastically: "We like

all this. Pollock is out a-questing and he goes hell-bent at each canvas, mostly big surfaces, not two sizes the same. Youthfully confident, he does not even title some of these painted puzzles. . . ."

An unsigned review in *Art News* was basically biographical. More significant, through the show Pollock established a relationship with Thomas B. Hess which was to be important to his later career. Hess, the future editor of *Art News,* saw the show while on furlough and kept thinking about *Wounded Animal.* (The title suggests the central image of a wolf or coyote with an arrow in its neck. The lower portion of the painting is dominated by the number *64,* perhaps an inversion of and/or improvisation on *46,* his address on East 8th St., as well as on Carmine Street in the early thirties.) More than a year later, when Hess was discharged from the army, the painting was still for sale. Hess bought it for around $100 and established a mutually respectful relationship with Pollock. He and Pollock would meet and talk seriously—often over drinks at the Ritz Towers—about "art and what was happening."

But most important to Pollock's career was the review by Clement Greenberg in *The Nation* (November 27). We will quote substantially from it and Greenberg's other reviews for, despite ambivalence and misunderstandings (particularly in regard to Pollock's use of color and scale), Greenberg became Pollock's greatest champion:

> There are both surprise and fulfillment in Jackson Pollock's not so abstract abstractions. He is the first painter I know of to have got something positive from the muddiness of color that so profoundly characterizes a great deal of American painting. It is the equivalent, even if in a negative, helpless way, of that American chiaroscuro which dominated Melville, Hawthorne, Poe, and has been best translated into painting by Blakelock and Ryder. The mud abounds in Pollock's larger works, and these, though the least consummated, are his most original and ambitious. Being young and full of energy, he takes orders he can't fill. In the large, audacious "Guardians of the Secret" he struggles between two slabs of inscribed mud (Pollock almost always inscribes his purer colors); and space tautens but does not burst into a picture; nor is the mud quite transmuted. Both

this painting and "Male and Female" (Pollock's titles are pretentious) zigzags between the intensity of the easel picture and the blandness of the mural. The smaller works are much more conclusive: the smallest one of all, "Conflict," and "Wounded Animal," with its chalky incrustation, are among the strongest abstract paintings I have yet seen by an American. Here Pollock's force has just the right amount of space to expand in; whereas in larger format he spends himself in too many directions at once. Pollock has gone through the influences of Miró, Picasso, Mexican painting, and what not, and has come out on the other side at the age of thirty-one, painting mostly with his own brush. In his search for style he is liable to relapse into an influence, but if the times are propitious, it won't be for long.

Finally, in the Winter 1944 *Partisan Review,* Robert Motherwell wrote that Pollock "represents one of the younger generation's chances. There are not three other painters of whom this could be said. In his exhibit, Pollock reveals extraordinary gifts: his color sense is remarkably fine, never exploited beyond its proper role; and his sense of surface is equally good. His principal problem is to discover what his true subject is. And since painting is his thought's medium, the resolution must grow out of the process of his painting itself."

It is interesting that in none of these reviews was the word "Surrealism" used or the connection with the movement established, even though Pollock himself was aware of his debt. In the *Arts & Architecture* questionnaire (prepared at about this time and published, with reproductions of his work, in February 1944), he stated: ". . . the fact that good European moderns are now here is very important, for they bring with them an understanding of the problems of modern painting. I am particularly impressed with their concept of the source of art being the unconscious. This idea interests me more than these specific painters, for the two artists I admire most, Picasso and Miró, are still abroad."

After looking at the approximately nine-by-twenty-foot canvas for about six months, Pollock finally, at the turn of the year, painted Peggy Guggenheim's mural in a single session, activating the entire surface with

his bold calligraphy. Though this painting (done on a vertical surface with conventional paint) is cruder, less lyrically free than his later mural-size works and though it contains vestigial anthropomorphism, the influence of Picasso is no longer visible; the "handwriting" is entirely Pollock's own—as in the most exciting portions of paintings in his first show, a sort of abstract Surrealism. Motherwell has said, "Probably the catalytic moment in [Pollock's] art was the day he painted the mural. . . . Dancing around the room, he finally found a way of painting that fitted him, and from then on he developed that technique and that scale." Greenberg, who saw the mural in January 1944, says it convinced him, more than any of Pollock's previous work, of the young painter's greatness. He remembers that another painter, Jean Helion, Peggy Guggenheim's son-in-law, criticized it for going on and on indiscriminately, while Greenberg thought it was just right for its length. However, most important to Pollock, Peggy herself liked it.

In April, a color reproduction of *The She-Wolf* (1943), another of the strong paintings from Pollock's first show, appeared in Sweeney's *Harper's Bazaar* article "Five American Painters." The other four artists illustrated and discussed were Graves, Gorky, Avery, and Matta. About Pollock, Sweeney wrote:

And if Matta may be considered as a painter of internal nature, Pollock is certainly his perfect foil—as explosive as Matta is smoldering—as coarse in his strength as Avery is delicate—as physical as Graves is mystical. Pollock would be one of the most interesting younger painters for nothing more than his courage to express himself freely. He has a fine intuitive ability to organize strongly contrasting colors. Harmony would never be a virtue in his work. An attempt to achieve it would necessitate toning down all his expression and lead to its final emasculation. He is a fine natural draftsman. He has power and curious animal imagination. He needs still to discipline his work considerably. Yet this discipline must not be bought at the sacrifice of boldness in color oppositions or force of brushwork. From his "She-Wolf" it is clear that he can achieve a completely satisfactory compositional unity without the sacrifice of either. Pollock's emphasis on the fury of animal nature is his personal poetry and his strength.

In May, after this additional publicity and after many months of deliberation and attempts at negotiation, *The She-Wolf* was bought by the Museum of Modern Art. To Sidney Janis—then collecting material for his *Abstract & Surrealist Art in America*—Pollock stated, "*She-Wolf* came into existence because I had to paint it. Any attempt on my part to say something about it, to attempt explanation of the inexplicable, could only destroy it." This "words kill" stance may well have been the model for later statements by Clyfford Still, Mark Rothko, and other artists of Pollock's generation who were to be neutralizingly lumped together under the label "Abstract Expressionists."

Peggy Guggenheim, in *Confessions of an Art Addict* (the revised 1960 version of her autobiography, in which she devotes much more space to Pollock than in her 1946 *Out of This Century*) states that Pollock was the best new painter she showed, "the greatest painter since Picasso." She goes on:

> *From . . . 1943 until I left America in 1947, I dedicated myself to Pollock. He was very fortunate because . . . Lee Krasner . . . did the same, and even gave up painting at one period, as he required her complete devotion. I welcomed a new protege, as I had lost Max [Ernst]. My relationship with Pollock was purely that of an artist and patron, and Lee was the intermediary. Pollock himself was rather difficult; he drank too much and became so unpleasant, one might say devilish, on these occasions. But as Lee pointed out when I complained, "He also has an angelic side," and that was true. To me, he was like a trapped animal who never should have left the prairies of Wyoming . . .*

During this period of first public encouragement, starting with the McMillen exhibition, Lee Krasner had been with Pollock more and more. She spent a great deal of time introducing him and his work to those who might be helpful. For example, she had her former teacher, Hans Hofmann, over to see Pollock's paintings. During that visit Hofmann asked about the importance of nature in Pollock's work. Pollock replied

aggressively, "I am nature." Though he meant by this that he was part of nature, connected with all its elements, Hofmann was shocked by the younger painter's seeming arrogance, which contrasted with Hofmann's comparative humility, as expressed on another occasion in Hofmann's own statement "I bring the landscape home in me." But now, at their first meeting, Pollock looked for pedantry in every question and statement of Hofmann's, and he finally said, "Your theories don't interest me. Put up or shut up. Let's see your work." Of this meeting, embarrassing to Lee as Hofmann's student, she says Jackson "had a fanatical conviction that the *work* would do it, not any outside periphery like *talk*."*

She also invited John Little, then a successful textile designer and thus one of the few serious young painters with money, and the photographer Wilfred Zogbaum, who shared studio space with Hofmann and later established a reputation as a sculptor. At about the same time she brought Pollock to the 42nd Street studio-apartment of her old friend Mercedes Matter (for whom she had sometimes modeled) and Mercedes' husband, Herbert, the photographer. Jackson and Herbert went to the lower floor and were so silent that the women became worried about their not having hit it off. Actually the two men were very comfortable with each other's shyness. Jackson, referring to various things happening in art, had said something like, "It's a terrific time to be living, isn't it?" Herbert remembers, "Jackson's statement gave us enough to think about. ... We never had to talk much. With my best friends I never really had to talk."

Through the Matters, the Pollocks had met James Johnson Sweeney, "the first," as Lee Krasner says, "to go into print for Pollock." Through them too, the Pollocks met Alexander Calder. When the Matters brought Calder to Pollock's studio, Calder studied the paintings and said, "They're all so dense." Jackson replied, "Oh, you want to see one less dense, one with open space?" He brought out the densest painting he had.

* See Bibliography No. 172.

Finally, Lee introduced Jackson to Sidney Janis, who was working on his book *Abstract & Surrealist Art in America*. At Hofmann's suggestion Janis had come to see Lee's work for possible inclusion in the book. He liked it and selected a 1943 composition to be reproduced ultimately in black-and-white in the Abstract section. However, he had hardly seen Lee's work before she took him to see Pollock's. Jackson was absolutely silent while he showed Janis some recent paintings, two of which Janis considered for the book. It wasn't until a subsequent visit, after the completion of *She-Wolf* (1943), that Janis became enthusiastic. That painting, ultimately in the Surrealist section, was one of the few reproduced in color.

The list of people Pollock met through Lee Krasner and her friends could be expanded. However, those mentioned are the more important. Pollock's meetings with some illustrate his defensiveness (generally presented as aggressiveness) in the face of power and/or established reputation. On the other hand, his meeting with Matter was typical of the way he met those he didn't feel threatened by. Like Matter, John Little and Wilfred Zogbaum were to remain Pollock's life-long friends.

By now Lee Krasner was devoting more time to Pollock than to her own work, which she did, if at all, at the other end of his apartment on 8th Street. In addition to the introductions and everything else, she had folded, addressed, and stamped announcements at Art of This Century and had stood by at the gallery when Peggy Guggenheim went for long lunches. In short, her identity was becoming lost. She was "Pollock's girl"—just that, which was no better than being known as "a woman painter" (possibly the reason she had long ago taken the sexually anonymous name "Lee").

She was born Lenore, in Brooklyn just before World War I. Her father, Joseph Krasner, had followed her mother's brother from a small village near Odessa, hoping to establish his family in America. He set himself up in a food shop and then had his wife and children (a son and three daughters) come to the United States. Lenore ("Lee") was born

almost nine months to the day after her parents' reunion. She grew up among women: her mother and sisters. Anna was a truly matriarchal figure. She ran the household; held things together; observed the Jewish holidays and dietary laws; remained close to her family, which was more orthodox than Joseph's; and, later, with her brother, invested in real estate.

There was no time in Anna's life for nonsectarian culture. Lee remembers her brother, Irving, bringing home some Caruso records. She remembers a print in the parlor, of Columbus receiving jewels from Queen Isabella. But what serious art she was exposed to as a young girl came mostly from the library: fairy tales, Maeterlinck, and then the Russian classics.

At home Russian, Yiddish, Hebrew, and English were all spoken. Of Lee's three closest friends one was German, one was French, and one was an American mulatto. It was in their homes, and in the Russian novels, that she saw the possibility of broader cultural horizons. However, it was not until she was ready to go to high school and had to express a "career preference" that she chose "art." Though she had been an independent girl, she herself was no less surprised by the choice than her family—she had simply never before thought about a career and never before expressed any particular interest in art. It sounded more alive than secretarial work—that was about all.

She chafed for a term at Girls High in Brooklyn, where she flunked everything, while waiting to get into Washington Irving High School in Manhattan ("the only girls' public high school at that time where I could major in art"*). It was a short subway ride from her home, but seemingly as remote and exotic as Turgenev's Paris. When she was transferred she did well in everything *but* art. That, she discovered, took more time than history and geography. Because she had done well in her other subjects, the school gave her a passing grade of 65 so she could go on to the Woman's Art School of Cooper Union. There, in 1927, her

* See Bibliography No. 23 for this and immediately subsequent autobiographical quotations.

career as an artist really began. No longer was there any doubt about what she wanted to do.

Cooper Union was at that time set up in a series of "alcoves." First alcove: casts of hands and feet. Second: casts of torsos. Third: casts of the full figure. Finally one was "promoted to life . . . working from live models and plants." A Mr. Hinton who "taught torsos" did not like her work. To get rid of her, he pushed her on to Victor Perard in the third alcove. He did like the work and had her do plates for a textbook which he was preparing. That was the first time she received payment for art. Otherwise, to get through school, she, like many of the students, depended on a little money from home and from modeling. From photographs, we know her figure was stunning.

The National Academy of Design was next. A step forward: Leon Kroll was there—well known then, even considered avant-garde—and other teachers whom we now think of as rather academic or provincial. She submitted her work. It was received with none of Perard's enthusiasm. She was put back in "antiques," and, what was worse, Mr. Hinton, who had transferred to the Academy, was teaching that subject. This time he couldn't quickly kick Lee Krasner upstairs. At the Academy promotion depended upon the vote of a full committee. For that, she submitted a self-portrait.

By then her family had moved to Huntington, Long Island, and in order to continue at school she had remained in Brooklyn with her sister Ruth, who had married very young. The self-portrait was done in the woods behind the Huntington house, where Lee had nailed a mirror on one tree and a stretched canvas on another. There she stands, in a smock with brushes and a rag in her right hand, her left hand raised toward the canvas. The portrait is strong, if not particularly original. It is influenced by Impressionism (Monet, perhaps, in the close-valued treatment of trees and leaves) and Post-Impressionism (Cézanne, in the flattened angularity of the canvas in the composition). But this is a painting by a girl in her early twenties. Forgetting the props, there is remarkable honesty, even

toughness, in her view of herself. It's all there in her face: the deepset intelligent blue-gray eyes; the full sensuous mouth, between proud prominent nose and jaw; the luxuriant red hair; the independence of the figure from its environment—a dozen aspects of emotion and intelligence, pride and vulnerability, all there, if not as yet fully resolved.

The committee members studied the canvas. The chairman said, "When you paint a picture indoors, don't pretend it's done outdoors." She assured him it had been done outside. She was promoted to life—on probation.

She remained at the Academy for about three years. During that period she went to the newly opened (1929) Museum of Modern Art. She was "hit very hard by this first live contact with the Paris School . . . Picasso, Matisse . . . mostly Matisse." She began doing bright paintings, and Kroll told her she "should go home and take a mental bath." However, by then, the Depression had hit as hard as Matisse, and harder than anything at the Academy; she was living in Greenwich Village, in an ambience of social realism and leftist politics; and, once out of the Academy, in order to continue painting she had to support herself.

She worked nights at the Sam Johnson, a restaurant–night club on Third Street owned by the poet Eli Siegel (*Hot Afternoons Have Been in Montana*) and "a defrocked rabbi," Morton Deutsch. It was a gathering place for such Village intellectuals and bohemians as Joe Gould, Maxwell Bodenheim, Lionel Abel, Parker Tyler, and the brothers David and Harold Rosenberg. There, in silk hostess pajamas, working for tips, Lee Krasner watched them nurse their beers. To this day she cannot use the word "intellectuals" without a somewhat angry or ironic tone, and (as did Pollock) she distrusts abstract language and tends to separate the talkers and writers from the doers. Yet these intellectuals did get work done. The talking, the exchange of ideas was part of the process. As Harold Rosenberg says, "The thirties were years of *hanging around*—in bars, in cafeterias. You could hang around on a nickel beer or cup of coffee." Yes, Rosenberg, like the rest of them, hung around. Like them

too, he was placing poems, short stories, and criticism in such magazines as *transition* and *Symposium*. And like most of them, he was interested in all cultural manifestations, not just literature but painting, music, philosophy.

While working at the Sam Johnson, Lee Krasner considered becoming an art teacher. By attending classes once or twice a week for several years, she completed the necessary pedagogical credits at C.C.N.Y. However, just then—after what is sometimes described as "the terrible winter of 1934–35," the very heart of the Depression—the government created the W.P.A. Federal Art Project. It sounded better to Lee than teaching and a lot better than continuing at the Sam Johnson. She became an assistant to the muralist Max Spivak, as did Harold Rosenberg, who devoted some of his time to *Art Front,* the Project's magazine, until he could transfer to the Writers' Project in 1937.

For a while Lee Krasner painted cityscapes and factory scenes and forgot about Matisse. The creation of art was no longer only a joyful end in itself, but the propagandistic means to political and social ends. She was put on the executive committee of the Artists Union. Where once talk in the art world had been about the power of painting, it was now about political and economic power. By contrast—perhaps for relief —during the late thirties and early forties, she studied with Hans Hofmann and sat in on his lectures. These were attended sometimes by Clement Greenberg, whom she met through Harold Rosenberg and his wife and to whom she suggested attending the lectures. Thus, by the late thirties, Lee Krasner knew the two men who would become the most influential American art critics of their generation.

It is clear from Lee Krasner's work of this period and that of others who studied with Hofmann that he was then teaching a sort of loosened-up Cubism—particularly emphasizing a respect for the flatness of the picture plane, but also a Fauvist pleasure in bright color. From Germany, by way of France, he brought the School of Paris—at least both of these major aspects of it—to New York. That was no small thing. However,

even more important than bringing New York esthetically up-to-date was his role as a responsive human being. The mental baths he prescribed were warm, as warm as Rimbaud's poetry. Lee Krasner scrawled these lines from *A Season in Hell* on her studio wall:

To whom shall I hire myself out? What beast must I adore?
What holy image is attacked: What hearts shall I break?
What lie must I maintain? In what blood tread?

Throughout the late thirties and early forties, when she remet Pollock, the words were all there, in black, on a white wall of her studio, except for these in blue: *What lie must I maintain?* Like every serious artist, like Rimbaud himself, she had come to the conclusion that there was no lie that could be maintained, that there was only the truth as one (she) felt it. Fritz Bultman, another Hofmann student, brought a writer to her studio, a young man named Tennessee Williams. Williams "pulled apart" the Rimbaud quotation. She asked him to leave. No one could tamper with those lines, particularly the one in blue.

By mid-1944, as we have seen, Pollock's career was off to a good "start": a first one-man show in probably the most chic gallery in town, a contract with that gallery, a mural commission from its owner, generally good notices, the questionnaire in a prestigious West Coast magazine, the color reproduction in *Bazaar,* the Modern Art purchase, and at least one bite and some nibbles by other institutional and private collectors, not including small purchases by Herbert Matter and the artist Jeanne Reynal. But remember that by now Pollock had been painting seriously for sixteen years, fourteen of them in New York. His good start can hardly be characterized as a fast one.

Lee and Jackson were, however, sufficiently encouraged to spend a long summer in Provincetown, then the most famous American art colony (Pollock would later be a major factor in shifting the center of

gravity to East Hampton). There were in Provincetown many of the realists and social realists who had made their reputations during the twenties and thirties, as well as a few of the avant-garde—for example, Hans Hofmann and his students John Little and Fritz Bultman. Lee and Jackson were able to rent a studio cheaply off Bradford, the "Back Street" of this two-street town, the one without an unobstructed view of the water. They worked very little—mainly on small watercolors and pen and ink drawings—walked the flats when the tide was out, sometimes hiked across the dunes to the ocean, but mostly sunned themselves. "It was not what you would call a productive summer," Lee Krasner remembers. "We had shipped up some rolls of canvas. In September they were still unpacked—all we had to do was change the FROM to TO. However, we got some rest. That was productive—these people who think paintings are made only at the moment paint goes on canvas!—and Howard Putzel came up for a couple of weeks, and Jackson's mother visited, and Tennessee (we'd patched things up) used to ride to our place on his bicycle. It was a good summer."

The relaxation was necessary. The open space and sky were exhilarating. When they returned to the city in the fall, Pollock was feeling good. He decided to experiment with graphics, willing by then, after a summer of smaller-scale work, to deal with confinement, and perhaps wanting again to test the "discipline" which Sweeney and others had said he lacked. Between the fall of 1944 and the spring of 1945 he made a series of engravings at Atelier 17, a studio school of graphics run by the British-born Stanley William Hayter, the artist to whom Pollock had been compared at the time of the McMillen show. Since the late thirties Pollock had known Hayter through his work and through reports from their mutual friend John Graham, but Pollock did not actually meet Hayter until 1943 when Reuben Kadish, who was close to him, returned from Mexico. From then on Pollock and Hayter met frequently by chance and saw each other at fairly regular intervals by appointment (as they would continue to do until Hayter's temporary departure from the States

in 1950). During 1944–45 (and, to a lesser extent, during the following five years) Pollock often visited Hayter at his house on Waverly Place and, often also, they would go together to nightclubs and bars. From the outset Hayter thought highly of Pollock's painting but recognized him as "a man with tremendous psychological difficulties."*

As to the work Pollock did at Atelier 17, it must be understood that the usual teacher–student relationship did not exist there. Hayter was available to answer technical questions and to criticize—again, from a technical standpoint. However, each "student" pursued his own work while sharing physical chores with the others, which is exactly what Pollock did.

Pollock could not have been happy working with the burin, which makes straight cuts more easily than curved ones. He must have felt frustrated by the ease with which Hayter made his own cursive plates as against the angular rigidity into which engraving seemed to drive Pollock himself. Even if by heavy cross-hatching Pollock did introduce a freer, softer, more flowing movement than might be expected from a novice in this medium, it is nevertheless unlikely he was satisfied with the results. Except for trial proofs, the plates remained unprinted until 1967 when seven editions were made under the supervision of William S. Lieberman of the Museum of Modern Art. Regardless of the degree of their success, these engravings at least attempt a swirling personal imagery that Pollock could handle much more comfortably in his ink drawings of the same period and would handle best in his black-and-white paintings of the early fifties.

Though Pollock did not take to engraving, finding it both insufficiently immediate and too resistant, he acknowledged "Bill" Hayter's technical skill and articulate pedagogy (however implicit). We can imagine how completely Pollock would have agreed with the following from Hayter's *New Ways of Gravure,* published just a few years later:

* Letter to the author, dated Mar. 11, 1971.

Particularly in engraving, which is essentially the art of the line, of the line in three-dimensional space, it became necessary to exploit the enormous possibilities of indicating the properties of matter, force, motion, and space. In the methods of etching, the arrangement of transparent webs to define planes other than the picture plane, often no longer parallel to it, of surfaces having tension or torsion, and the interpenetration of transparent surfaces, could more easily be realized than in the usual techniques of painting.

Pollock himself could not so precisely have explained what attracted him to Atelier 17 in the first place and was finally driving him from it to search beyond "the usual techniques of painting" *in painting itself.*

Pollock would also have agreed with Hayter's theory, if not necessarily his practice, concerning "... objects, things in the phenomenal world, [having] an order of reality which is less concrete than the reality of a human reaction to them. And I want to distinguish the pursuit of reality (the reality of the first order) from the pursuit of objects, and to combine the immediate experience with the experience of the imagination, which I should like to consider as the trace or record of assimilated previous experience, not necessarily restricted to the immediate lifetime of the individual."

Hayter was a remarkable "teacher." By the time Pollock left his atelier, he was convinced—possibly to a greater degree than by other Surrealists whom he trusted less *as people*—of what the curator Bernice Rose calls Hayter's "autonomy of line as a self-expressive force," and he had discovered for himself "the all-over linear configuration—the philosophy of risk underlying it ..." Though Pollock could not handle the burin "automatically," he had reached the stage—visible in this same period's work done directly on paper—where with ink and paint he was dazzlingly free and "automatic."

During this winter of print-making, besides Hayter and the Surrealist André Masson, who was working at the Atelier and whose work was close in spirit to Pollock's, Jackson saw a lot of his old friend Reuben Kadish. Rube worked with him pulling proofs at night when it was

quiet. Afterwards, sometimes with Hayter and others, they would drink —usually beer—at neighborhood bars including the Cedar Street Tavern and the Hotel Albert. Another favorite beer-drinking companion was John Little who now lived nearby in Hofmann's studio. Jackson frequently waited on John's stoop until he returned from designing textiles. Then they, too, would go to local bars to discuss art. Little recalls that "Jackson could get high on three beers." One afternoon, after having a few, Jackson began laughing satanically at the punched-in nose of the man next to him at the bar. The guy turned out to be a professional fighter and John was afraid Jackson would be killed, but Jackson charmed the boxer as easily as he had antagonized him. He could charm most bartenders too—especially at the Cedar where, despite various troublesome incidents, they kept letting him come back. Even Hofmann, to whom Pollock had been initially so aggressive, was forgiving, if not completely charmed. He recognized Jackson's significance as a man and an artist and spoke sympathetically of the emotional problems which had led to alcoholism. On one occasion that winter he and his wife invited the Pollocks and John Little to dinner and Jackson passed out, perhaps from the strain, this time, of trying to behave properly. Some years later Hofmann obtained a narrow horizontal painting of Pollock's; by that time he considered him the best painter of the younger generation.

In early 1945, Pollock was included in several traveling group shows—for example, "Abstract and Surrealist Art," selected by Janis for the Cincinnati Art Museum and "Twelve Contemporary Painters," organized by the Museum of Modern Art—but mostly he was making the drawings, gouaches, and thirteen paintings that would be in his second one-man show at Art of This Century. It opened March 19 and was very much a continuation and development of the work of the previous year. *There Were Seven in Eight,* about half the size in each dimension of the mural he had done for Peggy Guggenheim, is a richer, denser, more concentrated work on a similar theme, as is *Gothic.* The totemic imagery of *Totem I* and *Totem II* and *Night Sounds* is freer and less Picassoesque

than previously. *Portrait of H.M.* (probably named for his old friend Helen Marot) is totally nonfigurative, though somewhat tight.

Greenberg, in *The Nation* (April 7), was far less equivocal than he had been before:

> *Jackson Pollock's second one-man show ... establishes him, in my opinion, as the strongest painter of his generation and perhaps the greatest one to appear since Miró. The only optimism in his smoky, turbulent painting comes from his own manifest faith in the efficacy, for him personally, of art. There has been a certain amount of self-deception in School of Paris art since the exit of cubism. In Pollock there is absolutely none, and he is not afraid to look ugly—all profoundly original art looks ugly at first. Those who find his oils overpowering are advised to approach him through his gouaches, which in trying less to wring every possible ounce of intensity from every square inch of surface achieve greater clarity and are less suffocatingly packed than the oils. Among the latter, however, are two—both called* Totem Lessons—*for which I cannot find strong enough words of praise. Pollock's single fault is not that he crowds his canvases too evenly but that he sometimes juxtaposes colors and values so abruptly that gaping holes are created.*

A corollary of Greenberg's perception that "all profoundly original art looks ugly at first" was his later observation that "the real thing is always controversial." Both apply to Pollock throughout the mature years of his career and even after his death.

Howard Devree of *The New York Times* was as unenthusiastic as Greenberg, allowing for his reservations concerning Pollock's color, was enthusiastic. Devree wrote that "These big, sprawling coloramas impress me as being surcharged with violent emotional reaction which never is clarified enough in the expression to establish true communication with the observer." Parker Tyler, writing in the Surrealist magazine *View* ("Nature and Madness among the Younger Painters"), dubs Pollock a "neo-expressionist," describes "the nervous, if rough, calligraphy" as having "an air of baked-macaroni," and finally concedes that "on occasion [Pollock] is an interesting colorist." Manny Farber in *New Republic* (June 25) finds some of Pollock's work as "violent" as Devree does, but

comes to the opposite conclusion: that it is "masterful and miraculous." Farber's review, in fact, offers considerable insight concerning the direction in which the work is moving:

> ... *The dominant effects in Pollock's work arise from the expressionistic painting of emotion and from the uninhibited, two-dimensional composing of the surface, in which the artist seems to have started at one point with a color and continued over the painting without stopping, until it has been composed with that color. In the process great sections of the previous design may be painted out, or the design changed completely. The painting is laced with relaxed, graceful, swirling lines or violent ones, until the surface is patterned in whirling movement. In the best compositions these movements collide and repeat to project a continuing effect of virile, hectic action. The paint is jabbed on, splattered, painted in lava-like thicknesses and textures, scrabbled, made to look like smoke, bleeding, fire, and painted in great sweeping continuous lines. The painting is generally heavily detailed, and tries a great number of emphatic contrasts and horizontal movements in which a shape or a line will be improvised on and repeated in level, rhythmic steps and generally in a circular movement. One of the most characteristic notes is the way a shape is built out from the surface in great detail. The style is a rich, decorative kind that uses heavy, opaque color, extreme texturing and a broad, rounded list of colors. An extraordinary quality of Pollock's composing is the way he can continue a feeling with little deviation or loss of purity from one edge to the other of the most detailed design. ... The surface is no longer considered as something to be designed into an approximation of a naturalistic, three-dimensional world, but, more realistically, is considered simply as flat, opaque and bounded. Pollock's work explores the possibilities and the character of horizontal design. He shows that each point of the surface in flat painting is capable of being made a major one and played for maximum effect, and that when the conflicting elements in three-dimensional painting are removed, the two-dimensional relationships are liberated and made more powerful and clear. His manner of building form and surface out rather than in has produced original, dramatic and decorative effects, and the painting as a whole demonstrates again that abstract art can be as voluptuous as Renaissance painting.*

Farber is a painter in his own right and one of our important, though comparatively neglected, film critics. No wonder he understood the lively movement of Pollock's paintings.

Though the critics could not agree on whether Pollock's "violence" was an asset or liability or on whether he was a good colorist or bad one, they were unanimous at least in responding to the work, in not remaining indifferent to it. Their reactions, like those of the small general public, were visceral.

Two months after Pollock's second one-man show, Howard Putzel, who had by then left Peggy Guggenheim to establish his own 67 Gallery, organized an exhibition appropriately called "A Problem for Critics." By then Sam Kootz's book *New Frontiers in American Painting* had been out for two years and Sidney Janis's *Abstract & Surrealist Art in America* for one. In each book, as the art historian Irving Sandler has pointed out, the author-collector-(ultimately) dealer asks, respectively, where the "merging," the "potential" of Abstraction and Expressionism will lead. Then Sandler quotes Coates (*The New Yorker,* December 23, 1944):

> *There's a style of painting gaining ground in this country which is neither Abstract nor Surrealist, though it has suggestions of both, while the way the paint is applied—usually in a pretty free-swinging, spattery fashion, with only vague hints at subject matter—is suggestive of the methods of Expressionism. I feel that some new name will have to be coined for it, but at the moment I can't think of any. Jackson Pollock ... and William Baziotes are of this school.*

Evidently Putzel took his cue from Coates's inability as yet to find a term for the new style. (Not much more than a year later Coates would discover or rediscover—in any case, popularize—the term Abstract Expressionism.) Putzel now showed Pollock, Krasner, Gorky, Gottlieb, Hofmann, Pousette-Dart, and Rothko, all to become important figures of "the new American painting," within the context of work by such European artists as Arp, Masson, Miró, and Picasso. The Americans stood up well even in this company. In a statement accompanying the exhibition, Putzel wrote that the new unnamed "-ism" was particularly indebted to Arp, Miró, and Picasso. "I believe we see real American painting, beginning now." In *The New Yorker* (May 26, 1945) Coates substantially

agreed as to the particular debts and the recognition of an emergent American art. In *The Nation* (June 9, 1945), Greenberg commented:

> *... I disagree with Mr. Putzel that the inspiration of the new tendency came from Arp and Miró—both of whom, despite their desire to restore "poetry" to modern painting, continue the flattening-out, abstracting, "purifying" process of cubism. And their influence, moreover, was strong in abstract painting long before the new turn came. No, that owes its impulse to surrealist "biomorphism" ... [which] restoring the third dimension, gave the elements of abstract painting the look of organic substances.*
>
> *... One or two, however, have accepted just enough of surrealist cross-fertilization to free themselves from the strangling personal influence of the cubist and post-cubist masters. Yet they have not abandoned the direction these masters charted. They advance their art by painterly means without relaxing the concentration and high impassiveness of true modern style.*

Though the art scene in the city was not nearly as hectic as it was to become during the next two decades, for a man of Pollock's sensibility and shyness (or insecurity, masked often by bravado), there were already too many openings, parties, dealings with galleries and the art press, distractions of all kinds. During the previous year when *Arts and Architecture* had asked "Why do you prefer living in New York to your native West?" he answered, "Living is keener, more demanding, more intense and expansive in New York than in the West; the stimulating influences are more numerous and rewarding. At the same time, I have a definite feeling for the West; the vast horizontality of the land, for instance; here only the Atlantic Ocean gives you that." Though New York's advantages for an artist are put quite positively, we suspect that behind this public statement is a longing not only for the freedom of open space, but for the roots he had never had while moving from place to place in the West during his youth, or restlessly driving from coast to coast in the thirties, or even now shuttling between his studio in the Village and the gallery on 57th Street. The pressures, tensions, and interruptions were getting to him. He was drinking heavily.

Peggy Guggenheim describes his behavior at the time he completed her mural: "He not only telephoned me at the gallery every few minutes to come home at once and help place the painting, but he got so drunk that he undressed and walked quite naked into a party that Jean Connolly, who was living with me, was giving in the sitting room. Then he peed in the fireplace." The incident might easily be one of Gulley Jimson's adventures in Joyce Cary's *The Horse's Mouth*—we hardly know whether to laugh, cry, or be shocked. Though this happened during a period of unusual tension for Pollock, we know from other reports that incidents occurred—and continued to occur—similarly symptomatic of his unrest, aggravated by the art world's pressure on him, as well as by his own need, to exhibit, to show himself. In one incident, about eight years later, again he peed in a fireplace—this time at a party in the studio of Jan Muller. But by then any humor in the situation had worn off with repetition; besides, before anyone could have laughed he put his fist through a window. Perhaps a fireplace had become too small, too confining a target. A friend remembers Jackson urinating in the snow, spraying the stream from side to side, and saying, "I can piss on the whole world."

During the summer of 1945 for the first time Pollock and Lee Krasner visited Eastern Long Island. There Barbara and Reuben Kadish had taken over Bill Hayter's lease on a house in Amagansett which Hayter had found unsuitable. Hayter got another place nearby. Also not far away May and Harold Rosenberg had a house where Rube and Jackson spent some time shingling a portion of the roof while balancing a case of beer on it. But beyond attractions of their immediate social circle, looking past the summer to the fall and years to come, East Hampton looked like a calmer place to live than New York, more conducive to work, and yet close enough to the city (about a hundred miles) so that Pollock could remain in touch with his gallery and the then-few other galleries and museums showing contemporary art. Lee Krasner urged him to rent there for the winter, but he was not willing to consider this until they returned to the city. Then in the early fall they went house-hunting.

A typical nineteenth-century farmhouse was for sale on about five acres of land on Fireplace Road in Springs, some six or seven miles beyond the fashionable East Hampton town center. The house was in bad repair, but spacious and potentially comfortable. Directly behind it was the large barn which would become Pollock's studio. Off to one side were a garage and toolshed, and beyond all these a beautiful uninterrupted view of Accabonac Creek, marshland, and Gardner's Bay: a sense of space, in total contrast to the city. The place seemed—and was, in retrospect— a bargain for $5,000 ($2,000 cash, $3,000 mortgage), if one had the money. Neither Pollock nor Lee Krasner did. However, with the help of their friend William N. M. Davis, an early collector of Pollock's work, they persuaded Peggy Guggenheim to lend them the $2,000. At the same time a new contract with Pollock was arranged, under which for two years he was to get $300 per month (part to go to the repayment of the loan) and she was to receive his total output, except for one painting a year.

To digress, this is the contract (to be slightly modified and extended) upon which Peggy Guggenheim, some fifteen years later when Pollock was dead and internationally famous, based a lawsuit which dragged on for four years; in the spring of 1965, it was finally dropped and all charges retracted. Although Miss Guggenheim had received dozens of Pollock's paintings, she alleged she had not gotten all she was entitled to. The suit raised questions—philosophical, moral, and legal—as fascinating as anything in *Whistler vs. Ruskin.* When does a work of art begin? When is it completed? Is it ever, or is it merely abandoned, as Valéry says? Are sketches, studies, and notes works of art? What is a finished sketch as opposed to one that is unfinished? Do canvases which are being worked on at the time of contract fall within the contract period? If so, do those being worked on at the end of the contract fall outside it? Can critics date works of art with legal accuracy? Dozens of questions, including perhaps, once again, the definition of a pound of flesh.

Pollock and Lee Krasner married before leaving the city and having

to face the more provincial values of Springs. Despite his lack of formal religious affiliation—but also perhaps because of this lack and his continuing need for roots—he wanted a church wedding. After much discussion, Lee Krasner, who had also drifted far from the religion into which she had been born, was persuaded to go along with his wish. They made arrangements to be married on October 25, two days before her birthday, at the Marble Collegiate Church—quite neutrally Dutch Reformed, simply a church. There, at Fifth Avenue and 29th Street, May Rosenberg and Peggy Guggenheim would be witnesses—two women, since the wedding was planned for midday and the time and location might be inconvenient for men with jobs or studio routines. That was the plan. May Rosenberg said she'd be there. Peggy Guggenheim may have incorrectly connected May Rosenberg's name with that of the editor with whom she was working tensely on her memoirs. She said she had a previous lunch date she intended to keep. "You're married enough," she told Lee. "Why do you have to get more married?" The church furnished a witness to take her place.

Before the move to Springs Pollock brought what recent work he had to Art of This Century. The rest—early notebooks, and rough sketches in various media, and work still uncompleted—he packed along with his art supplies and Lee's and some of her paintings, mostly early work. (Much of her later work, particularly that of the early forties, was scraped down to salvage canvas for herself and Jackson.) That was most of the packing.

The front space at 46 East 8th Street was taken over by James Brooks, who after three years of service had received his discharge from the army and needed a studio. Jackson's brother (Marvin) Jay, then lithography foreman of a printing plant in New Jersey, used the rear apartment. Though Jim had met Jackson during the thirties and played the ocarina at some of the Bentons' musical evenings, he had at that time known the older Pollock brothers much better than he knew Jackson.

Only during the coming year, when Jackson would stay at 46 East 8th Street while visiting New York, and a few years later, when Jim and his wife would get a summer place in nearby Montauk, did they become close friends.

By the end of 1945 Pollock was working, in the smallest of the three upstairs bedrooms of the Springs house, on paintings for his third one-man show. In between these periods of painting, he began planning the conversion of the barn to a permanent studio. Although he helped Lee fix up the house, she did most of this work, beginning even then to turn it into a bright white space decorated with a few pieces of Victorian furniture, some paintings of their own, and such natural objects as plants, shells, gourds, stones, baskets of fruit and vegetables.

Of the paintings in Pollock's third show, it is impossible to say just which were done in New York and which during the first few months in Springs. This show of nineteen paintings, eleven of them oils, contains nothing "major," nothing that is an advance from the work in his 1945 show. In such typical paintings as *Circumcision* (1945) and *The Little King* (1946) the underlying totemic configuration is somewhat more obscured than in the previous show, and the surfaces more agitated, more densely and violently "doodled" upon. However, in these paintings, and even more in those on paper, there is a sense of the artist being confined and trapped, a sense of his struggle to get out of the maze—all possibly a carry-over of New York claustrophobia or a reaction to the small temporary studio in which he was now working.

The book jacket Pollock designed at this time for Peggy Guggenheim's *Out of This Century,* the original volume of her memoirs, is similarly split and unresolved. Both covers are vaguely totemic, the front suggestive of a single piece of Cubist sculpture and the rear of Pollock's more overall "automatic writing."

Clement Greenberg recognized that what seemed to be a moment of standstill frustration in Pollock's career was actually one of transition. He wrote in the April 13 *Nation:*

> ...*Pollock's superiority to his contemporaries in this country lies in his ability to create a genuinely violent and extravagant art without losing stylistic control. His emotion starts out pictorially; it does not have to be castrated and translated in order to be put into a picture.*
>
> *Pollock's third show in as many years ... contains nothing to equal the two large canvases, "Totem I" and "Totem II," that he exhibited last year. But it is still sufficient—for all its divagations and weaknesses, especially in the gouaches—to show him as the most original contemporary easel-painter under forty. What may at first sight seem crowded and repetitious reveals on second sight an infinity of dramatic movement and variety. One has to learn Pollock's idiom to realize its flexibility. And it is precisely because I am, in general, still learning from Pollock that I hesitate to attempt a more thorough analysis of his art.*

Greenberg's invidious comparisons here are mild compared with those in the December 28 *Nation* concerning Pollock's first painting in a Whitney Annual:

> *The best painting at the present show is Jackson Pollock's "Two." Those who think that I exaggerate Pollock's merit are invited to compare this large vertical canvas with everything else in the Annual. Mark Tobey, too, is represented by a strong picture, but in the presence of the Pollock the minor quality of his achievement, original as it is, becomes even more pronounced than before.*

The painting, sent to the Whitney before the April show and now singled out by Greenberg is, of this period, one of Pollock's most conservative—that is, most Cubistic and Picassoesque. It paraphrases Pollock's own *Male and Female* of three years before, which is roughly the same size and identically organized, though less literal. As to the other artists in the show, they included not only contemporaries of Pollock (Baziotes, Gorky, Gottlieb, Guston, Motherwell, Rothko, Stamos, Tomlin—typically all trying, also, to synthesize the carefully organized flat picture plane of Cubism and the more automatic and improvised imagery of Surrealism); but many of the official Surrealists themselves (Dali, Ernst, Matta, Tanguy); and established painters of the earlier American vanguard (Davis, Dove, Hopper, Kuniyoshi, O'Keeffe, Weber); and even

Pollock's second teacher, John Sloan; and his last, in a looser sense, Stanley William Hayter. It is pointless to argue about whether or not Pollock's painting was the best. It was strong, but not nearly so much his own as was the work of more mature artists *their own* in that 1946 Annual.

If Pollock must be judged by *Two* and other paintings of 1945 and those of early 1946, the verdict is clear: he is a minor Surrealist; historically, late; academically, particularly as a draftsman, not in the same class with Dali, Ernst, Masson, Matta, Tanguy, Gorky (the American culmination of the tradition); inventively, still far behind Picasso and Miró. Up to this point he has shown emotional intensity, expressed primarily in the visual vocabulary of Cubism, freed by Surrealism. Like Picasso and Miró and such younger artists as Giacometti and Dubuffet, he has indicated the possibility—in his case thus far, *only the possibility* —of moving past both Cubism and Surrealism. If Pollock had died then, in mid-'46, instead of ten years later, he would not have his "place in history." It is during the next ten years, and mostly during the first five of them, that he painted that place, struggled for it as an act of willful necessity.

Chapter Four

Roots in East Hampton
(1946–1947)

Sculpture and painting are not, it is true, capable of actual movement, but they suggest movement. Every statue, every picture, is a series of ordered relations, controlled, as the body is controlled in the dance, by the will to express a single idea. A study of the most rudimentary abstract design will show that the units of line or mass are in reality energies capable of acting on each other; and, if we discover a way to put these energies into rhythmical relation, the design at once becomes animated, our imagination enters into it; our minds also are brought into rhythmical relation with the design, which has become charged with the capability of movement and of life. In a bad painting the units of form, mass, color, are robbed of their potential energy, isolated, because brought into no organic relation; they do not work together, and therefore none of them has a tithe even of its own effect. It is just so with the muscular movements of a bad player at a game, a bad dancer.

When the rhythm is found we feel that we are put into touch with life, not only our own life, but the life of the whole world. It is as if we moved to a music which set the stars in motion.

LAURENCE BINYON
The Flight of the Dragon

So I had actually found a way of painting nature! I naturally repeated the experiment several times. The strange part was that I had actually endowed the colors with movement.

ITALO SVEVO
The Confessions of Zeno

Lee Krasner Pollock reminisces:*

...I think that living in Springs allowed Jackson to work. He needed the peace and quiet of country life. It enabled him to work.

The first two years we lived in Springs we had no car. You know, before I met him, there was an existence of dire poverty, about as bad as it can be.

* See Bibliography No. 172.

This was sometime between the time he arrived in New York and when he got on W.P.A. In the deep Depression he used to get a meal for five cents. I know that when he lived with Sandy he had to work as a janitor in the [City and Country School] in the Village. Later Jackson got a Model A Ford, but in the beginning we had to bicycle to do all the errands; that would take a good part of the day.

He always slept very late. Drinking or not, he never got up in the morning. He could sleep twelve, fourteen hours, around the clock. We'd always talk about his insane guilt about sleeping late. Morning was my best time for work, so I would be in my studio when I heard him stirring around. I would go back, and while he had his breakfast I had my lunch. His breakfast would not set him up and make him bolt from the table like most people. He would sit over that damn cup of coffee for two hours. By that time it was afternoon. He'd get off and work until it was dark. There were no lights in his studio. When the days were short he could only work for a few hours, but what he managed to do in those few hours was incredible. We had an agreement that neither of us would go into the other's studio without being asked. Occasionally, it was something like once a week, he would say, "I have something to show you." I would always be astonished by the amount of work that he had accomplished. In discussing the paintings, he would ask, "Does it work?" Or in looking at mine, he would comment, "It works" or "It doesn't work." He may have been the first artist to have used the word "work" in that sense. There was no heat in his studio either, but he would manage in winter if he wanted to; he would get dressed up in an outfit the like of which you've never seen. . . .

In the afternoon, if he wasn't working, we might bicycle to town. Or when we had a car, he would drive me to town and wait in the car for me while I shopped. When he was working, he would go to town when the light gave out and get a few cartons of beer to bring home. Of course, during those two years . . . he was on the wagon, he didn't touch beer either. We would often drive out in the old Model A and get out and walk. Or we would sit on the stoop for hours gazing into the landscape without exchanging a word. We rarely had art talk, sometimes shop talk, like who's going to what gallery.

One thing I will say about Pollock; the one time I saw temperament in him was when he baked an apple pie. Or when he tried to take a photograph. He never showed any artistic temperament. He loved to bake. I did the cooking but he did the baking when he felt like it. He was very fastidious about his baking —marvelous bread and pies. He also made a great spaghetti sauce.

He loved machinery, so he got a lawn mower. We made an agreement about the garden when he said, "I'll dig it and set it out if you'll water and weed." He took great pride in the house. One of the reasons for our move to Springs was that Jackson wanted to do sculpture. You know, it was his original interest in high school and art school. He often said, "One of these days I'll get back to sculpture." There was a large junk pile of iron in the backyard he expected to use.

He would get into grooves of listening to his jazz records—not just for days—day and night, day and night for three days running until you thought you would climb the roof! The house would shake. *Jazz? He thought it was the only other really creative thing happening in this country. He had a passion for music. He had trouble carrying a tune, and although he loved to dance he was an awkward dancer. He told me that when he was a boy he bought himself a violin expecting to play it immediately. When he couldn't get the sound he wanted out of it, he smashed it in a rage.*

. . . I can't say he was a happy man. There were times when he was happy, of course; he loved his house, he loved to fool in his garden, he loved to go out and look at the dunes, the gulls. He would talk for hours to Dan Miller, the grocery store owner. He would drink with the plumber, Dick Talmadge, or the electrician, Elwyn Harris. Once they came into New York to see one of his exhibitions.

It is a myth that he wasn't verbal. He could be hideously verbal when he wanted to be. Ask the people he really talked to: Tony Smith and me. He was lucid, intelligent; it was simply that he didn't want to talk art. If he was quiet, it was because he didn't believe in talking, he believed in doing.

Tony Smith, who was born the same year as Pollock and attended the Art Students League just after him, did not meet Pollock until the early forties. The meeting was at Fritz Bultman's apartment on 11th Street. Besides Bultman himself and Smith and Pollock, there were Tennessee Williams, and the painter Jerome Kamrowski, and the architect Ted van Fossen. For Smith the meeting was "a disaster." Pollock was "so sullen and intense, so miserable" that Smith was actually frightened and said to himself, "I've got to get out of here. I can't stand that guy."

Despite this bad beginning and despite a lack of sympathy for Pollock's Expressionistic work of the late thirties and early forties, Smith

became interested in the paintings of the middle forties. By 1948, when Pollock moved to Betty Parsons, he and Pollock were friendly, and Smith thought of him on that same level of leadership as Rothko and Still, who had had shows at that gallery in 1947, and Newman, who had not yet shown there but had organized an exhibition of Northwest Coast Indian Art. However, Pollock and Smith became really close at the time of Jerome Kamrowski's show in 1948. Then "Kamrowski had done about a dozen small paintings on both sides of some panels, and [Smith] had made a couple of supports for them in the middle of the gallery." Jackson asked Betty Parsons if Smith could design some floating panels for him. She was willing. However, when she and Smith visited the Pollocks in Springs and saw Jackson's new work it was obvious that the proposed method of installation "wouldn't have worked for Jackson's paintings because of their size." With that settled Smith and Pollock had plenty of time to talk.

Tony does not agree with Lee about Jackson being "verbal": "Jackson was detached and analytical. This led him to compartmentalize things. He had relatively few interests, but they were intense. He saw them as having no real connection with one another; the only way he could connect them was through some kind of action. I don't know if booze helped him in this. Anyhow, the way he looked at the physical world was characteristic of how he saw things—separately. He had a distinct posture for looking at the ground, another for looking at the horizon, and a third for looking at the sky. You might say that's just the way it is, but for him these seemed to be totally different modes of perception.

"Another example of what I mean: Jackson was puritanical. I've never known anyone who was more so—I mean stern. On the other hand, I have heard that he was fascinated by all sorts of things which he considered perverse. He seemed to be pretty familiar with Krafft-Ebing, and, although he didn't advertise it, he thought it important. The subject was a factor in his art, in the forms in his painting, animal and human,

male and female, in the metamorphoses of his shapes, in his conception of the links between things. There were real conflicts, partly due to the manner in which he kept things apart in his mind."*

The painter and teacher Julian Levi, who bought a house in Springs in 1947, also describes Pollock as anything but "verbal." He recalls Jackson's silences as much as his words and remembers that Jackson's talk had more to do with day-to-day problems than with an exchange of sophisticated ideas. His ideas were often expressed existentially. Once when Jackson was drunk he came into Levi's studio shouting against the use of frames, before proceeding to rip the frame off a painting. Another time, when Levi was on his way to teach in New York, Jackson shouted at him: "Painters should paint, not teach." However, as against these aggressive incidents there were the warm hospitality of the Pollock kitchen where a pot of coffee was always on the stove, and Jackson's pride in the Springs Fair for which he baked pies. In at least one connection Pollock was both hostile and sympathetic: he expressed contempt for the bird decoys Levi collected, but later when Pollock bought a neighbor's barn, he took great delight in negotiating for hours on Levi's behalf for some decoys he found there. Like so many others, Levi put up with the blatantly aggressive side of Pollock's personality because of the more gentle and innocently playful side. There was also the need for neighborly cooperation as when, after a blizzard, Julian and Jackson went for provisions in the Levi car (the East Hampton Bank had refused to lend Pollock $100 to buy a jalopy).

During winter nights when there were no movies in East Hampton and when, even if there had been, the Pollocks could not easily have afforded them, they made and ate dinner—sometimes with neighboring friends, more often alone. They might cook clams they had dug and serve them with spaghetti and Jackson's sauce, or Lee might fix that day's "special" from the market, or if it was "an occasion" Jackson might make an apple pie.

* See Bibliography No. 172.

Some nights they read, but critics have made too much of this, as if offering credentials for the Pollocks' culture. Neither was a great reader. The East Hampton *Star,* the Sunday *Times,* popular and art magazines (frequently given to them by friends weeks or months after publication) —these were more than enough to read; and even with these the reading was exceptionally physical, a matter of turning pages, recording images, tracing them with the hands, as one "reads" art books. Yes, Lee had long ago gone through some of the nineteenth-century Russian classics; and Jackson had read *Moby-Dick,* had taken titles for some paintings from it, and would name one of his dogs Ahab. But neither Lee nor Jackson remembered these books in detail; they had rather felt their spirit and absorbed the books in that more general way.

Charles Pollock has written to the critic William Rubin:

> *I have the Eighth Annual Report of the Bureau of Ethnology (Washington, Government Printing Office, 1891). Among other things, it contains 12 chromo-lithographic plates. Four of these are sand paintings, the others ritualistic paraphernalia—blankets, feathers, paints, etc.*
>
> *Jack had several volumes of this kind. As I remember, we bought them together in one of the then innumerable secondhand bookstores on 4th Avenue —sometime between 1930 and 1935.*

Pollock's friend Alfonso Ossorio has stated*:

> *He had an enormously catholic appreciation of the art of the past: Indian sand painting, Eskimo art, or the baroque. I think at one stage, when he was younger, he went to museums. He certainly knew the anthropological collection at the Museum of Natural History very well. And he knew the art of the American Indian because he had lived part of his life in the Southwest. He had the fifteen volumes published by the Smithsonian on American anthropology—he once pulled it out from under his bed to show me—I remember being surprised that someone so poor could have such a publication.*

It is difficult to imagine Pollock wading through all the material his brother and his friend describe, easier to imagine him studying the plates

* See Bibliography No. 172.

and dipping only here and there within the text. The same is true of D'Arcy Thompson's *On Growth and Form,* a gift from Tony Smith, and always listed as one of Pollock's favorite books. In this case it is possible he never read past the introductory chapter. Thompson's accomplishments as a classicist and mathematician as well as a naturalist—with all three of these disciplines so brilliantly balanced in this particular book, his masterpiece—may well have gone over Pollock's head. Surely Pollock would have been put off by all the quotations, not only from classical literature but from modern European. And the mathematical equations, beginning in the second chapter, would have been trying, despite some knowledge, from surveying days, of geometry and trigonometry. However, this is not to say that Pollock didn't love *On Growth and Form.* The words in that first chapter (along with the many beautiful illustrations which follow) may well have been enough for him. We can imagine the excitement with which he would have read:

> ... *But the physicist proclaims aloud that the physical phenomena which meet us by the way have their forms not less beautiful and scarce less varied than those which move us to admiration among living things. The waves of the sea, the little ripples on the shore, the sweeping curve of the sandy bay between the headlands, the outline of the hills, the shape of the clouds, all these are so many riddles of form, so many problems of morphology, and all of them the physicist can more or less easily read and adequately solve: solving them by reference to their antecedent phenomena, in the material system of mechanical forces to which they belong, and to which we interpret them as being due. They have also, doubtless, their immanent teleological significance; but it is on another plane of thought from the physicist's that we contemplate their intrinsic harmony and perfection, and "see that they are good."*
>
> *Nor is it otherwise with the material forms of living things. Cell and tissue, shell and bone, leaf and flower, are so many portions of matter, and it is in obedience to the laws of physics that their particles have been moved, moulded and conformed. ...*
>
> *While the protoplasm of the Amoeba reacts to the slightest pressure, and tends to "flow," and while we therefore speak of it as fluid, it is evidently far less mobile than such a fluid (for instance) as water, but is rather like treacle in its slow creeping movements as it changes its shape in response to force.*

We can imagine, too, the excitement with which Pollock would have studied the many plates of cells . . . shells . . . skulls . . . scales . . . snowflakes . . . worlds of growth and form from seeming chaos. . . .

Fixing up the studio is a common way for artists to relax, a way of stopping one's real work without having to suffer the guilt of not working at all. However, in Pollock's case the need to fix up the barn as a permanent studio was far more than a distraction from the pressures of the past year—particularly, the interruption of moving while preparing his show and then lack of progress in the show itself. Working on the barn would have been a relief but also a necessity. For half a year now Pollock had felt cramped painting in the bedroom; and, worse than cramped, had felt like a tourist on his own property. Every time he looked out the window he saw the barn, stark and strong against the flat space stretching to Gardner's Bay. He was unhappy up in the farmhouse bedroom. He wanted to be down there—settled, rooted—in his barn.

That summer of 1946, before beginning work on the barn, he moved it farther north. Thus, their home had a better, more open view and his studio more privacy. After he relocated the barn and began to paint in it, Lee Pollock took over the bedroom studio. There, in the late forties, she would make her "hieroglyphs." It is no accident that these abstract works of hers, heavily painted mostly in black and white and typically not exceeding two feet in either dimension, are quite secretive paintings which twist in upon themselves and speak in whispers. Nor is it an accident that once Jackson painted in the barn his work began to open up, to shout and sing.

Pollock worked furiously, demonically during the rest of 1946—partly in reaction to having "rested" in the early summer, partly in response to the large space in his new studio and its natural surroundings, and partly because Peggy Guggenheim announced her intention to close her gallery the following spring and return to Europe. Jackson asked her to give him one more show at Art of This Century. If only she could sell enough paintings for him to get a little more money than what was

guaranteed by their contract, he could make ends meet, maybe put a decent heating system in the house and a stove in the studio, maybe make some necessary repairs, maybe get a better car than the Model A Ford. . . .

Peggy Guggenheim did what she could. Despite his last show having closed only April 20 and despite the gallery's tight schedule for its final season, she managed to squeeze him in from January 14 to February 1, a period generally considered a difficult one in which to sell, being still too close to Christmas and too far from the spring return of the wealthy from sunny resorts. Nevertheless, Jackson was appreciative. He worked enthusiastically and by the end of 1946 had completed fifteen new paintings. In the exhibition catalogue these were divided into two series: *Sounds in the Grass,* seven paintings; and *Accabonac Creek,* eight. In addition Peggy Guggenheim's *Mural* was shown for the first time in the gallery (listed under the *Accabonac* series).

In titling the two series, Pollock wanted no doubt to express a debt to and an appreciation of his new environment. However, these designations were applied after the fact, that is, after the work had been completed. And this titling procedure was followed also with the individual paintings. Never very articulate himself, but responsive to the articulateness of others, Pollock had—at least since his first one-man show—frequently encouraged the people close to him, those whose sensitivity he trusted, to free-associate verbally around the completed work. From their responses, from key words and phrases, he often, though not always, chose his titles—typically vague, metaphorical, or "poetic." He thought of each title as a convenience in identifying his work rather than in any sense a verbal equivalent of its subject matter. To Pollock the meaninglessness of titles (as compared with the importance of the work itself) is evident not only in his having included the Guggenheim mural in his *Accabonac Creek* series but in his having a few years earlier retitled *Moby-Dick* of 1943 *Pasiphaë* at the suggestion of Sweeney.

Before the 1947 show some of the people who visited Pollock's studio, from whom he would have extracted titles or with whom he might

in effect have collaborated on them, included his wife; Peggy Guggenheim; his friend and collector W. N. M. "Bill" Davis, who bought both *Shimmering Substance* and *The Tea Cup* from the show before it opened and who also wrote a brief catalogue note, describing Pollock as "... working in perhaps a somewhat gayer mood"; and Clement Greenberg whose review appeared in the February 1 *Nation:*

> *Jackson Pollock's fourth one-man show in so many years is his best since his first one and signals what may be a major step in his development—which I regard as the most important so far of the younger generation of American painters. He has now largely abandoned his customary heavy black-and-whitish or gun-metal chiaroscuro for the higher scales, for alizarins, cream-whites, cerulean blues, pinks, and sharp greens. Like Dubuffet, however, whose art goes in a similar if less abstract direction, Pollock remains essentially a draftsman in black and white who must as a rule rely on these colors to maintain the consistency and power of surface of his pictures. As is the case with almost all post-cubist painting of any real originality, it is the tension inherent in the constructed, re-created flatness of the surface that produces the strength of his art.*

Up to this point Greenberg, concentrating on such high-keyed paintings as *The Blue Unconscious* and *The Key*, seems to be saying that their Post-Cubist originality is in their use of Cubist disciplines. However, in the last paragraphs of the review, his attention shifts to more totally abstract and radically Post-Cubist paintings (*e.g., Eyes in the Heat, Shimmering Substance*):

> *Pollock, again like Dubuffet, tends to handle his canvas with an over-all evenness; but at this moment he seems capable of more variety than the French artist, and able to work with riskier elements—silhouettes and invented ornamental motifs—which he integrates in the plane surface with astounding force. Dubuffet's sophistication enables him to "package" his canvases more skilfully and pleasingly and achieve greater instantaneous unity, but Pollock, I feel, has more to say in the end and is, fundamentally, and almost because he lacks equal charm, the more original.*
>
> *Pollock has gone beyond the stage where he needs to make his poetry ex-*

plicit in ideographs. What he invents instead has perhaps, in its very abstract-ness and absence of assignable definition, a more reverberating meaning. He is American and rougher and more brutal, but he is also completer. In any case he is certainly less conservative, less of an easel-painter in the traditional sense than Dubuffet, whose most important historical achievement may be in the end to have preserved the easel picture of the post-Picasso generation of painters. Pollock points a way beyond the easel, beyond the mobile, framed picture, to the mural, perhaps—or perhaps not. I cannot tell.

"Over-all" and the later variation "all-over" are key critical descriptions of Pollock's work from now on (as also of Dubuffet's and that of many other avant-garde painters).

In their total abstraction and in their gyrating repetitive rhythm, *Shimmering Substance* and *Eyes in the Heat,* both done in late 1946, are related to some of the untitled gouaches of the previous year. However, the newer paintings have considerably greater freedom and luminosity and a more relaxed rhythm than the earlier work. By using the palette knife as well as the brush in heavy oil paint (squeezed directly from the tube onto the canvas) Pollock now came closer to communicating an "over-all" immediacy and spontaneity. Though there are passages of drip-ping and splattering in this work, as there have been since the early for-ties, it remains for Pollock to create his new abstract images still more freely—and seemingly effortlessly—by using only dripped paint. That is, he must learn to draw with spilled paint and to control this as a total technique rather than to incorporate accidents within finished work done using conventional techniques.

But this presentation of problem and solution is much too program-matic. We will never know exactly how Pollock developed his totally dripped image. We can only know that the new technique was fully developed—full-grown—in 1947 and that by then Pollock had recog-nized that accidents (spillings, splatterings, puddlings, drippings) in-corporated in his work came closest to the look and feel he wanted. At the same time he was experiencing a mounting frustration because even

such paintings as *Shimmering Substance* and *Eyes in the Heat* retained a certain tightness, and a textural quality too reminiscent of Impressionism in general and of the juiciest Expressionism (say, that of Soutine).

So, without being programmatic, without making exclusively intellectual decisions, but rather intuitively, by responding to his own needs, one day perhaps Pollock thins his paint a little more than usual, perhaps even more than he intended, and spills some on a canvas. Or perhaps he kicks over a can of industrial enamel that is standing in the studio and likes what he sees. Or in anger or frustration he throws some paint at a canvas. Or notices that it distributes itself more evenly and more controllably when canvas is on the floor rather than tacked to a wall. . . .

Perhaps all these things happened in early 1947. Perhaps they have happened in the past, but are only now digested as experience. Either way, what look like accidents, what might be accidents for someone else, are now necessities for Pollock, the last lesson of Surrealist automatism and of Siqueiros's "experimental workshop," the inevitable end of a search begun by himself almost twenty years earlier in Los Angeles at Manual Arts High School and by the Impressionists almost a hundred years earlier in Paris. . . .

Perhaps soon after his final show at Art of This Century, Pollock is watching snow melt outside his studio and the ground itself begin to thaw. There in the sun, he sees a stain of moisture spread and mud form. Or, on another sunny day, he and his wife go for a walk on the beach. There, too, the snow is melting, melting on the dunes, and the sand soaks up this shimmering wetness and that of the surf pounding farther down at the shore. . . . Walking back to the house Jackson and Lee are struck once again by the look of bare trees traced against winter sky. . . .

Perhaps Pollock has been drinking heavily, drinking in that peculiarly cyclical pattern of his, in bouts that follow or precede (who can say which?) periods of hard work. Shaken, depressed, hung-over, guilt-ridden, he is alone now in his studio, as at some point he was alone in his drunkenness. As he looks at past work—some of it stretched and in racks along-

side the entrance to the studio, some of it still tacked to the white-painted barn walls, some of it in large cardboard portfolios—he feels once again that even paint is intractable, that somehow as it hardens it loses the oozing vitality it has when coming fresh out of the tube or can. . . . Perhaps, in his mind, he draws, following a line that reads like a continuous encephalograph, a linear proliferation, a flow of energy, wishing that this line could exist by itself, independent of canvas or paper, self-supporting, as strong as sculpture (the medium in which, after words, he feels least adequate and yet one for which he still feels a nostalgic fascination) . . . sculpture, perhaps forged out of steel, like that of David Smith. . . .

Perhaps initially Pollock was expressing, acting out, the tension between his frustrations and his rebelliousness by spilling paint. Perhaps he wanted to destroy the entire history of painting and to start fresh, screaming now, as during much of his life, "Fuck you," screaming this at the world, at history, with the most intensely positive and negative meaning, simultaneously loving and angry. . . . Like a naughty boy, Pollock may have wanted to make a mess, to disturb everything neat and orderly and faceless about the canvas, its clean surface, its regular texture, its rectangular shape, all reminiscent of dining tables he'd cleared and cleaned as a child and at the League, of dishes he'd washed and wiped until sparkling, of laundry on the line, of shirts he'd been told to tuck in, of rules of cleanliness, rules of composition, rules of the road, white stripes down the center of highways, speed limits, limits of all kinds, rigidities, Cubistic organization. . . . Yes, the gesture of spilling paint is an attack on art history as well as personal history, personal destiny. It is an act connecting past and future, the affirmative side of cracking up cars, picking fights, pissing in fireplaces, overturning tables, kicking out windshields, crushing hats, and all the rest, past and future; it is ultimately the conversion of negative energy into positive paintings, some among the most alive ever made.

Perhaps . . . There are so many possibilities, endless possibilities, possibilities within possibilities . . . all valid. . . . Whatever actually hap-

pened, remember that although Pollock was not the first to incorporate spilled paint in a finished work, he was the first to use this technique to present a total image, destructive and creative, the very pulse and rhythm of his own life, once again that pounding statement, "I am nature."

During 1947 Pollock made two of his rare public statements—that is, verbal statements. The first, somewhat echoing Greenberg, was in his application for a Guggenheim Fellowship (never granted):

> *I intend to paint large moveable pictures which will function between the easel and mural. I have set a precedent in this genre in a large painting for Miss Peggy Guggenheim which was installed in her house and was later shown in the "Large Scale Paintings" show at the Museum of Modern Art. It is at present on loan at Yale University.*
>
> *I believe the easel picture to be a dying form, and the tendency of modern feeling is towards the wall picture or mural. I believe the time is not yet ripe for a full transition from easel to mural. The pictures I contemplate painting would constitute a halfway state, and an attempt to point out the direction of the future, without arriving there completely.*

His more famous statement—and more public, too, though at the time it reached only a special art audience—was made in *possibilities 1,* "an occasional review" which unfortunately appeared on just this single occasion (Winter 1947–48). First, the statement—Pollock's voice— then a few words about the context in which it appeared:

> MY PAINTING *does not come from the easel. I hardly ever stretch my canvas before painting. I prefer to tack the unstretched canvas to the hard wall or the floor. I need the resistance of a hard surface. On the floor I am more at ease. I feel nearer, more a part of the painting, since this way I can walk around it, work from the four sides and literally be* in *the painting. This is akin to the method of the Indian sand painters of the West.*
>
> *I continue to get further away from the usual painter's tools such as easel, palette, brushes, etc. I prefer sticks, trowels, knives and dripping fluid paint or a heavy impasto with sand, broken glass and other foreign matter added.*

> *When I am in my painting, I am not aware of what I'm doing. It is only after a sort of "get acquainted" period that I see what I have been about. I have no fears about making changes, destroying the image, etc., because the painting has a life of its own. I try to let it come through. It is only when I lose contact with the painting that the result is a mess. Otherwise there is pure harmony, an easy give and take, and the painting comes out well.*

possibilities was edited by Robert Motherwell (art), Harold Rosenberg (writing), Pierre Chareau (architecture), and John Cage (music). Except for Chareau who was a generation older, the editors were contemporaries of Pollock's and, like him, members of the avant garde. Yet even to glance at most of the illustrations in *possibilities* is to recognize immediately the continuing dominance of Cubism and Surrealism. This is apparent in reproductions of six recent paintings by Baziotes, a collage and a wood relief by Arp, nine sculptures by David Smith, three photographs of a new Brazilian church by Niemeyer (and particularly the mosaic mural by Portinari), an ink drawing by Motherwell, two "automatic drawings" by Hayter, eight paintings by Mark Rothko. Of the six photographs "illustrating" Pollock's statement, five can properly be labeled Surreal Cubism or Abstract Surrealism (*The Key, Yellow Triangle, The Tea Cup,* all of 1946; and *Totem Lesson I* and *Totem Lesson II,* both of 1944); only the later 1946 painting *Eyes in the Heat* begins to suggest the kind of work Pollock is referring to in his statement. It is unfortunate that the first great dripped paintings of 1947 had not yet been photographed. Had they been, Pollock's statement—and the "possibilities" of a Post-Cubist/Post-Surrealist esthetic—would have been more comprehensible. Without the proper illustrations, the statement can only have been meaningful to his wife and Clement Greenberg and a few others who had seen Pollock's recent work (presumably Motherwell, living in East Hampton and building a house there designed by Chareau; Harold Rosenberg, also there; and perhaps the composer John Cage, whose use of chance in his work has some affinity to Pollock's approach, though more to that of the Dadaists).

If, at the time, the few hundred art-oriented readers of *possibilities* had understandable difficulty with Pollock's statement on himself (those stark words unsupported by up-to-date visual material), this difficulty was both quantitatively and qualitatively minor compared with that of the ten thousand or so less specialized, but equally highbrow, readers of Greenberg on Pollock in "The Present Prospects of American Painting and Sculpture," written for a special American double number (October 1947) of the prestigious British publication *Horizon:*

> *... the most powerful painter in contemporary America and the only one who promises to be a major one is a Gothic, morbid and extreme disciple of Picasso's Cubism and Miró's post-Cubism, tinctured also with Kandinsky and Surrealist inspiration. His name is Jackson Pollock, and if the aspect of his art is not as originally and uniquely local as that of Graves' and Tobey's, the feeling it contains is perhaps even more radically American. Faulkner and Melville can be called in as witnesses to the nativeness of such violence, exasperation and stridency. Pollock's strength lies in the emphatic surfaces of his pictures, which it is his concern to maintain and intensify in all that thick, fuliginous flatness which began—but only began—to be the strong point of late Cubism. Of no profound originality as a colourist, Pollock draws massively, laying on paint directly from the tube, and handles black, white and grey as they have not been handled since Gris' middle period. No other abstract painter since Cubism has been so well able to retain classical chiaroscuro.*
>
> *For all its Gothic quality, Pollock's art is still an attempt to cope with urban life; it dwells entirely in the lonely jungle of immediate sensations, impulses and notions, therefore is positivist, concrete. Yet its Gothic-ness, its paranoia and resentment narrow it; large though it may be in ambition—large enough to contain inconsistencies, ugliness, blind spots and monotonous passages—it nevertheless lacks breadth.*

How confused this larger group of readers must have felt after dealing with Greenberg's aggressive assertions (unsupported by *any* visual material). And what, anyway, could his superlatives have meant—those concerning Pollock and, elsewhere, Hofmann and David Smith—in an

article which in other sections dismisses Matisse for not being as "hard-headed" as "Cézanne, his paranoia notwithstanding; Bonnard; Picasso, as long as he was a Cubist; Gris; Léger; Miró; Brancusi; Kandinsky, before he discovered the Spiritual; Lipchitz, before he re-discovered the Mytho-logical"? Now, not in Pollock's paintings, we are in the presence of brutality—the crude catalogue based too often on ratings and competitive comparisons. And what did these superlatives mean if Greenberg could characterize Morris Graves and Mark Tobey as "the two most original American painters today, in the sense of being the most uniquely and dif-ferentiatedly American" and at the same time "so narrow as to cease even being interesting" and go on to compare these painters with the poets Emily Dickinson and Marianne Moore, whose art "does not show us enough of ourselves and of the kind of life we live in our cities, and there-fore does not release enough of our feeling." And what, finally, could all this mean a few pages from James Thrall Soby's well-illustrated article on Graves, the Representational Mystic, and Ben Shahn, the Social Realist—and, further on in the magazine, a portfolio of more objectively Realistic Chicago photographs by Walkers Evans?

Perhaps it means something about Greenberg's own mythology, his continuing search for *The* Great *American* Painter (with his particular emphases). Beyond the Greenberg in print—beyond, on the one hand, his superlatives and invidious comparisons and, on the other, his inconsis-tencies and hesitations—or perhaps not beyond but between the lines, there is a nonprofessional extracritical dialogue with Pollock. Green-berg's reservations about Pollock have intensified, but so has his identifi-cation with him and with "the genuinely violent and extravagant art," the Gothic American roughness and brutality for which Greenberg thinks Pollock stands. It is as though Greenberg was using Pollock to act out Greenberg's own fantasies—two peculiarly compatible ones in particular, that of the frontier (the Wild West) and that of the revolutionary artist.

How American a Scotch-Irish family from Cody must have seemed to Greenberg who was born in the Bronx and whose parents, he states in

Twentieth-Century Authors, "had come, in their separate ways, from the Lithuanian Jewish cultural enclave in northeastern Poland. . . . I spoke Yiddish as soon as I did English." How romantic was Pollock's boyhood compared with Greenberg's own, watching his father progress "from storekeeper (clothing) to manufacturer (metal goods)."

There was *that* identification—with Pollock as a sort of frontier American—and there was the other, the identification with him as the artist Greenberg may have wanted to be: "As a child I had been a precocious draughtsman, and I had drawn and sketched obsessively until college; but gradually I became much more interested in literature than in art (which I still find it hard to read about), and so when I began to write it was mainly on literature." His translations, book reviews, and other critical articles were published mostly in *Partisan Review, The Nation,* and *Contemporary Jewish Record* (later *Commentary*). "In the meantime my interest in art had reawakened and become a good deal more self-conscious than before; that is, I no longer took my opinions in the matter of painting and sculpture as much for granted, and began to feel responsible for them. By the end of 1941 I was writing an occasional piece on art for the *Nation,* for which I had been doing book reviews, and in 1944 I became its regular art critic." And from the mid-forties on he was "painting more and more seriously," though privately. That brings us just about to the beginning of what became Greenberg's increasingly profound involvement with Pollock. However, in addition, perhaps Pollock was for Greenberg a compounding, of Younger Brother and Surrogate or Prodigal Son—just as for Jackson, Greenberg may have been yet another surrogate father or even a fifth older brother, replacing the four who had scattered, particularly Sandy to whom Jackson had always been so close and from whom he was now quite removed; a father or older brother more proficient than Jackson's own in the intricacies of urban life and communication, a world now of critics, dealers, collectors, lawyers, accountants . . . a world in which Jackson felt inadequate, as expressed sometimes in his regrets at not having gone to college. As with Lee, there was

also the fact of Clem's response to Jackson's work and, in his case the articulateness in expressing that response, the willingness of this East Coast intellectual to attempt the impossible and try to put Jackson's paintings into words.

Pollock makes his paintings in the privacy and silence of his studio. At first the work is seen and responded to only by other artists; later, by critics (some of them painters *manqués*), dealers (existential critics), private collectors (frequently friends), public collectors (curators) ... From the small inner circle words begin to move out through a series of larger concentric rings. From *The Nation* and *Horizon* with their audiences of thousands Greenberg will be picked up by publications with circulations in the millions. And initially Greenberg, the interpreter, will receive more attention than Pollock, the maker.

Of the mass-circulation magazines *Time* responded first (December 1, 1947) with a one-column lead article on its art page (typically only a page then) called "The Best?" In it Greenberg's superlatives regarding Pollock as painter, David Smith as sculptor ("an art capable of withstanding the test of international scrutiny and which, like Pollock's, might justify the term major"), and Hofmann as teacher ("the most important figure in American art of the period since 1935 and one of the most influential forces in its entire history, not for his own work, but for the influence, enlightening and uncompromising, he exerts") are partially quoted above tiny black-and-white reproductions of an abstract work by each (Pollock's *The Key* upside down). Though the article is brief, sloppy, and scornful, it is important to Pollock's career and relationship to Greenberg. It will lead directly, in less than a year, to "A *Life* Round Table on Modern Art" in which Greenberg will again tout Pollock and, in less than two years, to a large color spread in *Life* on Pollock himself. Yes, as the quiet work done in the studio begins to move out into the world, the world begins to invade the studio.

At about the same time as Pollock was perfecting his totally dripped

image, the French poet Francis Ponge was in North Africa, where he made the following journal entry:

Sidi-Madani, Sunday 14 December 1947. Morning

This morning I want to begin to arrange the succession of thoughts suggested by the false marble of our bathroom here:

Title: "Of a new genre of art: the spot, the suggestive splatter."

Plan: I. Certain modern works of art considered as spots, suggestive splatters.

II. What need do these predicate, as their psychic or metaphysical bias? A desire to experience (acquire) startling feelings, suggestive forms and complexes of feeling unknown till then; that the work of art be considered as a way of modifying, of renewing one's sensual world, of forcing the imagination in new, unexplored directions.

III. Description of a work in this genre.

IV. How was this work made? It's exactly as if, having chosen his target and projectile, the "artist" proceeded thus: he throws, he examines the results, he uses them, corrects, modifies ... (or not).

Everything is significant, all is form. We choose, as phenomena to be exploited, our splatters, our creations ex nihilo, *rather than words that have already been created (not by us), rather than the objects of the external world (already there).*

For what advantage? Because the creation involves the material, because there is, here, a unity of material and meaning.

We create the external world. We express our internal complex already in the projection, the throw, the release.

To what extent is it art? in 1) the choice of the wall, the page, the base to be decorated; 2) the choice of the material to be thrown; 3) the preparation of the base and the material so that adhesion is achieved, and many happy possibilities of expression. ...

There will be many such correspondences between Pollock and contemporary writers (as well as actors, dancers, composers, musicians). The rapport with Ponge is particularly interesting because at this time there is no possibility that either knew the other's work. None of Pollock's recent

drip paintings had yet gone abroad or been reproduced anywhere. Ponge's journal had not yet been published. What they shared was not an immediate milieu but—with exceptional awareness—a larger environment, a consciousness of the postwar world: Ponge, admired by Breton and Eluard, and later (especially after Sartre's 1944 essay on him) by the Existentialists; and Pollock, freed also by Surrealism, to become the most Existential painter of his epoch.

The Club: An Interchapter
(1948–1962)

...The Club is a phenomenon—I was at first timid in admitting that I liked it.
Talking has been suspect. There was the prospect that the Club would be re-
garded either as bohemian or as a self-aggrandizing clique. But now I'm con-
sciously happy when I'm there. I enjoy the talk, the enthusiasm, the laughter,
the dancing after the discussion. There is a strong sense of identification. I say to
myself these are the people I love, that I love to be with. Here I understand
everybody, however inarticulate they are. Here I forgive everyone their vices,
and I'm learning to admire their virtues.

JACK TWORKOV
Journal Excerpt April 26, 1952

If there was an affinity between Pollock's ideas and those of someone as
far away as Ponge, what of the artists close to Pollock? How much of his
consciousness did they share? And if, as we have seen, New York critics
and dealers were beginning to feel something happening, something in
the air, an as-yet-unnamed ferment within the art community, then again
what of the artists themselves? What were they feeling and thinking?
The history of The Club partly answers these questions. Though Pollock
had nothing to do with its formation and little to do with its activities
(records show him only as "occasionally on mailing list" and members
recall his visits as infrequent and brief), the formative years of The Club
concur with those during which Pollock's awareness was developing and
taking shape in what we call his "style," in many ways both the most dar-
ing and most representative of the emerging School of New York. The
Club is, then, both communal background and support for the lonely
activity of Pollock in his Springs studio and, of course, for that of other
artists in their various studios across the country but mostly in New York
City lofts.

　　Many of those who formed The Club had met while on the Federal
Art Project and at meetings of the Artists' Union and the American Ab-

stract Artists. Some had gone to the Art Students League or Hofmann's school or Hayter's atelier. Some had spent time at such restaurants and bars as the Sam Johnson, Romany Marie, and the San Remo. Even the poorest had "hung around" Stewart's Cafeteria at 23rd Street and Seventh Avenue and the one on Sheridan Square and at Riker's on 8th Street near University Place and, most important, at the Waldorf Cafeteria on Sixth Avenue off 8th Street. By 1948 these scattered roots and others joined to form a school whose twisting and turning trunk would, however indirectly and independently, branch out and blossom into The Club.

A school called Subjects of the Artist ("in order to emphasize that abstract art, too, has a subject") was founded in 1948 by four alumni of Peggy Guggenheim's Art of This Century, William Baziotes, Robert Motherwell, Mark Rothko, and David Hare, who were joined a little later by Barnett Newman. In a loft at 35 East 8th Street this faculty talked to students and invited other advanced artists to speak on Friday evenings, which were open to the general public and usually attracted a capacity audience of 150. After a year three teachers from New York University's School of Art Education, Robert Iglehart, Hale Woodruff, and Tony Smith, took over the loft and for another year continued the Friday evenings but not the school, calling the program "Studio 35." Smith was undoubtedly the principal link between Subjects of the Artist and Studio 35. He believed that the main reason for architecture was to make a place for art. For him the images of the four painters to whom he was closest —Pollock, Newman, Rothko, and Clyfford Still, the last having helped with the planning of the school though he didn't teach there—were the crucial ones of the period. He understood their new large scale at a time when it just looked big to almost everyone else, and he wanted the work to be seen in an undomesticated context—unframed and uncrowded in uncarpeted space—so that others could experience it by "getting into it." This dream of the proper context for those he considered the four most visionary artists of his generation would later be expressed in several abortive projects.

Jackson Pollock at the age of sixteen, when his family moved from Riverside to Los Angeles, California. There he enrolled at Manual Arts High School. His classmates included the painters Philip Guston and Manuel Tolegian. His most influential teacher was Frederick Schwankovsky, who introduced him to mysticism.

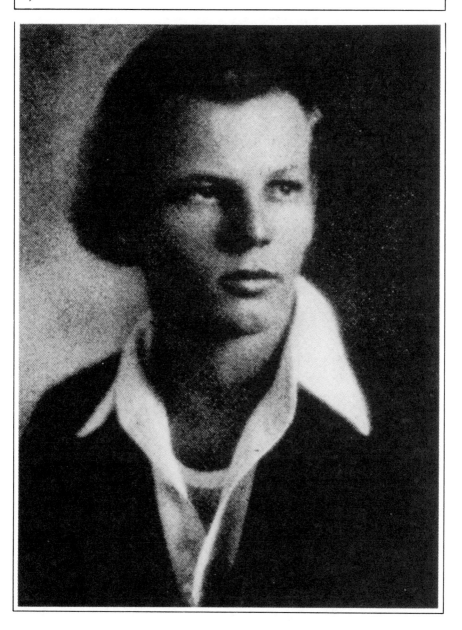

(Top) The Pollock family, 1917. Front row, left to right: Sanford, LeRoy, Frank, Jackson. Back row: Charles, Stella, and Jay. (Bottom) Jackson, about 1928, in the Western gear he wore while surveying the north rim of Grand Canyon with his father and his brother Sandy. This experience contributed to Jackson's lifelong love of endless space.

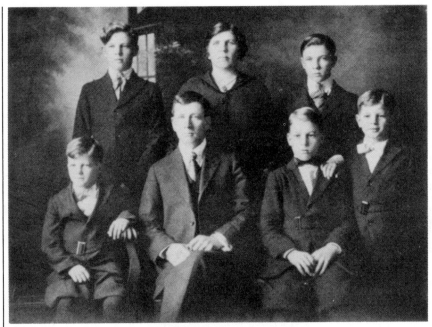

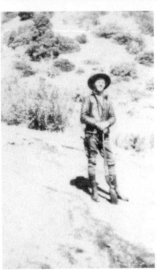

(Bottom, right) Jackson looking elegant in front of the Los Angeles home, while still enrolled at Manual Arts. (At left) A studious snapshot taken about 1930, the year he left home for New York City. (Top, right) In New York, 1936, with David Alfaro Siqueiros, one of the major Mexican muralists who influenced him.

Pencil sketch of Jackson, 1934, by his teacher Thomas Hart Benton: a study for Benton's *The Ballad of the Jealous Lover of Lone Green Valley,* completed the same year and reproduced on the next page. Jackson was not much of a harmonica player, but "country" music was very much a part of Benton's regionalism, and Jackson attended many of his "musical Monday evenings." Ten years after, Jackson said,

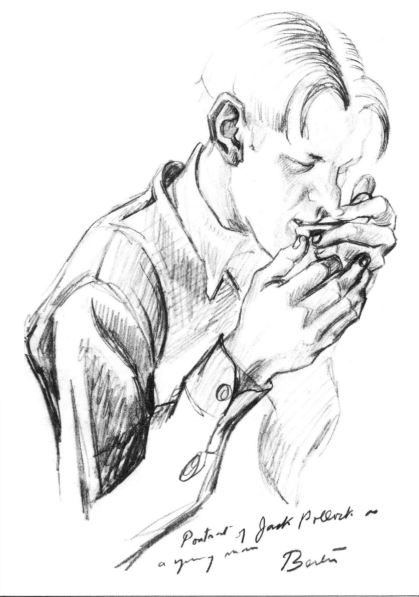

UNIVERSITY OF KANSAS MUSEUM OF ART

"My work with Benton was important as something against which to react very strongly, later on... better to have worked with him than with a less resistant personality who would have provided a much less strong opposition."

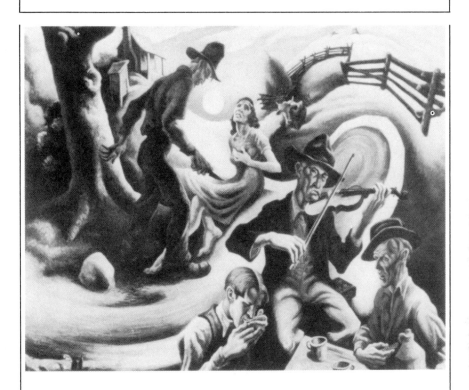

UNIVERSITY OF KANSAS MUSEUM OF ART

Jackson, shirtless, on the steps of the Bentons' summer home in Martha's Vineyard, about 1937. Behind him, wearing a hat, is Mrs. Benton. The writer Coburn Gilman is in the doorway. Elsewhere on the property the Bentons provided Jackson with his own small house, known as "Jack's shack."

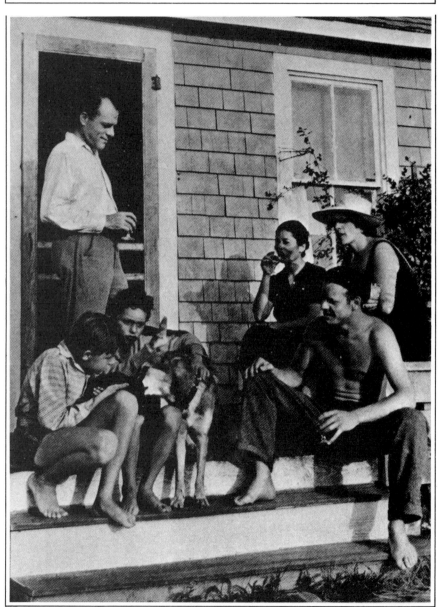

ALFRED EISENSTAEDT

A page from Pollock's notebook, probably done in the late thirties after his studies with Benton, but still influenced by his teacher's emphasis on the Renaissance. The upper and lower right studies are based on three paintings by El Greco. Lower left is a partial self-portrait, an inclusion which occurs occasionally throughout his work.

ESTATE OF JACKSON POLLOCK

(Top) Self-portrait of Lee Krasner, about 1930, long before she met and married Pollock. She used a mirror for this work, which accounts for the use of her left hand, though she is right-handed. (Bottom) Front and back jacket covers designed by Pollock for Peggy Guggenheim's 1946 autobiography.

Pollock, photographed in the late forties by Wilfred Zogbaum, a friend and neighbor, first on Eighth Street and later in East Hampton, where Zogbaum concentrated on sculpture rather than photography and was one of a distinguished group of artists in the Pollocks' circle.

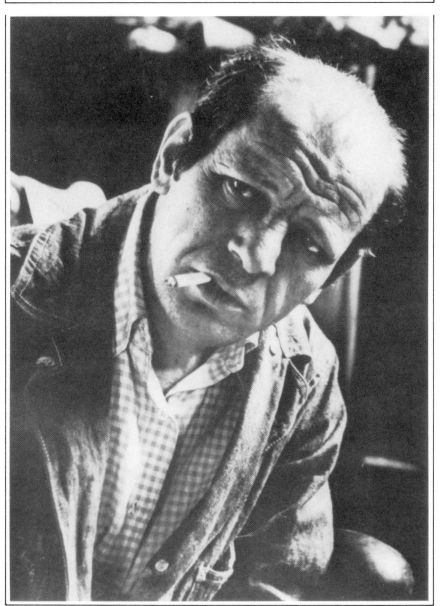

WILFRED ZOGBAUM

Pollock in front of the approximately eight-by-twenty-foot mural commissioned in 1943 by Peggy Guggenheim for the hallway of her home and shown—as in this photograph by Pollock's friend, the photographer Herbert Matter—at Miss Guggenheim's Art of This Century gallery in February, 1947. Pollock studied the large blank canvas for six months before painting it in a single session. Pollock's gallery

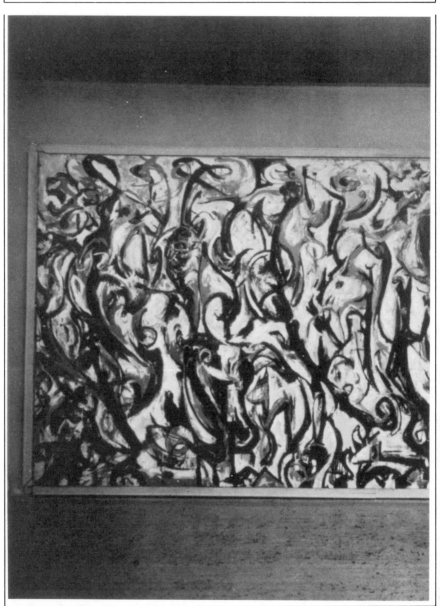

HERBERT MATTER

mate Robert Motherwell said this was "probably the catalytic moment in (Pollock's) art....Dancing around the room, he finally found a way of painting that fitted him, and from then on he developed that technique and that scale." Clement Greenberg, Pollock's critical champion, says it convinced him, even more than previous work, of the young painter's greatness.

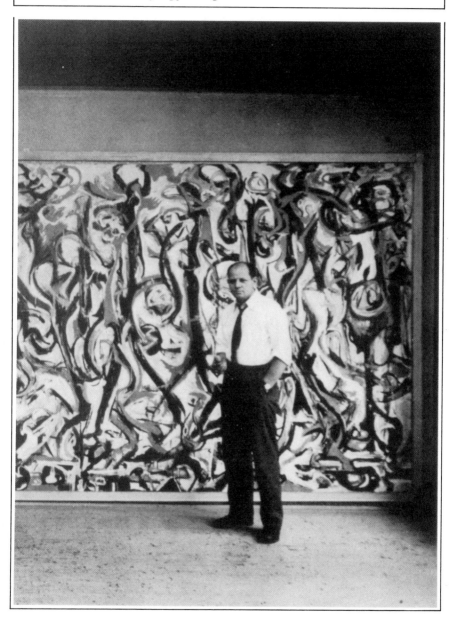

Four Arnold Newman portraits made in Pollock's studio barn for *Life* early in 1949, in anticipation of a "big story." Ultimately none was used. Besides showing him at work and with paintings of the period, there are the cans of enamel from which he "dripped," using sticks and hardened brushes.

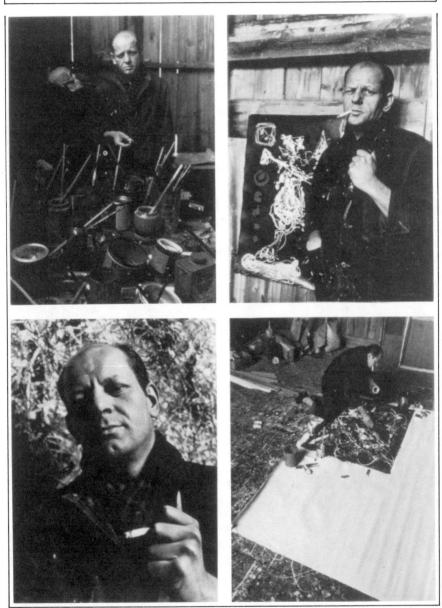

©ARNOLD NEWMAN

(Top) Another Newman portrait, one silhouetted in *Life,* August 8, 1949, where the article "Jackson Pollock: Is He the Greatest Living Painter in the United States?" made the artist famous. The painting in the background is *Summertime.* (Bottom) Pollock with Caw-Caw, a pet crow he trained.

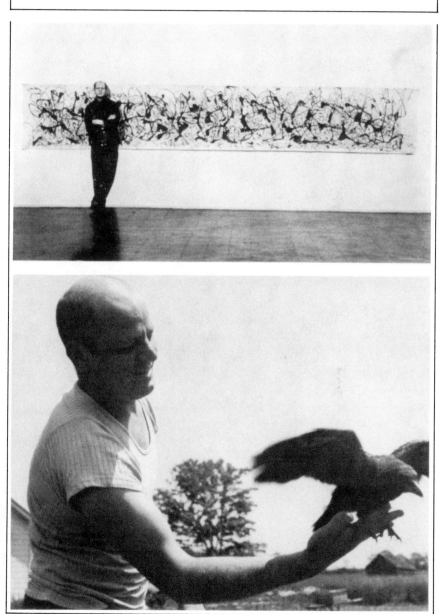

HERBERT MATTER

Jackson playing with a bone "mask" behind his house in Springs. Like his wife, he was fascinated by all sorts of natural objects—rocks, shells, gourds, driftwood, etc. These and their own paintings decorated their home, and natural forms appear frequently in Pollock's work.

(Top) Lee, Jackson, and their dog "Gyp" (short for Gypsophila) walking on the flat marshland extending to Accabonac Creek, behind their house in Springs, just outside East Hampton, Long Island. (Bottom) The front of the Pollocks' old farmhouse as seen from Fireplace Road on which Pollock ultimately met his death.

MARTHA HOLMES, LIFE MAGAZINE.©TIME INC.

The back of the Springs house as seen through the sculptural remains of a dead tree—again, the sort of found object Pollock loved, along with the boulders he later collected on this part of his property.

HERBERT MATTER

During the seasons 1948–49 and 1949–50, in addition to faculty, Friday night "lecturers" included the artists Arp, Ferber, Glarner, Gottlieb, Holtzman, Kees, Jimmy Ernst, de Kooning, Reinhardt . . . Joseph Cornell showing early films . . . John Cage on experimental music . . . the critics Nicolas Calas and Harold Rosenberg . . . the Dadaist, become psychoanalyst, Richard Hulsenbeck. . . . But by the end, according to the painter Robert Goodnough's account,* the "meetings . . . tended to become repetitious . . . partly because of the public asking the same questions at each meeting . . . it was decided to have a closed, three-day session among the advanced artists themselves. . . ." Goodnough, then a graduate student at N.Y.U., suggested and arranged the meetings. Among the dozens of artists asked to participate (including Pollock), the following actually attended one or more sessions: Baziotes, Biala, Bourgeois, Brooks, de Kooning, Jimmy Ernst, Ferber, Gottlieb, Grippe, Hare, Hofmann, Kees, Lassaw, Norman Lewis, Lippold, Motherwell, Newman, Pousette-Dart, Reinhardt, Rosenborg, Stamos, Sterne, David Smith, Tomlin.

Alfred H. Barr, Jr., of the Museum of Modern Art moderated the second day and part of the final day, when he asked: "What is the most acceptable name for our direction or movement? It has been called Abstract Expressionist, Abstract Symbolist, Intra-subjectivist, etc."

David Smith: "I don't think we do have unity on the name."

Ralph Rosenborg: "We should have a name through the years."

Smith: "Names are usually given to groups by people who don't understand them or don't like them."

Barr: "We should have a name for which we can blame the artists —for once in history!"

Motherwell: "Even if there is any way of giving ourselves a name, we will still all be called abstract artists. . . ." But at the end of the session: "In relation to the question of a name, here are three names: Abstract Expressionist; Abstract Symbolist; Abstract Objectionist."

* See Bibliography No. 38.

Brooks: "A more accurate name would be 'direct' art. It doesn't sound very good, but in terms of meaning, abstraction is involved in it."

Tomlin: "Brooks also remarked that the word 'concrete' is meaningful; it must be pointed out that people have argued very strongly for that word. 'Nonobjective' is a vile translation."

Newman: "I would offer 'self-evident' because the image is concrete."

De Kooning: "It is disastrous to name ourselves."

And there, as edited by Goodnough, the final session ended. A lot of words had been spoken by a lot of artists. And, judging by photographs, a lot of pretzels and Ballantine's beer had been consumed. But, after three days, the group was still nameless, anonymous as a group, no matter how strongly identifiable as individuals, one at a time, artist by artist.

No wonder when The Club was formed, by many of these same people, it, too, took such an anonymous name, never to be made more specific. And no wonder that through the years of its existence it sought anonymous lofts for its activities, spaces in which no paintings were hung for fear of siding with a particular school or viewpoint. And no wonder that the Cedar Tavern, the bar that was to continue The Club's activities afterhours, would be equally anonymous, without contemporary paintings, without character, without personality, a "no-environment" as de Kooning called it.

The need for a more private place to meet, one in which the public would not be "asking the same questions at each meeting," existed at least six months before the demise of Studio 35. Late in the fall of 1949 a group of artists, all of whom had probably attended Friday nights at Subjects of the Artist and Studio 35, met at Ibram Lassaw's, organized The Club, and then rented a loft at 39 East 8th Street, only one building removed from Studio 35. The twenty charter members were Lewin Alcopley, Giorgio Cavallon, the dealer Charles Egan, Gus Falk, Peter Grippe, Franz Kline, Willem de Kooning, Lassaw himself, Landes Lewitin, Conrad Marca-Relli, the patron and friend of artists E. A. Navaretta, Phillip

Pavia, Milton Resnick, Ad Reinhardt, Jan Roelants, James Rosati, Ludwig Sander, Joop Sanders, Aaron Ben-Shmuel, and Jack Tworkov. Soon others joined, including the dealer (then without portfolio) Leo Castelli, Herman Cherry, John Ferren, Philip Guston, Harry Holtzman, Elaine de Kooning, Al Kotin, Nicholas Marsicano, Mercedes Matter, Joseph Pollet, Robert Richenburg, the critic Harold Rosenberg, and Esteban Vicente. Though the club would continue to grow rapidly (by 1955 the membership would have to be limited to 150), its character was formed. Already it was truly an artists' club, which permitted an occasional critic or dealer or collector to join and attend meetings. Later Club membership lists overlapped previous ones and those of Subjects of the Artist and Studio 35 to form an almost inclusive list—Pollock, as indicated, was a primary exception—of the best American artists of one generation and then a second.

From 1949 until the spring of 1955 the sculptor Phillip Pavia, a contemporary of Pollock's at the League, pretty much ran The Club's affairs. His notebooks (now in the Archives of American Art)—supplemented by records of the now deceased painter John Ferren for 1955–56 and of the art historian Irving Sandler for 1956 until the spring of 1962, when The Club was discontinued—offer considerable documentation of membership, attendance, dues payment, and programs. Again, these lists read like a Who's Who of two generations of American painters and sculptors but also indicate the broader cultural interests of the artists involved. Not only did they give a party honoring the established American sculptor Alexander Calder but gave others honoring the visiting Italian sculptor Marino Marini and the Welsh poet Dylan Thomas. . . . Not only did they listen to Harold Rosenberg and Tom Hess and Robert Goldwater and James Johnson Sweeney—primarily art critics per se—but to William Barrett, Hannah Arendt, Heinrich Bluecher, Paul Goodman, Joseph Campbell, Lionel Abel, Edwin Denby, Ruthven Todd. . . . Edgar Varese and John Cage spoke on music; Frederick Kiesler and Peter Blake on architecture; Dr. Frederick Perls on "Creativeness in Art and Neu-

rosis". . . . There was "An Evening with Max Ernst," introduced by Motherwell. . . . There were symposia which included Baziotes, Busa, Elaine and Willem de Kooning, Diller, Ferren, Gottlieb, Guston, Holtzman, Kline, Mercedes Matter, McNeil, Reinhardt, Tworkov. . . . And the next generation of artists began to be heard from as well: Paul Brach, Jane Freilicher, Grace Hartigan, Alfred Leslie, Joan Mitchell, Larry Rivers. . . . And the next generation of poets: John Ashbery, Barbara Guest, Frank O'Hara, James Schuyler, all of whom would write on contemporary art . . . Lists, lists, endless lists, at first overlapping but now moving forward, extending into the present where some of those then fighting for recognition are established, and some are still struggling, and too many are dead . . .

The general style of The Club was from the start a nonstyle in the same sense that it existed in a no- (or non-) environment. However, surely from the beginning years—and to a lesser extent until the last—the majority of Club members belonged to the school (or nonschool) which came to be called most commonly Abstract Expressionism. Indeed one of the main reasons for The Club was that this "school," nameless and homeless, had existed as so many separate talents in need of mutual support. No wonder then that these artists who wanted to avoid the public and have more privacy than that afforded by Studio 35 moved from initial informality back to something like the more structured world of a school, a sort of nonacademic academy.

"At first, every member had a key and came when he pleased," Sandler writes. "Meetings were generally pre-arranged by phone calls on the spur of the moment. However, The Club soon took on a more public and formal character, first by inviting speakers (prompted by the Studio 35 sessions), and then by arranging panels. (This move was strongly, but unsuccessfully, resisted.) In keeping with its dual purpose, free-wheeling Round Table Discussions, limited to members, were held on Wednesdays (until 1954); on Fridays, lectures, symposiums and concerts were presented which were open to guests who were mainly critics, historians,

curators, collectors, dealers, and avant-garde allies in the other arts." At first, too, "only coffee was served. Drinking liquor was not the thing to do; besides, most members could not afford it. Subsequently, a bottle was bought to oil up the speakers, and still later, liquor was provided after the panels, the cost defrayed by passing a basket."

Much of the talking that went on at The Club seemed aimed at a definition of the newly emerging art. However, such a definition was as much resisted as sought. There was never agreement as to the rightness of any label but more as to the wrongness of all; Pavia called Abstract Expressionism "The Unwanted Title." There was never a manifesto or an official program or exhibition. What there was has been well summarized by Robert Goldwater: "The consciousness of being on the frontier, of being ahead rather than behind, of having absolutely no models however immediate or illustrious, of being entirely and completely on one's own— this was a new and heady atmosphere."

The new heady atmosphere existing for the first time in the history of American art, though emanating from The Club (and its predecessor groups of New York artists), could hardly be contained within it. Much talk, many unofficial activities—protests, letters to editors, exhibitions (none under the direct auspices of The Club)—spilled over into the Cedar Street Tavern, that appealingly misnamed bar where one was no longer a club member but rather an individual protester, signator, or exhibitor; that anonymous neighborhood bar to which, by geographical coincidence, Pollock had been coming since the thirties. There, at the Cedar, was an atmosphere closer to that of an ideal club—smaller, more informal, more "direct" (to use Jim Brook's word—and a favorite of Pollock's) than nearby 39 East 8th Street and other addresses to which The Club would move. There, in small groups, paying for their own drinks instead of depending on a communal bottle, the artists enjoyed more privacy. There—at first on Wednesdays and Fridays, but soon on any night —one could find congenial company. There, Pollock (in for a show or, later, for a session with a therapist) could find Bill de Kooning, Franz

Kline, and the rest. There, like the ongoing movement of one of his own paintings, Jackson could connect with the New York Art World and permit it to connect with him. There, at the Cedar, as perhaps nowhere else, he painted with words. His words, and those of the other artists, and those of critics and dealers and collectors will flow on through the balance of this book as a sort of chorus spoken quietly behind the action in the studio.

Fame
(1948–1949)

Give me the ease with figures that sailors have with ropes—to coil them through space, to make them fast, to join them together. Sometimes if I have dreamt well, I have it.

JOHN BERGER
A Painter of Our Time

The flow of energy through a system acts to organize that system.
HAROLD MOROWITZ
Energy Flow in Biology

Besides having given Pollock his final show at her own gallery, Peggy Guggenheim wanted, before returning to Europe that spring, to place him with another dealer and to arrange for his 1948 show. Virtually all of the young Americans who had exhibited at Art of This Century were already set at either the gallery of Betty Parsons or that of Sam Kootz, the only ones then truly committed to avant-garde American art. It was clear that Pollock belonged in one of these, but his case was special: there was that contract Peggy Guggenheim wanted taken over by his future dealer; and there was his drinking.

Sam Kootz was blunt: He liked Jackson's work, had even offered to take him on when he needed money to buy the house in Springs, wanted again (as he had with other artists) to go along with Peggy, trusted Clem's judgment, *but* no longer cared if Jackson was or was not the best painter in America, or the best in the world—Sam laughed, because he, like everyone else, knew Picasso was *that;* everyone except maybe Clem when he was being perverse—*but,* no matter what, didn't want to have to deal with a drunk in his gallery. So that was that, as blunt as business.

Betty Parsons liked Jackson's work too, liked the work of so many artists Peggy had shown, really wanted Jackson in her gallery, *but*—the

emphasis was not as pounding as Sam's, not so bluntly businesslike—*but* (she said in her small truthful girlish voice) she couldn't handle that contract, couldn't commit herself to $300 a month.

Peggy called other dealers. First, those showing already established American artists of the previous generation's vanguard, such as Marin, Davis, Calder, Dove ... They weren't interested in Pollock. He wasn't sufficiently controlled or disciplined; his art—like his life, they heard— was a mess. ... She tried some of the galleries which handled Realists and quasi-Realists, ranging from Hopper to Benton. These dealers reacted even more negatively. Finally she went back to Betty Parsons and worked out an agreement: Betty would take over Peggy's obligations to Jackson until early 1948 when his contract expired. Till then Peggy would receive any money from the sale of paintings still owned by her, would continue to pay Pollock his "monthly allowance," and would continue to receive Pollock's new work, except for the one painting per year which Jackson was permitted to retain (and had been giving to Lee). Beyond Peggy's $300 per month, Betty was entitled to all commissions during the remainder of the contract period, and she was obligated to give Jackson a show in the winter of 1948.

The question of excess commissions became academic. The show (January 5–23, 1948) didn't sell well. Not only was this the first public viewing of what we now think of as "classic" Pollocks, those totally dripped paintings begun in 1947, but once again the show's timing was bad. Even those few who came—painters mostly, some critics and dealers and museum people, but not enough collectors—found the work shockingly original.

At the opening—surrounded by a few close friends and relatives— Jackson was tense. As soon as the group left the gallery and went to the Hotel Albert for a small dinner party, John Little bought him a double bourbon, hoping it would relax him. It didn't. Jackson had a second stiff drink and then a third. Before anyone could stop him, he grabbed the new hat of Alma Pollock, the wife of his brother Jay, and destroyed it.

There were three major reviews of the seventeen paintings in his first show at Betty Parsons. These reviews happen to fall conveniently into categories of general reaction. The first, in *Arts Digest* (January 15), was antagonistic. There, Alonzo Lansford—like so many others, including the staff of *Time*—seems to have been at least partly reacting to Greenberg. Lansford begins, "At least two foremost critics here and in England have recently included Pollock in their lists of the half-dozen most important of America's 'advanced' painters. . . ." The broad "half-dozen" must have come from England, surely not from Greenberg whose connoisseurship was razor fine. Lansford continues to do his homework in public, studying statements *about* Pollock's painting, if not the painting itself:

> *Pollock has said that Thomas Benton was a good teacher because he taught him how not to paint like Benton; that he doesn't is startlingly patent. Pollock's current method seems to be a sort of automatism; apparently, while staring steadily up into the sky, he lets go a loaded brush on the canvas, rapidly swirling and looping and wriggling till the paint runs out. Then he repeats the procedure with another color, and another, till the canvas is covered. This, with much use of aluminum paint, results in a colorful and exciting panel. Probably it also results in the severest pain in the neck since Michaelangelo painted the Sistine Ceiling.*

Robert Coates, in *The New Yorker* (January 17), was once again more moderate, more middle-of-the-road:

> *Pollock is much harder to understand than most of his confreres. The main thing one gets from his work is an impression of tremendous energy, expressed in huge blobs of color alternating with lacings and interlacings of fine lines. Recognizable symbols are almost nonexistent, and he attempts to create by sheer color and movement the mood or atmosphere he wants to convey. Such a style has its dangers, for the threads of communication between artist and spectator are so very tenuous that the utmost attention is required to get the message through. There are times when communications break down entirely. . . .*

Greenberg (*Nation,* January 24) went further still:

Jackson Pollock's most recent show ... signals another step forward on his part. As before, his new work offers a puzzle to all those not sincerely in touch with contemporary painting. I already hear: "wallpaper patterns," "the picture does not finish inside the canvas," "raw, uncultivated emotion," and so on, and so on. Since Mondrian no one has driven the easel picture quite so far away from itself; but this is not altogether Pollock's own doing. In this day and age the art of painting increasingly rejects the easel and yearns for the wall. It is Pollock's culture as a painter that has made him so sensitive and receptive to a tendency that has brought with it, in his case, a greater concentration on surface texture and tactile qualities, to balance the danger of monotony that arises from the even, all-over design which has become Pollock's consistent practice.

In order to evolve, his art has necessarily had to abandon certain of its former virtues, but these are more than compensated for. Strong as it is, the large canvas "Gothic," executed three years ago and shown here for the first time in New York, is inferior to the best of his recent work in style, harmony, and the inevitability of its logic. The combination of all three of these latter qualities, to be seen eminently in the strongest picture of the present show, "Cathedral"—a matter of much white, less black, and some aluminum paint—reminds one of Picasso's and Braque's masterpieces of the 1912–15 phase of cubism. There is something of the same encasement in a style that, so to speak, feels for the painter and relieves him of the anguish and awkwardness of invention, leaving his gift free to function almost automatically.

Pollock's mood has become more cheerful these past two years, if the general higher key of his color can be taken as a criterion in this respect. Another very successful canvas, "Enchanted Forest"—which resembles "Cathedral," though inferior in strength—is mostly whitish in tone and is distinguished by being the only picture in the show, aside from "Gothic," without an infusion of aluminum paint. In many of the weaker canvases here, especially the smallest, and at the same time in two or three of the most successful—such as "Shooting Star" and "Magic Lantern"—the use of aluminum runs the picture startlingly close to prettiness, in the two last producing an oily over-ripeness that begins to be disturbing. The aluminum can also be felt as an unwarranted dissimulation of the artist's weakness as a colorist. ...

It is indeed a mark of Pollock's powerful originality that he should present problems in judgment that must await the digestion of each new phase of his

development before they can be solved. Since Marin—with whom Pollock will in time be able to compete for recognition as the greatest American painter of the twentieth century—no other American artist has presented such a case. And this is not the only point of similarity between these two superb painters.

In retrospect it is easy to see weaknesses in Greenberg's criticism of Pollock, but at the time what registered was his commitment to the young painter. Yes, he misunderstood Pollock's originality as a colorist, misread his use of aluminum (as "dissimulation"), and failed to respond to its molten-metal near-alchemical magic. Yes, Mondrian's work implied something beyond easel painting, but, except for a few works, he remained an easel painter throughout his career. Yes, there is "the danger of monotony that arises from . . . even, all-over design," but of all art critics on the American scene, no one more than Greenberg has embraced and continues to embrace such design (which later developed into Color Field Painting). Yes, all of these objections and many others can be raised, but still there was Greenberg's commitment. It is not surprising that his defensive-aggressive stance and passionate-propagandistic assertions irritated, provoked, and impressed other critics and journalists. Some undoubtedly paid more attention to Pollock's work than they might have without Greenberg; others were prejudiced against the work; and still others, like Lansford, were affected in both ways. In any case, Lansford's, Coates's, and Greenberg's views of the show were, in small, those of the world—at least that sliver known as "the art world." There were those who considered Pollock's work "the severest pain in the neck" (even if the phrase was intended as a pun), and those who liked some paintings and not others, but probably no one except Greenberg—surely not Pollock himself—who thought in terms of Pollock competing with Marin to be recognized "as the greatest American painter of the twentieth century." If anything, Pollock's ambitions were grander, less provincial—competitive, but less narrowly so.

The titles for this group of paintings shown at Betty Parsons—almost all given by the translator Ralph Manheim and his wife, neighbors

in Springs—were surely approved by Pollock himself. They reveal very nakedly Pollock's sense of a magical, god- and/or devil-like role as creator. Most of the titles group easily around the classic elements:

EARTH: Enchanted Forest, The Nest
AIR (*and* SKY): Shooting Star, Comet, Reflections of the Big Dipper, *and, less literally,* Unfounded
FIRE (*and* LIGHT): Lucifer, Phosphorescence, Magic Lantern, Prism
WATER: Sea Change, Full Fathom Five, Watery Paths

The remaining titles—*Alchemy, Vortex, Cathedral, Gothic*—encompass all of these elements. Pollock's aspiration is indeed huge. Again, he is abstracting the creative process itself. And yet, though he now has his method and though this is his "breakthrough" show, there is still a degree of tightness in his dripping. Not until after this show will he begin to feel completely at ease with his new technique.

From February 1948 on he continued to experiment with the preferences, expressed in his *possibilities* statement, for "sticks, trowels, knives, and dripping fluid paint or a heavy impasto with sand, broken glass and other foreign matter added." As the year went on he became increasingly confident of his ability to control these techniques and of his ability, also, to respond quickly, intuitively, almost by reflex to the accidents which occurred in the course of making a painting. More and more consistently he was achieving that "pure harmony, an easy give and take" of which he speaks at the end of his statement.

Number 1, 1948, the 5'8" by 8'8", predominantly aluminum, black, and white oil on canvas purchased two years later by the Museum of Modern Art, was among the best paintings Pollock made in 1948. Its arching movement suggests two great Gothic vaults seen in section and begs comparison with *Cathedral,* a typically tighter composition of the previous year. However, not only are the gestures which Pollock has now placed on canvas freer and stronger—a more natural, less forced record of arm and body movements rather than wrist and finger—but in leaving more of

himself, his activity, his energy on canvas, he has even permitted his cigarette butts to be swallowed by the paint and he has consciously made his handprints part of the composition, all as if to emphasize the extent to which he *is* his painting or at least literally *in* it.

At the same time as he was moving forward in the studio, there were encouraging signs of progress outside those walls. From the end of January through most of March, again a work of Pollock's—*Dancing Forms,* a watercolor—was hanging at a Whitney Annual. In June he was notified of a $1,500 grant from the Eben Demarest Trust Fund—connected with James Johnson Sweeney's family—and at the beginning of July he received the first of four very welcome quarterly payments. Also in the summer—from the end of May to the end of September—Peggy Guggenheim showed her collection, including six paintings by Pollock, at the Venice Biennale. Though none of his work was from later than 1946 (*Eyes in the Heat* and one gouache), it was a representative selection from the years during which he had shown at Art of This Century and included also *The Moon-Woman, Two,* and *Circumcision.*

Mercedes and Herbert Matter had been in California for about three years. When they returned, in 1947, they spent the summer in Springs and now, in 1948, they were spending a second summer there and seeing quite a lot of the Pollocks. Matter was making a film on Alexander Calder in which he wanted to relate the shapes and, even more, the movement in Calder's mobiles to natural phenomena. Several times, in the area of both East Hampton and Montauk, Jackson carried Herbert's equipment along the quiet shore of Long Island Sound and the more active Atlantic beaches. Sometimes Jackson asked questions about photographic procedures—he was always interested in how things worked—but mostly he and Herbert were silent, simply enjoying being outdoors as the photographer shot nature sequences for his film. Also they clammed and musseled together, and Herbert watched Jackson train a crow he called Caw-Caw, teaching the bird to return to him and to repeat a few words.

Later in the summer he clipped the crow's wings, which the Matters found cruel. As against this and episodes in which Jackson teased their dog, there was his more typical tenderness in regard to animals and children. When the pet goat of the Matters' six-year-old son died, Jackson saw the need to bury it immediately and dug the grave himself.

That summer, the Matters also remember seeing *Number 1, 1948* and other dripped paintings in Pollock's studio, and one night Lee Pollock, Mercedes Matter, and their friends the Petersens watched Pollock, in a spirit of drunken bravado, spread a piece of canvas on the living room floor and proceed to paint for them. Herbert who wasn't there heard about this, of course, and began to think about doing a film on Pollock similar in concept to the one he was completing on Calder. However, he says, "I was shy, as self-conscious about photographing Jackson as he was then about being photographed. I took very few pictures of him, no motion pictures."

John Little had just married, and he and his wife Josephine also saw a lot of the Pollocks during the summer of 1948. They had visited Lee and Jackson the previous year and bought an old house on Three Mile Harbor Road in East Hampton. Now they were fixing it up. Sometimes Jackson helped John with the repairs. Then their wives would join the men at the bedroom fireplace for John's steak or Jackson's pancakes. Later, when the kitchen was functioning, Jackson taught Josephine how to bake apple pie.

Another couple just getting settled on property near the Littles was Penny and Jeffrey Potter. They were strikingly handsome, both of them tall, dark, aristocratic in look and manner. Penny had been interested in theater, Jeff in writing, but now they were talking about a more outdoor life, investing in land and its development in the East Hampton area. The Potters, too, became close friends of the Pollocks as well as the Littles, and Jackson particularly liked looking at property with Jeff and, later, climbing up with him on a tractor or bulldozer or other piece of heavy equipment.

Though Jackson had become skilled at clamming and musseling, he

didn't know as much yet about fishing. One evening in the early fall John Little suggested going after some whiting. Jackson laughed at the idea of fishing at dusk; he had always heard that sunrise was when fish bite. In the next two hours they caught all the whiting they could carry, more than they could eat, and Jackson knew another source of food for when times were tough.

Life (October 11, 1948) ran a "Round Table on Modern Art." Though the table in the Museum of Modern Art penthouse, where the discussion took place, was not round, the conversation of the experts seated there did move circularly about it, as apparently no one was persuaded by anyone else and each returned to his original position. *Life* devoted twenty-four pages to the meeting, and illustrated it, mostly in color, with reproductions of works by Picasso (two), Braque, Matisse, Miró, and Rouault among modern European masters; Stuempfig, representing contemporary American Romanticism; Graves, Mysticism; Tanguy and Dali, Surrealism; and Baziotes, de Kooning, Gottlieb, Pollock, and Stamos, the "Young American Extremists." All this (along with small cuts of a Rembrandt and a Poussin, and photographs of the panelists) was sandwiched between a full-page ad for the Bendix automatic washer and a double-page spread for Ritz crackers and interlarded with ads for Bayer aspirin, Black & White scotch, Pall Mall cigarettes, Hughes hair brushes, Prestone antifreeze, Gaines Meal dog food, Pacific towels, Goodyear tires, Keystone cameras and projectors, Mojud hosiery, Venida hair nets, Peter Pan Merry-Go-Round bras, Woodbury soap, Warren's Feathertex baby pants, Eagle Knitting Mills, and Coty Pastel-Tint makeup base. With the help of Marshall McLuhan, we have come to understand that the medium is the message. No medium should more powerfully have pulled the "Young American Extremists" into the world of consumption. Perhaps, with the right critics doing their promotional copy, someday these artists too might rate the double-spread of Picasso (and Ritz crackers, and Goodyear tires).

The panelists were Clement Greenberg, "*avant-garde* critic"; James

W. Fosburgh, "*Life* adviser"; Russell W. Davenport, "moderator"; Meyer Schapiro, "professor of fine arts, Columbia University"; Georges Duthuit, "editor of *Transition Forty-Eight,* Paris"; Aldous Huxley, "noted author"; Francis Henry Taylor, "director of New York's Metropolitan Museum of Art"; Sir Leigh Ashton, "director of Victoria and Albert Museum, London"; Raymond Mortimer, "British critic and author"; Alfred Frankfurter, "editor and publisher, *Art News*"; Theodore Greene, "professor of philosophy, Yale"; James J. Sweeney, "author and lecturer"; Charles Sawyer, "dean of School of Fine Arts, Yale"; H. W. Janson, "professor of art and archaeology, Washington University, St. Louis"; A. Hyatt Mayor, "curator of prints, Metropolitan Museum"; and James Thrall Soby, "chairman, Department of Painting and Sculpture, Museum of Modern Art." Within this high-powered cross-section of the art world, Pollock knew only Greenberg and Sweeney, and, besides these two, very few of the others knew Pollock (even through his work). Except for the one painting purchased at Sweeney's urging by the Museum of Modern Art, Pollock's only other formal contact with this institution had been his participation in May at a protest meeting there against a recent statement of James S. Plaut justifying the decision of Boston's Institute of Modern Art to change the word "Modern" in its name to "Contemporary." (Plaut found advanced art obscure, negative, and dishonest. In Boston, the Modern Artist's Group had met in March to protest Plaut's characterizations. In New York, Bradley Walker Tomlin, Pollock's friend and gallery-mate, suggested that local artists support the Boston group, and a meeting was called by Paul Burlin in Stuart Davis's studio which led to the one at the Modern.) As to the men from institutions other than the Modern represented on *Life*'s panel, Pollock had had no contact with them and had yet to receive more than brief mention in *Art News.*

Long before the symposium got to Pollock, there was discussion of Picasso's *Ma Jolie.* Typically, Greenberg rated it "one of the greatest masterpieces ever put on canvas." Later he argued with Francis Henry Taylor about Taylor's belief that the subject matter of art should be fa-

miliar. Meyer Schapiro eloquently supported Greenberg, and made some negative comments concerning Dali which have positive implications in regard to Pollock: "We are suspicious of the paintings of Dali, for example, because we *recognize* the symbols. We are able to say, 'This came out of a book; this does not represent a real experience.' In the privacy of the symbolism there is a guarantee of its validity. We ourselves have experienced, within our own dreams and thoughts, unexplained things which surprise us. We therefore say when we encounter such things in a painting, 'This artist is genuine; he has really been able to utilize those experiences for painting.' "

Here, in their entirety, are the two paragraphs on the painting by Pollock which was at the symposium and reproduced in color by *Life:*

> *Pollock's* Cathedral *was championed by Mr. Greenberg who thought it a first-class example of Pollock's work, and one of the best paintings recently produced in this country. Mr. Duthuit said, "I find it quite lovely. It is new to me. I would never think of Beethoven, rather of a contemporary composer playing on his sensations." Sir Leigh Ashton said, "It seems to me exquisite in tone and quality. It would make a most enchanting printed silk. But I cannot see why it is called the* Cathedral. *It is exquisitely painted and the color is ravishing, but I do not think it has structural design."*
>
> *Mr. Taylor found it "very lovely." Mr. Huxley was less impressed. Said he, "It raises a question of why it stops when it does. The artist could go on forever. [Laughter] I don't know. It seems to me like a panel for a wallpaper which is repeated indefinitely around the wall." Mr. Frankfurter said he was no admirer of Pollock but thought this work remarkably good if compared with a lot of abstract painting that is being turned out nowadays. Mr. Sweeney thought it had "spontaneity," "freedom," "expression," "sense of textured surface" and "linear organization." Mr. Mayor remarked, "I suspect any picture I think I could have made myself." Dr. Greene said it left him completely cold and seemed "a pleasant design for a necktie."*

Having served its purpose at "the round table," *Cathedral* went to San Francisco where it was included in the Third Annual Exhibition of Contemporary Painting at the California Palace of the Legion of Honor.

And yet with all that was happening in the studio—and beginning to happen outside it—for Pollock, the single most important event of 1948 was the most internal and secret. With the help of Dr. Edwin H. Heller, an East Hampton general practitioner who during the previous year had helped to found the medical clinic there, Pollock was able, late in the fall, to stop drinking, to stop altogether for what would be two full years. During that period he went to Heller at the clinic every week or two to talk to him and sometimes to renew a prescription for pills. Lee Pollock asked her husband several times what Heller had done to start Jackson on his only successful alcoholism therapy. He never told her. "Once when I asked . . . Jackson said to me, 'He is an honest man, I can believe him.' Do you realize what that means? 'He is an honest man, I can believe him.' "* All she knew was that early in 1948 she had seen Heller for a minor ailment and had at the time discussed Jackson's drinking with him. When the doctor suggested that she tell Jackson to come in and see him, she explained that one didn't tell Jackson to do these things but that a moment would come, and she just wanted Heller to be aware of the situation. Inevitably during the year Jackson too developed some minor complaint. In the course of getting it taken care of he must have told Heller about his sporadic pattern of drinking and working, perhaps explaining that, although he didn't use alcohol while painting, it seemed to make painting possible, to make all those opposites float into an easier, more peaceful, less tense relationship. Perhaps, too, Pollock told Heller something of his medical history at Bloomingdale's and with Joseph Henderson and Violet de Laszlo and others. As far back as Jackson could remember, he had felt tension. A cycle of tension that built up and then got released in making drawings and paintings. Or in drinking. Or maybe sometimes it happened the other way around. Maybe the tension built when he worked and got released when he drank. Either way it was building all the time. The deeper he went into himself, the more it was there. Like the shorter tighter twists at the center of a watchspring.

* See Bibliography No. 172.

Heller told Pollock about tranquilizers, explained that these comparatively new drugs would do much of what alcohol had been doing for him without the physical or psychological damage, but that under no circumstances was he to combine alcohol with tranquilizers. Dosages were experimented with. Quite quickly Pollock learned to handle the new drug with none of the difficulty given by alcohol. He took the capsules on an irregular basis, as needed, and felt calmer than he had in many years. Before one of his subsequent openings he was able to say, "I didn't even have to take one." And during the next two years we can watch as his paintings become, if less violently lyrical, both more relaxed and calm, even sublime in such masterpieces as *One, Autumn Rhythm,* and *Lavender Mist.* However, it is a while yet before he reaches that point, that series of peaks. . . .

Lee and Jackson spent the Christmas holiday in Deep River visiting the McCoys and Stella Pollock, who was living with Sandy and his family. This was a test for Jackson, who had gone on some of his worst binges at the time of previous reunions with his mother. However, she didn't recognize this but, rather, saw his next show, coming near the end of January, as the real test: ". . . a hard one for Jack if he can go through that without drinking will be something I hope he can and will. Will be glad when the show is over and he is home again," she wrote to Charles. As it turned out neither the show nor being in New York for it made Jackson drink. He had been convinced by "the Dr," as his mother also wrote, that ". . . everything wine to beer . . . were poison to him." Beyond this, undoubtedly his wife's supportive love and the public recognition (the public love) he was now beginning to get freed him, at least temporarily, from the need for his mother's approval and that of his older brothers.

The show—twenty-six numbered paintings (some with additional descriptive titles, frequently just a listing of predominant colors), of which fifteen were on canvas and eleven on paper—was his best to date. Despite its timing (January 24–February 12), just a little better than the

last year's, several works sold, including some from that previous year. The work done in 1947 and exhibited in 1948 may have seemed conservative compared with the 1948 work just being exhibited. Even to New York's relatively sophisticated art viewers, such "mural friezes" as *Summertime* (33¼" × 18' 2"), *White Cockatoo* (35" × 9' 6"), and *Arabesque* (37¼" × 9' 8½") were shocking in scale and shape as well as image.

Once again the critics tell a story, if not necessarily *the* story. *Time* (February 7) added a few words to what Sam Hunter had written in the *Times* (January 30), and reproduced *Number Eleven* with the subcaption "Cathartic disintegration":

> *A Jackson Pollock painting is apt to resemble a child's contour map of the Battle of Gettysburg* (see cut). *Nevertheless, he is the darling of a highbrow cult which considers him "the most powerful painter in America"* (Time, Dec. 1, 1947). *So what was the cautious critic to write about Pollock's latest show in a Manhattan gallery last week?* The New York Times' *Sam Hunter covered it this way:*
>
> *"[The] show ... certainly reflects an advanced stage of the disintegration of modern painting. But it is disintegration with a possibly liberating and cathartic effect and informed by a highly individual rhythm.... At every point of concentration of these high-tension moments of bravura phrasing ... there is a disappointing absence of resolution in an image or pictorial incident, for all their magical diffusion of power.... Certainly Pollock has carried the irrational quality of picture making to one extremity.... And the danger for imitators in such a directly physical expression of states of being rather than of thinking or knowing is obvious.... What does emerge is the large scale of Pollock's operations...."*

Emily Genauer of *The New York World-Telegram* was equally "cautious." And Greenberg, reviewing himself and Pollock in *The Nation,* can only be characterized as Greenbergian:

> *Jackson Pollock's show this year ... continued his astounding progress. His confidence in his gift appears to be almost enough of itself to cancel out or suppress his limitations—which, especially in regard to color, are certainly there.*

> *One large picture, "Number One," which carries the idea of last year's brilliant "Cathedral" more than a few steps farther, quieted any doubts this reviewer may have felt—and he does not in all honesty remember having felt many—as to the justness of the superlatives with which he has praised Pollock's art in the past....*

A different tone and view were evident in the painter Elaine de Kooning's brief mention of Pollock's work in *Art News,* his first comparatively sympathetic appearance in that publication:

> *Jackson Pollock's new abstractions, violent in drawing and in application of pigment, are paradoxically tranquil in expression. Here, complex, luminous networks ... give an impression of being frozen in position. His flying lines are spattered on in intense, unmixed colors to create wiry, sculptural constructions, which stand immobile and apart, uninvolved with the backgrounds.*

The French avant-garde painter Georges Mathieu responded to Elaine de Kooning's piece by writing to Betty Parsons. In this letter he called Pollock "the greatest living American painter."

And yet another painter, Alfonso Ossorio—who, since 1941, had been exhibiting his own work with Betty Parsons—made the most important purchase from the show: *Number Five,* a particularly rich 8′ × 4′ vertical panel. (The Museum of Modern Art did not acquire *Number One* until the following year, after Pollock's next show.) Ossorio has said that until this time he did not like Pollock's work but that this 1949 show was a revelation: "Here was a man who had pulled together, existentialized all the traditions of the past—contemplative and active—a man who had gone beyond Picasso." The purchase by Ossorio led to his buying several more paintings by Pollock as well as some by Lee Krasner, helping to give the Pollocks at least a degree of economic freedom during the last half-dozen years of Jackson's life. Ossorio established a relationship with them which transcended economics and permitted an exchange —cultural, surely in the broadest sense—between three exceptionally disparate personalities: Pollock, the typically quiet, moody American

Westerner, the tough-tender WASP rebel; Krasner, the talkative and gregarious lady from Brooklyn; and Ossorio, the Manila-born son of a Spanish sugar processor and a Filipino-Spanish-Chinese mother, the Eurasian product of Benedictine training and Oriental refinement. On many levels theirs was a "meeting of East and West," to use a phrase which had then been popular for the few years since publication of Northrop's book.

By the time the show closed at Betty Parsons', the Peggy Guggenheim collection had traveled to Florence and within a week went on exhibition at the Strozzi Palace. There, all Pollock's works which had been seen during the previous summer at the Venice Biennale were shown again, plus a 1942 drawing and *Sounds in the Grass* and *Bird Effort.* In June the collection was shown in the Palazzo Reale in Milan. Also early in the year, Pollock's painting *Galaxy* was included in "Exhibition of Contemporary American Painting" at the University of Illinois. And, in July, East Hampton's Guild Hall, which had previously been very conservative, exhibited paintings by both Pollock and his wife along with those of fifteen other artists who lived in eastern Long Island. And during August, September, and the beginning of October, a 1948 oil on paper and a 1949 painted terra cotta piece were exhibited in "Sculpture by Painters" at the Museum of Modern Art. And . . .

As through the spring and early summer these things happened, they happened far enough outside Pollock's studio so as not to distract him. They were things that interested him and his wife; his scattered family; and his close friends, including his dealer, a few critics, a few museum people, a few collectors—in short, the—or more exactly, *his*—art world. But one external event reached everyone: Pollock in his studio, those close to him, those far away, and those in between, the gas station attendant, the grocer, the butcher. . . . It was the August 8 edition of *Life.* There Pollock got his two-page color spread (and an additional half-page of black-and-white). There he became a celebrity. There, in public, he was given fame and tormented by it.

Stretching, dancing across the top of the first two pages in the *Life* article is *Number Nine* (later called *Summertime*). In front of it, to quote the caption, Pollock "stands moodily next to his most extensive painting. . . . The picture is only 3 feet high, but it is 18 feet long and sells for $1800, or $100 a foot. Critics have wondered why Pollock happened to stop this painting where he did. The answer: his studio is only 22 feet long." That's for openers. But it's too easy to cast *Life* in the role of Philistine. The fact is that the world—the art world, in particular—agreed with *Life*. In 1949, $1,800 seemed very expensive for a contemporary American painting, even one so "extensive." Though today this painting would easily bring $10,000 a foot, no one was willing to spend $100 then. And though today we don't ask why a painting stops where it does, that acceptance of infinite space and expandability is largely due to Pollock's own work and its impact on younger artists. Note: *Summertime*, like most "classic" Pollocks, does not extend to the extreme ends of the canvas but rather turns back upon itself so that its rhythm, having neither visible start nor finish, is continuous and endless.

Before the open arabesques—some of them filled in with primary colors—of his eighteen-foot dance, Pollock stands in paint-spattered dungaree jacket and pants, wool scarf around his neck (the photograph was taken in his studio during the previous winter), jaw thrust forward, cigarette hanging from mouth, arms folded, legs crossed. The stance is not so much "moody" as compact, self-protective, hermetic. As always, since childhood, Pollock appears both tough and vulnerable.

The piece begins:

JACKSON POLLOCK.
Is he the greatest living painter in the United States?

Recently a formidably high-brow New York critic hailed the brooding, puzzled-looking man shown above as a major artist of our time and a fine candidate to become "the greatest American painter of the 20th Century." Others believe that Jackson Pollock produces nothing more than interesting, if inex-

plicable, decorations. Still others condemn his pictures as degenerate and find them as unpalatable as yesterday's macaroni. Even so, Pollock, at the age of 37, has burst forth as the shining new phenomenon of American art.

Pollock was virtually unknown in 1944. Now his paintings hang in five U.S. museums and 40 private collections. Exhibiting in New York last winter, he sold 12 out of 18 pictures. Moreover his work has stirred up a fuss in Italy, and this autumn he is slated for a one-man show in avant-garde Paris, where he is fast becoming the most talked-of and controversial U.S. painter. He has also won a following among his own neighbors in the village of Springs, N.Y., who amuse themselves by trying to decide what his paintings are about. His grocer bought one which he identifies for bewildered visiting salesmen as an aerial view of Siberia. . . .

By summer, although Pollock's paintings hung in five American museums, in New York none but the Modern owned his work, and of those outside New York none was comparable with the Modern in size or prestige. Also, although his paintings hung in forty private collections, many were gifts to those who had been kind to him, and others had been bartered for goods and services, as had the one owned by his grocer, Dan Miller. Once again, remember that although *Life* presents Pollock now as a painter already sky-rocketing to success, his limited material success will be more the result of *Life's* story than that story is the result of then existing success. Even the twelve out of eighteen pictures which had been sold were not from last winter's show, but from the one of the winter before. If we assume that these works averaged $300, then the twelve would have amounted to a gross of $3,600, less one-third commission, leaving Pollock $2,400 for the sold portion of a year's work, typically the smaller paintings.

The *Life* text is flanked by color reproductions of *Number Twelve* (1948, $22^{1}/_{2}''$ × $30^{5}/_{8}''$) and *Number Seventeen* (1948, $30''$ × $40''$). These two paintings, one on paper and one on canvas, are among Pollock's best small-scale works, and because they did not have to be reduced as drastically as *Summertime,* their sensuous complexity is more faithfully conveyed. Captions read: "*Number Twelve* reveals Pollock's liking for

aluminum paint, which he applies freely straight out of the can. He feels that by using it with ordinary oil paint he gets an exciting textural contrast"; and "*Number Seventeen* was painted a year ago in several sessions of work which took place weeks apart so Pollock could appraise what he was doing and 'get acquainted with the picture.' He numbers his paintings instead of naming them, so his public will not look at them with any preconceived notion of what they are."

On the last page of the article there are black-and-white shots of Pollock at the top and bottom and, sandwiched between them, a text which includes quotes from his *possibilities* statement. In both photographs Pollock, in the spattered dungaree suit, is crouching over canvas spread on the floor, with a can in his left hand. In the top picture, the can contains black enamel which he is spilling onto the canvas with a stick or perhaps an old stiffened paintbrush as he "draws" with this elusive medium. Pollock's concentration is obviously intense. Again, a cigarette, seemingly forgotten, hangs from his mouth. This photograph is captioned: POLLOCK DROOLS ENAMEL PAINT ON CANVAS. In the lower photograph, the cigarette is gone, the can contains sand which Pollock is carefully spilling onto the wet enamel. The hand is large, steady, powerful, there in space, cupped to hold the sand in a grip which is at once gentle and strong and almost identical with that in the other photo. However, this lower one is more neutrally captioned: HE APPLIES SAND TO GIVE ENAMEL TEXTURE.

What stayed primarily with *Life*'s readers were the photographic images of Jackson himself, a new non-arty American-style painter, working in dungarees, with commercial materials; and his work, also new, and as startling in its abstract imagery as anything since Mondrian. Indeed, about now Pollock's name began to enter the language ("That looks like a Pollock"), though it did not appear in a general dictionary (*The American Heritage*) until twenty years later.

The kind of pressure Pollock felt after the 1948 and 1949 *Life* articles is poignantly documented more than a decade after Pollock's

death by Tony Smith.* Smith, after speaking of Pollock's "feeling for the land and, related to it, his sense of property," continued:

"I don't think that Jackson painted on the floor just for its hard surface, or for the large area, or for the freedom of movement, or so that the drips wouldn't run. There was something else, a strong bond with the elements. The earth was always there.

"If he had more money, Jackson wouldn't have done anything really different; only more of what he was already doing. He would never have moved out of that little house of his. He would have fixed it up more, and added to the property. A while after Clem Greenberg had been quoted about Jackson in *Life* Magazine, we were in the kitchen, looking out the window. The Model A was in the driveway. Jackson asked if I had seen the article, and then he asked if I didn't think he should have a better car. I didn't have any car, and I said, 'The Model A's a good car. What the hell kind of car do you want?' 'Oh, I don't know, maybe a Cadillac or something. . . .' Well, he did get a Cadillac, a convertible, and later he bought some land that was next to his. . . .

"In many ways Jackson was a straight American boy. He wanted what most people want. Once, when he had been drinking and was pretty wild, he said, 'Let's go to the Stork Club.' 'Come on, Jackson, we can't get in there.' 'Why not?' 'You don't have a tie. They won't let you in.' 'I can get in.' 'On what basis?' 'On the basis of my reputation.' "

In another interview,** Ad Reinhardt said: "Pollock wanted to become a celebrity and he did. He got kicked out of the 21 Club many times . . ."

From mid-September to early October Sam Kootz put on an exhibition in his gallery called "The Intrasubjectives," for which Kootz himself and Harold Rosenberg wrote catalogue statements attempting to define the new American painting. Besides Pollock the show included Baziotes, Gorky, Gottlieb, Graves, Hofmann, de Kooning, Motherwell, Reinhardt,

* See Bibliography No. 172.
** See Bibliography No. 179.

Rothko, Tobey, and Tomlin: a remarkable list to have come up with in 1949.

The statement Kootz wrote for the catalogue began:

> *The past decade in America has been a period of great creative activity in painting. Only now has there been a concerted effort to abandon the tyranny of the object and the sickness of naturalism and to enter within consciousness.*
>
> *We have had many fine artists who have been able to arrive at Abstraction through Cubism: Marin, Stuart Davis, Demuth, among others. They have been the pioneers in a revolt from the American tradition of Nationalism and of subservience to the object. Theirs has, in the main, been an objective art, as differentiated from the new painters' inwardness.*
>
> *The intrasubjective artist invents from personal experience, creates from an internal world rather than an external one. . . .*

The balance of Kootz's statement, while differentiating between the emphases of the various artists (Pollock's "lyricism," Baziotes' "poetry," Tobey's and Graves' "calligraphy," de Kooning's "love of paint," etc.) at the same time attempts to lump the artists into a "movement." Only missing are the "right" labels, better than Intrasubjectivism, a term used by Ortega y Gasset in the August 1949 *Partisan Review* and now by Kootz as an epigraph in his catalogue:

> *The guiding law of the great variations in painting is one of disturbing simplicity. First, things are painted; then sensations; finally, ideas. This means that in the beginning the artist's attention was fixed on external reality; then on the subjective; finally, on the intrasubjective. These three stages are three points on a straight line. . . . After Cézanne, painting only paints ideas—which, certainly, are also objects, but ideal objects, immanent to the subject or intrasubjective.*

However, one such label, though not yet popular, already existed: Abstract Expressionism. It had been used by Alfred H. Barr, Jr., as early as 1929 to describe Kandinsky's early lyrical abstractions. More recently— in the March 30, 1946, *New Yorker*—Robert M. Coates had applied the

term to Hans Hofmann (". . . certainly one of the most uncompromising representatives of what some people call the spatter-and-daub school of painting and I, more politely, have christened abstract Expressionism"). The other term—Action Painting—would be forthcoming within the next three years from Harold Rosenberg himself. Meanwhile, in Kootz's catalogue, Rosenberg improvises existentially:

> *. . . The modern painter . . . begins with nothingness. That is the only thing he copies. The rest he invents.*
>
> *. . . Instead of mountains, copses, nudes, etc., it is his space that speaks to him, quivers, turns green or yellow with bile, gives him a sense of sport, of sign language, of the absolute.*
>
> *When the spectator recognizes the nothingness copied by the modern painter, the latter's work becomes just as intelligible as the earlier painting.*
>
> *Such recognition is not really very difficult. The spectator has the nothing in himself, too. Sometimes it gets out of hand. That busy man does not go to the psychiatrist for pleasure or to learn to cook. He wants his cavity filled and the herr doctor does it by stepping up his "functioning" and giving him a past all his own. At any rate, it was knowing the nothing that made him ring that fatal doorbell.*
>
> *Naturally, under the circumstances, there is no use looking for silos or madonnas. They have all melted into the void. But, as I said, the void itself, you have that, just as surely as your grandfather had a sun-speckled lawn.*

Even now, in 1949, Pollock would have felt the pressure of being cast by Rosenberg in the role of existential hero, just as he was already feeling the pressure of Greenberg's superconnoisseurship. Pollock was unhappy under both these pressures. He could not deal comfortably with Rosenberg's wit and must have felt engulfed by this critic's words describing the composite contemporary painter and thus denying him his individuality. Sometimes Rosenberg seemed more interested in the ideas behind painting than in painting itself, more involved with the art world —its sociology, its politics, even its metaphysics—than with "pure" art. And always the words poured forth, the Surrealist- and now also Existentialist-tinged words, clever and paradoxical ("Space is simple: it is merely

the canvas before it has been painted. Space is very complex: it is nothing wrapped around every object in the world, soothing or strangling it. It is the growing darkness in a coil of trees or the trunk of an elephant held at eye level. . . .''), words, like these, written for that Intrasubjectives show, or words spoken in Rosenberg's high nasal voice, punctuated by shrill laughter, words, fancy nerve-racking words. . . .

Though Rosenberg and his wife had known Lee since 1932, he was not really aware of Jackson until about a decade later, the time of the McMillen exhibition. From then until the end of Pollock's life, theirs was not like relationships Rosenberg would have with such artists as Hofmann, Gorky, de Kooning, and Kline, artists with whom he *talked*. No, Pollock's style was different, not so much inarticulate as uncomfortable with cultivated people. With Pollock, Rosenberg would eventually play poker, fish, drive, "do boys' things," as his wife remarked.

And though Greenberg came from a background similar to Rosenberg's, his style could not have been more different from Rosenberg's. Greenberg would manage to talk with Pollock about the implications of his work, although often he was as halting and drawling in speech as Pollock himself. He would stand in Jackson's studio, as he did also in galleries and museums, squinting, with brow furrowed, lips pursed, and fingers pressed beneath his eyes to help them focus. Sometimes his look was quick, sometimes long. Either way it was frequently followed by a judgment. The painting was first-rate, or second-rate, or missed altogether. (Just a few years later, Greenberg would occasionally bring with him the ambitious young painter Helen Frankenthaler, who was used to his methods, not only in relation to her own work but at exhibitions where she, with the critic, often graded everything in their catalogues or announcements and then compared notations.) In addition to the pressure of connoisseurship, Greenberg may have exerted the additional pressure of goading Pollock toward the theoretical limits implied by his work. Rosenberg has written*

* See Bibliography No. 12.

that Greenberg's part was greater than "merely . . . promoting Pollock's reputation . . . there is no doubt that, for better or worse, Greenberg affected his work itself, shoring up the artist's arbitrariness with his own and pressing him onward." And Motherwell has called Pollock's relationship to Greenberg his "nearest approach to collaboration." Though Motherwell's comment is less measured than Rosenberg's, there is little doubt that, through Pollock, Greenberg played the role of critic-as-artist. Nor is there much doubt that, through the "art world" and the larger world beyond, Rosenberg played artist-as-critic. In any case, their positions were opposed. Rosenberg states his position clearly opposite Greenberg's in "Action Painting: Crisis and Distortion" (*The Anxious Object*, 1966):

> *How responsible it seems to the young academician, or to the old salesman, to think of painting "as painting" rather than as politics, sociology, psychology, metaphysics. No doubt bad sociology and bad psychology are bad and have nothing to do with art, as they have nothing to do with society or with real individuals. And about any painting it is true, as Franz Kline once said, that it was painted with paint. But the net effect of deleting from the interpretation of the work the signs pointing to the artist's situation and his emotional conclusions about it is to substitute for an appreciation of the crisis-dynamics of contemporary painting an arid professionalism that is a weak parody of the estheticism of half a century ago.*

Indeed, a little further on in the same essay, Rosenberg's target is specific:

> *The will to remove contemporary painting and sculpture into the domain of art-as-art favors the "expert" who purveys to the bewildered. "I fail to see anything essential in it [Action Painting]," writes Clement Greenberg, a tipster on masterpieces, current and future, "that cannot be shown to have evolved [presumably through the germ cells in the paint] out of either Cubism or Impressionism, just as I fail to see anything essential in Cubism or Impressionism whose development could not be traced back to Giotto and Masaccio and Giorgione and Titian." In this burlesque of art history, artists vanish, and paintings spring from one another with the help of no other generating prin-*

ciple than whatever "law of development" the critic happens to have on hand. Nothing real is "anything essential"—including, for example, the influence on Impressionism of the invention of the camera, the importation of Japanese prints, the science of optics, above all, the artist's changed attitude toward form and tradition. In regard to historical differences the critic's sole qualification is his repeated "I fail to see," while name-dropping of the masters supplies a guarantee of value beyond discussion. . . .

Yes, Pollock would have felt the weight of both Rosenberg's and Greenberg's words, the pressure of the two most influential art critics of his generation. Redmountain and Greenmountain. He would have felt their presence as they felt his. But if these serious critics "got to" Pollock, if he felt sometimes that even they misunderstood him, accepted him incompletely, compared him crudely or lumped him with others, we can imagine how the more simplistic popular press affected him. For Pollock, who equated himself with his work, every misunderstanding was a misunderstanding of him personally, every attack an attack on him personally. For such a man, there could be but little satisfaction in fame and, necessarily, much pain.

So from the moment mass media (particularly *Time* and *Life*) had its attention brought to Pollock by small-circulation weeklies and occasional "little magazines," he was to become increasingly self-conscious and uncomfortable. He hardly knew whether he was a "reputation" (to use the word Tony Smith quotes) or a "star" (to use that lofty accolade of show biz). But he was aware now as he bought gas, groceries, or paint and hardware supplies that whatever he had been—among fellow artists and to some extent critics, dealers, and collectors—was now lifted, blown up, distorted into grotesque fragments of public celebrity. People stared, looking for signs of "the greatest living painter in the United States" . . . "the greatest American painter of the 20th Century" . . . "the shining new phenomenon of American art" . . . "the most talked-of and controversial U.S. painter." . . . And Pollock wondered if he was this celebrated thing, this superstar. He found himself torn between pleasure in the recognition

finally coming to him and pain from the misunderstanding nature of that recognition. He didn't feel he was competing within some league of local artists but rather measuring himself against the history of art. As he looked at reproductions of work by Goya or Picasso he was, as always, impressed, even overwhelmed by what had already been done. And as he looked at his own work, he felt mostly how much there was still to do and how impossible it would be to present visually the whole tangle of his emotions.

Soon after the *Life* article appeared, Pollock said, "I can no longer walk into a gallery and look at a show the way I used to." This remark must be understood from two viewpoints: that of Pollock, who on another occasion told his wife, "I feel like a clam without a shell," and that of the people in the gallery to whom his reactions and opinions suddenly mattered.

If being the local best was a prize too small and the image of himself in *Life* too simple, he must have felt driven to try, to keep trying, to get the larger, more complex image he had of himself down on canvas and paper. There were moments—explosive and orgasmic—when working, there on the studio floor, seemed very close to making love and when, as in the act of love, he would lose himself in his work. And there were moments when that rhythmic flowing or spurting of himself into his work seemed likely to assure his being loved in return, finally for the right reasons rather than for those in *Life*. However, privately as well as publicly, he continued to be misunderstood. Dr. and Mrs. Frank Seixas, East Hampton acquaintances, brought another couple to Pollock's studio to see his work. When he described his method to them, the wife asked, "But, Mr. Pollock, how do you know when you're finished?" He replied, "How do you know when you're finished making love?"*

Like all those other ambivalences which had tortured him throughout his life, no doubt he hoped his split feelings about fame could be re-

* See Bibliography No. 199.

solved—the pain and pleasure accepted, brought together in harmony—on paper or canvas. He was spending more and more time in his studio, searching there, if not for relief, at least for some degree of peace. His concentration was intense. When he worked he didn't think about fame, reputation, celebrity. These words existed outside the studio.

Pollock's bursts of creativity—sometimes moments; sometimes hours; or, more rarely, the better part of a day—lasted off and on from the dismantling of the early 1949 show at Betty Parsons until the installation of another at the same gallery later in the same year (November 21–December 10). During that period of approximately nine months, Pollock completed thirty-four more works, most of them numerically titled. Many were on sheets of paper approximately 31″ × 21½″, covered richly and intricately with skeins of enamel and aluminum paint in Pollock's by now "classic" style. Even these—and still smaller works on canvas, such as *White on Black* (24⅛″ × 17½″)—have an assurance and freedom that exists in only a few small works of the previous year. Indeed these paintings, though small in size, suggest a much larger scale and more continuing space. They are miniature murals, as rich and evocative as, say, the "major" 4′ × 8′ *Number 7 (Out of the Web)*, in which vaguely Surrealistic, biomorphic shapes have literally been cut out of the web (of oil and enamel) to expose the composition board on which the web is mounted. This painting, like two other cut-outs in the show, has a tentative, experimental, even belabored quality; it shows the additional, second-thought incisions made on the right side. However, all three—beginning with the simplest, a biomorphic cut-out, the discarded portion of which was later given to the dealer John Myers for his puppet theater—anticipate a problem to which Pollock would return again and again during the next two years or so: the extraction of the figure from the web, once having hidden it there; or, to put it more specifically, the use of line for configuration, once having invented the use of a nonfigurative line (i.e., one not intended to define shapes but rather to become part of a field of energy).

This was Pollock's only show that sold well, virtually out, though still at low prices. Among the purchases were Ossorio's of *Number 10,* a 1½' × 9' "frieze," and Roy Neuberger's of *Number 8,* having more conventional 3' × 6' dimensions. Ossorio stated his reaction to Pollock's work at the time of the earlier 1949 show. Since then his enthusiasm had further intensified as during the year, under Pollock's influence, he completed his last Surrealist works, and moved towards freer abstraction. Ossorio's response to Pollock was that of the artist-as-collector. A more common response—that, aspiringly, of collector-as-artist—is described by Daniel Robbins in *An American Collection:*

> *Roy Neuberger feels that this Pollock is the equal of any, except perhaps* One *(The Museum of Modern Art) and* Autumn Rhythm *(The Metropolitan Museum of Art). At the time of its acquisition, it represented a big departure for him, yet, by 1950, he already had two Baziotes, two Gottliebs, and was in the process of acquiring his David Hare. At Betty Parsons he had seen the Pollock with "only a slight suspicion of its greatness," but he could not get it out of his mind. He recalls discussing the work with Samuel Kootz, who told him categorically that if he wanted a Pollock, "now is the moment." [According to Kootz there was more than a discussion. Kootz says he selected the painting for Neuberger and insisted that the collector pay the asking price of $1,000.] On all sides [Neuberger] heard that Pollock needed money badly, but many artists were in the same boat and Neuberger knew that he had sometimes bought mistakenly in order to help the artist. He debated the purchase for several months, finally acquiring it in the summer of 1950. Living with it proved to be a revelation. Initially impressed with its extraordinary technique, he came to regard it as the canvas that most expressed the actuality of the unknown. He feels that it defies description and can be compared only to "the limitless area of the Universe."*

The "limitless" or, at least, muralesque aspect of Pollock's work was emphasized by the installation at Betty Parsons' gallery of the model of a museum for Pollock's work. The announcement read: "Murals in Modern Architecture. A Theatrical Exercise Using Jackson Pollock's Paintings and Sculpture. By Peter Blake." Blake had met Pollock in 1947 through

Herbert Matter. Since that time he had become increasingly committed to the artist's work and anxious for the Museum of Modern Art, where he was then Curator of Architecture, to do more for Pollock. However, it was against museum policy for a staff member to commit himself to a particular artist. Blake persuaded Ossorio to pay the cost of materials necessary for the comparatively small project he had in mind. It was described by Arthur Drexler (later also Curator of Architecture at the Modern) in the January 1950 *Interiors:*

> *Peter Blake has given the open-plan treatment to the paintings of Jackson Pollock, but in this case not merely to effect a circulation of visitors so rapid that no one stops to look at the exhibits. The pictures are heavily pigmented designs whose continuous rhythms often appear to end because there was no canvas left for more, and Mr. Blake feels that their distinguishing characteristics are best revealed by open space and by the absence of frames. The paintings seem as though they might very well be extended indefinitely, and it is precisely this quality that has been emphasized in the central unit of the plan. Here a painting 17' long constitutes an entire wall. It is terminated on both ends not by a frame or a solid partition, but by mirrors. The painting is thus extended into miles of reflected space, and leaves no doubt in the observer's mind as to this particular aspect of Pollock's work.*
>
> *The model also includes three small polychrome sculptures made by the artist for Mr. Blake's use, and one of them stands before a curved screen of perforated brass. This is the only wall in the ensemble which serves exclusively as a background. The largest of the sculptures rests on a square base, while the other two stand on the floor.*
>
> *In its treatment of paintings as walls the design recalls an entirely different kind of pictorial art; that of the Renaissance fresco. The project suggests a reintegration of painting and architecture wherein painting is the architecture, but this time without message or content. Its sole purpose is to heighten our experience of space.*

The general tone of Pollock criticism changes about now. Even if not always sympathetic, it becomes considerably more respectful. For the first time, whether critics like the work or not, they all take it seriously.

Stuart Preston's comments in the *Times* (November 27) are typical: "... Color is Pollock's forte. In the dense web of paint that weaves back and forth it is remarkable how the silvers, blacks, whites and yellows stand on their own instead of killing each other. In the very biggest canvas the myriad tiny climaxes of paint and color fail to add up to an over-all design, but in the long narrow ones a pleasingly large repeat design gathers momentum as it moves from left to right...."

Henry McBride, then the dean of American art journalists, did not review the latest show, but he wrote about Pollock soon afterward (*New York Sun,* December 23) when *Number 14* was included in the Whitney Annual:

> ...*The note of advance is sounded at once in the entrance hall by Jackson Pollock. For the first time I looked with respect and sustained interest upon one of his pictures. Previous works by him which I had seen looked as though the paint had been flung at the canvas from a distance, not all of it making happy landings. Even the present one has a spattered technic, but the spattering is handsome and organized.... The effect it makes is that of a flat, war-shattered city, possibly Hiroshima, as seen from a great height in moonlight. There is sparkle to the color and hints of a ribbon of a river holding the glimpses of the city together. The composition looks well in the entrance hall and will be the most discussed picture in the show.*

Perhaps these critics became more sympathetic to Pollock's work partly in response to the power of the Luce publications. Even as in its own ads, "*Life* makes things happen." However, it is ironic that while many critics were becoming more friendly, *Life* and *Time* were adopting an attitude of increasing hostility, perhaps backlash, to Pollock and other avant-garde American painters, which would last until Pollock's death. This editorial policy is analogous to that of the same magazines in relation to the "Beat" writers, several years later. There, too, the magazines brought the cultural phenomenon to popular attention and then felt the need to ridicule it and try to destroy it. *Time* (December 26) described the Whitney Annual: "Most of the pictures on the walls looked like more

or less distorted reflections of each other. Jackson Pollock's non-objective snarl of tar and confetti, entitled *No. 14,* was matched by William de Kooning's equally fashionable and equally blank tangle of tar and snow called *Attic.* If their sort of painting represented the most vital force in contemporary U.S. art, as some critics had contended, art was in a bad way."

On that note 1949 ended. It had been a good year—in the studio, where Jackson made at least thirty-four paintings; in the gallery, where those paintings were exhibited nine months after a show of twenty-six completed the previous year and where his contract was renewed until January 1, 1952; in other galleries here and abroad, many of them institutional; at home, where he hadn't had a single drink; everywhere, except in those publications where words came between him and his work.

Until the past two years Pollock had been one of many artists in the American vanguard. By 1948 he had been recognized by *Time* and *Life* as one of a smaller group of leaders. But by 1949—with the big *Life* story on him—his position was unique. No other American painter of his generation had received as much attention. From the general public's viewpoint Pollock was now the single leader and representative of the new American painting. However, from his peers' viewpoint, though surely *a* leader, he was not *the* leader.

Among several artists who could equally have claimed leadership, none was more respected than Willem de Kooning. Within the art world he was perfectly cast as Pollock's rival. Much of his best work was figurative, and much of his best abstract work was more obviously formal than Pollock's. In addition, he was more intellectual and more literary than Pollock. Though he spoke with a heavy Dutch accent and could not always find the exact English word he wanted, he was, allowing for a somewhat limited vocabulary, incisively articulate. Finally, though strikingly handsome, de Kooning's face was that of a beautiful Dutch boy rather than a rugged American, and he was very much smaller than Pollock.

A debt to both Pollock and de Kooning is generously acknowledged by many of the best painters among their contemporaries and those of the next generation. However, more peripherally, it became something of an art world game to choose between Pollock, the champ, and de Kooning, the slightly older but scrappy challenger. Until now Pollock and de Kooning had freely exchanged ideas in a small world that was comparatively unwatched, if not neglected. But as Pollock's work moved out into the larger world, de Kooning watched along with everyone else goading him on in the role of the competitor, not always the friendly competitor. The promoters of this championship fight were the critics. Greenberg was deeply committed to Pollock. Virtually alone he had led the popular press to Pollock's work which was beginning to be accepted as the most radical visual breakthrough since Cubism. To the extent that he had had any real support in this view it had come mostly from a few less influential—i.e., less public, more underground—"critics," if that designation can be applied to such as the painter John Graham and the architect-sculptor-lecturer Tony Smith. And it had come from comparatively small and amateurish dealers—Peggy Guggenheim, now in Venice; Howard Putzel, who had committed suicide; and now Betty Parsons. And, finally and most important, it had come from Lee Pollock herself, who was still fighting hard for Jackson, arranging for the right people to see his work and protecting him from friends whom she considered to be bad influences, mainly former drinking companions. On the other side, Rosenberg, until now closest to Sam Kootz's artists, especially Hofmann and Baziotes, was becoming more and more interested in Willem de Kooning. Since Gorky's death, in 1948, de Kooning's work was, he believed, the most powerful and thoughtful synthesis of Cubism and Surrealism. Alongside, or ahead of Rosenberg in this view was Tom Hess, by now second in command at *Art News,* and Elaine de Kooning, who wrote for the magazine, besides, like Lee Pollock, being a good painter in her own right and a wife very devoted to her husband's career.

To illustrate the mounting competitiveness, Phillip Pavia has de-

scribed a series of evenings at The Club a little later (1951), prompted by the publication of Hess's *Abstract Painting: Background and American Phase,* which raised many of the questions that needed answering. Pollock and de Kooning were present at the first of these discussions, perhaps the only one at The Club in which Pollock participated on a more than hit-and-run basis, though not much more. Even without reading the text, Pollock would have been affronted by the book's design and layout. For him, the message was there, right on the jacket, both sides of which contained details in color of Gorky's *The Betrothal, II;* and on the endpapers which contained still more greatly enlarged details in black-and-white from the same painting; and in the frontispiece which reproduced this Gorky again, now in its entirety, in color; and in the color illustrations immediately following the Gorky, works by Tobey, de Kooning, and Pollock *in that order;* and in the arrangement of the text, ending with Pollock. Initially all this would have been more important to Pollock than that his friends and gallery mates Clyfford Still and Barnett Newman were missing from the book. And it is most unlikely that he would have read the text carefully, for Hess's placement of him, at the end, was far from a put-down—at least, it suggests the culmination of the abstract tradition; at most, the beginning of a new tradition. Hess wrote:

> ... Not only painters had felt that the separate traditions of abstract painting and Expressionism, that the formal and the fantastic, the contrived and the automatic, must join. Collectors, connoisseurs, and museum officials also sensed this eventuality, and recognized its fulfillment in a Jackson Pollock.
>
> As the first of the group of New York abstractionists to become a public success, Pollock has had considerable influence on younger painters, in his use of calligraphy and in his insistence on the absolutely spontaneous touch, as well as by his example of glorifying the creative act—a more dangerous concept for the inexperienced....
>
> Like De Kooning's, Pollock's stature as a major artist seems already defined. ... It would be invidious and unprofitable to compare the two artists' accomplishments, but they stand at the extremes where the spirit of the painter and the body of his paint become indistinguishable.

And yet, as Pavia describes it, Pollock sat clutching the book as if he wanted to crush it. He disagreed noisily with passages that were read from it, swore a great deal, and finally threw the book at de Kooning's feet.

"Why'd you do that?" de Kooning asked. "It's a good book."

"It's a rotten book," Pollock replied. "He treats you better than me."

Hess, who was not there that night but remembers Pollock popping in during another night in the series, believes that Pollock's gesture was playful, his words bantering "as between two guys on the same team going after a home-run record." That may be part of the truth. But if, on one level, Pollock and de Kooning were playing on the same team, on another, they were playing for themselves. De Kooning himself has stated, "A couple of times [Pollock] told me, 'You know more, but I feel more.' I was jealous of him—his talent. But he was a remarkable person. He'd do things that were so terrific."*

Hess argues that then, at the beginning of the fifties, when one guy made it, it was good for everybody. And that, too, is part of the truth— perhaps the most objective part, historically accurate—but not the part seen or felt by the guy who makes it or by those who don't and have to watch him. Tom Hess said, "Maybe it was like Giacometti being mentioned in the same breath with Matisse—Pollock, like Matisse, was much more famous. . . . Anyway, Jackson couldn't have disliked the book so much—a little later he and Lee asked me to do one on him, an expansion, an amplification of that Betty Parsons catalogue [of the black-and-white show in 1951]." Once again we believe that Hess has part of the truth. Another part may be Jackson's (and Lee's) need for Hess's support in *Art News* and elsewhere.

Whatever the truth in all its multifaceted complexity, it is clear that by now Jackson recognized his public identity as a target or goal. He felt the pressure of contemporaries beside him and younger artists behind

* See Bibliography No. 218a.

him. From now on this painter who had been freely able to give or even throw away paint, emotions, and ideas would be forced to think about every stroke, every splash he made until finally his self-consciousness became paralyzing.

The "Biggest" Year
(1950)

...I saw Yin, the Female Energy, in its motionless grandeur; I saw Yang, the Male Energy, rampant in its fiery vigour. The motionless grandeur came up out of the earth; the fiery vigour burst out from heaven. The two penetrated one another, were inextricably blended and from their union the things of the world were born.

LAO TZU
(translated by Arthur Waley)

Early in 1950 Alfonso Ossorio left for the Philippines to do murals for the church his family was building in Victorias. Before leaving he offered —and the Pollocks accepted—his house on MacDougal Alley as a pied-à-terre and also as a place where Jackson could show large paintings. Ossorio asked the Pollocks to watch for a home in East Hampton for him.

With Peter Blake's help, Pollock had received a commission to do a $6' \times 8'$ mural for the Breuer-designed Geller House in Lawrence, Long Island, the only commission other than Peggy Guggenheim's he was ever to be given. Besides size, there was an additional stipulation: that the ground color be as close as possible to the rust tone of *Arabesque* (*Number 13, 1948*), a painting done on a commercially prepared ground. Pollock closely matched the color and was then free to make his mural. He completed it in March. Later in the spring he wrote to Ossorio, struggling with his much larger commission in Victorias:

Dear Alfonso,

The project sounds exciting and hope you have solved the painting medium —Summer has come upon us (people). The Geller mural is finished but not installed. The house is unfinished—the studio untouched—I am gradually getting into painting again—I sent you Parker Tyler's article on my painting in the Magazine of Art ["Jackson Pollock: The Infinite Labyrinth"], but forgot to send it air mail. You will probably get it a week before you leave. The recent things at 9 Mac [paintings by Ossorio] looked good to me—

Lee, who disliked writing as much as Jackson did, continued the letter. Not surprisingly, she thought Jackson's mural was beautiful and said that after a long drying period they would cope with its installation. (Later, the Pollocks' friend Giorgio Cavallon built a bookcase, to be used in the Geller house as a free-standing room divider, and mounted the mural on the back of it.) The rest of Lee's postscript was mostly lists of people and exhibitions seen and events attended, including part of a lecture at The Club, Recent Acquisitions at the Modern ("Brancusi's Fish and Pollock's painting shine"), and "an education reception" at the same museum.

The reception was given in connection with the Twenty-Fifth Venice Biennale. There, in June, the United States Pavilion would be divided, one-half for a John Marin retrospective, the other half for a selection of paintings by six younger artists: Arshile Gorky, Willem de Kooning, and Jackson Pollock, chosen by Alfred Barr of the Museum of Modern Art; and Hyman Bloom, Lee Gatch, and Rico Lebrun, chosen by Alfred Frankfurter, publisher of *Art News,* president of the Art Foundation, and United States Commissioner for this 1950 Biennale. One of the photographs taken at the reception in the museum penthouse shows Frankfurter with several members of the museum staff and four of the artists: Marin, Gatch, de Kooning, and Pollock. As projected in this particular photo, the most startling personality is Marin. With his long hair and flowing cravat, he "looks like an artist," though perhaps one of another era. His thin sensitive hands protruding from cuffs fastened by links add to the sense of bygone elegance. In comparison with him everyone else looks like a businessman. Even Pollock has discarded all hints of Western individualistic eccentricity. He appears positively Ivy League in striped tweed jacket, white shirt, black tie, gray flannels, dark socks, and loafers. He is trim, clean-cut, well-shaved, his little remaining hair cropped close. His expression is determined as, with lips pressed tight, he stares past and away from the camera, past everyone in the room, toward—what?—the future? We return to Marin and follow his eyes. He, too, is staring—straight at Pollock. Marin's expression is puzzled. He

may be asking himself if that critic Greenberg can possibly be right about this young man, more than forty years his junior, so quiet, so intense, so definite in the way he refused a drink, antisocial almost. Will Pollock, as Greenberg suggested, compete with him for recognition as the greatest American painter of the twentieth century? If Marin asks himself that, then in staring at Pollock, he too is staring into the future.

Not mentioned in the Pollocks' joint letter was an open letter of about the same time addressed to Roland L. Redmond, president of the Metropolitan Museum, in which Pollock and seventeen other so-called "irascible" painters (Baziotes, Brooks, Bultman, Jimmy Ernst, Gottlieb, Hofmann, Kees, de Kooning, Motherwell, Newman, Pousette-Dart, Reinhardt, Rothko, Stamos, Hedda Sterne, Still, Tomlin) refused to participate in a national competitive exhibition of "American Painting Today 1950"—scheduled by the museum for December—because the award juries were "notoriously hostile to advanced art." The letter charged that Francis Henry Taylor, museum director, had "on more than one occasion publicly declared his contempt for modern painting" and that Robert Beverly Hale, the museum's associate curator of American art, had, in accepting such juries, taken his "place beside Mr. Taylor." The signatures of the "Irascible Eighteen" were supported by those of ten sculptors, about as representative of the avant-garde as the painters.

It is interesting to look through the catalogue of this show: 6,248 paintings were entered in competition; 761 were accepted by regional juries; 307 were exhibited. Yet, judging by illustrations, virtually all of the paintings were Cubistic or Realistic, some of the latter having overtones of Expressionism and Surrealism. With the exception of Tobey's, there was nothing that represented post–World War II developments in painting. The signers of the letter were justified in complaining about the juries. The regional one for New York consisted of Burchfield, Kuniyoshi, Kroll, Sample, Vytlacil, and Pleissner, who was on the eight-man National Jury too, along with one other New Yorker, Maurice Sterne. The Jury

of Awards was still more conservative: William M. Milliken of Ohio, Franklin C. Watkins of Pennsylvania, and Eugene Speicher of New York. The awards were predictable: first prize ($3,500), Karl Knaths; second ($2,500), Rico Lebrun; third ($1,500), Yasuo Kuniyoshi; fourth ($1,000), Joseph Hirsch. The Jury of Awards may even have been stretching to show the Irascibles how advanced it was by giving the first two prizes to Cubist compositions. But of course a bigger stretch would have been to invite the Irascibles in the first place. Consider how much even the fourth prize would have meant to Pollock, not to mention the other seventeen, except for a few with money.

Some of this material appeared in *Life* (January 15, 1951: "The Metropolitan and Modern Art") soon after the exhibition opened. Confronting four pages of color reproductions of the prizewinning paintings and other comparatively conservative works is one full-page black-and-white photograph captioned IRASCIBLE GROUP OF ADVANCED ARTISTS LED FIGHT AGAINST SHOW. Nina Leen's collective portrait of fifteen of the eighteen Irascibles is the most famous group photograph ever made of this generation of American artists, each of them, like Pollock in the center, projecting an intense mixture of sadness and anger. The story begins: "The solemn people above, along with three others, made up the group of 'irascible' artists who raised the biggest fuss about the Metropolitan's competition. . . . All representatives of advanced art, they paint in styles which vary from the dribblings of Pollock . . . to the Cyclopean phantoms of Baziotes, and all have distrusted the museum since its director likened them to 'flat-chested' pelicans 'strutting upon the intellectual wastelands.' "

Sam Kootz wanted to exhibit paintings by the eighteen Irascibles. However, Tony Smith insisted that the work of Pollock, Still, Rothko, and Newman had to be seen in large scale, that the exhibition of small examples of their work—framed and treated as art objects in Kootz's comparatively small gallery—would reduce the artists. Smith discussed the possibility of showing the work of the four artists in depth, in the proper

context—perhaps in a circus tent on a parking lot. Though the tent was never put up, the idea of exhibiting a small group of related artists in a series of environmental large-scale one-man shows, rather than a lot of artists in a collection of isolated contextless single works, may well have influenced subsequent exhibitions of Abstract Expressionism, especially those, both here and abroad, of the Museum of Modern Art.

So much for the events of early 1950. By spring, when the Pollocks made their transition from the city to the country, they had had enough of New York's stimulation and confusion to last them awhile. It was good to see the Zogbaums, the Nivolas, John Little, and other year-round residents while preparing for the onslaught of summer people. But, most important, Jackson's gradual period of getting into painting again was over. By now he had plunged into it. During the summer and fall he would do thirty-two paintings—four of them among his greatest, in every sense including size—while struggling not to be distracted by an almost constant buzz of attention from both here and abroad, much of it centering around the Venice Biennale.

A few days before the Biennale opened Emily Genauer gave *New York Herald Tribune* readers a sort of pre(non)view of the United States Pavilion:

> *Visitors who enter to learn about the state of art in America will see (with the exception of a group of paintings by the distinguished octogenarian, John Marin) not one single painting by any of the artists who have been recognized by our leading museums, critics, collectors, and connoisseurs as the most creative and accomplished talents in America. There will be no canvas by Franklin Watkins, or Stuart Davis, or Max Weber, or Yasuo Kuniyoshi, or Feininger, or Shahn, or Reginald Marsh.... All that visitors will find ... will be several canvases by that singular and ubiquitous sextet, Jackson Pollock, Willem de Kooning, Hyman Bloom, Arshile Gorky, Lee Gatch, and Rico Lebrun.*

If ever a sextet wasn't a sextet, this was it: it was more like two trios, though not really that either. And it wasn't at all ubiquitous: we know of no other exhibition in which these six artists appeared together.

In the summer issue of *Art News* Alfred Barr wrote about his selections for the Biennale. He described Pollock's as "perhaps the most original art among the painters of his generation . . . an energetic adventure for the eyes, a *luna park* full of fireworks, pitfalls, surprises and delights."

By July 6 Douglas Cooper, writing for London's *The Listener,* was already responding to Barr:

> *The younger painters in this pavilion mostly imitate well-known Europeans, with a singular lack of conviction and competence though on a very large scale. One of them, however, Jackson Pollock, is a striking exception. He is undeniably an American phenomenon. Working without brushes, he spreads his canvas on the floor and dribbles the contents of paint-tubes on to it from above. The result is an elaborate if meaningless tangle of cordage and smears, abstract and shapeless, but, to quote Alfred Barr of the Museum of Modern Art, it is "an energetic adventure for the eyes." Personally, I think this is merely silly.*

By the following month *Time* would join the dialogue: "U.S. Painting did not seem to be making much of a hit abroad. At Venice's 'Biennale,' the U.S. pavilion (featuring the wild and woolly abstractions of Arshile Gorky and Jackson Pollock) was getting silent treatment from the critics." And by September 10 Aline Louchheim would reply in *The New York Times:* "It would be accurate to report . . . simply that Europeans do not bother to give our pavilion very serious consideration. Marin has received passing praise. . . . Even the most intelligent critics . . . spent little time looking at Gorky and de Kooning. . . . Pollock is a special case. . . . His detailed description of how he works (dripping paint, etc. on to canvas spread on the floor) has been assiduously translated and is grounds for violent arguments pro and con all abstract and automatic art."

Early in the summer—at the same time as the Biennale was beginning to receive attention—Berton Roueché interviewed Lee and Jackson for *The New Yorker*. Roueché was an East Hampton neighbor of theirs and Peter Blake, who had sent him the announcement of the Parsons "Murals in Modern Architecture" exhibition. However, the interview was more topically pegged to Pollock's inclusion in the Biennale and appeared

in the August 5 "Talk of the Town" under the title "Unframed Space." Though the comparatively short piece contains no new information about Pollock's background or art training, it is revealing about the relationship between Lee and Jackson, emphasizing the self-effacing, supportive nature of her role and the rather broad, Western style of his delivery:

> ...*Pollock, a bald, rugged, somewhat puzzled-looking man of thirty-eight, received us in the kitchen, where he was breakfasting on a cigarette and a cup of coffee and drowsily watching his wife, the former Lee Krasner, a slim, auburn-haired young woman who also is an artist, as she bent over a hot stove, making currant jelly. Waving us to a chair in the shade of a huge potted palm, he remarked with satisfaction that he had been up and about for almost half an hour. It was then around 11:30 A.M. "I've got the old Eighth Street habit of sleeping all day and working all night pretty well licked," he said. "So has Lee. We had to, or lose the respect of the neighbors. I can't deny, though, that it's taken a little while. When'd we come out here, Lee?" Mrs. Pollock laughed merrily. "Just a little while ago," she replied. "In the fall of 1945."*
>
> *"It's marvellous the way Lee's adjusted herself," Pollock said. "She's a native New Yorker, but she's turned into a hell of a good gardener, and she's always up by nine. Ten at the latest. I'm way behind her in orientation. And the funny thing is I grew up in the country. Real country..."*

At this point Pollock summarized the material with which we are familiar—from Cody to New York City—and then went on:

> "...*Lee and I came out here. We wanted to get away from the wear and tear. Besides, I had an underneath confidence that I could begin to live on my painting. I'd had some wonderful notices. Also, somebody had bought one of my pictures. We lived a year on that picture, and a few clams I dug out of the bay with my toes. Since then things have been a little easier." Mrs. Pollock smiled. "Quite a little," she said. "Jackson showed thirty pictures last fall and sold all but five. And his collectors are nibbling at those." Pollock grunted. "Be nice if it lasts," he said.*
>
> *We asked Pollock for a peep at his work. He shrugged, rose and led us into a twenty-five-by-[fifteen]-foot living room furnished with massive Italianate tables and chairs and hung with spacious pictures, all of which bore an offhand*

resemblance to tangles of multicolored ribbon. "Help yourself," he said, halting at a safe distance from an abstraction that occupied most of an end wall. It was a handsome, arresting job—a rust-red background laced with skeins of white, black, and yellow—and we said so. "What's it called?" we asked. "I've forgotten," he said, and glanced inquiringly at his wife, who had followed us in. " 'Number Two, 1949,' I think," she said. "Jackson used to give his pictures conventional titles—'Eyes in the Heat' and 'The Blue Unconscious' and so on —but now he simply numbers them. Numbers are neutral. They make people look at a picture for what it is—pure painting." "I decided to stop adding to the confusion," Pollock said. "Abstract painting is abstract. It confronts you. There was a reviewer a while back who wrote that my pictures didn't have any beginning or any end. He didn't mean it as a compliment, but it was. It was a fine compliment. Only he didn't know it." "That's exactly what Jackson's work is," Mrs. Pollock said. "Sort of unframed space."

The paintings by Pollock in the Biennale—including *Number 1, 1948,* the most important of three shown (and also the second and last to be purchased by the Museum of Modern Art until after his death)— were not his only works to be seen in Venice that summer. Early in the year Peggy Guggenheim had tried unsuccessfully to arrange a one-man show for him in Paris. Now, from July 22 to mid-August, she exhibited her entire collection of his works—twenty oils, two gouaches, and one drawing, including two paintings she had given to the Stedelijk Museum in Amsterdam. The original catalogue for this exhibition contained, in addition to introductory comments by Miss Guggenheim, an essay called "A Short Talk on the Pictures of Jackson Pollock" by Bruno Alfieri, reprinted from *L'Arte Moderna* (where, in the same issue, an Italian translation of Pollock's *possibilities* statement had also appeared). In the second version of the catalogue, the Alfieri essay was eliminated. This elimination is not difficult to understand:

Jackson Pollock's paintings represent absolutely nothing: no facts, no ideas, no geometrical forms. Do not, therefore, be deceived by suggestive titles such as "eyes in heat" or "circumcision": these are phony titles, invented merely to distinguish the canvases and identify them rapidly....

No picture is more thoroughly abstract than a picture by Pollock: abstract from everything. Therefore, as a direct consequence, no picture is more automatic, involuntary, surrealistic, introverted and pure than a picture by Pollock. I do not refer to André Breton's surrealism, which often develops into a literary phenomenon, into a sort of snobbish deviation. I refer to real surrealism, which is nothing but uncontrolled impulse. . . .

In any case it is easy to detect the following things in all of his paintings:
—chaos
—absolute lack of harmony
—complete lack of structural organization
—total absence of technique, however rudimentary
—once again, chaos. . . .

It is true that he does not think; Pollock has broken all barriers between his picture and himself: his picture is the most immediate and spontaneous painting. Each one of his pictures is part of himself. But what kind of a man is he? What is his inner world worth? Is it worth knowing, or is it totally undistinguished? Damn it, if I must judge a painting by the artist, it is no longer a painting that I am interested in, I no longer care about the formal values contained in it. On the other hand, however, Pollock never meant to insert formal values in his pastiches. What then? Nevertheless, there are some formal values in his pictures; I can sense something there, because I can see shapes (garbled and contorted) that say something to me. What do they say? If they are pieces of Pollock, they will show Pollock to me—pieces of Pollock. That is, I start from the picture, and discover the man: suddenly, without reasoning, instantaneously, more instantaneously than with any other modern painter. . . .

The exact conclusion is that Jackson Pollock is the modern painter who sits at the extreme apex of the most advanced and unprejudiced avant garde of modern art. . . . Compared to Pollock, Picasso, poor Pablo Picasso, the little gentleman who, for a few decades now, troubles the sleep of his colleagues with the everlasting nightmare of his destructive undertakings, becomes a quiet conformist, a painter of the past.

Except for Aline Louchheim's brief general reference to it, Alfieri's "short talk" would not be picked up by the American press until the fall. Meanwhile, *The New Yorker* piece was followed within two weeks by a

long local-boy-makes-good rehashing of it in the East Hampton *Star,* the first of many articles there on Pollock.

In October the Modern Art's Department of Circulating Exhibitions began touring a show called "Calligraphic and Geometric: Two Recent Linear Tendencies in American Painting," which included Pollock's *Number 13, 1949* and later, in lieu of it, *Number 12, 1948.* (The show made twenty-five stops in its travels around the States, covering a period of three-and-a-half years.) Later in the month, the Sidney Janis Gallery (in Sam Kootz's former space, across the elevator landing from Betty Parsons) did an exhibition organized by Leo Castelli and called "Young Painters in U.S. and France." In it Pollock's *Number 8, 1950* hung with Lanskoy's *Heavenly Harvest* within a context of other comparisons: Gorky–Matta, Kline–Soulages, de Kooning–Dubuffet, Rothko–de Staël. On November 10, the day before the exhibition closed and less than three weeks before Pollock's own exhibition at Parsons, there was an open meeting at Janis on "Parallel Trends in Vanguard Art in the U.S. and France." Besides Castelli, the panel included Greenberg and Rosenberg, Frederick Kiesler, Nicolas Calas (a Surrealist critic, whom, like Kiesler, Pollock knew from Art of This Century days), Ritchie of the Modern, and the painter and devotee of the arts Theodore Brenson.

Though the painterly, Surrealist-oriented work of Gorky and Matta was closely related, the resemblances between the other American and European artists were superficial. Pollock and Lanskoy painted overall, Kline and Soulages used a broad slashing brushstroke, de Kooning and Dubuffet were interested in surface, etc. But the panelists cared more about the differences they saw than the similarities Janis had seen. As happened too often also at The Club, the comparisons were made invidious and chauvinistic: it was not enough to point out the virtues of the New York School—its directness, physicality, and honesty—one had to attack the Paris School for its painterliness, slickness, and dishonesty.

As Pollock was deep in his work, probably none of these events centering on Venice and New York distracted him very much. They must

have been like so many flies in his studio—there, in and out, but not taking up much room or demanding much attention. However, when *Time* (November 20) published "Chaos, Damn It!" it did annoy him:

> *Jackson Pollock's abstractions* (Time, *Dec. 1, 1947 et seq.*) *stump experts as well as laymen. Laymen wonder what to look for in the labyrinths which Pollock achieves by dripping paint onto canvases laid flat on the floor; experts wonder what on earth to say about the artist. One advance-guard U.S. critic has gone so far as to call him "the most powerful painter in America." Another, more cautious, reported that Pollock "has carried the irrational quality of picture-making to one extremity" (meaning, presumably his foot). The Museum of Modern Art's earnest Alfred Barr, who picked Pollock, among others, to represent the U.S. in Venice's big* Biennale *exhibition last summer, described his art simply as "an energetic adventure for the eyes."*
>
> *Pollock followed his canvases to Italy, exhibited them in private galleries in Venice and Milan. Italian critics tended to shrug off his shows. Only one, brash young (23) Critic Bruno Alfieri of Venice, took the bull by the horns.*
>
> *"It is easy," Alfieri confidently began, "to describe...." [The balance of the article quoted extensively from Alfieri's essay, including the passage on chaos.]*

Pollock responded quickly with a telegram that was not published until the December 11 issue of *Time:*

> NO CHAOS DAMN IT. DAMNED BUSY PAINTING AS YOU CAN SEE BY MY SHOW COMING UP NOV. 28. I'VE NEVER BEEN TO EUROPE. THINK YOU LEFT OUT MOST EXCITING PART OF MR. ALFIERI'S PIECE. [*Pollock was probably thinking of the comparison between himself and Picasso.*]

But of all the fall's many events—continuing, beginning, ending, weaving in and out of Pollock's life as if elements in one of his own paintings—none were more climactic than those surrounding a short film on Pollock, produced by Hans Namuth and Paul Falkenberg. Namuth, a professional photographer with a summer home in nearby Water Mill, had met Pollock at a Guild Hall exhibition. Namuth continues the story in a statement written for the *American Society of Magazine Photograph-*

ers' Picture Annual at the time of Pollock's death and used again eight
years later in a pamphlet distributed with *Convergence*, "The World's
Most Difficult Jigsaw Puzzle" (of which, by 1970, more than 100,000
would be sold):

> *I had little contact with Jackson Pollock's work before I met him. The impact
> of his personality had a great deal to do with my relationship to his art: it was
> a sudden recognition. I felt related to him—and to his painting—from the
> moment I spoke to him.*
>
> *The day before I was to come to his studio (Summer 1950) he had prom-
> ised that he would start a new painting for me and perhaps finish it while I
> was still there. When I arrived, however, he shrugged his shoulders and told
> me it was too late, the painting was done; we could not take any pictures.*
>
> *I was disappointed; I also was aware of his reluctance to have anyone
> present while he was at work. Hesitantly, I suggested going into the studio.*
>
> *An enormous painting covered almost the entire surface of the floor.
> Dripping wet paint, white, black, maroon; the painting was finished.*
>
> *There was complete silence. (He never communicated much, verbally.) I
> looked aimlessly through the ground-glass of my Rollei. He examined the
> painting. Suddenly (he must have decided then that there was more work to be
> done) he took hold of a paint can and a brush and began to re-do the entire
> painting, his movements, slow at first, gradually becoming faster and almost
> dancelike....*
>
> *He had forgotten that I—and Lee, his wife—were present.*
>
> *It was an exciting and also a strangely self-effacing session. (It was, too,
> the first hour of a friendship that was interrupted only by his death in August,
> 1956.)*
>
> *The cap of childhood legends which makes its bearer invisible would be
> a great asset to a photographer. Sometimes, on rare occasions, this fairy-tale gift
> becomes ours.*

In subsequent black-and-white still photographs Namuth recorded
Pollock's entire procedure: unrolling canvas on the floor, crouching in
readiness before the empty canvas with a can of black enamel in his left
hand and a brush in his right, drawing with paint spilled from the brush
onto the canvas, dancing around the canvas, sometimes stepping onto it

and then backing off, switching to white enamel and other colors, and finally standing and looking at the finished painting.

"It was great drama," Namuth said in an article written a year later for the graphic arts magazine *Portfolio,* "the flame of explosion when the paint hit the canvas; the dancelike movement; the eyes tormented before knowing where to strike next; the tension; then the explosion again . . . my hands were trembling."

Like Matter a few years before, Namuth knew that in order best to present Pollock on film he should be photographed in motion. There was a period of persuasion. Though Pollock—especially the sober Pollock of this period—may still have felt "reluctance to have anyone present while he was at work" and though being photographed while working may have seemed intrusive at the least and perhaps almost obscene, quite comparable to being photographed while making love, Namuth had nevertheless built up a rapport with him. By August of 1950, Pollock had accepted the idea of a motion picture. The first very short film was done on a minimal budget in black-and-white. But then Namuth felt that, besides motion, Pollock required color. Since neither Namuth nor his coproducer Falkenberg could afford the elaborate lighting necessary for indoor color photography, they decided to do the film almost entirely outdoors. Namuth shot it on the Pollock property in several sessions during September and October of 1950 and one brief session at the Betty Parsons gallery in early December, after Pollock's next show had been installed.

The film begins with Pollock painting his signature and the date " '51" (in anticipation of when the film would be completed). He takes off his loafers and puts on paint-spattered work shoes. His voice, rather strained and tense, is heard on the soundtrack: "My home is in Springs, East Hampton, Long Island. I was born in Cody, Wyoming, thirty-nine years ago. In New York I spent two years at the Art Students League with Tom Benton. He was a strong personality to react *against. . . .*" The narration—basically a collection of previous statements by Pollock—

continues for a minute or so as images of the studio and surrounding property are presented. Then he makes a painting on canvas.

This was the first part of the film shot by Namuth. Again he realized it lacked something. "I wanted to *see* the painter painting—his face, his hands. One night I couldn't sleep, thinking about it. I literally dreamed the idea of having Jackson do a painting on glass. I discussed it with Jackson, who was a good carpenter. He got the idea right away and interpreted what I had vaguely suggested. He built the wooden horses for the glass and a platform for himself high enough so I could photograph from underneath."

As the sequence begins Pollock says, "This is the first time I am using glass as a medium." We watch him arrange pebbles and wire mesh on the 4′ × 6′ sheet of glass and then begin to pour paint. After about a minute and a half he stops, wipes the paint and other materials from the glass, and says, "I lost contact with my first painting on glass, and I started another one." Again we see him place objects on the glass: scraps of wire mesh, bits of string, shells, pebbles, small colored glass rods and sheets. These things are isolated until joined by the flow of spilled paint which we see hit the glass surface and spread as though alive. Tony Smith says,* "I think that his feeling for the land had something to do with his painting canvases on the floor. I don't recall if I had ever thought of this before seeing Hans Namuth's film. When he was shown painting on glass, seen from below and through the glass, it seemed that the glass was the earth, that he was distributing flowers over it, that it was spring."

When the poet Frank O'Hara wrote the first monograph on Pollock, he described the painting-collage on glass, *Number 29* (as it was designated), as perhaps

> [*Pollock's*] *most remarkable work of 1950, from a technical standpoint . . . it is majestic and does not depend on novelty for its effect. It is unique in that it is a masterpiece seen front or back, and even more extraordinary in that it is*

* See Bibliography No. 172.

the same masterpiece from opposite sides of viewing. What an amazing identity Number 29 *must have!—like that of a human being. More than any other work of Pollock, it points to a new and as yet imponderable esthetic. It points to a world a young experimentalist like Allan Kaprow, who has written on Pollock in another vein, is searching for, and it is the world where the recent works of Robert Rauschenberg must find their emotional comfort. Other paintings of Pollock contain time, our own era with valuable elements of other eras revalued, but* Number 29 *is a work of the future; it is waiting. Its reversible textures, the brilliant clarity of the drawing, the tragedy of a linear violence which, in recognizing itself in its own mirror-self, sees elegance, the open nostalgia for brutality expressed in embracing the sharp edges and banal forms of wire and shells, the cruel acknowledgement of pebbles as elements of the dream, the drama of black mastering sensuality and color, the apparition of these forms in open space as if in air, all these qualities united in one work present the crisis of Pollock's originality and concomitant anguish full-blown. Next to* Number 29, *Marcel Duchamp's famous work with glass* [The Bride Stripped Bare by Her Bachelors, Even] *seems mere conjecture, a chess-game of the non-spirit. This is one of the works of Pollock which it is most necessary to ponder deeply, and it is unfortunate for the art of the future that it is not permanently (because of its fragility) installed in a public collection.* [Number 29 *was purchased in 1968 by the National Gallery of Canada.*]

The last outdoor sequence of the film—that is, the sequence in which Pollock made *Number 29*—was completed in the afternoon of a clear, very cold day in late October. By three-thirty or four, when Namuth and Pollock returned to the house, they were chilled. Pollock went right for the bourbon and poured stiff drinks for Namuth and himself. Namuth knew immediately what was happening: that after being on the wagon for two years, Jackson was going off. What he didn't know was that Dr. Heller had recently died and that Jackson would never again find anyone who could help him with his alcoholism. "Don't be a fool," Hans said, but by dinnertime Jackson was drunk. Namuth describes the evening in a way which agrees substantially with a description by Lee Pollock:*

* See Bibliography No. 172.

".... we were having ten or twelve people for dinner. Jackson and Hans Namuth were at one end of the table. I don't know what the argument was about, but I heard loud voices and suddenly Jackson overturned the whole table with twelve roast beef dinners. It was a mess. I said, 'Coffee will be served in the living room.' Everyone filed out and Jackson went off without any trouble. Jeffrey Potter and I cleaned up."

Everyone who has talked about that day's events—Hans Namuth, Alfonso Ossorio, and Lee Pollock—emphasizes the penetrating cold, the early touch of winter in the air. And yet, having a chill, Pollock might have drunk coffee or tea or soup. Isn't it possible that what he was feeling was being photographed as much as being cold? What was it like painting on a "glass canvas," with Namuth beneath it, pointing a camera at him? And in those days, before commonplace television interviews, before the mass selling of artists (and politicians, and everyone else), wouldn't having a film made about oneself—even a short art film—have struck Pollock as the ultimate in celebrity, the conclusion of a sequence beginning with little magazines and moving on to big ones? To be in a film! How many American artists had had that? Only Calder, as far as he knew. No one of his own generation ... There was that side of it: a positive sense of excitement in being on screen. And on the other side: knowing intuitively that this was the final reduction of himself to subject matter, to becoming a thing, a commodity, an entertainment. Pollock's ambivalence about all the publicity received during the past two years may well have intensified as he faced Namuth's camera. Pollock may even have remembered Herbert Matter's reluctance to photograph him. Then, something had been said about mutual discomfort.... And someone— was it Herbert too?—had told him about Chinese artists who several times during their careers changed their names in order to preserve their privacy....

However, Namuth believes that Pollock was totally at ease and felt no tension in connection with the film until a few months later when the time came for recording his portion of the soundtrack. In support of

Namuth's view, one can quote Bryan Robertson, an Englishman who, after O'Hara, wrote the next monograph on Pollock. Robertson said:

> *Pollock works on the painting, in front of the camera, with a total absence of self-consciousness and a riveting degree of ease and spontaneity; more to the point, the formal command is consummate. The formidable dexterity and control shown here by Pollock in selecting materials at hand and using them with extreme fluency and inventiveness could only be rivalled by that other genius, Alexander Calder. To perform in public in this way is abhorrent to most European artists but the film convinces one of Pollock's utter absorption in the work in progress. There is not the slightest suggestion of a bravura exercise. Later Pollock liked to place this glass painting outside his studio and see landscape through it. Again we see the isolated specific incident set against a generalized background, or another kind of imprint on the land. [Hess of Art News quotes Pollock as saying, "The fields and beach looked wonderful through it."]*

Pollock's fourth exhibition at the Betty Parsons Gallery—his eighth one-man show in as many years—opened November 28. It was surely his greatest to date. In it there were thirty-two paintings, all on canvas, except for *Number 29*. Note now the arbitrariness of the numbering: it was simply a matter of convenience, based as much as anything on how paintings were stacked, rolled, or hung in the studio (often a matter of size) and the order in which they were removed. From Namuth's photographic documentation we know that *Number 32* preceded *Number 31* (*One,* now in the collection of the Modern, after being bought by Ben Heller during the last year of Pollock's life) and *Number 30* (*Autumn Rhythm,* now in the collection of the Metropolitan); and we know that all three preceded *Number 29*. These four works are the only ones of this year that we can date within a month: *Number 29,* late October; *Number 32,* July or August; *Number 31* and *Number 30,* September or October.

Surely *Number 32, One,* and *Autumn Rhythm* are among Pollock's masterpieces of 1950. The second and third of these 9′ × 18′ paintings is an enrichment or at least a further improvisation on the gloriously lyrical

themes stated in the previous painting, with *One* and *Autumn Rhythm* related to each other not only in size and rhythmic pattern but palette as well. The other unquestionable masterpiece was *Number 1 (Lavender Mist)*. As indicated, it is no more likely that this was Pollock's first painting of 1950 than that *Number 32* was his last. Because of its richness, sensuousness, and seductiveness, as well as its comparatively large scale (7'3" × 9'10"), we would date it close to *One*. Ossorio, back from the Philippines and soon to be on his way to Paris, bought it immediately. It was the only major painting that sold from the show, which received far less attention than it deserved. Perhaps by now Pollock was taken for granted.

Howard Devree, in *The New York Times* (December 3), expressed strong reservations:

> *More than ever before . . . it seems to me that Pollock's work is well over toward automatic writing and that its content (not definite subject-matter but content) is almost negligible—that what one gets out of it one must first put there. . . .*

The painter Robert Goodnough, reviewing for *Art News* (December), was among the few who responded enthusiastically:

> *Jackson Pollock . . . the most highly publicized of the younger American abstractionists whose controversial reputation is beginning to grow abroad, has been deeply occupied with some enormous paintings this summer—the largest are 18 by 9 feet. No. [32] of this series is done in great open black rhythms that dance in disturbing degrees of intensity, ecstatically energizing the powerful image in an almost hypnotic way. His strength and personal understanding of the painter's means allow for rich experience that projects a highly individualized (yet easily communicable to the un-selfconscious observer) sense of vision that carries as well through to the smaller colorful paintings in which convergences of tensions rule. Pollock has found a discipline that releases tremendous emotive energy combined with a sensitive statement that, if to some overpowering, can not be absorbed in one viewing—one must return.*

Perhaps this show—so grand in both its aspirations and achievements—could be appreciated only by artists and serious critics. There was no new story for the popular press. The editorial board of *Art News* in its January issue voted Pollock's the second most outstanding one-man show of the year (with Marin's first, and Giacometti's third). Hess, by then managing editor of the magazine, was completing the manuscript of his book *Abstract Painting.* In it he very well summed up Pollock's position at the end of 1950:

... with ... gratifying attentions have come several equally distasteful ones. When conservatives or Marxists wish to point to some real or fancied evil, they almost invariably hit at Pollock. The Soviet art critic and the one writing for Time *magazine, both covering the 1950 Biennale exposition in Venice ... were hunting, respectively, for some particularly horrifying evidence of bourgeois decadence, and for some un-American scrawling. Both found what they sought in Pollock. He is accused of being too fashionable and too obscure, the head of a coterie and minor eccentric, etc., etc. Thus true fame has come to him from his detractors, and his best publicity has been of the wrong kind. ...*

Chapter Eight

Black and White
(1951)

> "... *Strictly speaking, drawing does not exist! ... The line is the method by which man expresses the effect of light upon objects; but there are no lines in nature, where everything is rounded; it is in modelling that one draws, that is to say, one takes things away from their surroundings.... Observe that too much knowledge, like ignorance, leads to a negation. I doubt my own work!"*
>
> BALZAC
> *"The Unknown Masterpiece"*

Though Pollock's show had closed December 16, he and his wife were still in New York at Ossorio's MacDougal Alley house in January. At that time he wrote to Ossorio and his friend Edward Dragon in Paris:

> *Dear Alfonso and Ted,*
> *The two Dubuffet books came this very moment—they are really very beautiful. There is a photograph of him in this issue of Art News—a surprise. We have had no word from [Pierre] Matisse about borrowing the two D[ubuffets]. Gorky's show [a memorial retrospective, January 5–February 18, at the Whitney] opened yesterday—it's really impressive and wonderful to see an artist's development in one big show. More than 90 per cent of the work I'd never seen before—he was on the beam the last few years of his life. The catalogue doesn't have enough reproductions in it—but will send you one anyway.*
> *I found New York terribly depressing after my show—and nearly impossible—but am coming out of it now....*

Jackson's letter crossed one from Alfonso covering five closely written pages, begun December 23 and completed December 30. Alfonso mentions first the difficulties of getting settled ("the difference between living in an hotel with a bilingual staff & being on one's own is quite startling"). He asks about the last week of Jackson's show at Parsons. "Did all the pictures come down safely? I still think of the magnificence

of that room, & I hope Hans took adequate photographs; I await them very anxiously. . . ." He describes the complications in getting a painting of Jackson's through French customs. He requests a progress report on a project of Tony Smith's for a church containing murals by Jackson (a project which will drag on for many months before being abandoned). He mentions Dubuffet's interest in seeing more of Jackson's work. The letter ends with requests to Lee to take care of various matters having to do with Alfonso's bank account, bills, the loan of two Dubuffets to Pierre Matisse, the shipment of twelve bottles of varnish, etc. "I shall write again very soon (as soon as I have more for you to do!) . . ."

Three weeks later he wrote the following short note:

> *Dear Jackson, In my last letter to Lee I enclosed $200 to be applied towards the next painting of yrs. we acquire. We'd like to continue sending this amount on a monthly basis if this sort of arrangement is agreeable to you & Lee. We've no particular painting (or sculpture) in mind at the moment but I know that there'll [be] many we'll want in the future.*
>
> > *Love to you both,*
> > *Alfonso*

Late in January Lee and Jackson returned to Springs. From there Jackson wrote again to Paris:

> *Dear Alfonso—*
> *I really hit an all-time low—with depression and drinking—NYC is brutal. I got out of it about a week and a half ago—followed with a constructive dream—(happily Tony was here to interpret it for me) and now your letter. It is so thoughtful and kind—I won't try to find words (of my feeling). Last year I thought at last I am above water from now on in—but things don't work that easily I guess. I have seen a great deal of Dr. [Elizabeth Wright] Hubbard [a homeopathic physician in New York he had been seeing intermittently since 1943] she has been extremely helpful. . . . The Museum of M.A. opened the survey of American abstract painting [January 23–March 25, Abstract Painting and Sculpture in America, in which Pollock's Number 1, 1948 was shown in the "Expressionist Biomorphic" category] with drinks—and supper for about two hundred painters in the pent house—and at least five*

thousand down stairs in the gallery—couldn't get any idea of the show, will send a catalogue. Betty [Parsons] was seen in Florida the past ten days. [Clyfford] Still's show opens this Monday—am anxious to see it up—liked some things I saw recently. I was really excited about Dubuffet's show—was prepared not to. Your two canvasses hold with his best. I have been asked to be on a jury in Chicago the 9th and 10th of Feb. which I accepted, something I swore I'd never do. But I think seeing Chicago and the experience might do me good, at any rate I'll try it. We'll drive out, two days going two days there and two days coming back, the show I'm to have there will be mid season next year.

I'm very happy to hear of Peggy's interest in your work, perhaps you will return here via Venice if you have a show there. Have you seen the Matisse Church and design or is that terribly far from Paris? Hans and Falkenberg are still working on the movie. We have seen nothing more of it. . . .

Again Alfonso I am really moved by your sensitivity and thoughtfulness, and of course you and Ted may have first on anything I do. I hope this letter doesn't seem so damned down and out—because I have been making some drawings on Japanese paper—and feel good about them.

> *With love to you both,*
> *Jackson*

The jury on which Pollock had been asked to serve was typical in its diversity. He himself represented the extreme avant-garde; Max Weber, the old Cubist avant-garde, softened now into a more sentimental Expressionism; and James Lechay, then at the University of Iowa, middle-of-the-road Romanticism. The artists to be judged called themselves the "Momentum" group and were in opposition to discriminatory (i.e., anti-abstract) policies of the Art Institute of Chicago. Since the jurying might well have developed into a tense situation and since Jackson was drinking again, he decided it would be best not to make the long trip to Chicago by car. He mentions the trip, among other things, in his next letter to Paris:

> *. . . There is a lot of unrest among the painters in [Betty Parsons'] gallery. I don't know what, if anything, is the solution. P. Matisse didn't put red stars on any of D[ubuffet's] paintings. I met a collector in Chicago [Maurice Culberg] who has seventeen and had just given the Art Institute there one. There is an*

enormous amount of interest and excitement for modern painting there—it's too damned bad Betty doesn't know how to get at it. The jurying was disappointing and depressing—saw nothing original being done—out of 850 pieces we picked 47 and it still wasn't a very good show. I flew out and back alone—and liked it, flying, and also Chicago.... This issue of Vogue has three pages of my painting (with models of course)....

For the balance of the winter and spring, the Pollocks were in and out of New York. They visited their doctors, including a new one to whom Jackson had been recommended, Dr. Ruth Fox, a psychiatrist specializing in alcoholism. He saw her intermittently from March 1951 until June 1952, took part in group therapy sessions and sometimes, but evidently not frequently enough, used Antabuse, a drug which is sickening when one drinks alcohol. She recalls an anxiety-filled dream of Jackson's in which he was on a high structure, possibly a building or a scaffold, and his brothers were trying to push him off. When the break with this doctor occurred it was caused by her "attack" on a chemist who, during the same year, had persuaded Jackson that his problem could be solved by establishing a proper balance of gold and silver in his urine!

In early 1951, there were also several art events which would have brought Pollock to New York, events with which he was involved—or should have been. The first of these (March 16–April 29) falls into that latter category: The 75th Anniversary Exhibition of Painting and Sculpture by 75 Artists Associated with the Art Students League of New York, presented by the Metropolitan Museum of Art. It is startling that in this historical survey—beginning with George Inness, John LaFarge, and Thomas Eakins—there was room for only three artists born in the twentieth century: Isabel Bishop, Peter Blume, and Jon Corbino. Pollock, by now surely the best-known painter of his generation, is included at the back of the catalogue in a "Partial List of Artists Associated with the Art Students League 1871–1951." (The League's next major anniversary show would be called "American Masters from Eakins to Pollock," but that would take place eight years after Pollock's death.)

Hans Namuth's famous photograph of Pollock sitting on the running board of his Model A Ford. It was first used in the February 1952 *Harper's Bazaar* (with a note by Clement Greenberg), and the year after Pollock's death, on the cover of *Evergreen Review* (again with a note by Greenberg).

HANS NAMUTH

Seven action shots and one of a corner of Pollock's studio taken by Namuth during the summer of 1950 when Jackson was at the height of his powers, having just completed such mural-size masterpieces as *One* and *Autumn Rhythm*. These photographs led shortly to the photographer's two motion-picture films of Pollock, the first in black and white, the second in color. The photographer felt that Pollock's working

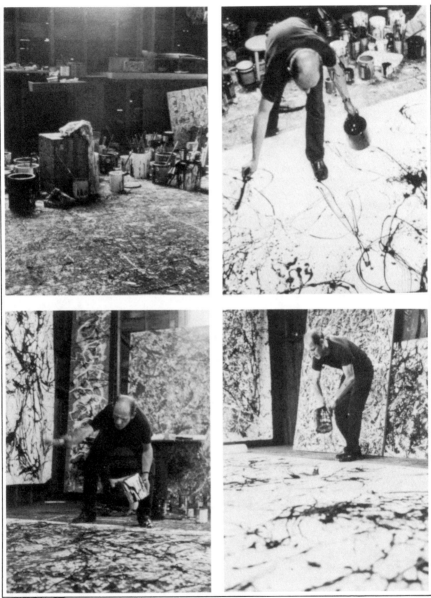

HANS NAMUTH

methods could only be appreciated in motion and color. The color film was completed after Jackson's 1951 show at the Betty Parsons gallery.

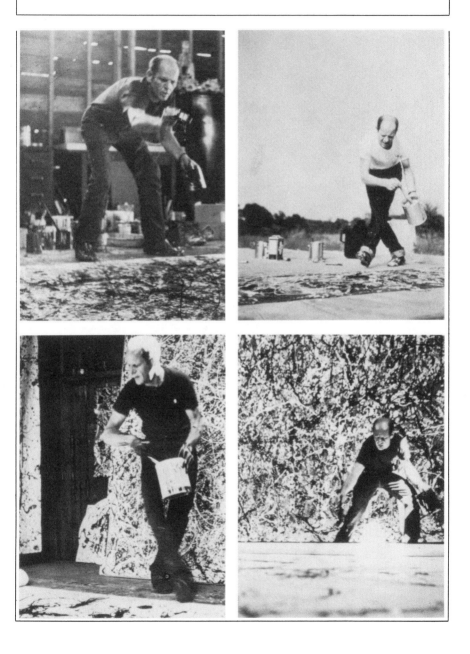

Jackson in front of a section of the approximately nine-by-eighteen-foot *One* (1950). He is studying the gallery register of visitors to this 1951 show, perhaps his greatest. Though many came, few bought. However, the critics were appreciative. *Art News* voted the show "second most outstanding of the year."

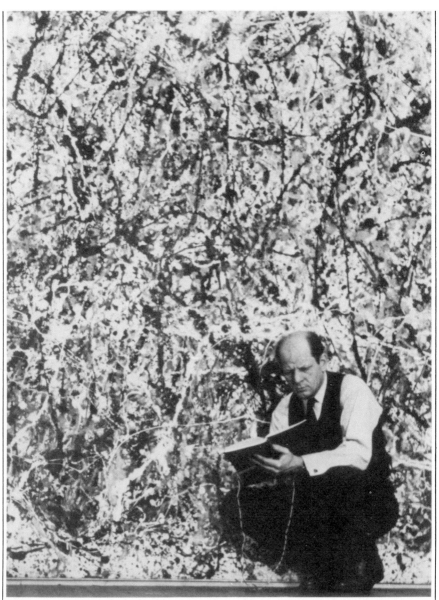

HANS NAMUTH

Lee and Jackson Pollock in a corner of the living room of their Springs house, soon after settling there and before furnishing. Jackson found the old anchor on a nearby beach. The powerful sculptural quality of this man-made object had the same attraction for him as forms found in nature.

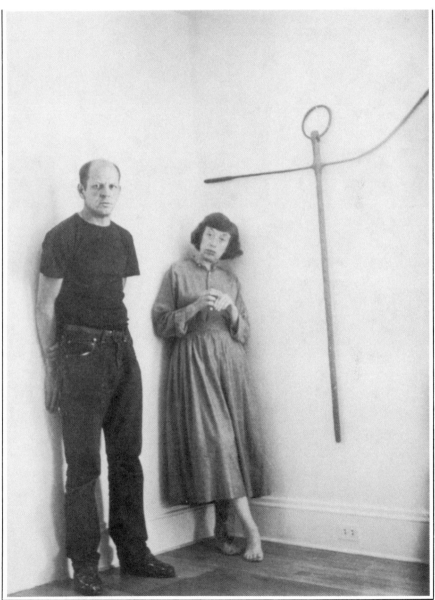

HANS NAMUTH

(Top) Pollock cleaning up after work. (Bottom) Another of Namuth's famous portraits. This one, like several of the others, was widely reproduced, particularly after the artist's death. The dissemination of this image of Pollock was so wide that by 1967 Gudmundur Erro, an Icelandic painter working in Paris,

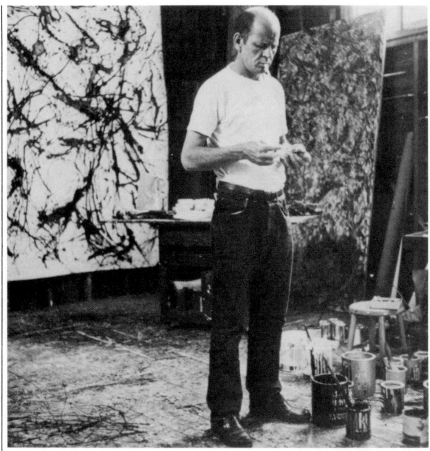

HANS NAMUTH

would make it central to his painting, *The Background of Pollock,* which includes works of Expressionists, Fauves, Cubists, Surrealists—in short, the history of modern art.

(Top, left) Mrs. Stella Pollock with her sons Charles, left, and Jay, right. Behind them, left to right, are Frank, Jackson, and Sandy. (Top, right) Jackson between his friends the painter Barnett Newman and sculptor-architect-lecturer Tony Smith, in front of a Newman painting at Betty Parsons. (Bottom) In the penthouse of the Museum of Modern Art, 1950, left to right: Steichen, D'Harnoncourt, Marin, Ritchie,

JACK CALDERWOOD

Gatch, Frankfurter, De Kooning, and Pollock. (Bottom) "The Irascibles" who protested a show at the Metropolitan Museum in 1950: front row, left to right, Stamos, Ernst, Newman, Brooks, Rothko; middle row, Pousette-Dart, Baziotes, Pollock, Still, Motherwell, Tomlin; back row, De Kooning, Gottlieb, Reinhardt, Sterne.

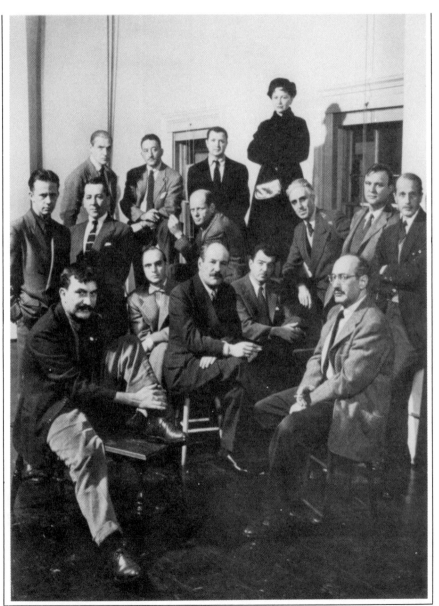

NINA LEEN. LIFE MAGAZINE. ©TIME INC.

(Top, left) Pollock with his friend, the painter James Brooks, in Montauk. (Top, right) With another friend, Daniel T. Miller, who traded groceries for the painting on the wall. In background are Mrs. Pollock and the sculptor Tino Nivola. (Bottom) Pollock meditating outside his studio.

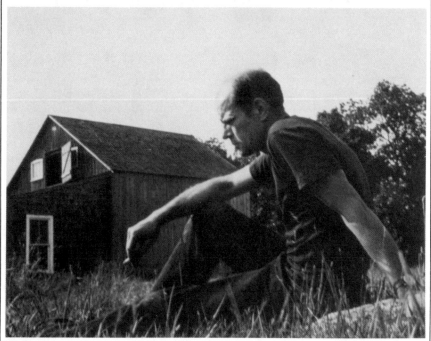

HANS NAMUTH

(Top, left) 1955 passport photo made in Riverhead when Jackson was considering a trip to Europe. He never went. (Top, right) In the same year, with his dogs Gyp and Ahab. (Bottom) Jackson alongside *Search,* which is generally believed to be his last painting.

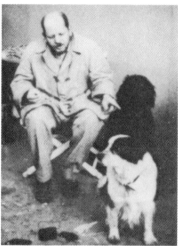

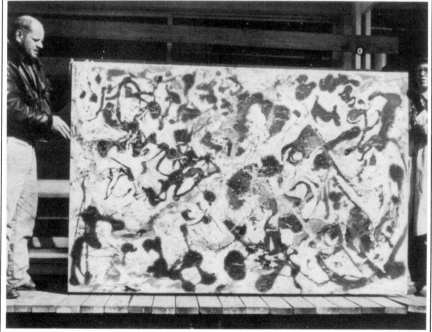

HANS NAMUTH

(Top) In the Pollock living room, Lee and Jackson have their backs to the camera as they face their friends, the painter John Little, flanked by the Petersens. Lee made the mosaic table and the "hieroglyph" painting on the right wall, Jackson the vertical on the left. (Bottom) A typical night at the Cedar Tavern, and the sign which hung outside.

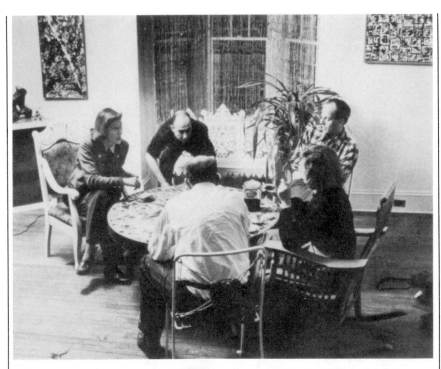

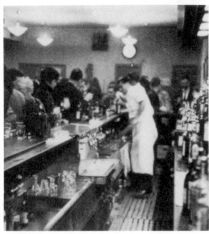

FRED W. McDARRAH

DUDLEY GRAY

Jackson, in front of a self-portrait portion of his 1953 painting *Portrait and a Dream.* About his work of this period (his last nonretrospective exhibition) Robert Coates wrote, "his 'dribble' technique... is generally used with more formal, compositional purpose, or as a background motif, instead of as an end in itself."

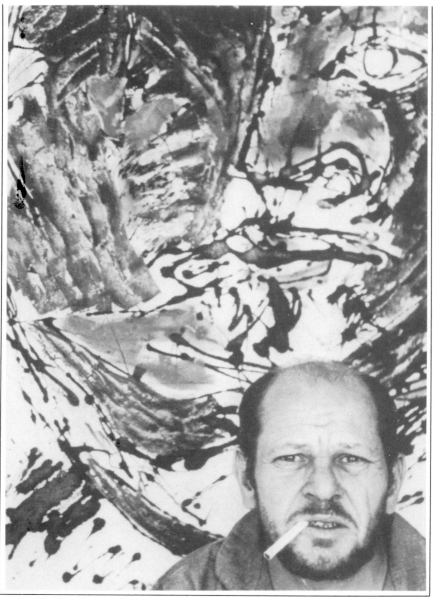

HANS NAMUTH

Pollock was the subject of much satire, both during his life and after his death. This 1957 cartoon is by Whitney Darrow, Jr., who was a classmate and close friend of his at the Art Students League. They made a "sketching trip" to the West Coast in the summer of 1932.

"Is it all right to sneer at these now?"

DRAWING BY WHITNEY DARROW, JR.: © 1959 THE NEW YORKER MAGAZINE. INC.

Pollock, heavy and depressed, shortly before his death in an automobile accident, August 11, 1956. His friend the painter Conrad Marca-Relli speaks of the spotlight that by that time had been on Jackson for so long, "a light as cruel as that in which a rabbit freezes."

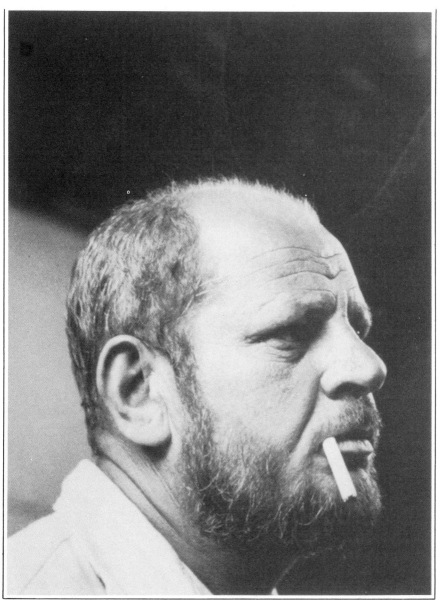

HANS NAMUTH

Pollock's grave at the Green River Cemetery in Springs. Beside it stands Nicholas Carone, one of his many friends and neighbors. Others buried here include: Stuart Davis, Wilfred Zogbaum, Frank O'Hara, Frederick Kiesler, A. J. Liebling, George Cooke, Ad Reinhardt, and Judy Heller—all friends and/or colleagues of the artist.

HANS NAMUTH

Number 3, 1951 (Image of Man)

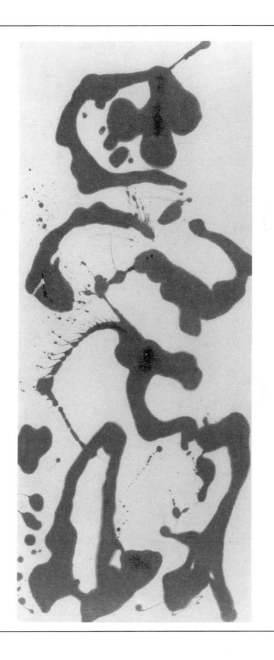

The Guardians of the Secret (1943)

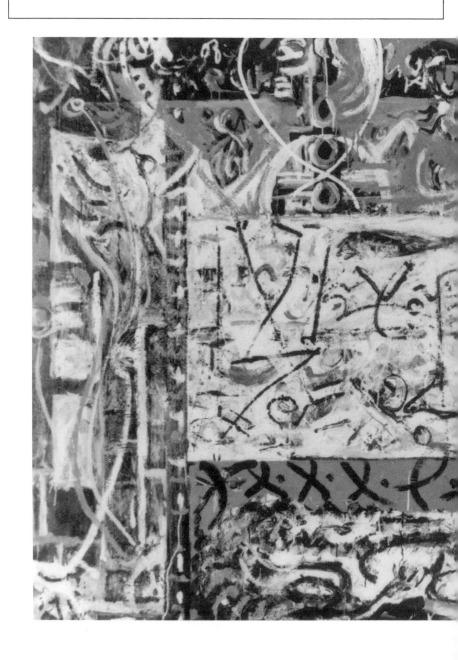

The She-Wolf (1943)

Lucifer (1947)

Number 14, 1948: Gray

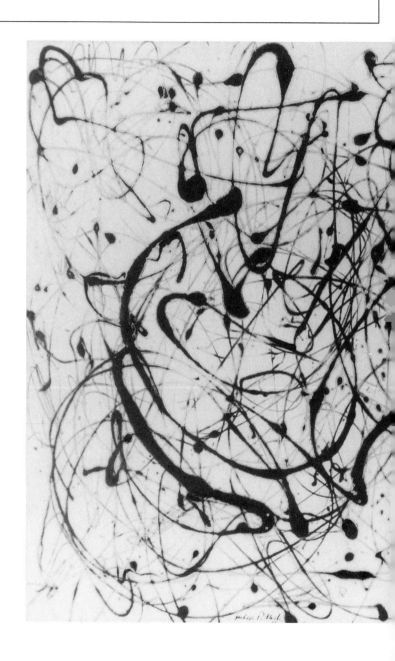

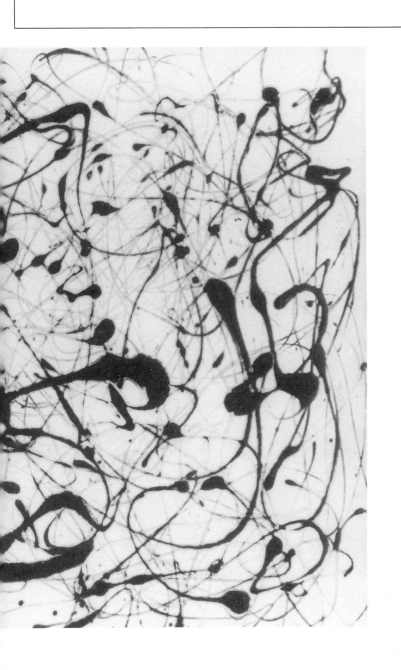

Number 8 (1949)

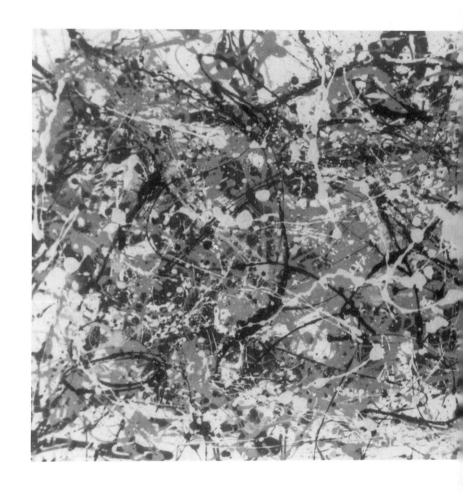

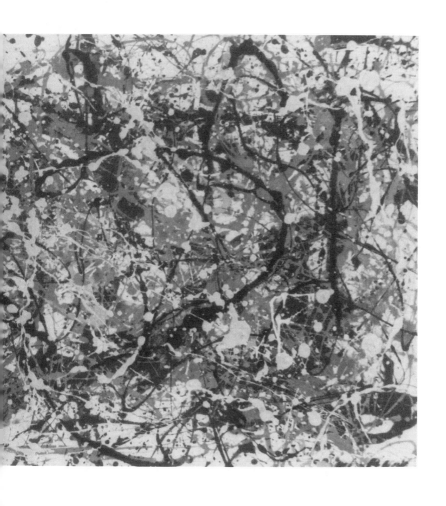

Convergence: Number 10, 1952

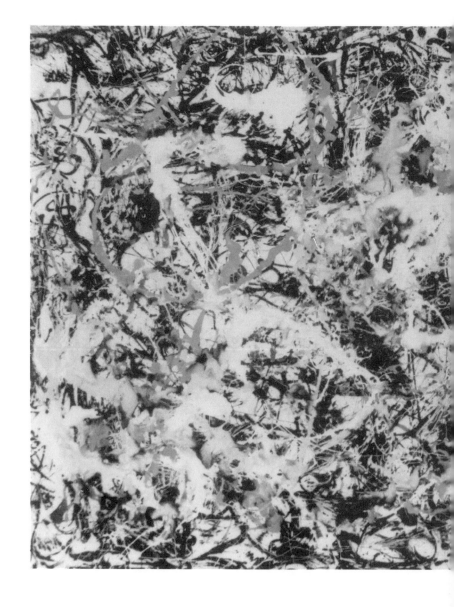

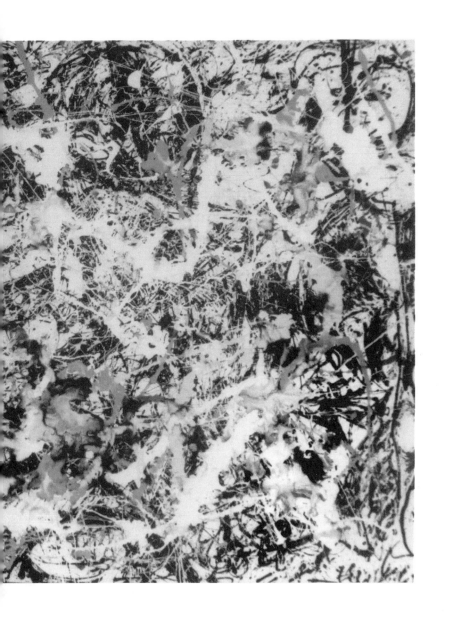

Search (1955)

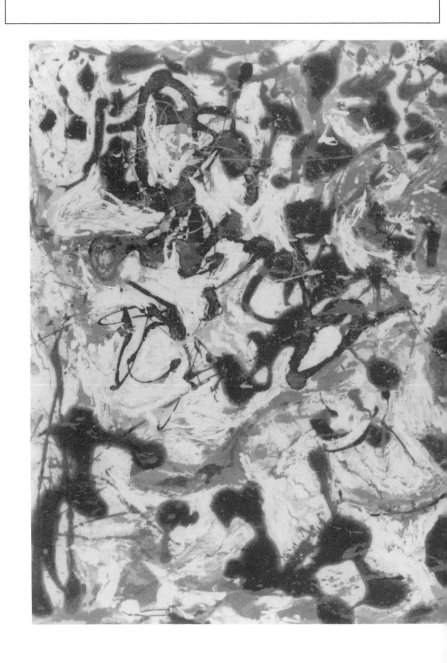

On St. Patrick's day, the day after the opening at the Metropolitan, there was one for a Whitney Annual which included Pollock's watercolor *Number 1, 1951*. And ten days later was the Peridot Gallery's "Sculpture by Painters." For this Pollock had made an untitled work in papier-mâché by covering chicken wire with some of those "drawings on Japanese paper" about which he had written to Ossorio in late January. The piece, approximately five feet long, was mounted on a door, flat on the floor. Judging only from photographs of it in the gallery, it had the raw powerful presence of an animal carcass and indeed suggested a Rembrandt side of beef. (The sculpture itself was later deliberately left outside in Springs to see if it could withstand the weather. It couldn't.) And finally, there was the famous 9th Street Show (May 21–June 10)—organized by members of The Club (most notably Franz Kline, who designed the announcement) and chosen and installed by Leo Castelli—in which Pollock's *Number 1, 1949* hung with the work of sixty other American artists.

Also early in 1951, Falkenberg was editing the film. As soon as that was completed, the composer Morton Feldman was called in to see it. He says, "I watched the film, got the exact span of time for each of the sequences—the shots of the studio and the Springs property, the painting on canvas, the two on glass—and then wrote the score as if I were writing music for choreography." For the soundtrack Daniel Stern played the two cello parts in Feldman's composition, and Pollock nervously read his statements.

Away from New York other things were happening, and reports were coming in: a selection of nineteen works by Pollock from Peggy Guggenheim's collection of "Surrealism and Abstraction" was shown at the Stedelijk Museum in January and February, at the Brussels Palais des Beaux-Arts in March, and at the Zurich Kunsthaus from mid-April to mid-May; two paintings were in the Third Tokyo Independent Art Exhibition (February 27–March 18); and one was shown through most of March in Véhémences Confrontées, a Paris exhibition at Galerie Nina

Dausset ("For the first time in France the confrontation of the most advanced American [besides Pollock, only de Kooning], Italian and French painters of today presented by Michel Tapié").

Thus far in 1951 Pollock's impulse had been toward drawing—mostly on paper—but by early June, as he wrote in yet another letter to Paris, he was drawing on canvas:

June 7, 1951

Dear Alfonso and Ted,

It's really great to be back in Springs. Lee is doing some of her best painting—it has a freshness and bigness that she didn't get before—I think she will have a handsome show. I've had a period of drawing on canvas in black—with some of my early images coming thru—think the nonobjectivists will find them disturbing—and the kids who think it simple to splash a Pollock out. Joe Glasco I think really liked them. He asked Viviano if she thought Matisse would handle me. She definitely thought he would—(but that I might be better off in her gallery)—I don't intend asking him and anyway his real interest is in his French painters. Have a letter (yesterday) from the Associated American Artists Gallery—do you know it?—asking me to come in and talk with them— Will see him (Reeves Lewenthal) Monday. His gallery is a kind of department store of painting (most of it junk) but they do a terrific business. I suppose the best thing for me is to stick with Betty another year. Tony Smith suggested I make the drawings I've made into a portfolio of prints—either lithographs or silk screen—I may try a couple to see how they look. Tony has done some exciting houses. He is doing a studio for Stamos in Greenport—that is on the south shore. We see the film at the Museum of Modern Art next Thursday— everyone in New York city has been asked (if they come). I'm anxious to see it and hear the music young Feldman (a friend of John Cage's) has done— think it might be great—I speak in the movie which I'm not too happy about. We shall see.

Haven't heard anything on the summer art activity here yet—I have a show in Maryland (close to Washington D.C.) this month [June 26–July 8, Hilltop Theater Art Room, Lutherville, Md., twelve works from between 1948 and 1951]—(means nothing)—The show at the Chicago Arts Club has been set for next October [at which Pollock would show seven paintings along with

selections of work by Ben Shahn and Willem de Kooning]—it is a new gallery designed by Mies—van der Rohe—I think there might be some good reaction to my stuff out there....

This is the only one of his six letters written to Ossorio and Dragon in 1950 and 1951 which is actually dated (rather than dated from internal evidence). Note also that Pollock wrote to Ossorio only during this period and once again (March 30, 1952) when Ossorio was in Paris. Writing was always a great effort for Pollock. In the remaining years of his life, when he was able to afford it, he used the phone for almost all social and professional communication that couldn't be handled in person.

Neither in this letter to Ossorio and Dragon, nor in his next (in early August) does Pollock mention an exhibition of American art to be shown in West Berlin in September where he would have two paintings or the first biennial in São Paolo where he would have one. Most likely he did not yet know anything of these events, handled in an institutional way by the American Federation of Arts and the Museum of Modern Art, respectively. The details of his career were proliferating now at a rate he couldn't keep up with.

A long interview with Pollock was done at about this time for station WERI in Westerly, R.I., by William Wright, who lived across the road from Pollock:*

"Modern art . . . is nothing more than the expression of contemporary aims. . . . All cultures have had means and techniques of expressing their immediate aims—the Chinese, the Renaissance, all cultures. The thing that interests me is that today painters do not have to go to a subject matter outside of themselves. Most modern painters work from a different source. They work from within.

* The tape has never been heard publicly since the Westerly broadcast in 1951, though it may be used in connection with a reediting of the Namuth–Falkenberg black-and-white and color films of Pollock. Excerpts were published in *Art in America* (August–September 1965) and both sides of the entire interview in an appendix to the O'Connor chronology.

". . . new needs need new techniques. And the modern artists have found new ways and new means of making their statements. It seems to me that the modern painter cannot express this age, the airplane, the atom bomb, the radio, in the old forms of the Renaissance or of any other past culture. Each age finds its own technique . . . the strangeness will wear off and I think we will discover the deeper meanings in modern art. . . . [Laymen looking at a Pollock or other modern painting] should not look *for,* but look passively—and try to receive what the painting has to offer and not bring a subject matter or preconceived idea of what they are to be looking for. . . . The unconscious is a very important side of modern art and I think the unconscious drives do mean a lot in looking at paintings. . . . [Abstract art] should be enjoyed just as music is enjoyed —after a while you may like it or you may not. . . . I like some flowers and others, other flowers I don't like. . . . I think at least give it a chance.

". . . the modern artist is living in a mechanical age and we have . . . mechanical means of representing objects in nature such as the camera and photograph. The modern artist, it seems to me, is working and expressing an inner world—in other words, expressing the energy, the motion, and other inner forces . . . the modern artist is working with space and time, and expressing his feelings rather than illustrating. . . . [Modern art] didn't drop out of the blue; it's part of a long tradition dating back with Cézanne, up through the Cubists, the post-Cubists, to the painting being done today. . . . Well, method is, it seems to me, a natural growth out of a need, and from a need the modern artist has found new ways of expressing the world about him. I happen to find ways that are different from the usual techniques of painting, which seems a little strange at the moment, but I don't think there's anything very different about it. I paint on the floor and this isn't unusual—the Orientals did that. . . .

"Most of the paint I use is a liquid, flowing kind of paint. The brushes I use are used more as sticks rather than brushes—the brush doesn't touch the surface of the canvas, it's just above. . . . I'm able to be more free and to have greater freedom and move about the canvas with

greater ease . . . with experience it seems to be possible to control the flow of the paint to a great extent, and I don't use . . . the accident. . . . I deny the accident.

"[A preconceived image] hasn't been created. . . . Something new—it's quite different from working, say, from a still life where you set up objects and work directly from them. I do have a general notion of what I'm about and what the results will be. . . . I approach painting in the same sense as one approaches drawing—that is, it's direct. I don't work from drawings, I don't make sketches and drawings and color sketches into a final painting. Painting, I think, today—the more immediate, the more direct, the greater the possibilities of making . . . a statement.

". . . painting today certainly seems very vibrant, very alive, very exciting. Five or six of my contemporaries around New York are doing very vital work, and the direction that painting seems to be taking here is away from the easel, into some sort, some kind of wall—wall painting. . . . [Some of my canvasses are] an impractical size—9 × 18 feet. But I enjoy working big and, whenever I have a chance, I do it whether it's practical or not. . . . I'm just more at ease in a big area than I am on something 2 × 2. I feel more at home in a big area. . . . I do step into the canvas occasionally—that is, working from the four sides I don't have to get into the canvas too much.

". . . the first thing I've done on glass . . . I find it very exciting. I think the possibilities of using painting on glass in modern architecture—in modern construction—terrific. . . . In this particular piece I've used colored glass sheets and plaster [lath] and beach stones and odds and ends of that sort. Generally it's pretty much the same as all of my paintings. . . . The possibilities . . . are endless, what one can do with glass. It seems to me a medium that's very much related to contemporary painting . . . the result is the thing, and it doesn't make much difference how the paint is put on as long as something has been said. Technique is just a means of arriving at a statement."

Much of the material in this interview—the single longest series of

statements we have by Pollock—is compressed in a handwritten note, found in the artist's files, undated but possibly also from about this time:

Technic is the result of a need——————
new needs demand new technics——————————
total control——————denial of
the accident——————————
states of order——————
organic intensity——————
energy and motion
made visible——————————
memories arrested in space,
human needs and motives——————————
acceptance——————

And the ideas in this highly compressed statement may have influenced part of the catalogue introduction (quoted later in this chapter) which Ossorio was to do for Pollock's forthcoming show.

In August Pollock wrote Ossorio and Dragon:

Dear Alfonso & Ted—I get quite a different picture of Tapié's gallery [Studio Paul Facchetti, at which Ossorio will arrange for an exhibition of Pollock's work]—I think I would rather wait until you get back here and advise me on what to send—I'll need a lot of painting here for the two shows (Chicago and N.Y.). Betty sailed last Sat. Aug 4. She has probably written you. As usual there was no time to plan or discuss things. The mural (A[ssociated] A[merican] A[rtists]) isn't definitely out—but is a matter of waiting (how long I don't know) and it involves other things and people too damned involved to try and explain in a letter. Tell Betty I suggest she talk to you about it. . . . We showed the movie out here (clipping enclosed) the reaction was mixed—am anxious for you to see it. I think the house idea had better wait until you are here— Then we can see what is available and at what price. Happy [Macy] said last night that the place across from the one you had was now for sale (Ted got flowers there) and that it is in excellent condition. There are probably many such places but you have to see them. This has been a very quiet summer— no parties, hardly any beach—and a lot of work. Until later—

Love to you both,
Jackson

The place Ossorio had had was the Helmuth house, which he rented during the summer of 1949. To give some idea of the accelerating infiltration of East Hampton by the art world, after Ossorio's rental the house was sold to the art dealer Leo Castelli; shared by him and his wife with the de Koonings; and, finally, rented and then sold to the collector Ben Heller, who still owns it. Very soon after writing, Pollock must have phoned or wired Ossorio that Mrs. Macy had discovered that The Creeks, a sixty-acre showplace on Georgica Pond, was being offered for sale by the estate of the painter Albert Herter. Ossorio had seen this property in 1949. He remembered it well. It was not one of "many such places"; it was unique. Before the end of August he flew over to contract for its purchase.

For about five years Lee Pollock had been working in the cramped bedroom studio, making mostly those tense little paintings which read like hieroglyphics, or cuneiform, or some other ancient and mysterious writing. Though there are works of this period which have a less geometrically organized web or skein, all are heavily painted, with color absent or subdued and the image small and overall. By 1950 she began to break through these self-imposed conventions and was using thin paint, more color, and a different kind of tension, developed between vertical and horizontal space rather than between organic form and geometric or Cubist grid. She must have felt a great sense of liberation and, with Jackson's encouragement, a strong desire to show her new paintings and to forget those of the five years leading up to them. It is one of the ironies of her career that the fully realized small-image paintings were never shown, except for isolated examples in later group exhibitions. Instead, her first one-person show (Betty Parsons Gallery, October 15 – November 13, 1951) consisted only of transitional breakthrough work having, as Jackson wrote, "a freshness and bigness that she didn't get before," but nevertheless lacking the authority of work done both earlier and later. Betty Parsons remembers* that Jackson "telephoned me and

* See Bibliography No. 172.

asked me to give her a show.... I said I never showed husbands and wives, but he insisted. He was charming with Lee when he was sober; she ruled the nest. But when he was drunk, *he* ruled the nest. Lee always protected his business interests. Business ideas bored him, though he was fairly wise about them."

The tender tone of Betty Parsons' reminiscence is sustained throughout an interview done some sixteen years after Lee Krasner's only show at her gallery and what turned out to be Pollock's last. Thus, her tenderness is even more remarkable, considering that when recorded she spoke as Pollock's rejected dealer:

> *I loved his looks. There was a vitality, an enormous physical presence. He was of medium height, but he looked taller. You could not forget his face. A very attractive man—oh very.*
>
> *He was always sad. He made you feel sad; even when he was happy, he made you feel like crying. There was a depression about him; there was something desperate. When he wasn't drinking, he was shy; he could hardly speak. And when he was drinking, he wanted to fight. He cursed a lot, used every four-letter word in the book. You felt he wanted to hit you; I would run away.*
>
> *His whole rhythm was either sensitive or very wild. You never quite knew whether he was going to kiss your hand or throw something at you. The first time I went out to see him at Springs, Barney [Newman, whom the Pollocks then met for the first time] brought me; we were planning Jack's first show. After dinner we all sat on the floor, drawing with some Japanese pens. He broke three pens in a row. His first drawings were sensitive, then he went wild. He became hostile, you know. Next morning he was absolutely fine.*
>
> *I had met him around New York since 1945. One day in '47 he telephoned me and said he wanted a show in my gallery. I gave him a show the next season. In all the time he was with me he was never drunk either during the show or during the hanging. At Sidney Janis' [Pollock's next dealer] it was different; once they waited for him until four in the morning to hang a show....*
>
> *He was either bored, or terrified of society. He thought most women were terrible bores. He needed aggressive women to break through his shyness. He liked very few artists. He liked Barney Newman, Tony Smith, Franz Kline,*

Alfonso Ossorio, and Bradley Tomlin. He thought artists were either awful or terrible—it had entirely to do with their work.

He thought he was the greatest painter ever, but at the same time he wondered. Painting was what he had to do. But he had a lot of the negative in him. He was apt to say, "It didn't work—it'll never work." When he got in those terrible negative states he would drink.

He associated the female with the negative principal. The conflict showed clearly in The She Wolf *(1943). Inside himself was a jungle, some kind of jungle, because during his life he was never fulfilled—never—in anything. Of course, this didn't diminish his power as a painter. His conflicts were all in his life, not in his work.*

He was a questioning man. He would ask endless questions. He wanted to know what I thought about the world, about life. He thought I was such a jaded creature because I'd traveled; he wanted to know what the outside world was like—Europe, Asia. He was also intrigued with the inner world—what is it all about? He had a sense of mystery. His religiousness was in those terms—a sense of the rhythm of the universe, of the big order—like the Oriental philosophies. He sensed rhythm rather than order, like the Orientals rather than the Westerners. He had Indian friends, a dancer and his wife [the Vashtis], with whom he talked at length and who influenced him greatly.

His most passionate interest after painting was baseball. He adored baseball and talked about it often. He also loved poetry and meeting poets. He often talked about Joyce. He loved architecture and talked a lot about that too. He adored animals; he had two dogs and a crow—he had tamed the old crow. He had that kind of overall feeling about nature—about the cosmic—the power of it all—how scary it is.

I could never relax with Jack. He certainly was pursued by devils.

Life is an endless question mark, but most of us find a resolution. He never did. But I loved him dearly. The thing about Pollock is that he was completely unmotivated—he was absolutely pure.

We may disagree with some of these statements. Was Jackson's first show prompted only by a phone call from him? Was Lee's? How close was he to the Vashtis? How passionate about baseball?—yet all in all it rings emotionally, if not always factually, accurate. This is the complex and tortured man who is now working on his black-and-white show,

surprising not only in the lack, the seeming denial of color but in the several examples of a return to figurative work. It was not so surprising to his wife who says* she

had one advantage that very few others had— I was familiar with his notebooks and drawings, a great body of work that most people didn't see until years later, after Jackson's death. I'm not talking about drawings he did as a student of Benton, but just after that, when he began to break free, about in the midthirties. For me, all of Jackson's work grows from the thirties; I see no more sharp breaks, but rather a continuing development of the same themes and obsessions. The 1951 show seemed like monumental drawing, or maybe painting with the immediacy of drawing—some new category.... There's one other advantage I had: I saw his paintings evolve. Many of them, many of the most abstract began with more or less recognizable imagery—heads, parts of the body, fantastic creatures. Once I asked Jackson why he didn't stop the painting when a given image was exposed. He said, "I choose to veil the imagery." Well, that was that painting. With the black and whites he chose mostly to expose the imagery. I can't say why. I wonder if he could have.

Q: Then do you consider these paintings more "naked" than his earlier work?

A: No, no more naked than some of those early drawings—or paintings like Male and Female *or* Easter and the Totem. *They come out of the same subconscious, the same man's eroticism, joy, pain.... Some of the black-and-whites are very open, ecstatic, lyrical; others are more closed and hidden, dark, even oppressive, just as with the paintings in color.*

Q: In the 1950 show there seems to have been something like a primitive horror vacui: *the entire canvas, or nearly all, needing to be filled—except for* Number 32. *In that painting, as in the 1951 black-and-whites, there's an acceptance of empty space, negative space, the void. The voids read positively. Do you think the 1951 show came out of that one monumental black-and-white in the '50 show?*

A: After the '50 show, what do you do next? He couldn't have gone further doing the same thing.

Q: Pollock spoke about liking the resistance of the hard surface of the floor when he painted. Perhaps, in a sense, limiting himself to black and white may have been another form of self-imposed resistance?

* See Bibilography No. 264.

A: *I haven't a clue to what swung him exclusively into black-and-white at that point—besides the drawings, he did some black-and-white paintings of considerable size earlier—but it was certainly a fully conscious decision. There were no external causes, no shortage of color or anything like that.*

Q: *He very much admired* Guernica *and the studies for it. Was he still responding to that, reacting to it?*

A: *If so, it was an awfully slow burn—say, fifteen years. But there's no question that he admired Picasso and at the same time competed with him, wanted to go past him. Even before we lived in East Hampton, I remember one time hearing something fall and then Jackson yelling, "God damn it"—or maybe something stronger—"that guy missed nothing!" I went to see what had happened. Jackson was sitting staring; and on the floor, where he had thrown it, was a book of Picasso's work.... Jackson experienced extremes of insecurity and confidence. You only have to see the film of him making his painting on glass to know how sure he was of himself: the way he wipes out the first start and begins over. But there were other times when he was just as unsure. A little later, in front of a very good painting—not a black-and-white—he asked me, "Is this a painting?" Not is this a good painting, or a bad one, but a painting! The degree of doubt was unbelievable at times. And then, again, at other times he knew the painter he was. It's no wonder he had doubts. At the opening of the black-and-white show one of the New York dealers, supposedly in the know, told him, "Good show, Jackson, but could you do it in color?" A few weeks later another dealer said—to me this time: "It's all right, we've accepted it." The arrogance, the blindness was killing. And, as you see, not only from the outside world, but the art world itself.*

Q: *What about the imagery? Did Pollock ever talk about it?*

A: *I only heard him do that once. Lillian Kiesler and Alice Hodges were visiting and we were looking at* Portrait and a Dream [*a diptych of 1953, in which the left panel is black-and-white, abstractly suggestive of two anthropomorphic figures, and the right—gray, orange, and yellow—is clearly a man's head, probably a self-portrait*]. *In response to their questions, Jackson talked for a long time about the left section. He spoke freely and brilliantly. I wish I had had a tape-recorder. The only thing I remember was that he described the upper right-hand corner of the left panel as "the dark side of the moon."*

Q: *Several writers have connected some black-and-white paintings—and some colored ones too—with the feel of the East Hampton landscape, particularly in winter: the look of bare trees against the sky and flat land moving out toward sea.*

A: *Jackson was pretty explicit about that in the* Arts and Architecture *questionnaire. Then [1944] he emphasized the West, but by the time of the black-and-white show, after living in Springs for six years, I think he would have given just as much emphasis to this Eastern Long Island landscape—and seascape. They were part of his consciousness: the horizontality he speaks of, and the sense of endless space, and the freedom.... The only time I heard him use the word "landscape" in connection with his own work was one morning before going to the studio, when he said, "I saw a landscape the likes of which no human being could have seen."*

Q: *A visionary landscape?*

A: *Yes, but in Jackson's case I feel that what the world calls "visionary" and "real" were not as separated as for most people.*

Q: *...How were these paintings made? What was the physical procedure?*

A: *...Jackson used rolls of cotton duck, just as he had intermittently since the early forties. All of the major black-and-white paintings were on unprimed duck. He would order remnants, bolts of canvas anywhere from five to nine feet high, having maybe fifty or a hundred yards left on them—commercial duck, used for ships and upholstery—from John Boyle down on Duane St. He'd roll a stretch of this out on the studio floor, maybe twenty feet, so the weight of the canvas would hold it down—it didn't have to be tacked. Then typically he'd size it with a coat or two of Rivit glue to preserve the canvas and give it a harder surface. Or sometimes, with the black-and-white paintings, he would size them after they were completed, to seal them. The Rivit came from Behlen and Brother on Christopher St. Like Boyle, it's not an art-supplier. The paint Jackson used for the black-and-whites was commercial too—mostly black industrial enamel, Duco or Davoe & Reynolds. There was some brown in a couple of the paintings. But this "palette" was typically a can or two of the black —thinned to the consistency he wanted—standing on the floor beside the rolled-out canvas. Then, using sticks, and hardened or worn-out brushes (which were, in effect, like sticks) and basting syringes, he'd begin. His control was amazing. Using a stick was difficult enough, but the basting syringe was like a giant fountain pen. With it he had to control the flow of paint, as well as his gesture. He used to buy those syringes by the dozen at the hardware store.... With the larger black-and-whites he'd either finish one and cut it off the roll of canvas, or cut it off in advance and then work on it. But with the smaller ones he'd often do several on a large strip of canvas and then cut that strip from the roll to study it on the wall and make more working space. Sometimes he'd ask, "Should I cut it here? Should this be the bottom?" He'd have long sessions of cutting*

and editing, some of which I was in on, but the final decisions were always his. Working around the canvas—in "the arena" as he called it—there was really no absolute top or bottom. And leaving space between paintings, there was no absolute "frame" the way there is working on a pre-stretched canvas. Those were difficult sessions. His signing the canvases was even worse. I'd think everything was settled—tops, bottoms—and then he'd have last-minute thoughts and doubts. He hated signing. There's something so final about a signature.... Sometimes, as you know, he'd decide to treat two or more successive panels as one painting—as a diptych, or triptych, or whatever. Portrait and a Dream, though a little later, is a good example. And, do you know, the same dealer who told me Jackson's black-and-whites were accepted, asked him then, two years later, why he didn't cut Portrait and a Dream in half!

From mid-October, when Lee's show opened at Parsons, until just before the end of the year, the Pollocks were seldom in Springs, mostly in New York, and once or twice briefly in Deep River, Connecticut. It was a hectic, pressured, difficult stretch of time. Her show was perhaps a bad omen. It was poorly received, and nothing sold. Betty Parsons felt Lee's disappointment, and Jackson's too. Knowing that on top of this he was not satisfied with the way his own work had been selling and that there was a good chance he would leave her gallery at the end of the year when his contract expired, she did what she could to make his show a success. She had recently, and continued now, to go along with Jackson's suggestions and those of his friends. First, there had been his desire for a catalogue, something he had never had for any of the selections of his work shown in America. Alfonso Ossorio, whose own show was hung right after Lee's came down and before Jackson's went up, had written an appreciation of Pollock after seeing his new work during a brief visit to East Hampton in August. Originally Ossorio thought of it as a possible catalogue introduction for the Pollock show he was arranging in Paris. But could it be used now? Yes. Tony Smith had suggested a portfolio of black-and-white prints. What about that? Yes, that too, after Betty Parsons got Alexander Bing to provide $400 for printing. And if Jackson wanted his brother Sanford to do the silk-screening in Connecticut? Yes.

Like Lee Krasner's, Alfonso Ossorio's show was transitional and

rather poorly received: another bad omen. In Ossorio's work the influences of Surrealism, Pollock, and Dubuffet had been well assimilated, but he had not as yet produced the completely personal imagery of his maturity. The introduction to the Pollock catalogue is as much a description of Ossorio's searchings at mid-career as it is of Pollock's findings at the zenith of his:

> *These paintings are another assertion of the unity of concept that underlies the work of Jackson Pollock. Through the work that he has already done and through these more recognizable images there flows the same unifying spirit that fuses together the production of any major painter; the singleness and depth of Pollock's vision makes unimportant such current antithesis as "figurative" and "non-representational." The attention focused on his immediate qualities—the unconventional materials and method of working, the scale and immediate splendor of much of his work—has left largely untouched the forces that compel him to work in the manner that he does. Why the tension and complexity of line, the violently interwoven movement so closely knit as almost to induce the static quality of perpetual motion, the careful preservation of the picture's surface plane linked with an intricately rich interplay upon the canvas, the rupture with traditional compositional devices that produces, momentarily, the sense that the picture could be continued indefinitely in any direction?*
>
> *His painting confronts us with a visual concept organically evolved from a belief in the unity that underlies the phenomena among which we live. Void and solid, human action and inertia, are metamorphosed and refined into the energy that sustains them and is their common denominator. An ocean's tides and a personal nightmare, the bursting of a bubble and the communal clamor for a victim are as inextricably meshed in the coruscation and darkness of his work as they are in actuality. His forms and textures germinate, climax, and decline, coalesce and dissolve across the canvas. The picture surface, with no depth of recognizable space or sequence of known time, gives us the never ending present. We are presented with a visualization of that remorseless consolation—in the end is the beginning.*
>
> *New visions demand new techniques: Pollock's use of unexpected materials and scales are the direct result of his concepts and of the organic intensity with which he works, an intensity that involves, in its complete identification of the artist with his work, a denial of the accident....*

Pollock's show contained sixteen oil paintings and five watercolors and drawings, all done in 1951. In addition, *Number 2, 1951* was hanging at the new Whitney Annual which had opened November 8. Of all these, not one of the very large works sold, only a few of the smaller ones did, and even the portfolio—at $200 for a signed edition of six prints, each limited to twenty-five copies—was bought by but a few collectors. It is no wonder that Greenberg would write in "Feeling Is All," the "Art Chronicle" in the January–February 1952 *Partisan Review:*

> *Jackson Pollock's problem is never authenticity, but that of finding his means and bending it as far as possible toward the literalness of his emotion. Sometimes he overpowers the means but he rarely succumbs to it. His most recent show, at Parsons', reveals a turn but not a sharp change of direction; there is a kind of relaxation, but the outcome is a newer and loftier triumph. . . . Now he volatilizes in order to say something different from what he had to say during the four years before, when he strove for corporeality and laid his paint on thick and metallic. What counts, however, is not that he has different things to say in different ways, but that he has a lot to say.*
>
> *Contrary to the impression of some of his friends, this writer does not take Pollock's art uncritically. I have at times pointed out what I believe are some of its shortcomings—notably, in respect to color. But the weight of the evidence still convinces me—after this last show more than ever—that Pollock is in a class by himself. . . . If Pollock were a Frenchman, I feel sure that there would be no need by now to call attention to my own objectivity in praising him; people would already be calling him "maître" and speculating in his pictures. Here in this country the museum directors, the collectors, and the newspaper critics will go on for a long time—out of fear if not out of incompetence—refusing to believe that we have at last produced the best painter of a whole generation; and they will go on believing everything but their own eyes.**

For the February 1952 *Harper's Bazaar* Greenberg did a more "popular" note on Pollock's recent paintings—three of which were reproduced, much too small, down the left margin of the page. However, on the entire facing page, overpowering the cramped illustrations and

* See also the revised version of this review in Bibliography No. 26, pp. 152–153.

brief text, appeared a Namuth photograph of Pollock, probably taken the previous summer. In it Pollock sits pensively on the running board of his battered Model A Ford, looking downward or inward, but not at the camera. There is a sense of exhausted relaxation, of his having just finished work, conveyed not only by paint-spattered dungaree suit and loafers but by the solid weight of head, shoulders, and hands centered over feet, the inevitable cigarette barely held, seemingly forgotten between his fingers. Like the earlier *Life* photographs, it is one of the images of Pollock that grips our minds as forcefully as his paintings.

Besides the two pieces by Greenberg, other critics, even if powerless to help sales, were enthusiastic too. Howard Devree of the *Times,* the painter Fairfield Porter writing for *Art News,* and James Fitzsimmons in *Art Digest* were all pleased by the direction in which Pollock was moving —away from what they called a "dead end" or "blind alley."

Less than two weeks after the black-and-white show closed, one of the paintings in it, *Number 9*—along with another of two years earlier bearing the same number—had been moved to the Sidney Janis Gallery at the other end of the fifth floor. There Janis, once again with the help of Leo Castelli, was presenting an "American Vanguard Art for Paris Exhibition," a group of paintings which would be shown at Galerie de France from the end of February through mid-March. The list of artists in this exhibition is slightly heterogeneous: Albers, Baziotes, Brooks, de Kooning, Goodnough, Gorky, Gottlieb, Guston, Hofmann, Kline, Matta, MacIver, Motherwell, Russell, Reinhardt, Tobey, Tomlin, Tworkov, Vicente. Yet one can read much of the list as threads in Pollock's biography, as friendships and associations going back as far as Manual Arts High School in Los Angeles, moving through the Project, Art of This Century, Springs, the Cedar, threads moving forward and backward, in and out, touching and separating and touching again, until this moment on the threshold of the Janis Gallery.

On January 3, 1952 the East Hampton *Star* devoted most of a column to Alfonso Ossorio's purchase of and actual taking title to The

Creeks, where by summer his important Pollocks, Dubuffets, Stills, and more than a thousand pieces of L'Art Brut—the Raw Art, collected by Dubuffet, of self-taught artists, often institutionalized or imprisoned— would be installed along with a more modest sampling of his own work, three small de Kooning *Women* on paper, and examples of paintings by Lee Krasner, Wols, and Fautrier. Alongside the story of the purchase was a smaller item:

JACKSON POLLOCK, ARTIST,
WRECKS CAR, ESCAPES INJURY
NO HOLIDAY FATALITIES

Village and Town police report a fairly quiet weekend and New Year's Day, with no serious accidents.

Early Saturday morning, Jackson Pollock, 39, abstract artist who makes his home in Springs, escaped injury when his Cadillac convertible left the road while turning a corner at the intersection of The Springs-Amagansett Road and the Louse Point Road. It mowed down three mail boxes, and glanced off a telephone pole, bringing down a wire, and continued on for fifty feet, stopping when it hit a tree. Mr. Pollock was driving alone, and was unhurt. The car was badly damaged.

Some critics treat Pollock's career as if it ended here, as if perhaps he had died in that holiday crash. There are even some who would chop it off a year earlier—that is, in 1950—considering his black-and-white paintings, particularly the figurative ones, retrogressive. It is true that from 1952 on, for the remaining four-and-a-half years of his life, there will be no more radical changes in style. His career will indeed take on a rather retrospective character. Even now, in 1952, the big events will appear to be his first Paris show and his inclusion in the "15 Americans" show at the Museum of Modern Art. However, although Pollock will make no more radical discoveries, his explorations of the world he has discovered in himself will continue. In 1952 he will paint his most controversial masterpiece, *Blue Poles,* the related *Convergence,*

and *Number 12;* in the following year *Easter and the Totem, Portrait and a Dream, Ocean Greyness,* and *The Deep;* in 1954 *White Light;* and in 1955 *Scent* and the appropriately named *Search.* Yes, the annual lists of his paintings will grow shorter. Nevertheless, to abandon Pollock now would be to miss too much of his short life and too much of its meaning. The black-and-white paintings, particularly the semifigurative ones, were rather another transition in Pollock's development, employed (Frank O'Hara said in the subsequent catalogue *New Images of Man*) "as one of the elements in an elaborate defense of his psyche.... It is drawing, as so many of the great masters seem to tell us, that holds back the abyss." The abyss, previously only visited by Pollock, will become a dwelling place during the next five years.

The Action Painter
(1952)

Esthetics is for the artist as ornithology is for the birds.
BARNETT NEWMAN

Pollock's first one-man show in Paris—during March, at the Studio Paul Facchetti—was a labor of love. Ossorio helped Michel Tapié finance and organize it. Tapié wrote a catalogue introduction and had Ossorio's Betty Parsons introduction translated (now given the title, "Mon Ami, Jackson Pollock"). Hans Namuth contributed photographs. ... Yet maybe there was about all this something too gentle, too amateurish (in the most literal sense). The gallery was not long established—it had been a photographer's studio, hence its name. The eight-page paperbound catalogue was rather skimpy and poorly printed. And Tapié's introduction bristled with such phrases as "one of the most prestigious representatives of the contemporary American pictorial adventure ... a bomb in the Paris art world ... a first-rank position in the present great pictorial adventure ... huge paintings that are among the most compelling phenomena of our time ..."—none likely to have seduced the typically chauvinistic French press. No, it was, rather, the artists who responded: Mathieu, for example, who had long since written Betty Parsons that he considered Pollock "the greatest living American painter," and Henri Michaux, poet and painter referred to in Tapié's text. (Dubuffet was not now in Paris. He had returned to New York after a trip to Chicago. But in 1950 he wrote Ossorio that Pollock "is one of the few living painters ... whose oeuvre interests me.")

Few paintings sold, notably *Number 19, 1951* to the Milanese collector Carlo Frua de Angeli. And Tapié bought two smaller works—*Number 17, 1949* (which had been reproduced in *Life*) and *Number*

8, 1951—for himself, but at a dealer's discount of fifty percent. After this discount and the normal one-third commission on the other purchases plus reimbursement for crating, shipping, and catalogue publication, there was only about $1300 left for Pollock. In Paris the real reaction, the more broadly positive reaction occurred a year or two later, when still younger Americans would receive the benefits of this missionary work and European dealers would begin to see and buy American paintings.

However, it may be too easy now, a generation later, to make these evaluations. At the time, Pollock's were quite different:

> *Monday, March 30, 1952*
>
> *Dear Alfonso,*
>
> *First we like the catalog as everyone did who saw it—haven't yet had a decent translation of Tapié's forward—even Dubuffet couldn't do too well. Also I had one of the nicest letters from Tapié before the show opened—I hope you will thank him for me (I will write him this week.) And of course the sales are out of this world—certainly not expected by me, and everything around the sales are of course satisfactory—and if there are further decisions— you can use your own judgment. I have offers by two good galleries here—but I don't plan to make any final decision until you are back. The Museum of Modern Art show opens next week (I'll send the catalogues out as soon as they are ready). There is no change with Betty—haven't seen her since you left. This getting settled in a new gallery isn't easy to solve personally. I feel I have been skinned alive—with my experience with Dr. [Grant] Mark [a biochemist who had Pollock dieting on minerals and proteins as well as bathing in a solution of rock salt] which got more involved each weak [sic] until a crisis last week—I'm still a little dazed by the whole experience. All this we can discuss when you return—including Tapié's offer. If there are any Paris catalogues left I could use a few more, and if there are any newspaper reports would love to see them....*
>
> *Our love to you both,*
> *Jackson*

Pollock's comments about the catalogue may have been politeness— after all, Ossorio had initially paid for it. However, those about the sales

cannot be taken for anything but sincerity; the tone of appreciation is unmistakable. As famous as Pollock now was, even four European sales were still unexpected. That, he must have thought, was the trouble with Betty—she just didn't sell, didn't know how. In most other ways she was perfect. There was a tendency to be undiscriminating, to show too many artists, but still she was really sensitive and understanding, even painted herself. However, when it came to putting a little pressure on a collector or an institution—well, she couldn't do it. At the turn of the year and the termination of his contract, Jackson may have said some of this to her, told her how much he liked her, but made it clear that he needed a more aggressive dealer. Of course she was hurt, wanted him to understand how hard she had been trying, the extent of her investment in him. At the end of January she had written, asking him to stay with her until May so she might at least get the benefit of possible sales still pending from his last show and others that might come from interest stimulated by the one about to open at the Museum of Modern Art. Jackson had gone along with her request and had agreed to keep an open mind, if she succeeded in doing some business. Meanwhile, without committing himself, he listened to the propositions of some of the other dealers. More aggressive, less nice than Betty, they talked tougher and spoke of art as merchandise. And yet, maybe, as Leo Durocher was fond of saying, "Nice guys don't win ballgames." Janis met with Lee and Jackson and asked, "Do you think the Pollock market has been reached?" Lee replied, "The surface hasn't been scratched." They all knew there was a rapport.

"15 Americans" was one of a series of exhibitions organized by Dorothy Miller at the Museum of Modern Art. For them she selected an arbitrary number of artists, each of whom had developed his own style and was deserving of what amounted to a small one-man show. Pollock was shown with Baziotes, Still, Rothko, Tomlin, Corbett, Ferber, and Kiesler, among others. Miss Miller's previous "14 Americans" (1946) had included Tobey, Gorky, Motherwell, Hare, and Roszak, and her "12

Americans" (1956) would include Brooks, Guston, Kline, Lassaw, and Lipton. Thus a substantial part of what was to become the official institutional list of Abstract Expressionists (one which excludes Lee Krasner, among others) was already formed or being formed, and once again we see in this list threads of Pollock's biography, associations from the past— California, the Project, Art of This Century, the Cedar, Springs–East Hampton, Betty Parsons Gallery—leading to future biographical threads, particularly the Sidney Janis Gallery.

Eight paintings representing Pollock's work from 1948 to 1951 were selected, including the mural-sized *Autumn Rhythm* and the glass *Number 29, 1950* (installed free-standing and illuminated so that its shadow was cast on the wall). Soon after the opening Pollock wrote Miss Miller: "I want you to know what a wonderful job I think you did in hanging my room at the Museum. There was probably extra work for you (or was there?) in my staying away. At any rate I think it was wise of me. . . ."

In the catalogue, Pollock's work was introduced by Ossorio's piece for the 1951 show, slightly modified. This may have been Pollock's way of repeating what he said to Janis in 1944: ". . . Any attempt on my part to say something about it, to attempt explanation of the inexplicable, could only destroy it." Ossorio echoes Pollock's fear in his phrase "the communal clamor for a victim." So does Rothko in the same catalogue: ". . . It is . . . a risky act to send [a picture] out into the world. How often it must be impaired by the eyes of the unfeeling and the cruelty of the impotent who would extend their affliction universally!" And Still:

That pigment on canvas has a way of initiating conventional reactions for most people needs no reminder. Behind these reactions is a body of history matured into dogma, authority, tradition. The totalitarian hegemony of this tradition I despise, its presumptions I reject. Its security is an illusion, banal, and without courage. Its substance is but dust and filing cabinets. The homage paid to it is a celebration of death. We all bear the burden of this tradition on our backs but I cannot hold it a privilege to be a pallbearer of my spirit in its name.

These statements indicate a mood, a spirit in the air, a sense of drama and urgency—indeed, of life and death—in painting which had emerged during the past decade or so. This ambience was best expressed by Harold Rosenberg in his essay "The American Action Painters," which appeared in the December 1952 *Art News:*

> ... *At a certain moment the canvas began to appear to one American painter after another as an arena in which to act—rather than as a space in which to reproduce, re-design, analyze, or "express" an object, actual or imagined. What was to go on the canvas was not a picture but an event.*
>
> *The painter no longer approached his easel with an image in his mind; he went up to it with material in his hand to do something to that other piece of material in front of him. The image would be the result of this encounter.*
>
> ... *To work from sketches arouses the suspicion that the artist still regards the canvas as a place where the mind records its contents—rather than itself the "mind" through which the painter thinks by changing a surface with paint.*

In Pollock's files at the time of his death there was, along with the handwritten statement already quoted, this one:

> *No Sketches*
> acceptance of
> *what I do—.*
> _____
> Experience of our age in terms
> of painting—not an illustration of—
> (but *the equivalent.*)
> Concentrated
> fluid

Compare for a moment Pollock's public (and economic) reception with that given to other vital cultural phenomena emerging in America at about the same time: "cool" jazz, Actors' Studio, the Beat Writers, "serious" stand-up night-club comedians. It is not difficult to find similarities between Pollock's life and those, for example, of Charlie "Bird"

Parker (1920–55), James Dean (1931–55), Jack Kerouac (1923–69), and Lenny Bruce (1926–1966).

A phrase from Bird's saxophone swoops through the mind, diving in a thin line, spreading out in a glide, exploding as if hit by a bullet.

James Dean's face twitches; his mouth opens; the sounds are those of feeling rather than known words; he starts to run; he talks with his body.

A little later—with the publication, in 1957, of *On the Road*— Jack Kerouac comes up from underground: "... bleary eyes, insaned mind bemused and mystified by sleep, details that pop out even as you write them you don't know what they mean, till you wake up, have coffee, look at it, and see the logic of dreams in dream language itself ..."*

And Lenny Bruce: "All my humor is based on destruction and despair. If the whole world were tranquil, without disease and violence, I'd be standing in the breadline—right back of J. Edgar Hoover."

How similar Kerouac's words are to Pollock's statement in *possibilities*. How similar are all of these approximately contemporaneous statements, whether made on the stage or in the studio. But there is this difference: after whatever early struggles, an audience did finally buy drinks and, later, records to hear Bird and Lenny; did pay for tickets to see Jimmy and for books to read Jack. A large paying audience. Pollock never had that. Never during his lifetime. For him there was no *New York Times* item like the following:

> *The newest and in some ways most scarifyingly funny proponent of significance ...to be found in a nightclub these days is Lenny Bruce, a sort of abstract-expressionist stand-up comedian paid $1750 a week to vent his outrage on the clientele....*

So, in context, the context of "The American Action Painters," Rosenberg is writing about a comparatively quiet aspect of existential art, the private, solitary studio world of the canvas as mind. He goes on:

* See Bibliography No. 275.

... What matters always is the revelation contained in the act. It is to be taken for granted that in the final effect, the image, whatever be or be not in it, will be a tension.

A painting that is an act is inseparable from the biography of the artist. The painting itself is a "moment" in the adulterated mixture of his life—whether "moment" means, in one case, the actual minutes taken up with spotting the canvas or, in another, the entire duration of a lucid drama conducted in sign language. The act-painting is of the same metaphysical substance as the artist's existence. The new painting has broken down every distinction between art and life.

In these fragments of Rosenberg's composite portrait there are broad reminders of Pollock's life and outlook. In the remainder of the essay the reminders seem sometimes to refer even more specifically to Pollock (who himself referred to the essay as "Rosenberg's piece on me")—that is, more than to de Kooning and Kline who must have been Rosenberg's other principal models. Rosenberg has, in any case, written the author*: "Action Painting was *not* intended to describe Rothko, Still, Gottlieb or Newman. Nor Gorky either.... In short, A.P. is not a synonym for Abstract Expressionism, though there is a connection...." He continues, in the essay itself:

... Their type is not a young painter but a reborn one. The man may be over forty, the painter around seven.

... The American vanguard painter took to the white expanse of the canvas as Melville's Ishmael took to the Sea.

... Lacking verbal flexibility, the painters speak of what they are doing in a jargon still involved in the metaphysics of things: "My painting is not Art; it's an Is." "It's not a picture of a thing; it's the thing itself." "It doesn't reproduce Nature; it is Nature." ...

Language has not accustomed itself to a situation in which the act itself is the "object." Along with the philosophy of TO PAINT appear bits of Vedanta and popular pantheism.

In terms of American tradition, the new painters stand somewhere between

* Letter dated June 22, 1970.

Christian Science and Whitman's "gangs of cosmos." That is, between a disci-
pline of vagueness by which one protects oneself from disturbance while keep-
ing one's eyes open for benefits; and the discipline of the Open Road of risk
that leads to the farther side of the object and the outer spaces of the conscious-
ness.

... What is a painting that is not an object nor the representation of an
object nor the analysis or impression of it nor whatever else a painting has
ever been—and that has also ceased to be the emblem of a personal struggle?
It is the painter himself changed into a ghost inhabiting The Art World. Here
the common phrase, "I have bought an O" (rather than a painting by O) be-
comes literally true. The man who started to remake himself has made himself
into a commodity with a trademark.

... Considering the degree to which it is publicized and feted, vanguard
painting is hardly bought at all. It is used in its totality as material for educa-
tional and profitmaking enterprises: color reproductions, design adaptations,
human-interest stories. Despite the fact that more people see and hear about
works of art than ever before, the vanguard artist has an audience of nobody.
An interested individual here and there, but no audience. He creates an environ-
ment not of people but of functions. His paintings are employed not wanted....

Rosenberg presented the situation of the Action Painter as it was in
1952 and as it would remain until about 1956, the time of Pollock's
death. It must be reemphasized that as yet neither Pollock nor his less-
well-known and even less-well-selling contemporaries had any sizable
audience but other artists. The middle-class executives and professional
people who were willing to give these painters a few minutes—a few
condescending chuckles, more often than not—as they flipped through
the pages of *Time* were not yet ready to spend the several hundred dollars
an average-size painting or drawing would cost. In short, Pollock's success
was not economic but professional. Of his most important paintings only
about half a dozen were sold during his lifetime, half of these during his
last year. The Museum of Modern Art acquired *Number 1, 1948* for about
$1,000 in 1950; *Lavender Mist* went, at the time of its first showing, to
Ossorio for about $1,500 spread over a considerable period; *Blue Poles*
to Dr. Fred Olsen for $6,000, a year after its first showing; and *One* to

Ben Heller, five years after its first showing, for $8,000 to be spread over four years and with a medium-size black-and-white given to Heller "in recognition of his commitment to Pollock's work." In addition, just before Pollock's death, Heller bought *Echo,* an important black-and-white of 1951 (about which Greenberg had enthused in *Partisan Review*), for a price difficult to establish because it involved a discount, but rumored to have been approximately $3,500. Finally, in March 1956, *Convergence* (1952) was bought at an undisclosed price by Seymour H. Knox for the Albright-Knox Art Gallery in Buffalo. If one deducts dealers' commissions and routine working and living expenses, Pollock had a meager income at the end of his life. In the early fifties he could barely survive. Tony Smith says,* "The financial pinch must have been terrible, especially when you realize how generous the Pollocks were. I think Jackson started to drink again . . . just out of despair. Despair at his plight. He had done so much, and so little had come out of it . . . he gave me a sketchbook to draw on while going to New York on the train. He had figured out his income tax on the cover; the whole income was only $2,600 or something like that."

> *. . . Art comes into being not through correct reasoning but through uniting contradictions of reason in the ambiguities of a metaphor. To remove the object and make the artist's action into the work of art is to bring the artist face to face with the audience. . . . The Action painter does not, like the Surrealist, begin with an image, nor does he proceed by the association and combination of images. From his first gesture on the canvas, be it a sweep of yellow or the figure 4, he establishes a tension upon the surface—that is to say, outside himself—and he counts upon this abstract force to animate his next move. What he seeks is not a sign representing a hidden self, the unconscious, but an event out of which a self is formed, as it is formed out of other kinds of action when those actions are free and sufficiently protracted. It is in this sense that Action painting could be said to break down the barrier between art and life—not by merging art into the environment, as in Pop and Happenings, but through engaging in art as a real (that is, total) activity.*

* See Bibliography No. 172.

Though the P in Action Painting has become small, the voice is the same. It is that of Harold Rosenberg, clarifying and expanding upon the concept; doing so almost twenty years later, in *The New Yorker,* where by then he has replaced Robert Coates and where an audience now exists for long philosophical essays on art, an audience previously to be found reading only little magazines and specialized art journals. Again, it is probably no accident, but rather a subconscious association, that made Rosenberg choose the figure 4 as a way of establishing tension on the surface of the canvas. Pollock had used the number often—in *Stenographic Figure,* in *Male and Female,* in *Wounded Animal,* and elsewhere —sometimes only as a doodle; sometimes in 46, his address on East 8th Street (and earlier on Carmine); sometimes as that number reversed.

By September 1952 Pollock's black-and-white show had been down for nine months, with none of the largest paintings sold. By then Janis's "American Vanguard" had been seen at Galerie de France, and Pollock's one-man show at Studio Facchetti. By then a watercolor had been shown at yet another Whitney Annual. By then "15 Americans" had come and gone. By then a black-and-white painting had been included in "The First International Art Exhibition" at the Metropolitan Art Gallery in Tokyo, from which it traveled to Osaka, Nagoya, Fukuoka, and Kyoto. By then Pollock knew that another black-and-white would be in the Carnegie Institute's "Pittsburgh International" and that Greenberg was organizing a retrospective show of eight paintings ranging from the 1943 *Pasiphaë* to *Number 25, 1951,* scheduled to open at Bennington College in November and then travel to Williams College in December. By then Pollock had completed about nine paintings that year—including *Number 2,* a triptych—all of which were pretty much a continuation of the previous year's work in black-and-white. And he had left Parsons and joined Janis, had added that pressure to all the others out there beyond the studio, including being rated best by Greenberg and being defined as prototypical Action Painter by Rosenberg. There can be little doubt that as Pollock contemplated his most recent paintings and the empty canvas before him,

the pressure of his next show was there, intruding on the void. We can imagine how much he wanted "to make a splash" with his first show at this more high-powered gallery where not only the work of young Americans—several of them, like Pollock himself, formerly at Parsons—but that of established Europeans was shown *and sold.*

During the two months or so remaining until his November 10 opening, Pollock completed three outstanding paintings—outstanding within the context of the work done earlier in the year, within that of his total oeuvre, and within that of all twentieth-century art. *Number 10* (*Convergence*), which had been black-and-white and was then added to in color; *Number 11* (*Blue Poles*), which he had worked on through the year, re-entering it several times; and the explosive *Number 12* were singled out for praise by almost every reviewer—Fitzsimmons, Devree, Goodnough, Faison—and must have been the basis on which this exhibition was voted by *Art News* (January 1953) the second-best one-man show of the year in New York—second this time to Miró.

Perhaps because *Numbers 10, 11,* and *12* were immediately so well received, there was a sort of backlash on the part of some painters and critics, particularly at The Club, who said that these works represented a further falling off from the high period of 1947 to 1950 (or, in Greenberg's case, 1951). Instead of seeing the particular power of the recent paintings and the daring of their palette, they saw garish color applied to a crude repetition of previously done, warmed-over patterns. And in *Blue Poles* they saw a return, as in the black-and-whites, to line used to define shape. But worse, they saw references to work by Pollock's contemporaries. The stained areas in *Number 12* reminded them of work by Mark Rothko, and the near-verticals of *Blue Poles* of the stripes or "zips" of Barnett Newman. Newman reinforced the second of these superficial views with a witticism: "My blood is in that painting." By this he said he meant only to refer to stepping on broken glass in Pollock's studio when the painting was spread on the floor.

Whatever the reasons, *Convergence* did not sell until the March

preceding Pollock's death. *Blue Poles,* too, was not sold until his last year and then probably only because of the urging of Tony Smith, who was designing a new house for the Olsens in Guilford, Connecticut. (After Pollock's death Olsen sold it to Heller for what at the time seemed a huge price: $32,000, representing a profit to Olsen of $26,000)* *Number 12,* the only one of these three paintings sold soon after the show, was bought by Nelson Rockefeller who subsequently took it with him to Albany. There, in the Governor's Mansion, it was badly damaged by fire in 1961.

In 1959, when Frank O'Hara's monograph on Pollock was published, he stated:

> *Much has been written about Pollock's difficulties in the last three years of his life, and more has been spoken. The works accomplished in these years, if created by anyone else, would have been astonishing. But for Pollock, who had incited in himself, and won, a revolution in three years (1947–50), it was not enough. This attitude has continued to obscure the qualities of some of these works, for in* Blue Poles *he gave us one of the great masterpieces of Western art, and in* The Deep *a work which contemporary esthetic conjecture had cried out for.* Blue Poles *is our* Raft of the Medusa *and our* Embarkation for Cythera *in one. I say* our, *because it is the drama of an American conscience, lavish, bountiful and rigid. It contains everything within itself, begging no quarter: a world of sentiment implied, but denied; a map of sensual freedom, fenced; a careening licentiousness, guarded by eight totems native to its origins* (There Were Seven in Eight). *What is expressed here is not only basic to his work as a whole, but it is final.*

When the next monograph on Pollock was written—that, previously mentioned, of the British critic Bryan Robertson—*Blue Poles* was its focus. He begins defensively: "... this picture is considered by some American observers to go over old ground too much and to return a shade hysterically ... to the celebrated style of Pollock's great paintings of the 1949–51 period...." before asserting: *"Blue Poles* is in fact a masterpiece and one of the half-dozen key paintings in Pollock's output. There is no slackening of invention or uneasy groping back to an earlier and

*In September 1973 Heller sold *Blue Poles* to the Australian National Gallery in Canberra for $2,000,000.

more familiar manner. On the contrary, *Blue Poles* should be considered as a definitive summing-up work of magisterial proportions and conviction. . . ."

Blue Poles is all the things Robertson says and at least one more: it is the last of Pollock's "murals"; like the other great ones, it was private and uncommissioned. However, it may well have reminded Pollock's friends of the possibility of an architectural commission. During the extended period in which Pollock worked on it, Ossorio continued to speak to Tony Smith and to Pollock himself about designing and decorating a Catholic church. It was understood that such a project would be speculative, with no particular site in mind, and that Pollock would be free to decorate prescribed areas according to his own feelings about required emotional content, achieved through scale, color, rhythm, etc., rather than traditional iconography. Pollock and Smith were receptive to the plan, and Ossorio agreed to pay Smith a fee for sketches and a small model. Smith remembers that while he developed these, Pollock questioned him about Catholicism. However, though one hears rumors that in the last desperate years of his life, Pollock was considering converting to Catholicism, the specific possibility was never discussed with Smith nor with Ossorio who, like Smith, was Catholic. Smith attributes Pollock's interest in Catholicism to his background (the McCoys were Catholic), his longstanding general interest in all religions, and the specific appeal of the external form and symbolism of Catholicism.

The church Smith designed was poised above a cemetery, suspended there, like a honeycomb, between earth and sky, a cluster of prefabricated hexagonal elements, an elegant enclosure for art. It was a church, like Pollock's painting on glass, through which one saw and felt the landscape. Ossorio and Pollock were delighted. Ossorio arranged to have a group of prominent Catholics associated with avant-garde art (Eloise Spaeth, patron, writer, and active committeewoman; the critic and curator James Johnson Sweeney; Father Ford of Columbia; Maurice Lavannoux, editor of *Liturgical Arts*) meet Smith at the carriage house on MacDougal Alley.

However, some of those present showed such a lack of enthusiasm or even receptivity to both the church and paintings by Pollock in the house that Smith left in disgust.

Nothing came of the meeting. Peter Blake wanted very much to publish these studies, along with others Smith had done previously, but as always Smith refused. He went on to use the hexagon as the basis for another project, a much less costly hexagonal tent, possibly to be built in East Hampton, in which Pollock's work could be shown without patronage. This, too, was never built and never published.

The Final Years
(1953–1956)

"... I'm a dawdler! I'm a failure! I shall do nothing more in this world. ... I've been sitting here for a week, face to face with the truth, with the past, with my weakness and poverty and nullity. I shall never touch a brush! I believe I've neither eaten nor slept. Look at that canvas! ... That was to have contained my masterpiece! Isn't it a promising foundation? The elements of it are all here." And he tapped his forehead with that mystic confidence which had marked the gesture before. "If I could only transpose them into some brain that had the hand, the will! ..." And he pointed with a gesture I shall never forget at the empty canvas.

HENRY JAMES
"The Madonna of the Future"

In Action painting the pressing issue for artists was: When is a painting finished? Answer: At exactly the end of the artist's lifetime.

HAROLD ROSENBERG
Act and the Actor

1953 will be the first year since 1944 in which Pollock won't have had at least one one-man show. He is tired now, tense, confused, desperate, drinking more than ever, under pressure to paint masterpieces, to maintain the standard of those three paintings which salvaged his 1952 show. On the one hand he is too proud, too honest to want to repeat himself, to give the critics more of what they seem to think is his best work, and on the other he isn't sure of where he's going, where he can go. He is lost at sea, foundering between recapitulations and new quests.

At Janis's urging, because the dealer feared the possibility of confusion resulting from the use of the same numbers in different years (or even in the same years, by different artists), Pollock—with help from friends, including Jeffrey Potter—named the paintings in his 1954 show. There were ten, all completed between the end of 1952 and the beginning of 1954 and all dated 1953; some of the titles, as well as the im-

ages themselves, tell the story. There is the vast sea of his subconscious, turbulent and churning, no longer moving in the more regular rhythms of tides and waves: *Ocean Greyness; The Deep.* There is the sense of strain, of labor rather than joy, of grayness rather than color, of variations in gray itself and even in its spelling: *Ritual; Sleeping Effort; Ocean Greyness; Grayed Rainbow.* There are the partially representational recapitulations: *Sleeping Effort; Easter and Totem; Portrait and a Dream*—of which the first two contain suggestions of Matisse and Picasso not seen in Pollock's work for about ten years. There are these things, and yet one more, looked at as paintings rather than art history, they are all strong work. Two are unique among Pollock's entire output. The diptych *Portrait and a Dream* Lee Pollock has already commented on. We want only to emphasize how well this painting holds in tension its panels of black and white and color, of abstraction and figurative portraiture. It is a startling resolution of opposites. A more difficult, a more totally abstract resolution, is *The Deep.* Discussing this painting immediately after his remarks on *Blue Poles,* O'Hara wrote:

> The Deep *is the coda to this triumph. It is a scornful technical masterpiece, like the* Olympia *of Manet. And it is one of the most provocative images of our time, an abyss of glamour encroached upon by a flood of innocence.*

The dark central area of the painting can be read more prosaically as an abyss of gloom. However, one supposes that O'Hara was projecting into the painting his own knowledge of Pollock's life, his sympathy for the public, indeed overly publicized, man.

But, at the time—during February 1954, when the show was up—the reviewers, though generally enthusiastic, responded with more detachment than O'Hara. They noted changes in Pollock's work—some uncertainty, less dripping, more figurative elements—and in this unevenness they looked for positive transition and growth. Stuart Preston in the daily *Times* said the works "are painted in an angry manner, heaped high and churned up with paint-color, now thick, now thin; and design will vary from the sequence of leaping forms of harsh color in 'Ocean Grey-

ness' to baroque spirals in 'Four Opposites' and to the powerful ambiguity of restless shapes in 'Sleeping Effort.' " Preston concluded that these "strong pictures . . . mark a happy advance over the impersonality of much of his early work." By Sunday, in an "Abstract Roundup," Preston noted, "there are indications that the return to subject matter is not all just talk. In Jackson Pollock's impressive new pictures . . . unmistakably intuitions seethe under restless and tortured surface textures. . . ." The same day Emily Genauer, in the *Herald Tribune,* saw "a new and promising approach. To begin with they're really painted, not dripped!" In *The New Yorker* Robert Coates saw "new trends." S. Lane Faison, Jr. of *The Nation* observed that the paintings "are surprisingly different, one from the other. As a result the consistency of style that marked Pollock's work of three or four years ago is patently disrupted. This is a normal occurrence, of course, particularly if it turns out to be a period between periods."

As to the art magazines as such, James Fitzsimmons observed in *Arts & Architecture:* ". . . Pollock has confounded his critics and bemused his admirers. For one thing, he has not repeated himself. And though he has introduced figurative elements into his work, he has not succumbed to . . . failure of nerve and imagination. . . ." And Thomas Hess in *Art News:* ". . . Pollock still walks on the edge separating violence from decorativeness; in the new pictures containing figurative elements, the edge separates violence from sentimentality. That he passes so seldom beyond violence, and that he so consistently roots the image in its pictorial qualities, reaffirms one's belief in his international importance."

The absence of a review by Greenberg of the 1952 show had been conspicuous. Now again, for the time being anyway, he abstained from public comment, though he told Pollock privately that he was disappointed in the recent work. Indeed, by this time he may have been a little bored by Pollock and wanted to "discover" someone new, the "discovery" of Pollock having become possibly too large a part of Greenberg's identity. In any case, he did not refer to the 1954 show in print until the fol-

lowing year when his well-known essay " 'American-Type' Painting"* appeared:

> *...Though Pollock is a famous name now, his art has not been fundamentally accepted where one would expect it to be. Few of his fellow artists can yet tell the difference between his good and his bad work—or at least not in New York. His most recent show, in 1954, was the first to contain pictures that were forced, pumped, dressed up, but it got more acceptance than any of his previous exhibitions had—for one thing, because it made clear what an accomplished craftsman he had become, and how pleasingly he could use color now that he was not sure of what he wanted to say with it. (Even so, there were still two or three remarkable paintings present.) His 1951 exhibition [the black-and-white show], on the other hand, which included four or five huge canvases of monumental perfection and remains the peak of his achievement so far, was the one received most coldly of all.*

Further on in this article, which attempted to define the American art scene and which has indeed been used by many collectors and curators as a working definition, Greenberg referred to

> *the emergence of Clyfford Still as one of the most important and original painters of our time—perhaps the most original of all painters under fifty-five, if not the best.... Rothko and especially Newman are more exposed than Still to the charge of being decorators by their preference for rectilinear drawing. This sets them apart from Still in another way, too. By liberating abstract painting from value contrasts, Still also liberated it, as Pollock had not, from the quasi-geometrical, faired drawing which Cubism had found to be the surest way to prevent the edges of forms from breaking through a picture surface that had been tautened, and therefore made exceedingly sensitive, by the shrinking of the illusion of depth underneath it.*

One does not have to italicize phrases like "if not the best" and "as Pollock had not" to recognize how far Greenberg has moved from his initial commitment to Pollock. However, it must be noted that neither

* See Bibliography No. 108 and compare with revised version in No. 26.

now nor later did Greenberg modify his opinions of Pollock's earlier work. Where most critics began to concentrate on the "classic" work of 1947 to 1950, Greenberg maintained his interest in key paintings of the early and middle forties and in the black-and-white paintings of 1951.

These are the last reviews of current work by Pollock. From now on such critical commentary as appears will be retrospective—some in response to "15 Years of Jackson Pollock" at Janis, almost two years later, half a year before his death; most in response to larger retrospective exhibitions after his death. As a painter, Pollock is, and will continue to be for the remaining two-and-a-half years of his life, "a ghost inhabiting the Art World."

During the summer of 1954 Elaine and Bill de Kooning, Franz Kline and Nancy Ward, and Ludwig Sander, another painter, rented the big oxblood-colored house in Bridgehampton on the north side of the Montauk highway. They were still getting settled, putting books out of the way which had been stored there by Don Braider, when Jackson drove up in his Model A. There was the usual horsing around, the same sort of bear-hugging and back-slapping and sparring as went on at the Cedar. Jackson helped and hindered. He carried a load of books to the basement, but mostly he interfered. While they worked inside and outside the house, he helped himself to beer and continued to kid around. No one knows quite how it happened but at some point he stumbled in a hole and broke his ankle. His friends got him to the clinic and then had the job of calling Lee. Of course she was furious and blamed them for getting Jackson drunk. De Kooning said later, "He's a big boy. If he wants to take some beer from the refrigerator I'm not going to stop him." It was weeks before Jackson's ankle was sufficiently healed so that he could pick up his Model A. By then, because of his inactivity, he was beginning to put on the weight which would so markedly change his appearance during the last two years of his life. And by then also, he had begun to grow a beard.

Meanwhile career details accumulated—past work appeared in

Whitney Annuals and "The New Decade" (1955) at the same institution; in exhibitions at or emanating from other New York museums (the traveling shows organized by the Modern; "Younger American Painters" at the Guggenheim) and museums in other American cities (Urbana, Baltimore, Washington, San Francisco, Los Angeles, Colorado Springs, St. Louis, Newark, Pittsburgh for another Carnegie "International") and abroad (Paris, Düsseldorf, Stockholm, Helsinki, Oslo, Bern, Zurich, Barcelona, Frankfurt, London, The Hague, Vienna, Belgrade, Venice for "American Artists Paint The City" in the 28th Biennale, New Delhi, Caracas).... Catalogue details, dots on maps representing places Pollock had never been and will never be, less than dots, nothing ... nothing to fill the void of the empty canvas before him, nothing now to ease those twin pressures: not to repeat himself and to be as good as he had been ... as he had been as recently as in 1953 when painting *The Deep.*

Days, weeks, months, years, more than two full years go by, during which Pollock makes only a few medium-sized paintings in a style that, typically now, is torn between dripping and heavy brushwork. Two of these late paintings, *White Light* and *Search,* were shown at the Janis Gallery along with fourteen earlier ones (none yet in collections except for three of the smallest, including one belonging to Peggy Guggenheim) in "15 Years of Jackson Pollock" through December 1955. Not a single reviewer mentioned either of the late works.

Although Pollock accepted the idea—that of Janis, encouraged by Lee—of a small retrospective, he may have felt that to have one was to be buried prematurely. Could he have accepted the reassurances of friends who said that looking backward did not preclude looking forward again? To Pollock there must have been something terribly final about this show at Janis, final in the same way he found signing a canvas final. And here his signature was, spread over the walls of the gallery, spread all the way from *The Flame* (1937) to his most recent *Search.*

Typically the press treated Pollock as an old master, a past master; gave him a premature funeral; buried him beneath thousands of words.

However, where most publications were eulogistic, *Time* (December 19, 1955), even in its selective anthology from other reviews, was snide:

THE CHAMP

Jackson Pollock, at 43 the bush-bearded heavyweight champion of abstract expressionism, shuffled into the ring at Manhattan's Sidney Janis Gallery, and flexed his muscles for the crowd with a retrospective show covering 15 years of his career. The exhibition stretched back to the time when Pollock was imitating imitations of Picasso, reached a climax with the year 1948, when Pollock first conceived the idea of dripping and sloshing paint from buckets onto vast canvases laid flat on the floor. Once the canvases were hung upright, what gravity had accomplished came to look like the outpouring of Herculean energy. Pollock had invented a new kind of decoration, astonishingly vehement.

That was Pollock's one big contribution to the slosh-and-spatter school of postwar art, and friend and foe alike crowded the exhibition in tribute to the champ's prowess. They found a sort of proof of his claims to fame in the exhibition catalogue, which lists no less than 16 U. S. and three European museums that own Pollock canvases. But when it came down to explaining just what Pollock was up to, the critics retreated into a prose that rivaled his own gaudy drippings. Items:

The New York Times *regretted that "until psychology digs deeper into the workings of the creative act, the spectator can only respond, in one way or another to the gruff, turgid, sporadically vital reelings and writhings of Pollock's inner-directed art."*

The New York Herald Tribune *stated firmly that "whether or not you like Pollock's painting, or think the results no better than color decorations, one must admit the potency of his process."*

Art News *explained that Pollock's work "sustains the abstract-size scale toward which his vision has probably always been directed. It is a 'cosmic' scale because of the multiple overlay and continuous spiral movement in conjunction with the non-figurativeness."*

Arts summed up: *"A Pollock painting, charged with his personal mythology, remains meaningless to him for whom Pollock himself is not a tangible reality. An Indian sculpture is related to Vedic and Upanishadic thought, exactly so are Pollock's canvases related to his self. Ignore that relation and they remain anonymous and insignificant."*

In other words you can't tell very much about the champ without a per-sonal introduction.

Pollock must have been hurt and angry, and there was no comfort in the other articles on the art pages of *Time.* The lead piece dealt blithely and condescendingly with a Pascin retrospective commemorating the twenty-fifth anniversary of this painter's suicide at forty-five ("The pasty little man with the well-ripened nose sat fingering a razor blade"). "Sculpture on the Bargain Counter" was about a sale of antiquities at the City Art Museum of St. Louis ("Art objects of various neglected periods proved to be even better bargains than contemporary pictures by little-known artists"). These were no better than the piece on himself, so full of oversimplifications, half-truths, outright lies; so full of shit, he would have thought. Did *The Flame,* the earliest painting in his show, have anything to do with Picasso? Didn't they know he had drawn with spilled paint before 1948? And was 1948 "a climax" when viewed in the context of *Out of the Web* (1949)? *Autumn Rhythm* (1950)? *Echo* (1951)? *Convergence* (1952)?—all in the show, hanging right before their eyes, those collective eyes of Time, Inc. And why at this stage in Pollock's career did Janis have to list museum collections (sixteen in the U.S., not "no less than 16")? Why did *Time* have to pick up on those credentials? Weren't his paintings, there on the walls, credentials enough? And if *Time* was going to do things like this, why didn't it dig a little deeper? Why didn't it say that many of the works in museums were there as tax-deductible gifts from Peggy Guggenheim? Why, instead of presenting him as some kind of best-selling success, didn't it come right out and say that he needed sales, needed money, had had and was continuing to have a hard time supporting himself and his wife? And why did *Time* have to rip from their context the words of a responsive and sensitive critic like Leo Steinberg in *Arts* and turn these words into more shit, more lies? Why?

Pollock could tell himself that *Time* didn't matter, that words didn't

matter, that the reactions of the outside world didn't matter, that the only thing which really mattered was the work itself, doing it, being alive in it. He had been able to tell himself these things during the years when he was working. But even then perhaps the outside world had meant more than he was willing to admit. Now blocked, unproductive, unalive, he had no present work to fall back on, no work immediately ahead of him, nothing but the empty canvas, waiting to receive him but receiving instead reflections of the world.

Within two months, *Time* (February 20, 1956) was, from Pollock's point of view, after him again—after him and his colleagues: Gorky, who had hanged himself in 1948, de Kooning, Guston, Baziotes, Motherwell, Rothko, Gottlieb . . . none of them much better off than he himself, some born richer but drinking just as much, advancing now almost as little in their work, and all needing recognition. . . . The long article, called "The Wild Ones," presented Abstract Expressionism as—economically, if not esthetically—a success story. There were color reproductions of the eight artists' work, including Pollock's most recent painting, *Scent* (1955); and besides background references to him, there was this paragraph:

> JACK THE DRIPPER. *Adolph Gottlieb's* Blue at Noon, *for example, conveys a strong sense of light and dark skies and of lilting movement. Looking at it is rather like watching a snowstorm through a windowpane and remembering Thomas Nash's line: "Brightness falls from the air." Jackson Pollock's* Scent *is a heady specimen from what one worshipper* calls his "personalized skywriting." More the product of brushwork than of Pollock's famed drip technique, it nevertheless aims to remind the observer of nothing except previous Pollocks and quite succeeds in that modest design. All it says, in effect, is that Jack the Dripper, 44, still stands on his work.*

Perhaps Pollock would have glanced from this issue of *Time* (with the smiling face of Ohio's Governor Frank Lausche on the cover) to earlier issues of *Time* and *Life* which he had saved. And we can imagine him looking at the 1951 *Life* containing that group portrait of the Irascibles.

*See Bibliography No. 91.

How sad they all appeared, especially his friend Brad Tomlin, the first of this group to go, having died in 1953 just as he was about to move to Springs. And Pollock might have looked at the two issues of *Life* he had saved since the late forties: one containing "Is he the greatest living painter in the United States?" and one with the "Round Table on Modern Art." Again, as with *Time,* images would have flashed by: cover men, cover girls, news photos, printed words, ads . . . the overwhelming amount of material consumed by magazines—human material mostly—to be re-consumed by a hungry public. Perhaps Pollock wondered about the brief lives of these people and products and people/products. Not only had many of the names of these people already been forgotten, but so had some of the trade names, the creations of once seemingly immortal corporations. Perhaps Pollock wondered, too, about his own name and the longevity of what he had done. . . . Had done—almost everything now existed in the past tense.

How long can a man face an empty canvas? How long can he look at himself in one? How long before he needs a drink? How long before he flees the studio?

Jackson had often said to his wife, "Painting is no problem; the problem is what to do when you're not painting." He used to say that in the early days when the barn was simply too cold to paint in or the light inadequate. Now, even with a good stove or even in the summer (which had always been the season in which he worked best), he could have said it—he could have said it anytime and all the time.

The painter Conrad Marca-Relli, a neighbor and close friend of Pollock's during the final years, has described Jackson's going to the studio in the morning and lighting the stove, even long after he had stopped painting. Marca-Relli asked him why he did this, why he wasted the time, and the cost of fuel. Jackson replied, "I light the stove so the studio will be warm in case this is the day I can start to paint again."

Of course Marca-Relli understood. The previous summer Jackson had told him that Janis wanted the paintings remaining in the studio to be moved from there to a fireproof warehouse. Jackson was reluctant to

do this, felt it might be a kind of entombment, but understood the danger of leaving them in the barn. Conrad had said, "You're out of your mind. You mustn't consider storing your life away. You need the warmth of your work around you. One day you'll begin reworking one of these paintings and then you'll move on to new work. Don't think of your life as being over. Your best work is still ahead of you."

Pollock appreciated Marca-Relli's encouragement. He never stored the paintings, but neither did he start work again. By the spring of 1956 he was in even more need of encouragement.

"What's the biggest painting you've ever done?" Conrad asked.

"About nine by twenty—the one for Peggy."

"Why don't you do something really big, something no one's ever done, maybe forty by sixty, something great?"

Jackson's eyes brightened. "I could," he said. "Tony has a garage that size."

During the final years, in his lonely terror of the blank canvas, Pollock became both increasingly gregarious and aggressive. More than ever before, he needed people to drink with. Sometimes artists. One can read between the lines of this item which appeared in the East Hampton *Star* (September 2, 1954):

JACKSON POLLOCK INJURED

A collision occurred on Tuesday night when two cars met head on through the fallen tree in front of Nelson Osborn's house on Main Street. Lester Hildreth was in a 1950 Chevrolet, on the south side of the tree. He was facing north, and waiting to go around the tree. Franz Kline, operating a 1937 Lincoln roadster, was going south and he was unaware of the one lane traffic. He pulled out to pass the cars going south, and crashed through the tree. He met Hildreth head on. Jackson Pollock, a passenger in Kline's car, was the only injured person. He suffered a cut on the lower lip.

But by then the local police knew Jackson and liked him. He had had several automobile accidents. Even more frequently he had forgotten

where he parked his car during evenings of carousing and had either de-
pended on the police to find it for him or had found it for them. Either
way they would laugh and warn him and protect him as much as possible.
So did some New York bartenders, as in an incident at the Cedar de-
scribed by the poet Robert Creeley: *

*... I'd been in the Cedar Bar talking with Franz Kline, and another friend of
Kline's and Fielding Dawson probably was there. We were sitting over at a
corner booth, and they were talking and drinking in a kind of relaxed manner.
But I, again, you know, very characteristic of me, I was all keyed up with the
conversation and I'd start to run to get the beer, or whatever we were drinking,
and it wasn't coming fast enough. I'd go up to the bar, have a quick drink, and
return to the table and pick up the drink that by then had come, and I was
getting awfully lushed, and excited, and listening, and I was up at the bar get-
ting another drink, when the door swings open and in comes this very, you
know, very solid man, this very particular man, again with this intensity. He
comes up to the bar, and almost immediately he made some gesture that bugged
me. Something like putting his glass on the bar close to mine, that kind of busi-
ness where he was pushing me just by being there. So I was trying to re-assert
my place. The next thing we knew we were swinging at each other. And I re-
member this guy John, one of the owners, just put his hand on the bar and
vaulted, literally, right over the bar, right between us, and he said, like, "Okay,
you guys," and he started pushing at both of us, whereupon, without even
thinking, we both zeroed in on him, and he said, like, "Come on now, cut it
out." Then he said, "Do you two guys know each other?" And so then he intro-
duced us, and—God! It was Jackson Pollock! So I was showing him pictures of
my children and he was saying, "I'm their godfather." Instantly affable, you
know. We were instantly very friendly. And he was very good to me. . . .*

Sometimes, as Lee Pollock mentioned, he would drink with the local
plumber, Dick Talmadge, or the electrician, Elwyn Harris, or sometimes
he would just talk for hours with Dan Miller, the owner of the general
store near the Pollocks' house. Miller has said: **

* See Bibliography No. 79.
** See Bibliography No. 219.

You have to understand that when the Pollocks first moved here . . . they were in many many ways different from the common concept of an artist. They did not dress or act or do anything to their appearance that was different from ordinary people. They rode up and down here on a couple of bicycles for several years before he got an old Model A Ford. I might make the point here that Jackson Pollock didn't basically move to Springs—he was moving away from something more than he was moving to something. He told me that himself openly and hinted at it several times. There were conditions in New York that had developed that he wanted to get away from, associations to a certain extent. He wanted to get away. Jackson Pollock was in many ways a very very conservative man. . . .

. . . In his art and in his belief in himself he was very sincere and honest. And I think one of the things that he was moving away from was the tendency to be surrounded by people who were not as sincere or as able. In other words he wanted to get away from the fraud, the foam, and battle the waves himself. . . .

He was liked, he was accepted, no problem. He wasn't belittled as a man but his art was not understood. People wouldn't take one of his paintings for a gift. I had one of his paintings. Hung it on the wall in here for many long years. He sort of traded it off for a grocery bill. . . .

Now my brother had a farm hand working for him. Charlie, an old man who didn't know much but who could drive horses and mow. Sometimes in the summer he mowed the leaves along the side of the road for the Town. He was in here one day, the team was out in front. Pollock drove by here—he had acquired his beat up old model A Ford by then—and Charlie liked Jackson. He liked him, worked for him some, mowing around the yard. "That old Pollock" he said, "lazy son-of-a-bitch, aint he, Dan?" And I said, "Charlie, what do you mean he's lazy?" "Why I never see him do a day's work, did you?" he said. That was pretty much the local reaction; not bitter, not evil or vicious, but it was just the way he would talk about anybody else around here. See, at that time Jackson wasn't considered wild-hide or anything.

. . . If [Charlie] didn't see a man out there he didn't see him working. . . . I told Jackson what Charlie said. I've known many artists and wonderful people but a good many of them I couldn't have told that story to, but I told Jackson and didn't he laugh. Instead of being offended he loved Charlie all the more. That's the kind of guy he was—he was a tremendous man.

. . . I did take Pollock flying more than once. I laughed the first time I took him to Block Island. We were coming home, and we sat there in this plane you

know. We wheeled up over the creek here and started to go across those light wires over the field there and I could feel his knees banging up against mine. When we hit the ground I said, "Jackson, one of your legs is nervous, isn't it?" He grinned and said, "By God I didn't know what you were going to do." ...

You know one day we were talking and it was a time when he was having sort of a hard time. He was beginning to get recognized, there had been a write-up in some magazine or other, and that had opened up the criticism of people who were supposed to be critics and writers and it opened up the criticism on the part of the Bonackers [a nickname for the inhabitants of East Hampton which is derived from the name of the original residents of the area, the Accabonac Indians] who didn't know much about painting, except that what he did was something different....

He came in this day and he was speaking of a few things and was a bit mad and discouraged—discouraged isn't the word. He talked a bit about it and as he was going he stopped in the doorway and said to me "Dan, I want to tell you something—I am a great artist. I don't give a damn what anybody said, I'm a great artist and I know it." And do you know I believed him. I believed that he was.

The native people around here weren't ready to admit to themselves that they were wrong. Of course I guess that a good many of them made peace with themselves by figuring that Life *magazine was crazier than Pollock....*

Well he was proud of it, of course. Say what you want, we have certain things by which we measure our efforts in life. Money is one of them, gratification is another. People many times use the word 'notoriety' in speaking of Jackson and I do not believe that word was ever well used. I don't believe that whatever notoriety there may have been gave him a bit of pleasure. But that Life *article did signify achievement, some recognition of what he was trying to do and succeeded in doing. Obviously it wouldn't have been there if he hadn't.*

Well his big problem with alcoholism comes right on back to the basic conservative man that he was. He sought an answer to problems in the same way it's been sought since recorded history began.... Jackson among other things got to the point where there was something inside of him that he was not being able to put down on canvas. The way he wanted to. And it was frustration, that's what I believe. Then without going into detail there arose a certain set of circumstances and conditions that he had to strike out at, that he had to get relief from, and what did he do? Just the same as generations for hundreds of thousands of years—he turned to women and alcohol. It's been done a million times. That's basic—there's nothing new in that reaction.

His problem was not the alcohol but frustration, the frustration that there was in him that he might not be able to express. I believe that with Jackson it drove him nuts. . . .

I believe that alcohol brought out a Jackson Pollock that was one hundred percent different than the Jackson Pollock when he was sober. I have seen it in other people reveal the vilest part, the part that all of us try to keep hidden and subdued. When he'd been drinking he was immediately foul-mouthed and irresponsible and he got himself kicked out of almost every ginmill around because he was offensive.

Now I've thought of that many times and my belief is that because he was an artist that there were things in him that had to bust out and that's the way they bust out. Things that I might have been able to cover up and control and maybe the ordinary man could, but in Jackson Pollock they could not be kept down. I presume the time came when his wife probably tried to correct him and it probably just made things worse. Evidently things were going to pot to some extent. But there is nothing unusual in that, that was no unusual thing. Lord we've seen it a thousand times the same way. . . .

Well the first number of years life was pleasant, seemed to me. It appeared in general that he was doing what he wanted to do and needed to do. I suppose it was a frustration of some kind that seemed to enter the picture. I felt that up to a point he could do his work and was apparently satisfied with it. Whether other people were or not, he was happy with it, and he began to get recognition. Then there was something that began to bother him and he was not as happy with his work and he was not happy with his home. . . .

Oh I would say within a year or two of when he was killed. . . .

I might not have sensed this thing right off the bat but he did begin to change. It was a frustration that led not only to a breaking out, but an eruption, a violent reaction seeking relief. It also led to an attitude on occasion of 'to hell with it.' . . .

I've seen him drive up here to these gas pumps for gas and get in and drive away with Mrs. Pollock sitting beside him, and I wouldn't have sat beside him in the condition he was in but she did.

There was a quality there of love or however you want to put it. But the point I wanted to make is that she didn't just get up and run when things got a little bit rugged. She sure didn't. I thought to myself more than once 'Well, Lee, I wouldn't drive with that son-of-a-gun—I'd get up and walk off' but she didn't. . . .

When Lee would speak to Jackson about her own problems with his drinking—not knowing where he was, who he was with, if he was alive or dead; not able to make plans for a day ahead or even a few hours—he would reply, "Yes, I know it's rough on you. But I can't say I'll stop, because, you know I'm trying to. Try to think of it as a storm. It'll soon be over."

He was trying. In the summer of 1955, he had resumed therapy—this time with Ralph Klein, a clinical psychologist of the Sullivan Institute (i.e., the Interpersonal School)—and he had begun the weekly trips to visit this doctor in New York which would continue until the end of his life. Lee Pollock was in therapy too, with a doctor of the same school, trying to deal with their situation.

Since her first one-man show at Betty Parsons in 1951, she had cut up most of those transitional paintings and reworked them into large-scale large-image collages, now about to be shown at Eleanor Ward's Stable Gallery. These collages are dominated by shapes, typically quite linear, some torn or cut from the previous paintings and drawings of her own, discarded scraps of Jackson's, and heavy black paper. The large collage elements are placed with great authority. They command their backgrounds, even hot in color as some of these backgrounds are. The collages sing like Matisse's *papiers coupés,* though more raucously, as if torn from the throat of a blues singer. She had produced a body of work she could well be proud of, as was Jackson too. And yet, without Jackson working, without the sense of shared effort, there was less feeling of pleasure than should have been. She spoke defensively about her work, especially to Jackson.

There has been much said about competition between a wife and husband practicing the same profession, not enough about such a union's special closeness resulting from the mutual interest. And besides, although Lee Pollock had confidence in the quality of her own work, she never thought of it in the same terms as those in which she thought of Jackson's. That was obvious in her public and private statements, obvious in

their studio arrangements, and obvious in their home where only a few small paintings of hers hung among his large ones. In short, she thought of herself as a good painter, a serious, committed painter—she thought of Jackson as a genius. For her even his very late paintings (*White Light, Search, Scent*), even his unfinished or discarded canvases were works of genius, precious compared with the more routine work of others. She "supported" him to that extent even as, in his unproductive frustration, he sometimes attacked other artists' work. By now Pollock was tied into aggressive-defensive knots. In the past he had taken Ossorio around to see and buy the work of de Kooning and Clyfford Still. Now he could still be kind in praising their paintings and those of Ossorio himself and Nick Carone, younger artists whose work he accepted. And he was encouraging to the still younger Sheridan Lord, a neighbor who worshiped him, and Ronald Stein, a nephew of Lee's still at Yale Fine Arts. But just as often he would attack the work of his contemporaries and that of the generation coming up behind him. Larry Rivers had this to say:*

> *Helen Frankenthaler and I visited the Pollocks in The Springs in the spring of 1951. We saw his large light studio; tremendous canvases piled up on the floor, perhaps 15 one on top of the other. He lifted the corners so we could peek. We had lunch in his house. The amount of work combined with his serious talk and the monastic lack of housiness moved us. About an hour after the visit Helen and I were standing on a deserted beach with drawn faces looking into the ocean which by now had become the ancient abyss, promising to devote ourselves even more determinedly and forever to ART. By 1954 this had all changed considerably. He had tried to destroy a piece of sculpture of mine commissioned by Castelli that stood in Castelli's driveway by running it down with his Ford. He made many offending remarks about my work, some published [in Selden Rodman's Conversations with Artists], some just brought by mouth, and some directly. . . .*

Despite, or maybe because of, the incident in which he overturned the table the evening Namuth finished filming Pollock's painting on

* See Bibliography No. 127.

glass, Lee Pollock insists:* "Jackson's violence was all verbal. There was never any physical violence. He would just use more four-letter words than usual. Or he would take it out on the furniture." Then she tells a story about Pollock and de Kooning: "Jackson and he were standing at the Cedar Bar, drinking. They started to argue and de Kooning punched him. There was a crowd around them and some of the fellows tried to egg Jackson on to hit de Kooning back. Jackson turned to them and said, 'What? Me? Hit an artist?' "

Motherwell provides this postscript:** "Sometime before his death, he came uninvited to my house to a big party I was giving for Philip Guston and behaved cordially, though fiercely baited by Kline and de Kooning (I suppose because of some past history, perhaps the episodes at the Cedar Bar). I marveled at Pollock's restraint, because I had often seen him violent; and at Kline's bruality, because I had never seen him anything but gentle. . . ."

Even more complex was Pollock's relationship with Philip Guston whom he had known since high school when they were already competitive as Schwankovsky's two best students. Of the two, Guston was probably the better, surely the more facile, and, until the late forties, the recipient of greater official recognition (first prize at Carnegie Institute, 1945; Guggenheim Fellowship, 1947; Prix de Rome, 1948). However, Guston was artist-in-residence at the University of Iowa when Pollock began showing at Art of This Century, and he was in Italy and elsewhere abroad, working in a comparatively Academic Cubist syle, when Pollock's dripped paintings made *Life*. By the early fifties, when Guston had developed his own intensely lyrical image, Pollock was already established, a master, at least among artists.

Guston remembers a weekend at this time when he and Tomlin visited Pollock in Springs while Lee was away. It was a good weekend. Jackson's mood was gentle, even the second night when Guston and

* See Bibliography No. 172.
** See Bibliography No. 127.

Tomlin did most of the talking. However, at some point in the course of their discussion of Renaissance art, Jackson picked up a very large nail and drove it into the living room floor, saying, "Damn it, that's art."

In 1953, Pollock came to Guston's show at the Egan Gallery, looked at the pulsing gestures hung on the walls, and tore down the paintings without ever explaining why or how this art, more intimate than his own, had offended him.

After that they met mostly by accident—at the Cedar, at galleries, at parties. But in 1956, wherever they met, Pollock ended up at Guston's studio and liked his recent, larger-scale work enough to call Sidney Janis immediately and insist on Guston's being given a show. Though Janis had previously seen the work with Leo Castelli, who was then scouting for him, Pollock's call assured its being shown soon after at the Janis gallery.

A less totally ambivalent, more particularly painful deterioration of a professional relationship occurred between Pollock and Clyfford Still. October 29, 1953 (three months prior to the showing of *The Deep, Portrait and a Dream,* and the eight other paintings completed during 1953), Still had written to Pollock:

> *Went up to Janis' gallery with Barney [Newman] the other day & took the liberty of pushing into the office to see some of the paintings you did this summer.*
>
> *What each work said, what its position, what each achieved you must know. But above all these details and intentions the great thing, to me, came through. It was that here a man had been at work, at the profoundest work a man can do, facing up to what he is and aspires to.*
>
> *I left the room with the gratitude & renewal of courage that always comes at such moments. This is just my way of saying thanks, & with the hope that some of my work has brought some of the same to you.**

* Still has subsequently explained (in a letter of Nov. 7, 1971, to the author): "The paintings of Pollock's I saw that day in Janis' back room were especially interesting to me on two counts. First, they indicated Jack had decided to try to break away from the device that had brought him critical and financial approval. Second, the cocktail gossip in reference to the works I saw had become bitter—labeling the latest work as failures. And Jack was palpably depressed by the comments and attitudes of the critics and presumed friends. . . ."

But by March 15, 1955, Still would write to Ossorio, expressing his disappointment in Pollock, and seeing cowardice, wretchedness, and destructive self-hatred in him, second only to that of Mark Rothko. And early in 1956, just after "15 Years of Jackson Pollock" closed, Still would write Pollock that he didn't know why he hadn't been invited to the opening, and ask if it was because Pollock was ashamed of his work, or ashamed of the people using him and insulting him as an artist. At one o'clock in the morning Pollock, in East Hampton, was still upset by the letter and crying as he read it to a friend in New York. There was no way to comfort him. Finally he said, "I'm in a terrible state," and hung up.

During the last years of his life, Jackson did a lot of telephoning late at night. Barney Newman's widow, Annalee, who was still teaching at the time, remembers several weekday nights when at two or three in the morning Barney was still at the studio or at a party, and Jackson awakened her with a call. No matter how drunk he was, he would always apologize, saying he knew she had to get up early. And he would keep on apologizing until Annalee told him very tenderly that she forgave him and knew she would be able to get back to sleep.

Pollock's agitation and restlessness intensified. During the summer of 1955 he and Lee drove with the Marca-Rellis to Riverhead and took out passports. The Pollocks did not know where or when they wanted to go. They thought that perhaps they might follow some of his paintings to Europe or even more distant parts of the world, anywhere away from his present problems, problems visible even in his passport photograph. (Notoriously bad as these are, his is not just the product of harsh light.) There, set above powerful shoulders and bull-neck, is the bloated and bearded face of a wounded giant. His eyes lack their former intensity; they are almost blank, withdrawn, ineffably sad. They no longer stare into the distant future but create their own distance by receding into the past. This photograph has a tragic heaviness. One feels not only the bloat of beer and whiskey but the weight of emotional and physical "accidents" which have made Pollock less active. Though the photograph shows him

only from the shoulders up, one knows his grace and litheness are gone. One can imagine, almost read in his face, that accident of the previous summer when he stumbled and broke his ankle in Bridgehampton. One can imagine him, more recently, rebreaking the ankle as he fools with Sherry Lord in the parlor. The emotional and physical accidents, like their causes and effects, seem interchangeable.

Going abroad and seeing his own art within the context of great art of other periods may have seemed for a moment to offer possible answers to the questions and doubts about his work, his life, which now plagued him. But the next moment travel may have been the last thing he wanted. Could he now sustain a long trip anymore than a long relationship? How much more could he take of his wife's "supportive" advice? How much before he was drowned in her love, the way he had been drowned in his mother's? How many more doctors could he see? How many more of their nonanswers could he listen to? It was almost impossible to believe that for two years, from 1948 to 1950, only five or so years ago, he had been on the wagon, had found peace not in a bottle but in his work— exactly where he found nothing, nothing but torment, now.

How many more times could he listen to a friend's anecdotes, hear the same ones over again, more polished each time as if for some night-club routine? How many more times could he deal with another friend's aristocratic politeness? How many more times call, ask how this friend was, and get no response but "How are *you?*" How many more times could he see and hear still another friend ape the Western inflection of his speech, the gestures he made with his hands, the way he used to walk before breaking his ankle and becoming heavy? How many more times could he listen to critics talking art, drowning him in *that,* that sea of words?

And these, all these, were people Jackson was fond of. But if a man bases his life on his work and that goes sour, everything goes sour. Which may be only another way of saying that if a man goes sour, his work goes sour.

Jackson was drinking all the time now—beer mostly, from morning

to night. The beer calmed him. If he stayed on it, he could get through the day and into the night. When he drank whiskey he folded faster; but first, before the inevitable oblivion, there was a momentary lift, a tightening of nerves, heightened excitability. Jackson spent the last months of his life juggling whiskey and beer as if they were two different drugs, as if one counteracted the other.

He was also juggling Springs and New York, practically commuting from one to the other in a continuing round of doctors' appointments, visits to his own gallery and others, nights at the Cedar, reunions with Lee at the Earle, long drives when he felt up to them, train rides when he didn't, beer, beer, beer, and some whiskey. . . .

He couldn't concentrate long enough to read a book or sit through a play or movie. In Springs, where he was able to move around when he listened to music, he played his favorite Fats Waller and Jimmy Yancey records. But in New York the concert situation was impossible and even the jazz clubs too confining, the music there too immediate. One night three of us went to hear a Chicago group at Jimmy Ryan's. At some point Jackson left the bar and began edging up to the bandstand where several prep-school or college boys stood tapping their feet and bobbing their heads. Jackson stood next to them and seemed to be studying one, a clean-cut crew-cut kid wearing a sports jacket, button-down shirt, black knit tie, gray flannels, cordovan shoes: the uniform of the day. Just as a number ended and everyone was beginning to applaud Jackson grabbed the boy by the shoulder, turned him so he faced Jackson, then squared off and socked him in the jaw. All this happened fast. The boy had hardly fallen to the floor, was still there shaking his head, when his friends jumped Jackson.

"You bum! You son-of-a-bitch! You dirty old bastard!" they yelled as they punched him.

We rushed to Jackson, wanting to get him away before these kids killed him. As we held them off and led him out, we explained that he was a painter, a great painter, that he was upset, sick, hypersensitive to

sound. . . . The kids weren't having any of that. They kept on punching at him. They asked, "How does his being a painter give him the right to go around slugging people?"

Of course there was no answer to that, anymore than to why Jackson had socked the kid in the first place. The boy had said nothing, done nothing. There was not even any particular thing about him that had bothered Jackson. Except maybe that itself, the lack of particularity, the clean blank anonymity.

There was another night—or early morning—when several of us were in a taxi taking Jackson back to the Earle, trying to talk him out of stopping for a nightcap at the Cedar. The cab headed down Park, making good time because of the light traffic late at night. Suddenly he opened the door beside him and announced that he was leaving, that he'd find a bar over on Lex. We grabbed him just as he was about to jump out of the moving cab.

. . . Beer, beer, beer, cases of beer, and the occasional shot-glass or tumbler of whiskey; and the cigarettes, the omnipresent Camels; and the coffee, sometimes late at night and always at breakfast, whenever that was, lunchtime for most people . . . alcohol, nicotine, caffeine, the terrible diet padding him in fat and at the same time stretching and jangling his nerves . . .

There was yet another night when a waiter at Luchow's dropped a tray and Jackson jumped off his seat and out of the restaurant, looking once again for someplace else, someplace quiet and peaceful, someplace like places used to be. . . .

By now Jackson had only a few calm hours a day—and these only on lucky days. Even at the beach where once he had been able to remain quiet for long stretches, watching waves, clouds, gulls, an occasional ship in the distance, now he became restless and wanted to leave after a short time. When he swam, he no longer gave himself to the sea but fought it, liked to stand up to a big wave and more often than not be knocked down.

Frequently he was difficult, impossible. One afternoon on the beach someone mentioned seeing *Rebel without a Cause:* "The story's phonied up, the psychiatric orientation's oversimplified, but Dean's fine."

"I'm not involved with movies," Pollock snarled.

"You'd like this. It's almost as good as *The Wild One.*"

Pollock raised his voice: "What do they know about being wild? I'm wild. There's wildness in me. There's wildness in my hands." He paused, picked up some sand, let it trickle through his heavy fingers. "There was," he finished softly. Those two small words—*There was*—trailed off, like the last grains of sand spilling between his fingers; he spoke them as tenderly as he handled the sand. After all the loud snarling, after being "impossible" (as we say), there was still tenderness, as during the years when he mixed so much of it with the sheer power of his paintings.

Pollock didn't like to be quoted. He said, "I'd rather stand on my painting," and he didn't mean this as the pun suggested by *Time,* in its "Jack the Dripper" paragraph. And yet, as certainly as the painting assures him of his place in history, it assures us of our interest in everything he did and said. There are so few of his words recorded that we want to preserve all of them. Here, from this writer's journals and notes, are a few more of the things he said during the last year or so of his life:

"Art is coming face to face with yourself. That's what's wrong with Benton. He came face to face with Michelangelo—and he lost."

"My concern is with the rhythms of nature . . . the way the ocean moves. . . . The ocean's what the expanse of the West was for me. . . . I work from the inside out, like nature."

"You can't learn techniques and then try to be a painter. Techniques are a result."

"Cézanne didn't create theories. They're after the fact."

"Orozco said, 'You don't make a scientific report on love when you're making love. It's a beautiful thing or it isn't.' "

"You've got to deny, ignore, destroy a hell of a lot to get at truth."

And, finally, there's an image—just that, not even a sentence—which an acquaintance reports Pollock used one night at the Cedar in much the same way he used his own locked hands or the spike in the living room floor to indicate the connection between seeming opposites. The image, profoundly impressed upon his mind, was something he had seen in the Gettysburg National Military Park—two musketballs, one Confederate, one Union, which had collided and fused in midair.

There were these moments of intense clarity about himself and art, and there were the others, muddied and increasingly more frequent, the moments in which he thought that the next drink he swallowed, the next place he went, the next person he met would somehow end his problems or change his luck.

Girls were beginning to come to the Cedar—particularly after meetings at The Club—young models and painters and sculptors who offered themselves to Pollock and other established artists. They didn't always know or understand what he or the others had done. The important thing was that one had done something and was recognized. Sometimes giggly girls would make little jokes which Jackson would call them on in a loud voice: "Look, don't play games, I have a *point of view.*" They'd become even more interested as his voice became louder, his face more flushed, and he seemingly larger: a wild animal, an American *fauve,* an Abstract Expressionist, the biggest Abstract Expressionist.

In *An Emotional Memoir of Franz Kline* the artist and writer Fielding Dawson gives us a real sense of Pollock's last days at the Cedar:

JUNE, 1956. AT THE BAR.
Franz pointed to the men's room. "See the door there?"
 I nodded. He said,
 "Notice it isn't very straight on its hinges."
 I saw the door wasn't set in straight. Franz said,
 "One night, Jackson ripped it off its hinges."
 Jackson was a husky man, maybe six two with long arms and huge power-

ful hands. *His head was square, with a large clear forehead and a small dome;
his heavily lined eyes sharply displayed his emotions—his whole face was ex-
pressive, as was his body. His bearlike size and strength made him fluidly hard
to keep up with, or track of, as he changed in a matter of seconds hoping to
be followed, or met. It was his game and pleasure. He'd dance in laughter,
cringe in withdrawal and return rapidly angrily bright-eyed.*

*I was sitting at the bar having a beer, and I heard John, the bartender,
murmur,*

"Oh. No."

*In the small square window of the red front door, I saw a part of Jackson's
face; one brightly anxious eye was peering in. John walked down the duck-
boards towards the end of the bar near the door, and stopped, put his left fist
on his hip, and extended his right index finger at the small window. He shook
his head. The eye looked hurt. John was tightlipped. I was laughing.*

The eye disappeared.

*John muttered out of the corner of his mouth and he is a man who can
mutter out of the corner of his mouth,*

"He'll be back."

We watched the square window.

Jackson's eye popped in.

"NO!" John yelled. "YOU'RE 86 JACKSON!"

The eye was sad and puzzled. Me 86?

*The eye got angry. Jackson's face slid across the window; then his whole
face was framed by it; mask of an angry smile.*

"NO!" John shouted, shaking his head. "Beat it!"

*Jackson's eyes became bright, and he smiled affectionately. John shook his
head.*

"Whaddya gonna do? I can't say no to the son of a bitch."

*He sighed. "All right!" he cried, and pointed to the window, wagging his
finger, "But you've got to be GOOD!"*

*The door opened and Jackson loped in and they faced each other over the
corner of the bar. Jackson had a happy friendly smile. John jabbed a finger in
his face.*

*"Remember—one trick and you're finished." John leaned forward. "Do you
get that? No cussin', no messin' with the girls—"*

Jackson said, darkly,

"Scotch."

With the drink in his hand Jackson left John angrily wiping the bar; and as I was the only one at the bar that Jackson vaguely recognized, he made his way toward me, looking intently at me. You never knew. When he got to the empty stool beside me he put his hand on it and a little stooping gave me his flickering friendly Rumpelstiltskin smile,

"Okay if I sit here?"

I stammered sure Jackson sure, and in my apprehension rather compulsively arranged the pack of matches exactly in the center on top of a new pack of cigarettes. Jackson watched me, and glanced down at my neat arrangement, and then at me, then at the cigarettes; then at me. He gravely shook his head. Wrong. He crushed my smokes and matches in his left hand.

He gazed back where people sat at tables, eating supper. Many of them were watching him. It was the right beginning for another eight-cylinder Monday night. They had come from the Bronx, from Queens, from New Jersey and from the upper East Side to eat at the Cedar and wait until Jackson finished his fifty minutes with his analyst, and came down to the bar to play. Jackson walked by each table glaring down at them. They trembled. Pity the poor fellow that brought his date in for supper, for Jackson was happy to see her. He immediately sat beside the fellow, glared nastily at him and then gave his full crude nonsensical attention to the girl while the fellow said—something— timidly—"Say, now just a minute—" Jackson turned to him, and looking at the poor guy with a naughty smile, swept the cream pitcher, salt, pepper, parmesan cheese, silverware, bread, butter, napkins, placemats, and drinks on the floor, while waiters screamed, John shouted, Jackson leaned toward the guy with an expression as if to say, how do you like that?

We all got a little of it. But Franz was the real one who gave it back, and then some. One time Franz and Nancy were sitting at the bar, talking, and unaware Jackson was behind them, staring at Franz. Jackson grabbed Franz by the hair and threw him backwards off the barstool onto the floor. Franz got up, straightened himself, glanced at Jackson, and said,

"Okay Jackson, cut it out."

Jackson had backed away, slightly stooped, head thrust forward, eyes bright. He was so happy he glittered. After Franz had sat down Jackson did it again.

"Jackson!" Nancy cried.

But when Franz got up the third time, he wheeled, grabbed Jackson, slammed him up against the wall and let Jackson have it in the gut with a hard

left-right combination. Jackson was much taller, and so surprised, and happy—
he laughed in his pain and bent over, as Franz told me, whispered, "Not so
hard." ...

One night in the bar Jackson whipped off Franz's hat, crushed it, and
tossed it up, out of reach on the shelf which overhung the bar. Franz was angry
and laughing; Jackson was happy. One night shortly thereafter, Jackson appeared
at the bar with a brand new bowler hat on, and when he reached Franz, he
glared at him, took off the bowler, crushed it and tossed it up on the shelf....

Jackson had affairs before and during the years of his marriage, some possibly with older women. Now, at the Cedar, desperate as he had ever been, he met Ruth Kligman, a plump, pretty, brunette twenty-five-year-old artist's model from Newark. Ossorio said,* "That last relationship ... was so pathetic—a young girl throwing herself at his feet." However, Ossorio may not have fully recognized how dead Pollock felt at the time, how much he needed to be told he was still alive, still a man even if he wasn't painting. Perhaps Ruth Kligman told him physically—and verbally, in a style that was half–Actors Studio, half–New Jersey, and punctuated by the word "like."

Pollock's relationship with Ruth Kligman began casually in February 1956 and intensified in the spring. Morton Feldman remembers a spring night when he and John Cage were giving a concert at Carl Fischer Hall and had invited Lee and Jackson. Jackson never showed. After the concert Feldman took Lee for a bite at Riker's and then dropped her at the Earle. He went on to the Cedar for a nightcap. Jackson and Ruth Kligman were just leaving. "He looked happy," Feldman recalls.

There may then have been one or two nights when Jackson didn't join Lee at the Earle. Since they had always had a very honest and open relationship, no more than that would have been necessary to precipitate a discussion. Perhaps then Lee suggested that if she went away for a few weeks, it might help Jackson to find out how he really felt.

Lee and Jackson planned the trip together. She intended to spend about six weeks in Europe divided equally between Paris, where she would

* See Bibliography No. 172.

stay with the painter Paul Jenkins and his wife; Venice, where she would see Peggy Guggenheim; and London, where she would stay with the art dealer Charles Gimpel and his wife. Since she hated planes, Lee booked a cabin on the Queen Elizabeth. In mid-July Lee left from New York, feeling reasonably confident that the present storm, as Jackson might have called it, would blow over. She looked forward to the ocean voyage as both a rest and a period in which to try to sort out some of her problems.

After Lee left, Jackson invited Ruth Kligman to visit him in Springs. During this first visit, there may have been times when he felt younger, less concerned about the days slipping by without any work done. But basically nothing changed. He was drinking hard, though still mostly beer. And he was as restless on the beach as at cocktail parties. In fact these social events—and the Coast Guard Beach was, as much as any party, a meeting place for the art community—presented new tensions. Whispers followed Ruth and Jackson wherever they went. Some old friends of Lee and Jackson ignored Ruth or deliberately cut her; everyone stared. Though Ruth seemed to enjoy the role of starlet or mistress to a star, Jackson felt awkward with this kid, this child, this betrayal of Lee. Lee had always handled social arrangements. Now he was on the phone, accepting invitations if it was all right to bring Ruth, or asking people over but being careful to mention that Ruth would be there. Sometimes Ruth and Jackson didn't arrive where they were expected. Other times, if an event became particularly uncomfortable, Jackson would grab Ruth, lead her to his car—a green 1950 Oldsmobile convertible which the dealer Martha Jackson had traded for two of his black-and-white paintings—and speed home.

Friday night, August 10, Jackson was alone, expecting Ruth to come from New York the following morning. Feeling depressed and too tired to sleep, he visited Conrad Marca-Relli. Conrad offered him a beer. After a while Jackson said, "Life is beautiful, the trees are beautiful, the sky is beautiful, but I only have the image of death."

Marca-Relli recalls that Pollock had said similar things on other oc-

casions but that this time he believed him. He thought that Jackson was sick both physically and mentally, that he needed medical help. He remembered times he had watched Jackson leave for the city or had gone in with him. Then Jackson had looked very neat in his shirt and tie and jacket, all pulled together for his therapist. But always when he returned he was a mess, needing a milk cure or some kind of recuperation. Several times he had asked Jackson why he went. Why, feeling good in the country, did he go to the city where he had to have several drinks to even talk to the doctor and God knows how many more afterwards to unwind? Why? Now, for the first time, just when the analysts were on August vacation, Conrad felt Jackson needed one.

Jackson spoke of the forty by sixty mural he was going to do at Tony Smith's. Perhaps he'd begin this coming weekend. But tonight this was impossible to believe. Conrad thought of the spotlight that had been on Jackson for so long, a light as cruel as that in which a rabbit "freezes." Like many other painters, perhaps like Jackson himself, Conrad felt that the magazines, the museums, and the rest had never recognized that Jackson had made a statement, a contribution to the history of art. Rather they had made him feel that this week his work was news but that next week someone else's would be. . . .

Thoughts such as these were going through Conrad's mind when Jackson put down his barely started can of beer and said, "This is one time Pollock doesn't finish his drink."

Ruth Kligman may have felt the need for someone her own age, someone interested in fun, someone she could talk to, someone who kept the same hours as she. For the second weekend in August she invited her close friend Edith Metzger, a beautician from the Bronx, to join her at Pollock's. We can imagine their conversation on the Saturday morning train out to East Hampton. Ruth would have told her friend about painters, collectors, dealers, critics she'd met in East Hampton, some for the first time, some after previous acquaintanceship, particularly at the

Cedar. She may have remarked on the cars they drove and the homes they lived in. Most likely she would have described from hearsay the house they were going to that night for a charity concert: The Creeks, home of Alfonso Ossorio, who had recently returned from Europe. There was a lot to look forward to: a new setting, new art, probably some new faces.

Jackson met the girls at the East Hampton station and drove them to Springs. There he drank beer through the afternoon and evening. He was not eating and he seemed weak and exhausted.

He may well have been hesitant about going to the concert. A public appearance with one young girl was difficult enough, but with two? made up and dressed up the way they were?—Jackson stalled. There may also have been other deterring factors. Though Feldman has described Jackson's happy glow at the beginning of his relationship with Ruth, by now, in East Hampton, there had been less glowing incidents. For example, one friend witnessed Jackson throwing Ruth out of his studio, another saw him slap her at a public bar, and Greenberg remembers him being abusive to her. Anyway, having stalled for a long time, Jackson finally took the girls to a roadside place for sandwiches and coffee. From there, at about nine, just as Ossorio was introducing the concert, Pollock called The Creeks. A maid answered. He left the message that he would arrive soon.

He may even have started toward The Creeks and changed his mind once again. However, at about a quarter past ten he was speeding north towards home on Fireplace Road, just a few hundred yards from his house, when he lost control of the convertible, seemingly didn't have the strength to hold the wheel on a sharp curve. First it ran off the east side of the road at the curve, hit a soft shoulder, then swerved and plowed 175 feet through underbrush on the west side until it ran over a clump of young white oaks. The car pivoted, turned end over end, and landed upside down about three feet from the road.

According to the *Herald Tribune,* Edith Metzger was found dead "in

the trunk of the car, presumably rammed there by the impact." Her death certificate lists the causes of death as "fracture of neck, laceration of brain." Ruth Kligman was thrown clear. She suffered a fractured pelvis, back injuries, cuts and bruises. Pollock was also thrown clear, but his head hit a mature oak and he was killed instantly. The death certificate lists causes as "Compound fracture of skull, laceration of brain, laceration both lungs. Hemothorax—shock."

Post-mortem
(1956–)

*As for his drunkenness—publicized and censured with an insistence which could
make it appear that all the writers of the United States, except Poe, are angels
of sobriety—something should be said. Several explanations are plausible, and
none exclude the others. . . .*

*I am informed that he did not drink as an epicure but barbarously, with
a speed and dispatch altogether American, as if he were performing a homicidal
function, as if he had to kill something inside of him, a worm that would not
die. . . .*

CHARLES BAUDELAIRE
Edgar Poe: His Life and Works

News of Pollock's death moved quickly from Springs to East Hampton
and from there to New York City and the rest of the world. Casper
Citron, a summer resident then running for Congress in New York and
later a radio interviewer, was in the car behind Pollock's. Citron saw the
accident and pulled over. The lights of Pollock's upside-down car were
bright, the wheels still turning, the horn jammed on. Ruth Kligman
moaned, "Jackson, Jackson . . . " Citron ran to the nearest house and
called the police and the East Hampton Clinic, then stopped a car with
MD license plates, and finally left the scene of the accident because his
wife was pregnant. (She delivered the baby, a month premature, two
days later). While Ruth Kligman was being rushed to the Southampton
Hospital, a Bonacker recognized Pollock's car and, knowing he was a
friend of Conrad Marca-Relli's, ran the short distance to the Marca-Relli
home and rapped on the window. Marca-Relli got to Pollock's car at
about the same time as Earl Finch of the East Hampton Police who
asked him to identify Pollock. Then Marca-Relli returned home to call
Ossorio who quickly left the concert with Greenberg.

The wait for them was flooded with memories of the good neighbor

Jackson had been during the winter of 1952–53 when the Marca-Rellis had gutted and rebuilt a six-room farmhouse, turning it into one-and-a-half spacious rooms; of Jackson drunk and limping around after breaking his ankle for the first time during the summer of 1954; of Jackson strutting into the Cedar and challenging someone with the question "D'you call yourself a painter?" or, another of his famous questions, "What're you involved in?" There was no separating the good Jackson from the bad Jackson, the aggressive one from the gentle one. Often Conrad had felt that Jackson teased and baited people to establish contact. But this time he had established contact too hard.

Within half an hour after the accident Dave Edwardes was taking flash photographs for the newspapers. Finally Greenberg and Ossorio arrived. Greenberg took one look at Pollock and said, "That son-of-a-bitch, he did it." Ossorio closed Jackson's eyes and covered his face with a handkerchief.

"The saplings were so thin."
"Who would have believed they could turn over a car?"
"Who would have believed they could kill two people?"
"Who can believe Jackson Pollock is dead?"

By late Saturday night many of Pollock's friends had heard the news. It swept through the East Hampton area and beyond in a chain reaction of phone calls and short shocking encounters. For example, the Brookses, the Lassaws, and the Littles had been out to dinner together. Nick Carone, who had heard from Conrad Marca-Relli, had been trying to reach them. It was not until late at night that he got an answer at the Littles. And by early Sunday morning the Littles were over at the Pollock house. There two ladies who had also heard the news came by to pick up a painting Pollock had promised for an exhibition at Guild Hall. John refused to let them have it. They argued that the show must go on. He refused again. "Over my dead body," he said finally.

By now the news was on radio and television. Mainly from these

broadcasts it was carried quickly by word of mouth. In his autobiography Thomas Hart Benton tells how it reached him at his comparatively isolated camp in Chilmark:

> ...*I was sitting... on the front steps of our Martha's Vineyard home when two men walked up. I recognized one of them, a former student, Herman Cherry, who had attended my classes at the Art Students' League in New York, back in the early thirties. He introduced me to his companion, the "abstract expressionist" painter Willem de Kooning, and said they had something to tell me. I invited them into the house and pointed out chairs, but they didn't sit down.*
>
> *Cherry said, "Jack Pollock was killed last night in an automobile accident. We thought you should know." After that, they left. With such news there was nothing to talk about.*

Franz Kline had heard the news late Saturday night and was still drinking Sunday night. Fielding Dawson describes him in the Cedar, "at the end of the bar, crying, slumped on a barstool":

> *By nightfall he was exhausted. I stood beside him drinking beer, and he looked up, saw me looking at him tenderly. He touched me, and later, I asked him, perfectly, what he thought Jackson had done.*
>
> *Franz responded softly as tears ran down his cheeks,*
>
> *"He painted the whole sky; he rearranged the stars, and even the birds are appointed."*
>
> *He looked up in misery and pointed down at the front door of the bar, and said huskily,*
>
> *"The reason I miss him—the reason I'll miss him is he'll never come through that door again."*
>
> *Then he really let it come.*

The late edition of the *Times* carried the story on the front page. The *Herald Tribune* didn't carry it until Monday. Then, on the front page of the second section, in a two-column spread, was a late Namuth photograph of Pollock, bearded, with brow furrowed and cigarette hanging from his mouth and, at the bottom of the page, an Edwardes photo of the

upside-down car. That same day, the *Times* referred again to Pollock's death. The article began:

8 SUFFOLK DEATHS
SPUR CRASH STUDY

COUNTY POLICE SYSTEM
AND A SAFETY PROGRAM STRESSED
AFTER AUTO ACCIDENTS

THREE TEACHERS KILLED

JACKSON POLLOCK A VICTIM—
DISTRICT ATTORNEY
TAKES CHARGE OF INQUIRY

SOUTHAMPTON. L. I., Aug. 12—*District Attorney George W. Percy Jr. assumed supervision today of an inquiry into two automobile accidents that took eight lives Saturday night.*

"They are not being treated as routine accident cases," Mr. Percy said. He declined to explain further, saying only that his office was investigating the activities of some of the individuals involved.

More broadly, Mr. Percy indicated that the fatalities might become a dramatic argument for a county-wide police system for Suffolk County and for an improved highway safety program.

Four persons were injured critically in the two accidents, and two more persons in a third and separate crash Saturday afternoon. Among the dead were Jackson Pollock, abstract painter, and three public school teachers in Northport, L. I.

The police said Mr. Pollock was at the wheel of his convertible when it failed to make a bend in Fireplace Road near his home on Springs Road, East Hampton. The car left the highway, struck four trees and overturned ...

The weekly East Hampton *Star* did not appear until Thursday August 16. On its front page, in addition to Edwardes' photograph of the overturned Olds, was another called "A STILL LIFE": two cans of Rheingold beer, a hubcap, and Pollock's right loafer, all nestled among the leafy underbrush of the accident site. Beneath the picture was the caption:

TRAGIC AFTERMATH *of Saturday night's automobile accident on the Springs Road. The photographer took this picture half an hour after the crash. The objects shown were not arranged; that is the way they fell. The Star publishes this dramatic picture in the hope that it may further the safer driving campaign being carried on by nation and state. Nassau and Suffolk counties are among the worst offenders in this state with regard to automobile accidents.*

Time, in its issue dated August 20—ironically, an issue of which Pollock would very much have liked the cover subject, Duke Ellington— listed Pollock among its current "Milestones." He was there with the other deaths: those of John Latouche, thirty-eight, lyricist; Archie Galbraith Cameron, sixty-one, Speaker of Australia's House of Representatives; John Carl Williams Hinshaw, sixty-two, a Republican on the House Interstate and Foreign Commerce Committee and the Joint Congressional Committee on Atomic Energy; Dr. Mincho Neichev, sixty-nine, Bulgaria's foreign minister; Ab Jenkins, seventy-three, auto racer; Grove Hiram Patterson, seventy-four, editor of the Toledo *Blade;* Frieda Emma Johanna Maria von Richthofen Weekley Lawrence Ravagli, seventy-seven, wife of D. H. Lawrence until his death in 1930 and then (since 1950) of Angelino Ravagli, Italian painter and ceramist—all these arranged according to age at death, with Pollock falling between Latouche and Cameron thus:

DIED. *Jackson Pollock, 44, bearded shock trooper of modern painting, who spread his canvases on the floor, dribbled paint, sand and broken glass on them, smeared and scratched them, named them with numbers, and became one of the art world's hottest sellers by 1949; at the wheel of his convertible in a side-road crackup near East Hampton, N.Y.*

Newsweek of the same date published the following item in its "Transition" column:

Jackson Pollock, 44, abstract painter and famous student of Thomas Hart Benton, whose technique of dripping paint onto a canvas laid flat on the floor was hailed as "original" by some art critics, "unorganized" by others; in an auto crash near East Hampton, N.Y., Aug. 11.

One is reminded of the reaction of Thomas Hudson, the central character in Hemingway's *Islands in the Stream,* when after reading about the death of his sons in *Time,* he reads a similar item in *Newsweek: "Newsweek* had the same facts. But reading the short item Thomas Hudson had the odd sensation that the man who wrote it was sorry that the boys were dead." If one doesn't really feel sorrow on the part of *Newsweek,* one does at least experience greater neutrality, less editorializing than in *Time.*

Life (August 27) devoted most of a page to "Rebel Artist's Tragic Ending"—all but one column (given to an ad for Bluettes: "Your Hands Tell Your Age—Only Household Gloves Keep Them Young"). At the top of the page, reduced in size and substantially cropped, is the famous picture of Pollock, thirty-seven and at his prime, standing in paint-splattered denim before *Number 9, 1948.* Below this, in startling contrast, is a photograph taken ten days before his death, in which his face is swollen and "sports recent growth of shaggy beard." And at the bottom of the page—also in contrast, but to the 1948 painting—is *Scent* of 1955 ("Late canvas shows painstaking brushwork"). After a paragraph of recapitulation (including reference to its August 8, 1949, issue), the text reads:

> *...Pollock's method made him famous. His big canvases now sell for as much as $10,000 apiece—nearly every major U.S. gallery owns one—and his style stirred a whole generation of young painters. His designs have found their counterparts in many objects of everyday use, from fabric to linoleum. Shortly before his death Pollock's art began to be less chaotically abstract as he gave up some of his dribbling and used carefully planned brush strokes.*

There are two errors. First, no canvas by Pollock sold for $10,000. The Metropolitan Museum had recently considered *Autumn Rhythm* at that price and turned it down. The next year it would buy the painting for three times the amount, but at Pollock's death Ben Heller's purchase of *One* at $8,000 remained the highest price. Second, the statement "nearly every major U.S. gallery owns one" is exaggerated. Even if we assume

that by "gallery" *Life* means "museum," the list would still be substantially the same as that of the institutions presented on the first page of the "15 Years of Jackson Pollock" catalogue.

The Metropolitan's delayed purchase of *Autumn Rhythm* had to be fought for by Robert Beverly Hale, the same curator of American art who had been accused by the Irascible Eighteen of being a reactionary accomplice of former Director Francis Henry Taylor. In fact Hale was by now doing Pollockesque paintings of his own. However, despite the degree of his present commitment, there is a story that he would not have been able to persuade the new Director James Rorimer and the Board of Trustees to make the purchase, if a group of school children had not at that moment congregated in the alcove where the painting had been specially hung. The children evidently expressed a degree of interest and response that made the trustees want to take another look. Finally, they approved the $30,000 price, providing Pollock's widow would take back a previously purchased black-and-white and credit the museum $10,000. She did, thus—with the Metropolitan's help—establishing the initial stage of posthumous Pollock prices. (About a dozen years later Heller would sell *One,* the companion painting of *Autumn Rhythm,* for $350,-000. The purchaser was Sidney Janis, who wanted a major Pollock to be part of his own collection, then being given to the Museum of Modern Art.)

. . . Details, details, and more details, some seemingly isolated phenomena, others the effects of specific causes, and yet all the details, all the facts, all the things, all the things as facts, all the drips, splatters, spots, stains, all the cigarette butts, handprints, footprints, grains of sand, shells, pebbles, bottlecaps, keys, tacks, nails, all these add up to a total flowing image of time past, present, and future, an image bigger than the sum of its parts, an image extending beyond the limits of the frame and beyond death, an image of energy and its abstraction as money. . . .

Dealers will scour the Hamptons, looking for cheap Pollocks. . . .

The East Hampton Highway Department will make Fireplace Road safer by somewhat straightening the bend and strengthening its shoulder. . . .

Autobiographies will be revised, giving retrospective emphasis to Pollock. . . .

Ruth Kligman will recover and take up with Bill de Kooning and years later marry Carlos Sansegundo, another painter, and still later attempt to publish her memoirs. The following item will appear in "Vitamin G," John Giorno's satirical gossip column in the underground newspaper *Culture Hero:*

> *It looks like everyone has started writing their memoirs. We met Joe LeSueur on Second Avenue and he said that ... flamboyant Ruth Kligman Sansegundo is breaking her 14 years of silence to write* MY 7 MONTHS WITH JACKSON POLLOCK *by Ruth Kligman as told by Joe LeSueur. Joe said, "What I really want to call it is - - - - - - - -."*...

LeSueur's proposed title was witty but obscene. Years before, Frank O'Hara, who died in 1966, had come up with an equally witty, but clean, epithet: *Death Car Girl.* . . .

Lee Pollock and several of the artists closest to Jackson will cancel their subscriptions to the *Star* and for some time continue to boycott the paper. They will argue that Pollock and the many other artists by then living in the East Hampton area were responsible for its vitality, chic, real estate values, and tourist business and that therefore Pollock deserved thanks rather than that "still-life" photographic editorial. And the *Star* will respond by treating Pollock, his widow, and the art community in general with more gentleness and respect. After his death this local paper will carry story after story concerning Pollock exhibitions here and abroad; and Krasner exhibitions; and the rigging necessary to remove large Pollocks from the Hellers' apartment and hoist them into public galleries; and showings of the Namuth film; and Peggy Guggenheim's lawsuit against Mrs. Pollock and the Jackson Pollock Estate; and many sympathetic stories about other artists in the community. . . .

And the editorial policies of *Time* and *Life* will change too and become less condescending and flippant as now, with each passing year, Pollock's art becomes more safely established, more expensive. For example, toward the end of 1959, *Life* (November 9, reported in the *Star* November 12) published the first of a two-part series headlined "BAFFLING U.S. ART: WHAT IT IS ABOUT." The entire first part, including ten pages of color, was devoted to Pollock. However, as with the *Star,* the change in editorial policy benefited other reputations besides that of Pollock. Part Two would deal with de Kooning, Still, Rothko, and Kline. And implicit Parts Three, Four, Five—week after week in *Time* as well as *Life*—would deal with contemporaries of Pollock, so-called First-Generation American artists, and, through the booming activity of the sixties, those of the Second and Third Generations as generations began to come seemingly closer and closer together. By 1971 *Time* would run a full-page ad in *The New York Times* announcing itself as "THE NEWSMAGAZINE FOR ART LOVERS."

No longer will it be enough for the art world to thank Pollock for breaking the ice, running some esthetic risks, granting some esthetic permissions—in short, changing the history of painting. No, the world will also have to thank him and his estate for instrumental roles in creating a market and dragging dozens of artists, dealers, critics, and collectors into it, where for the first time the American avant-garde can earn a living.

Harold Rosenberg will write an article on "The Art Establishment" for *Esquire* (January 1965). In it there is another "composite portrait," this one—a dozen years later—of the Action Widow:

Another recently emerged power is the artist's widow. The widow is identified with the painter's person, but she is also an owner of his art properties—in the structure of the Establishment widows stand partway between artists and patron-collectors. Commonly, the widow controls the entirety of her dead husband's unsold production: this enables her to affect prices by the rate at which she releases his work on the market, to assist or sabotage retrospective exhibitions, to grant or withhold documents or rights of reproduction needed by publishers and authors. (Mrs. Jackson Pollock, besides being a painter in her own right,

is often credited with having almost single-handedly forced up prices for contemporary American abstract art after the death of her husband.) She is also in a position to authenticate or reject unsigned paintings or drawings in the hands of others. Finally, she is the official source of the artist's life story, as well as of his private interpretation of that story. The result is that she is courted and her views heeded by dealers, collectors, curators, historians, publishers, to say nothing of lawyers and tax specialists. It is hard to think of anyone in the Establishment who exceeds the widow in the number of powers concentrated in the hands of a single person.

Rosenberg knows what an artist's widow is called upon to do. However, the idea that meetings with dealers, collectors, curators, historians, lawyers, accountants, etc., might involve hundreds of painful impositions seems, for the moment, to have escaped him. So does the idea that the widow's motivation for releasing the work slowly and reluctantly may have something to do with love for the artist and his only living remains.

Several of us conferred about the disposition of the Pollock estate. We advised Lee Pollock to release the paintings in a slow but regular manner, beginning as soon as possible, so the proceeds could be invested and so she could get back to her own work. She chose to release Pollock's paintings more slowly than we suggested. That decision was uncalculated. It was based upon commitment to the work. It was based upon love, not power politics.

In the late sixties, Dr. Joseph Henderson and Dr. Violet de Laszlo will sell Pollock's drawings made during the periods of therapy with them, thus raising many questions, ethical and legal, about "privileged communication," culminating with the publication of Wysuph's monograph and the circulation of the eighty-three drawings sold by Henderson to Maxwell Galleries. . . .

When one writes about Pollock there is the hope—only that—of moving liquidly between past, present, and future. The writer becomes jealous of the simultaneity with which Pollock had been able to present

different moments in time. The writer, too, would like to interweave layers of experience, layers of life and death. True, he can use press clippings as Pollock used cigarette butts and photographs as he used handprints. The writer can skip a space here and there as the painter leaves portions of the canvas uncovered. He can reveal and conceal with words as the artist does with paint. And yet, and yet in the end, the two media are not interchangeable. The writer must deal with the linearity of words:

It is again close to midnight Saturday August 11. Ossorio and Greenberg have by now succeeded in telephoning Jackson's brother Sandy and his mother in Deep River, Connecticut, who will inform the other brothers. However, Ossorio and Greenberg have had no luck in reaching Lee Pollock. According to her itinerary she should by now have been in Venice. They did not know that during her initial two weeks in Paris she had run into the Gimpels, who urged her to come with them to their country place at Ménerbes in the Midi, as they would not be returning to London before her planned departure. From Ménerbes, Kay Gimpel called Peggy Guggenheim to have her get a hotel room for Lee Pollock. It was clear immediately that there would be no welcome in Venice. Peggy said the place was filled with tourists visiting the Biennale—there were no rooms to be had, nothing. The words were definite, final as a door slamming.

Lee Pollock decided to go back to Paris. There, until she could get a room at the Quai Voltaire, she was staying with the Jenkinses again, when Greenberg called them to find out where she had gone. He delivered his sad message to Paul who delivered it to Lee.

The next hours were blurred and hectic. The Jenkinses called American friends in Paris to tell them about Jackson's death and to ask for their help in getting Lee on a plane at the peak of the tourist season. Among the friends they reached was Helen Frankenthaler who came over immediately. To prepare Lee for the plane ride and to kill the hours before departure, she and Paul Jenkins took Lee for a walk, stopping for cognac at several cafés.

Aboard the plane, the hostess gave her a sedative and described her situation to the man next to her. But despite everyone's attentions, despite the brandy and the sedative, she could not sleep. Questions ran through her mind concerning the exact circumstances of Jackson's death. Intuitively she knew just which bad bend in the road Clem meant when he had spoken to Paul. But now she wondered if Jackson had been drinking, if that girl had been with him, and, perhaps most of all, if she herself should ever have gone to Europe. Would Jackson be alive if she hadn't left? That was the most tormenting question, the one that would gnaw at her during this plane ride—and for months and years to come.

Patsy Southgate (then married to Peter Matthiessen and, like her husband, an old and close friend of the Pollocks), Lee's nephew Ronald Stein, and Alfonso Ossorio drove from East Hampton to meet Lee at Idlewild Airport. Ben Heller came from New York to help speed her through customs. And other close friends and neighbors of the Pollocks cleaned the house, checked the studio, went through drawers, cupboards, closets, everything, wanting not to leave a trace of "that girl"—already reduced to anonymity, an interchangeable prop.

In the village of East Hampton, Hans Namuth visited the Yardley and Williams funeral parlor intending to see Jackson for the last time, as he would not be able to attend the funeral because of a job commitment in California. After a quick look at him with Frederick Williams, Namuth thought of photographing Jackson. Cameras, tripod, lighting equipment were all in the trunk of his car parked outside. However, Williams refused to let him take pictures without the consent of the widow. Namuth explained that she was just returning, that there'd be no opportunity to ask her before the funeral, but that if he could take the pictures and leave the film there, he would try to get the permission later, at a more convenient time. Again the mortician refused. To this day Namuth regrets not getting final photographs of Pollock: "Even in death his head was beautiful."

When Lee Pollock got off the plane her eyes were red and sore from crying, her face tense. She was exhausted. She looked as if she had aged

four years in the four weeks or so she had been gone. During the ride back to Springs, she asked Ossorio some of the questions she had been asking herself. He was relieved he could say that he, too, had just returned from Europe, that he hadn't seen Jackson since June but had expected to the night of the accident, that he knew nothing. He, like Stein, kept bringing the conversation back to the arrangements for Jackson's funeral—these were what had to be dealt with now.

Lee Pollock's ideas about these arrangements had become surprisingly clear during those long hours on the plane when she had been unable to sleep or eat or read a magazine, when with eyes shut—wrapped in the privacy of that darkness and the privacy, too, of the motors' roar blocking out all other sound—she had been thinking about what Jackson would have wanted, remembering things he had said, as once again the past moved into the present and future and the present slipped back into the past. . . . For one thing, she was sure he would have wanted a church ceremony, just as he had almost eleven years before, when they were married. She was also sure he would have wanted to be buried in Springs where he had lived for these eleven years, the longest period anywhere, except for New York City during the nightmare years of the Depression and World War II.

"We used to visit the Green River Cemetery on walks . . . and Jackson . . . expressed a desire to be buried there."

One by one, during that evening and the following day, the details fell into place. The funeral service would be held on Wednesday in the Springs Chapel, then the burial at Green River. A boulder or two, such as those Jackson had dragged behind the house — "he had a thing for boulders" —would mark the grave. Ossorio and Dragon offered to put up Jackson's mother and some brothers at The Creeks. Other close friends agreed to put up other relatives of Jackson and Lee and friends of theirs from out-of-town. Lee's sister Ruth would stay with her in Springs. There, at the Pollock house, after the burial would be a reception. Friends were already volunteering to provide hams, turkeys, cheeses, salads, cakes, drinks. . . .

Lee Pollock spoke to Clem Greenberg about delivering a eulogy. He refused—on what would be described years later as "moral grounds." However, the then-unexplained refusal was the first of several shocks centering around the funeral, breaches as deep as the grave.

Another occurred after the funeral, at the reading of the will. In it, as Lee Pollock knew, Jackson gave everything to her, nothing to his family. What came as a surprise was a letter he had attached to the will, providing that his mother and brothers could each borrow one painting. The words in that letter must have fallen like salt in everyone's wounds. It is not surprising that none of the family ever borrowed a painting. Ossorio says,* "His whole family was mean about his work; they did not take it with the seriousness it deserved. Only his brother Sandy was sympathetic." Yet one wonders if Jackson really remembered just how sympathetic Sandy had been. Did he remember that Sandy had treated him more like a son than a brother and that his wife Arloie had completely accepted Sandy's love for Jackson and had put up with so much? Or had that relationship with Sandy been soured by parental overtones? Perhaps Jackson's ambivalence toward father figures would also explain his feelings about Charles—and, to a lesser extent, Frank—who had taken care of him when he came to New York. Even Jay, of all the brothers the one with whom Jackson had the least contact, did own two early paintings by Jackson and had offered to trade a collection of Navaho rugs and blankets for one of his later works. . . . Unanswerable questions flood our minds now, just as thoughts and memories must have flooded theirs during the reading of the will.

Wednesday, August 15, 1956, is clear and hot. By four the parking area next to the Springs Chapel is crowded with cars, many from New York City, and the chapel itself is half-full. Here are the year-round neighbors of the Pollocks, the native shopkeepers and mechanics as well as the exurban painters and writers; and here also are the summer people,

* See Bibliography No. 172.

the collectors, the dealers, the critics, the curators—all the familiar faces but sadder than usual—the women wearing dark dresses, the men wearing ties and jackets. Several of the museum people are from the Modern. With some bitterness they talk about the irony that has changed a Pollock "artist in midcareer" exhibition, planned for the end of the year, into a memorial show.

By four-thirty Lee Pollock and the Pollock family have, as she wished, been seated in separate front pews, and the chapel is full. The Reverend George Nicholson reads from the Bible, recites some of the basic facts concerning the life of Pollock, whom he hardly knew, and the service is over. There are comments about its impersonal nature, questions about the lack of a eulogy or at least a passage from, say, Thomas or Joyce or Melville, someone whose work was close to the spirit of Pollock. But with distance—distance the Reverend had and we didn't—his selection seems very appropriate: the Phillips translation of the declaration of St. Paul in Romans, Chapter 8, beginning

In my opinion whatever we may have to go through now is less than nothing compared with the magnificent future God has planned for us. The whole creation is on tiptoe to see the wonderful sight of the sons of God coming into their own. The world of creation cannot as yet see reality, not because it chooses to be blind, but because in God's purpose it has been so limited—yet it has been given hope. And the hope is that in the end the whole of created life will be rescued from the tyranny of change and decay, and have its share in that magnificent liberty which can only belong to the children of God!

Some drive to the cemetery, others walk the short distance. There again Pollock's family and friends assemble, and again the Reverend reads.

Fifteen years later, he writes:*

It seemed to me that at that moment when the art world had collected around that grave, on that beautiful day, all our skills & philosophies added up to a fragmentary & sorry collection. Like Plato's cave we were men living in a

* Letter to the author dated Apr. 22, 1971.

shadowy illusory world of sounds & sights—like dogs in an art gallery—sniffing around at corners.

No, I didn't know J. Pollock. But in the Epistle to the Romans Chapt. 8 there is more than a hint of glory and greatness—always in short supply.

Shaded by a tall white oak, a boulder marks the head of the grave. Even more than the tree, the stone makes a direct powerful statement about endurance. Like the tree, it looks as if it has grown out of the ground, but it looks too as if it has been there longer, much longer, perhaps forever.

The present becomes the future: it will take a year for ivy and moss to cover the ground scars and to creep over portions of the headstone, joining it more gently to the earth.

By then, after a lot of looking, Lee Pollock and the painter John Little will have found a much larger boulder to mark the grave, and the Pollocks' friend Jeff Potter will have hauled it by tractor to the cemetery. The headstone is about the same length as the grave and set at right angles to it. In profile it suggests a whale's head emerging from the sea. Placed on the stone is a bronze plaque bearing only Pollock's signature and dates.

By then there will have been "An Evening for Jackson Pollock at The Club." There, on East 14th Street at nine-thirty Friday, November 30, many of his friends and admirers gathered to speak with some of the personal passion that was lacking at the funeral. The Club's postcard announced that "James Brooks, Willem de Kooning, Clement Greenberg, Rube Kadish, Frederick Kiesler, Franz Kline, Corrado di Marca-Relli and others will speak" and that Harold Rosenberg would be chairman. Though the announcement suggested a panel discussion, the evening had a much more informal character, with a great deal of give-and-take between Pollock's close friends at the front of the room and others, some equally close, seated further back in the audience. . . . Kadish spoke about their schooling in California, their early ideas about art, and Jackson's love

of rocks, stones, elemental shapes. He told the story of fishing the block of sandstone from the bed of the Los Angeles River. . . . Brooks recalled the years on the Project when he was particularly close to Jackson's brothers and then the years when Jackson used to stay with him and his wife at 46 East 8th Street and finally the purchase in 1949 of a place in Montauk from which, on Fridays for the next five summers or so, the Brookses would drive to East Hampton to take care of their shopping and laundry and sometimes to see a movie and almost always to have dinner with the Pollocks. But Brooks himself hardly remembers what he said that night at The Club: "I don't suppose any of us really said anything. What can you say about a man you knew and loved and admired? I felt the enormous scale of his personality and his art." Brooks's commitment to Pollock was just as strong and more fully expressed a decade later when he wrote:"*

> *Jackson's break into the irrational was the most violent of any of the artists', and his exploration of the unconscious, the most daring and persistent. A highly responsive draftsmanship swept his work through a world of revelations and frights, and he was always past the point of no return.*
>
> *Perhaps there was no immediate Pollock school of painters because his work acted in a very different way—as a destroyer and a liberator over a wide spectrum, fertilizing seemingly opposite expressions by its disgust with the threadbare and by its strong assertion of life.*

Grace Hartigan repeated de Kooning's remark about Jackson's breaking the ice. Greenberg responded, "Broke the ice for whom?" suggesting that he thought de Kooning was not part of the same tradition as Pollock but more closely identified with Cubism. De Kooning explained that he had used a typically American phrase about a typically American guy, that he had not meant that Pollock's esthetic leadership was unique or exclusive but part of a moment in history, and that what Pollock had opened up was the recognition of American artists and a market for their work. . . .

* See Bibliography No. 127.

In another exchange Newman announced dramatically, "Jackson lives!" and de Kooning replied, "What do you mean? I saw him buried in Springs." . . . There was so much talk about Jackson as an artist that May Rosenberg spoke from the floor to remind everyone that Jackson had been a man as well, a man who loved children, animals, plants—all aspects of nature, and games, and cooking, and tinkering with automobiles. . . . In short, throughout the evening two opposing feelings were expressed strongly: first, that this should be a proper memorial, and second, that there should be neither sloppy sentimentalizing nor premature myth-making. Of the announced speakers Conrad Marca-Relli didn't appear, and Franz Kline was the only one of them who never said a word; he was silent as Lee Pollock.

By then—again, within the year following Pollock's death—Louis Guglielmi, a New York painter who summered in nearby Amagansett, will have died. His widow remembers, "When friends came to help, I said, 'Put him in that cemetery where Pollock was buried.' " And in subsequent years so many others—artists, writers, friends—will be buried in Green River Cemetery: Stuart Davis; Wilfred Zogbaum; Frank O'Hara; Frederick Kiesler; A. J. Liebling; George Cooke, a journalist and friend of Pollock's who requested a keg-shaped tombstone (since replaced by a more conventional one). . . . By 1966 Ad Reinhardt would freshen up an old joke, "The place is getting so famous that people are dying to go there," and in an interview at about the same time would say, "Happenings were being replaced by funeral services. That's the latest thing. That's the latest place where you can see artists in any quantity. There's no other way to see them. You know, I don't think artists go to openings, certainly not to the Museum of Modern Art. . . ."* By 1967 Reinhardt himself will be buried in Green River Cemetery, at fifty-three, a comparatively ripe age for this generation of artists. And by 1970 Ben Heller's wife, Judy, forty-one, will die in yet another automobile accident and be buried there. . . .

* See Bibliography No. 179.

But it is August 15, 1956. On one side of the grave stands Stella McClure Pollock, age eighty-one, flanked by two of her sons, Charles and Sanford. Although she carries a cane and has placed it in front of her, there is no weight on it now. Erect and expressionless, she listens to the words of the minister. (A dozen years later, Charles Pollock will write:* " . . . I am aware that others—besides yourself—had been puzzled by my mother's composure at Jack's funeral. That puzzlement seems to me to stem from a mistaken belief that deep emotion must be visible.")

On the other side, Lee Krasner Pollock, having stood alone, leans now on two friends as she sobs. Sherry Lord and Peter Matthiessen hold Jackson's dogs, Gyp and Ahab. As the coffin is lowered slowly into the earth, the dogs began to strain at their leashes. That physical straining, felt and passionate, may have been the eulogy we wanted to hear. Surely many of us were released by it and knew it was something Jackson would have understood; knew this as later, back at his house, we knew he would have understood our drinking.

For many of us the drinking was not "social" in the ordinary sense but in a much more profound sense, that of Jackson's Celtic ancestors who had established the wake as a way of dealing with death. This evening we did not drink just to ease the tension, we did not stop after one or two, we drank on and on wanting somehow to drown our communal pain and to join Jackson in oblivion.

Early in the year following the funeral, the president of Grove Press, Barney Rosset, who had bought the Motherwell house in East Hampton, published the first number of *Evergreen Review.* During its early years this would be an extremely vital publication, presenting some of the most

* Letter to the author, dated Oct. 27, 1968.

daring young American writers along with those of the European avant-garde. Indeed, in the late fifties, this magazine was a publishing equivalent of galleries which had, in the early forties, asked Pollock to participate in mixed European and American group shows. *Evergreen Review* No. 3 (1957) is typical, except for the number of threads which connect it with Jackson Pollock. On the cover is Namuth's *Harper's Bazaar* photograph of Pollock on the running board of his beat-up Model A Ford. The lead piece is Camus's "Reflections on the Guillotine." This is followed by three poems by William Carlos Williams and three by Frank O'Hara. O'Hara's poem "A Step Away from Them" contains the lines:

> *...First*
> *Bunny [V. R. Lang] died, then John Latouche,*
> *then Jackson Pollock. But is the*
> *earth as full as life was full, of them?*

Next is a story by Patsy Southgate. . . . Without going through the entire table of contents, there are more poems (*e.g.,* Gregory Corso, Barbara Guest, Gary Snyder). There is a section "From an Abandoned Work" by Samuel Beckett. There is the biographical note on Pollock by Greenberg (from which we quoted early in this book). It introduces four more photographs of Pollock by Namuth. There is an essay and three prose "snapshots" by Robbe-Grillet. There is a story by Ionesco.

A few issues later (No. 6, 1958) O'Hara interviewed Franz Kline, who referred several times to his dead friend:

> *... When Pollock talked about painting he didn't usurp anything that wasn't himself. He didn't want to change anything, he wasn't using any outworn attitudes about it, he was always himself. He just wanted to be in it because he loved it. ...*
>
> *If you're a painter, you're not alone. There's no way to be alone. You think and you care and you're with all the people who care, including the young people who don't know they do yet. Tomlin in his late paintings knew*

this. Jackson always knew it: that if you meant it enough when you did it, it will mean that much....

Like with Jackson: you don't paint the way someone, by observing your life, thinks you have to paint, you paint the way you have to in order to give, that's life itself, and someone will look and say it is the product of knowing, but it has nothing to do with knowing, it has to do with giving. The question about knowing will naturally be wrong. When you've finished giving, the look surprises you as well as anyone else....

Also in *Evergreen Review* No. 6 is the "Ode to Jackson Pollock" by Mike McClure. Many of its lines read like powerfully compressed biography—for example, "You made your history. Of pain." Later in the poem, McClure dares to use the word "heroic."

And Tony Smith recalls:* "At the funeral, someone said, 'He was just like the rest of us.' Well, it wasn't true. He had more of the hero about him, and everyone knew it."

Yes, Pollock's was an heroic American success story. Unarmed, unwilling to become a thing, awkwardly he took on mass media, and like so many American artists of his generation he died young in the process. It would remain for artists of another generation to accept the role of thing, of machine, of artist as entertainer, in one vast cool electronic entertainment; to resist thus the fateful coupling of their own self-destructiveness and society's cannibalism.

Much has been written about the direct influence of Pollock on younger artists who assimilated the implications of his work—for example, the Color Field painters. Yet where the resemblance isn't as obvious, his influence may have been at least as profound: in his exemplary and enduring reminder that "new needs demand new technics."

A year after Pollock's death, Robert Rauschenberg will demonstrate *his* control in *Factum,* two duplicate dripped canvases intended to be hung side by side; but he will then go on to new adventures in "combine draw-

* See Bibliography No. 172.

ings," electronically programmed imagery, dance.... Andy Warhol will exploit commercial silk-screen processes in endlessly dazzling serial images of soup cans, Coke bottles, famous faces, electric chairs; he will direct multi-track movies; he will say, "Machines have less problems. I'd like to be a machine, wouldn't you?"... Claes Oldenburg will write his *Store Days* journal: "Lately I have begun to understand action painting that old thing in a new vital and peculiar sense—as corny as the scratches on a NY wall and by parodying its corn I have (miracle) come back to its authenticity! I feel as if Pollock is sitting on my shoulder, or rather crouching in my pants!" In 1963 Oldenburg will create a motel *Bedroom Ensemble* environment that is monumental in both its size and its falseness. The room will contain simulated zebra headboard, pillows, couch; simulated leopard coat on the couch; simulated burl veneer dressers and night tables on which are lamps with simulated marble shades; and, on the walls, simulated Pollocks of framed fabric.... Roy Lichtenstein will create his monuments—in Benday—from cartoon images, details of paint drips, thirties decor.... Allan Kaprow, like Oldenburg a pioneer of happenings, will write (*Art News,* October 1964):

> *According to the myth, the modern artist is the archetypal victim who is "suicided by society" (Artaud). In the present sequel, the artist is entirely responsible for his life and death; there are no villains any more. There are only cultured reactionaries, sensitive and respected older radicals, rising up in indignation to remind you that Rembrandt, Van Gogh and Pollock died on the Cross....*

... And Jim Dine, yet another originator of happenings, will describe his first, *The Smiling Workman:*

> *...I had a flat built. It was a three-panel flat with two sides and one flat. There was a table with three jars of paint and two brushes on it, and the canvas was painted white. I came around it with one light on me. I was all in red with a big, black mouth: all my face and head were red, and I had a red smock on, down to the floor. I painted "I love what I'm doing" in orange and blue. When I got to*

"what I'm doing," it was going very fast, and I picked up one of the jars and drank the paint, and then I poured the other two jars of paint over my head, quickly, and dove ... through the canvas. . . .

But Pollock's impact was not restricted to Americans nor to plastic artists. It was felt by important writers here and abroad. For example, in 1962, Michel Butor's *Mobile,* a "study for the representation of the United States," was published by Editions Gallimard. Janet Flanner (Genêt) described it in a *New Yorker* "Letter from Paris" as "undoubtedly the oddest, most fragmentary, yet stimulating journey-record ever compiled from so much humdrum mileage in our vast land." The book is a structural collage of personal journal entries, commercial brochures, historical documents, present and past voices of all kinds. It is at once fragmentary and continuous, abstract and concrete. It is dedicated "To the Memory of Jackson Pollock."

In a foreword to the second edition (1969) of *The Anxious Object,* Rosenberg will write:

> *. . . painting is no longer a haven for self-defeating contemplatives but a glamorous arena in which performers of talent may rival the celebrity of senators or TV stars.*
>
> *Given these transformations, inner and outer, anxiety as a psychological state is today no more typical of artists than of doctors, truck drivers or physicists (though it is typical of all of them). Noting the comfortable prospects for painters and sculptors, some critics have concluded that the disturbance of art is a phenomenon of the past; it is a mood, they tell us, that belongs to the decade following the war. Anxious painting in this view is the kin of Existentialism and the Theatre of the Absurd. It is an aspect of the life style of dusty lofts, blue jeans, the Cedar Tavern (at its old address), no sales, tumescent paint letting go in drips. Today, this stereotype continues, anxiety is no longer a reality in art, which is at last properly concerned with its own development. To mention anxiety is to arouse suspicion of nostalgia or of a vested interest in the past, if not of a reactionary reversion to the middle-class notion of genius suffering in a garret.*
>
> *In this capsule wisdom the problem of contemporary civilization is mis-*

taken for an episode in the history of fashion. Only the grossest materialism, such as pervades American cultural journalism, could equate poverty with anxiety, high income with serenity. Psychologically, Action painters twenty years ago were no more anxious than Pop artists or kinetic geometers are today. All indications are that they were probably much less anxious. They were re-signed to being who they were and where they were. Spending most of their time with other artists, they led a far more relaxed and vivacious social life than the lions rampant of today's art world. Most important, in Action Painting the act of painting is a catharsis—theoretically at least, it is able to reach the deepest knots of the artist's personality and to loosen them. By contrast, in the recent cool modes of painting and constructing, process prevails, and the un-excited artist performs the necessary steps without upsetting his normal condition of uneasiness.

Within another context, that of a story called "The Show"—illustrated with Ernst-like collages of old engravings—Donald Barthelme will write (*The New Yorker,* August 8, 1970):

It is difficult to keep the public interested.
The public demands new wonders piled on new wonders.
Often we don't know where our next marvel is coming from.
The supply of strange ideas is not endless.
The development of new wonders is not like the production of canned goods.

But even if this applies, however ironically, to any one artist (Warhol?), the work produced by that artist does take its place in the endless history of art and therefore in the endless history of life. . . .

Toward the end of World War II there had been a moment in which Lee and Jackson Pollock thanked God that they were painters rather than writers. Then all the writers were seemingly being devoured by America—more specifically, Hollywood—or destroying themselves in the struggle not to be devoured. In Hollywood, never having completed a successful film script, Nathanael West had died in an automobile accident and Scott Fitzgerald had drunk himself to death, and William Faulkner,

drinking just as hard, was writing tough movie dialogue in order to do his other writing in Mississippi.... Of the best fiction writers, only Hemingway was dealing with Hollywood at long distance, writing his own script and starring in it, but paying the same terrible price as his colleagues—in alcoholism and creative frustration. Yes, during World War II and for a short time thereafter, the new generation of painters had seemed comparatively lucky and free, unbothered by mass media. But now, as we look back on the lives of the Abstract Expressionists, as we think about the suicides of Gorky and Rothko, the car accident of Pollock and the truck accident of David Smith, the premature deaths of Tomlin, Kline, Baziotes, Reinhardt, Newman, the heavy drinking (at once, self-destructive and -protective) of most of these artists and several others who survive, it becomes impossibly naïve to use words like "accident" and "premature." As with the brilliant but vulnerable writers of the previous generation, at the same time as we appreciate the uniqueness of their gifts, we must face the typicalness of their fates in a society which wastes lives and automobiles with equal callousness. This is not to say that Pollock and the others were "suicided by society" but that a self-destructive society nourished his (and their) self-destructiveness. Pollock was not murdered; he did not murder himself; but in his death, as in his life, he had accomplices.

Selective Bibliography

(following substantially the structure of the bibliography in No. 10 below, with additional categories and with additions and deletions within categories)

POLLOCK STATEMENTS, WRITINGS, AND INTERVIEWS (arranged chronologically)

1. (Answers to a questionnaire.) *Arts & Architecture*, LXI, February 1944, p. 14.

2. (Statement.) *in* Janis, Sidney. *Abstract & Surrealist Art in America.* New York: Reynal & Hitchcock, 1944, p. 112.

3. "My Painting," *possibilities* (New York), Winter 1947–48, pp. 78 ff.

4. "Unframed Space," *New Yorker*, XXVI, August 5, 1950, p. 16.
 Interview with Jackson and Lee Pollock.

5. (Narration for the film *Jackson Pollock* made by Hans Namuth and Paul Falkenberg, 1951.) Typescript in the Library, The Museum of Modern Art, New York.

6. (Excerpts from an interview taped by William Wright, Springs, Long Island, 1950.) *Art in America* (New York), LIII, August–September 1965, pp. 111 ff. Entire interview in No. 10.

7. (Statements.) *in* Rodman, Selden. *Conversations with Artists.* New York: Devin-Adair, 1957. Pp. 76–87. (Statements: *see* also No. 13.)

MONOGRAPHS

8. Henderson, Joseph L. "Jackson Pollock: A Psychological Commentary." Unpublished paper, 1966; revised 1968. *See* No. 14.

9. O'Connor, Francis V. "The Genesis of Jackson Pollock: 1912 to 1943." Unpublished Ph.D. dissertation, The Johns Hopkins University, Baltimore, 1965.

10. ———. *Jackson Pollock.* New York: The Museum of Modern Art, 1967.

11. O'Hara, Frank. *Jackson Pollock.* (The Great American Artists Series.) New York: George Braziller, 1959.
 rev.: Folds, Thomas M., in *College Art Journal* (New York), XX, Fall 1960, pp. 52 ff.

12. Robertson, Bryan. *Jackson Pollock.* New York: Harry N. Abrams, Inc., 1960.
 British ed.: London, Thames & Hudson, 1960—German ed.: Cologne, DuMont Schauberg, 1961.
 rev.: Archer, W. G., in *Studio* (London), CLXI, April 1961, p. 161; Frampton, Kenneth, in *Arts Review* (London), XIII, June 3–17, 1961, p. 2; Rosenberg, Harold, in *Art News* (New York), LIX, February 1961, pp. 35 ff; Tyler, Parker, Letter to the editor in response to Rosenberg review, *Art News*, LX, March 1961, p. 6; Sweeney, J. J., in *Herald-Tribune*, January 1, 1961, p. 29; *Times Literary Supplement* (London), February 3, 1961, p. 70.

13. Rose, Bernice. *Jackson Pollock: Works on Paper.* New York: The Museum of Modern Art in association with the Drawing Society, Inc.,

1969. (Statements by Pollock pp. 16, 102.)

14. Wysuph, C. L. *Jackson Pollock: Psychoanalytic Drawings.* New York: Horizon Press, 1970.

GENERAL WORKS

15. Ashton, Dore. *The Unknown Shore: A View of Contemporary Art.* Boston and Toronto: Little, Brown & Company, 1962.

Baur, John I. H., *see* No. 25.

16. Benton, Thomas Hart. *An Artist in America,* Third Edition. Columbia, Missouri: University of Missouri Press, 1968.

17. Blesh, Rudi. *Modern Art USA, Men, Rebellion, Conquest, 1900–1956.* New York: Alfred A. Knopf, 1956.

18. Candee, Marjorie Dent (ed.). "Pollock, Jackson," *Current Biography Yearbook.* New York: H. W. Wilson, 1956.

19. C(hoay), F(rançoise). "Pollock," *Dictionary of Modern Painting,* eds., Carlton Lake and Robert Maillard. 3rd ed. New York: Tudor, 1964.

Tr. from the French *Dictionnaire de la peinture moderne.* Paris: Hazan, 1955.

20. Dawson, Fielding. *An Emotional Memoir of Franz Kline.* New York: Pantheon Books, 1967.

21. Friedman, B. H. *School of New York: Some Younger Artists.* New York: Grove Press, 1959.

22. ——— and Guest, Barbara. *Goodnough.* Paris: The Pocket Museum (Editions Georges Fall), 1962.

23. ——— *Lee Krasner: paintings, drawings and collages.* London: Whitechapel Gallery, 1965.

24. ———. *Alfonso Ossorio.* New York: Harry N. Abrams, 1973.

25. Goodrich, Lloyd, and Baur, John I. H. *American Art of Our Century.* New York: Frederick A. Praeger, 1961.

26. Greenberg, Clement. *Art and Culture: Critical Essays.* Boston: Beacon Press, 1961.

27. Guggenheim, Peggy. *Confessions of an Art Addict.* New York: Macmillan, 1960.

rev. ed. of *Out of This Century.* New York: Dial, 1946.

28. Haftmann, Werner. *Painting in the Twentieth Century.* 2 vols. New York: Frederick A. Praeger, 1960; new and expanded ed., 1965.

German eds.: Munich, Prestel Verlag, 1954–55; rev. ed., 1957.

29. Hess, Thomas B. *Abstract Painting.* New York: Viking, 1951.

30. Hunter, Sam. "Jackson Pollock: The Maze and the Minotaur," *New World Writing.* (Ninth Mentor Selection.) New York: New American Library, 1956.

31. ———. *Modern American Painting and Sculpture.* New York: Dell, 1959.

32. ———. "USA," *Art since 1945.* New York: Harry N. Abrams, Inc., 1958.

33. Janis, Sidney. *Abstract & Surrealist Art in America.* New York: Reynal & Hitchcock, 1944.

34. Kootz, Samuel M. *New Frontiers in American Painting.* New York: Hastings House, 1943.

35. McDarrah, Fred W. *The Artist's World in Pictures.* (Introduction by Thomas B. Hess, commentary by

Gloria Schoffel McDarrah.) New York: E. P. Dutton & Co., 1962.

36. McGinley, Phyllis. *Times Three.* New York: The Viking Press, 1960, pp. 69–70.
 "Spectator's Guide to Contemporary Art" appeared originally in *New Yorker,* May 21, 1955, p. 114.

37. Miller, Edwin Haviland, editor. *The Artistic Legacy of Walt Whitman.* New York: New York University Press, 1970.
 Includes "The Radical Vision of Whitman and Pollock" by Miller.

38. Motherwell, Robert, and Reinhardt, Ad, editors. *Modern Artists in America.* New York: Wittenborn Schultz, Inc., 1952.

Neuberger, Roy R., *see* No. 42.

39. O'Connor, Francis V. *Federal Support for the Visual Arts: The New Deal and Now.* Greenwich, Conn.: New York Graphic Society, 1969.

40. Pierre, Jose. "Surrealism, Jackson Pollock and Lyric-Abstraction," in *New York, D'Arcy Galleries. Surrealist Intrusion in the Enchanters' Domain.* 1960.

41. Ponente, Nello, *Modern Painting. Contemporary Trends.* Lausanne: Albert Skira, 1960.

Reinhardt, Ad, *see* No. 38.

42. Robbins, Daniel, and Neuberger, Roy R. *An American Collection.* Rhode Island: Museum of Art, Rhode Island School of Design, 1968.

43. Rose, Barbara, *American Art since 1900.* New York: Frederick A. Praeger, 1967.

44. ———. *Readings in American Art since 1900.* New York: Frederick A. Praeger, 1968.

45. Rosenberg, Harold. *The Tradition of the New.* New York: Horizon Press, 1959.

46. ———. *Arshile Gorky: The Man, the Time, the Idea.* New York: Horizon Press, 1962.

47. ———. *The Anxious Object: Art Today and Its Audience.* New York: Horizon Press, 1966.
 Reprinted New York: The New American Library, A Mentor Book, 1969, with "Foreword to the Second Edition."

48. ———. *Artworks and Packages.* New York: Horizon Press, 1969.

49. ———. *Act and the Actor: Making the Self.* New York and Cleveland: The World Publishing Co., 1970.

50. Sandler, Irving. *The Triumph of American Painting: A History of Abstract Expressionism.* New York: Praeger Publishers, Inc., 1970.

51. Seuphor, Michel. *Dictionary of Abstract Painting.* New York: Paris Book Center, 1957.
 Tr. from the French *Dictionnaire de la peinture abstraite.* Paris: Hazan, 1957.

52. Soby, James Thrall. *Contemporary Painters.* New York: The Museum of Modern Art, 1948.

53. ———. "Jackson Pollock," *New Art in Ameria,* ed. John I. H. Baur. Greenwich, Conn.: New York Graphic Society and New York: Frederick Praeger, 1957.

ARTICLES AND MISCELLANEOUS REFERENCES

54. Alfieri, Bruno. "Piccolo discorso sui quadri di Jackson Pollock," *L'Arte Moderna* (date and place of publication not known).

55. Alloway, Lawrence. "U.S. Modern: Paintings," *Art News and Review* (London), VII, January 21, 1956, pp. 1, 9.

56. ———. "Background to Action. 2. The Marks," *Art News and Review* (London), IX, October 26, 1957, pp. 1–2.

57. ———. "The Art of Jackson Pollock: 1912–1956," *Listener* (London), LX, November 27, 1958, p. 888.

58. ———. "London Chronicle," *Art International*, II, December 1958–January 1959, pp. 33–34, 73.

59. ———. "Sign and Surface. Notes on Black and White Painting in New York," *Quadrum 9*, 1960, pp. 49–62.

60. ———. "Notes on Pollock," *Art International*, V, May 1961, pp. 38–41.
———, *see* Nos. 246–249.

61. "Americans Abroad," *Time*, LVI, August 21, 1950, p. 49.
Archer, W. G., *see* No. 12.

62. Armstrong, Richard. "Abstract Expressionism Was an American Revolution," *Canadian Art*, XXI, September–October 1964, pp. 263–65.

63. "Art of Jackson Pollock," *Times* (London), November 7, 1958.

64. Ashton, Dore. (Reviews.) *Arts & Architecture*, LXXIII, January 1956, pp. 10 ff.; LXXIV, March 1957, pp. 10 ff.; LXXVI, January 1959, p. 6.

65. ———. "Perspective de la peinture américaine," *Cahiers d'Art*, XXXIII–XXXV, 1960, pp. 203–20.

66. ———. "Pollock: Le nouvel espace," *XX^e Siècle*, XXIII, December 1961, pp. 75–80.

67. Barr, Alfred H., Jr. "Gorky, de Kooning, Pollock," *Art News*, XLIX, Summer 1950, pp. 22–23.

68. Berger, John. "The White Cell," *New Statesman*, LVI, November 22, 1958, pp. 722–23.

69. "The Best?" *Time*, L, December 1, 1947, p. 55.

70. Burrows, Carlyle. (Review.) *Herald-Tribune*, November 27, 1949.

71. C.M. (Review.) *Burlington Magazine*, C, December 1958, p. 450.

72. "The Champ," *Time*, LXVI, December 19, 1955, pp. 64, 66.

73. "Chaos, Damn It!" *Time*, LVI, November 20, 1950, pp. 70–71.
Response by Pollock in Letters to the Editor, December 11, 1950, p. 10.

74. Choay, Françoise. "Jackson Pollock," *L'Oeil*, No. 43–44, July–August 1958, pp. 42 ff.

75. Clark, Eliot. "New York Commentary," *Studio* (London), CLIII, June 1957, pp. 184–85.

76. Coates, Robert M. (Reviews.) *New Yorker*, May 29, 1943, p. 49; November 20, 1943, p. 97; January 17, 1948, p. 57; December 3, 1949, p. 95; December 9, 1950, pp. 109–11; November 22, 1952, pp. 178–79; February 20, 1954, pp. 81–82; December 29, 1956, pp. 47–49; November 16, 1957, p. 222.

77. Connolly, Jean. (Reviews.) *Nation*, May 1, 1943, p. 643; May 29, 1943, p. 786.

78. Cooper, Douglas. "The Biennale Exhibition in Venice," *Listener* (London), XLIV, July 6, 1950, pp. 12–14.

79. Creeley, Robert. "The Art of Poetry X" (interview by Linda Wagner and Lewis MacAdams, Jr.), *Paris Review,* XI, 44, Fall 1968.

80. Crehan, Hubert. "Pollock: A Janus-Headed Show," *Art Digest,* XXVIII, February 15, 1954, pp. 15 ff.

81. Devree, Howard. (Reviews.) *New York Times,* March 25, 1945; December 3, 1950; December 2, 1951; November 16, 1952.

82. D(rexler), A(rthur). "Unframed Space: A Museum for Jackson Pollock's Paintings," *Interiors,* CIX, January 1950, p. 90 .

83. Faison, S. Lane, Jr. (Reviews.) *Nation,* December 13, 1952, p. 564; February 20, 1954, pp. 154, 156.

84. Farber, Manny. "Jackson Pollock," *New Republic,* June 25, 1945, pp. 871–72.

85. Fitzsimmons, James. (Reviews.) *Art Digest,* XXVI, December 15, 1951, p. 19; XXVII, November 15, 1952, p. 17; *Arts & Architecture,* LXXI, March 1954, pp. 7 ff.

Folds, Thomas M., *see* No. 11.

Frampton, Kenneth, *see* No. 12.

86. Frankenstein, Alfred. (Review.) *San Francisco Chronicle,* August 12, 1945.

87. Fremantle, Christopher E. "New York Commentary," *Studio* (London), CXLVII, June 1954, pp. 184 ff.

88. Fried, Michael. "Jackson Pollock," *Artforum,* IV, September 1965, pp. 14–17.

In addition to this and No. 193 below, the issue contains valuable related critical material by Lawrence Alloway, Max Kozloff, Philip Leider, Barbara Rose, and Sidney Tillim, plus interviews with or reminiscences by Paul Brach, Friedel Dzubas, Robert Goodnough, Matta, and Robert Motherwell.

89. ———. (Review.) *Art International,* VIII, April 1964, pp. 57–58.

90. Friedman, B. H. "The New Baroque," *Art(s) Digest,* XXVIII, 20, September 15, 1954, pp. 12–13.

91. ———. "Profile: Jackson Pollock," *Art in America,* XLIII, December 1955, pp. 49 ff.

92. ———. "Current and Forthcoming Exhibitions (New York)," *The Burlington Magazine,* XCVIII, May, June, July, September, November 1956.

93. ———. "Jackson Pollock," *Gutai,* 5, 6, October 1956, April 1, 1957.

94. Genauer, Emily. (Review.) *New York World-Telegram,* February 7, 1949.

95. ———. (Review.) *New York Herald-Tribune,* May 28, 1950; February 7, 1954.

96. ———. "Jackson Pollock's Endless Search," *New York Herald-Tribune: New York,* January 19, 1964, p. 29.

97. ———. (Review.) *World Journal Tribune,* April 4, 1967.

98. Giorno, John. "Vitamin G," *Culture Hero,* I, 5, 1970.

99. Glaser, Bruce. "Jackson Pollock. An Interview with Lee Krasner," *Arts Magazine,* XLI, April 1967, pp. 36–38.

100. Glueck, Grace. "Artists Find 'In' Place on L.I.," *New York Times,* September 26, 1968, p. 49.

101. Goodnough, Robert. "Pollock Paints a Picture," *Art News*, L, May 1951, pp. 38 ff.

102. ———. (Reviews.) *Art News*, XLIX, December 1950, p. 47; LI, December 1952, pp. 42–43.

Gray, Cleve, *see* No. 172.

103. Graham, Hugh. "Trails of the Unconscious," *Spectator* (London), CCVI, June 2, 1961, p. 797.

104. Greenberg, Clement. (Reviews.) *Nation*, November 27, 1943, p. 621; April 7, 1945, p. 397; April 13, 1946, p. 445; December 28, 1946, p. 768; February 1, 1947, pp. 137, 139; January 24, 1948, p. 108; February 19, 1949, p. 221.

105. ———. "The Present Prospects of American Painting and Sculpture," *Horizon* (London), Nos. 93–94, October 1947, pp. 20–30.

106. ———. "Art Chronicle: Feeling Is All," *Partisan Review*, XIX, January–February 1952, p. 102.

107. ———. "Jackson Pollock's New Style," *Harper's Bazaar*, LXXXV, February 1952, p. 174.

108. ———. "'American-Type' Painting," *Partisan Review*, XXII, Spring 1955, pp. 186–87.
 Reprinted in somewhat revised form in his *Art and Culture*, Boston: Beacon Press, 1961.

109. ———. "Jackson Pollock," *Evergreen Review*, I, 1957, pp. 95–96.

110. ———. "The Jackson Pollock Market Soars," *New York Times Magazine*, April 16, 1961, pp. 42 ff. Issue of April 30, 1961, contains letters to the editor.

111. ———. "America Takes the Lead, 1945–1965," *Art in America*, LIII, August–September 1965, p. 108.

112. ———. "Jackson Pollock: 'Inspiration, Vision, Intuitive Decision,'" *Vogue*, CXLIX, April 1, 1967, pp. 160–61.

113. Gruen, John. "A Turbulent Life with Jackson Pollock," *New York—World Journal Tribune*, March 26, 1967, pp. 14–15.

114. ———. "The Past Gets a Cleaning," *New York*, November 1969, pp. 47–48.

115. "Handful of Fire," *Time*, LIV, December 26, 1949, p. 26.

116. "The Hero-Figure of Action-Painting," *Times* (London), November 11, 1958.

117. H(ess), T(homas) B. "Jackson Pollock 1912–1956," *Art News*, LV, September 1956, pp. 44–45.

118. ———. (Reviews.) *Art News*, LIII; March 1954, pp. 40–41; LV, February 1957, pp. 8–9.

119. Hess, Thomas B. "Pollock: The Art of a Myth," *Art News*, LXII, January 1964, pp. 39 ff.

120. Hodgson, Simon. "Neurasthenic Dazzle," *Spectator* (London), CCI, November 21, 1958, pp. 688–89.

121. Hoffman, Edith. "Current and Forthcoming Exhibitions (New York)," *Burlington Magazine*, XCIX, February 1957, p. 68.

122. Horn, Axel. "Jackson Pollock: The Hollow and the Bump," *Carleton Miscellany* (Northfield, Minn.), VII, Summer 1966, pp. 80–87.

123. "How a Disturbed Genius Talked to His Analyst with Art," *Medical World News*, XII, 5, February 5, 1971.

124. "How They Got That Way," *Time*, LXXIX, April 13, 1962, pp. 94–99.

125. Hunter, Sam. "Abstract Expressionism Then—and Now," *Canadian Art*, XXI, September–October 1964, pp. 266–68.

126. ———. (Review.) *New York Times*, January 30, 1949.

127. "Jackson Pollock: An Artists' Symposium, Part 1," *Art News*, LXVI, April 1967, pp. 29 ff.
Statements by James Brooks, Adolph Gottlieb, Al Held, Allan Kaprow, Alex Katz, Elaine de Kooning, Robert Motherwell, Barnett Newman, Phillip Pavia, Larry Rivers.

128. "Jackson Pollock: An Artists' Symposium, Part 2," *ibid.*, May 1967, pp. 27 ff.
Statements by Al Brunelle, Jane Freilicher, David Lee, Joan Mitchell, Kenneth Noland, David Novros, Claes Oldenburg, George Segal.

129. "Jackson Pollock: Is He the Greatest Living Painter in the United States?" *Life*, XXVII, August 8, 1949, pp. 42 ff.

130. Jewell, Edward Alden. (Review.) *New York Times*, November 14, 1943.

131. Jewett, Eleanor. (Review.) *Chicago Daily Tribune*, March 6, 1945.

132. Judd, Don. "Jackson Pollock," *Arts*, XLI, April 1967, pp. 32–35.

133. Kaprow, Allan. "The Legacy of Jackson Pollock," *Art News*, LVII, October 1958, pp. 24–26.
Letter from Irving H. Sandler, *ibid.*, December 1958; reply by Kaprow, *ibid.*, February 1959.

134. ———. "Impurity," *Art News*, LXI, January 1963, pp. 53–54.

135. ———. "Should the Artist Become a Man of the World?" *Art News*, LXIII, October 1964, pp. 34–37, 58–59.

136. Karp, Ivan C. "In Memoriam: The Ecstasy and Tragedy of Jackson Pollock, Artist," *Village Voice* (New York), September 26, 1956.

137. K(ooning), E(laine de). (Review.) *Art News*, XLVIII, March 1949, p. 44.

138. Kozloff, Max. (Review.) *Nation*, Feburary 10, 1964, pp. 151–52.

139. ———. "The Critical Reception of Abstract-Expressionism," *Arts*, XL, December 1965, pp. 27–33.
Article based on a lecture given at the Los Angeles County Museum of Art August 1965 in connection with the exhibition *New York School; see* No. 257.

140. Kramer, Hilton. "Month in Review," *Arts*, XXXI, February 1957, pp. 46–48.

141. ———. "Jackson Pollock and Nicolas de Staël. Two Painters and Their Myths," *Arts Yearbook*, No. 3, 1959, pp. 53–60.

142. ———. (Reviews.) *New York Times*, April 5, 1967; April 9, 1967.

143. K(rasne), B(elle). (Review.) *Art(s) Digest*, XXV, December 1, 1950, p. 16.

144. Kroll, Jack. "A Magic Life," *Newsweek,* April 17, 1967, p. 96.

145. L(ane), J(ames). (Review.) *Art News,* XL, January 15–31, 1942, p. 29.

146. L(ansford), A(lonzo). "Automatic Pollock," *Art(s) Digest,* XXII, January 15, 1948, p. 19.

147. Lavin, Irving. "Abstraction in Modern Painting: A Comparison," *Metropolitan Museum of Art Bulletin,* XIX, February 1961, pp. 166–71.
Includes an analysis of *Autumn Rhythm.*

148. Laws, Frederick. "Jackson Pollock in Perspective. Much More Than 'Drool,'" *Manchester Guardian,* November 10, 1958.

149. "A Life Round Table on Modern Art," *Life,* XXV, October 11, 1948, pp. 56–70, 75–79.

150. Louchheim, Aline B. (Review.) *New York Times,* September 10, 1950.

151. L(owengrund), M(argaret). "Pollock Hieroglyphics," *Art(s) Digest,* XXIII, February 1, 1949, pp. 19–20.

152. McBride, Henry. "Not Bad for These Times," *Art News,* L, April 1951, pp. 38–39.

153. ———. (Review.) *New York Sun,* December 23, 1949.

154. McClure, Mike. "Ode to Jackson Pollock," *Evergreen Review,* II, Autumn 1958, pp. 124–26.

155. Melville, Robert. (Reviews.) *Architectural Review,* CXIX, May 1956, pp. 267–68; CXXV, February 1959, p. 139; CXXX, August 1961, pp.

130–31; *Arts,* XXXIII, January 1959, p. 16.

156. "The Metropolitan and Modern Art," *Life,* XXX, January 15, 1951, pp. 34–38.

157. Michelson, Annette. "Paris," *Arts,* XXXIII, June 1959, pp. 17–18.
Review of and summary of reactions to the two exhibitions, organized under the auspices of the International Council at the Museum of Modern Art, shown simultaneously in Paris, *Jackson Pollock 1912–1956* and *The New American Painting. See* Nos. 243, 244.

158. Middleton, Michael. "Pollock," *Motif* (London), No. 2, February 1959, pp. 80–81.

159. "Milestones," *Time,* LXVII, August 20, 1956, p. 90.

160. Mock, Jean Yves. "Pollock at the Whitechapel Gallery," *Apollo,* LXVIII, December 1958, p. 221.

161. Motherwell, Robert. "Painters' Objects," *Partisan Review,* XI, Winter 1944, pp. 93–97.

162. Namuth, Hans. "Jackson Pollock," *Portfolio. The Annual of the Graphic Arts* (Cincinnati), 1951, 6 pp.

163. ———. "Jackson Pollock," *American Society of Magazine Photographers' Picture Annual.* New York: A Ridge Press Book published by Simon & Schuster, 1957.

164. ———. "Four Photographs of Jackson Pollock," *Evergreen Review,* I, 3, 1957, p. 96 and cover.

165. Newton, Eric. "Jackson Pollock at the Whitechapel Gallery," *Time and*

Tide (London), XXXIX, November 15, 1958, p. 1371.

166. Nugent, Joseph F. "Some Thoughts on Pollock," *New Bulletin* (Staten Island Institute of Arts and Sciences), XI, April 1962, pp. 94–95.

167. O'Connor, Francis V. "Growth out of Need," *Report*, I, February 1964, pp. 27–28.

168. ———. "The Genesis of Jackson Pollock: 1912 to 1943," *Artforum*, V, May 1967, pp. 16–23.

169. O'Hara, Frank. "A Step Away from Them," *Evergreen Review*, I, 3, 1957, pp. 60–61.

170. ———. "Franz Kline Talking," *Evergreen Review*, II, 6, Autumn 1958, pp. 58–64.

171. ———. "Jackson Pollock 1912–1956," in Selz, Peter. *New Images of Man*. New York: The Museum of Modern Art, 1959, pp. 123–28.

172. Plessix, Francine Du, and Gray, Cleve. "Who Was Jackson Pollock?" *Art in America*, May–June 1967, pp. 48–59.
Interviews with Alfonso Ossorio, Betty Parsons, Lee Krasner Pollock, Anthony Smith.

173. "Pollock Revisited," *Time*, LXXXIX, April 14, 1967, p. 85.

174. P(orter), F(airfield). (Review.) *Art News*, L, December 1951, p. 48.

175. Preston, Stuart. (Reviews.) *New York Times*, November 27, 1949; December 4, 1955.

176. Raynor, Vivien. "Jackson Pollock in Retrospect—'He Broke the Ice,'" *New York Times Magazine*, April 2, 1967, pp. 50 ff.

177. Read, Herbert. "The Limits of Painting," *Studio* (London), CLXVII, January 1964, pp. 3–4.

178. "Rebel Artist's Tragic Ending," *Life*, XLI, August 27, 1956, p. 58.

179. Reinhardt, Ad. "An Ad Reinhardt Monologue," (tape-recorded by Mary Fuller on April 27, 1966), *Artforum*, IX, 2, October 1970, pp. 36–41.

180. Rexroth, Kenneth. "Americans Seen Abroad," *Art News*, LVIII, June 1959, pp. 30 ff.

181. Riley, Maude. (Reviews.) *Art(s) Digest*, XVIII, November 15, 1943, p. 18; XIX, April 1, 1945, p. 59; June 1, 1945, p. 12.

182. R(obinson), A(my). (Review.) *Art News*, XLVIII, December 1949, p. 43.

183. Rose, Barbara. "New York Letter," *Art International*, VIII, April 1964, p. 52.

184. Rosenberg, Harold. "The Art Establishment," *Esquire*, January 1965, pp. 44–46, 114.

185. ———. (Review.) *New Yorker*, XLIII, May 6, 1967, pp. 162–71.
———, *see* Nos. 12, 45, 47, 48, 189.

186. Rosenblum, Robert. "The Abstract Sublime," *Art News*, LIX, February 1961, p. 41.

187. Rubin, William. "Letter from New York," *Art International*, II, December 1958–January 1959, pp. 27–28.

188. ———. "Notes on Masson and Pollock," *Arts*, XXXIV, November 1959, pp. 36–43; December 1959, p. 9.

189. ――――. "Jackson Pollock and the Modern Tradition," *Artforum*, V, February 1967, pp. 14–22; March 1967, pp. 28–37; April 1967, pp. 18–31; May 1967, pp. 28–33.
The April and May issues contain correspondence between Harold Rosenberg and William Rubin.

190. Russell, John. "Yankee Doodles," *Sunday Times* (London), January 8, 1956.

191. ――――. "Pollock in Panorama," *Sunday Times* (London), November 9, 1958.

192. ――――. "The 'New American Painting' Captures Europe," *Horizon* (London), XI, November 1959, pp. 32–41.

193. Sandler, Irving. "The Club," *Artforum*, IV, 1, September 1965, pp. 27–31.
――――, *see* No. 133.

194. Sawyer, Kenneth B. "Jackson Pollock. 1912–1956," *Cimaise* (Paris), Ser. 4, No. 2, November–December 1956, pp. 22–23.
English tr. p. 10.

195. Schapiro, Meyer. "The Younger American Painters of Today," *Listener* (London), LV, January 26, 1956, pp. 146–47.
Talk delivered on the BBC on the occasion of the exhibition *Modern Art in the United States* shown at the Tate Gallery.

196. Schneider, Pierre. "Paris," *Art News*, LVIII, March 1959, p. 47.
Review of the two exhibitions, organized under the auspices of the International Council at the Museum of Modern Art, shown simultaneously in Paris, *Jackson Pollock 1912–1956* and *The New American Painting. See* Nos. 243, 244.

197. S(chuyler), J(ames). (Reviews.) *Art News*, LVI, December 1957, p. 10; LVII, December 1958, p. 12.

198. Seiberling, Dorothy. "Baffling U.S. Art: What It Is About," *Life*, XLVII, November 9, 1959, pp. 68–80; November 16, 1959, pp. 74–86.
A two-part series on Abstract Expressionism in the United States; part 1 is devoted primarily to Pollock.

199. Seixas, Frank A. "Jackson Pollock. An Appreciation," *Art Gallery*, VII, October 1963, pp. 11–13, 23.

200. Smith, Richard. "Jackson Pollock 1912–1956," *Art News and Review* (London), X, November 22, 1958, p. 5.

201. Southgate, Patsy. "The Eastern Long Island Painters," *Paris Review*, VI, 21, Spring–Summer 1959.

202. Steinberg, Leo. "Month in Review," *Arts*, XXX, December 1955, pp. 43–44.

203. Strauss, Michel. "London," *Burlington Magazine*, CIII, July 1961, pp. 327 ff.

204. Sutton, Denys. "Modern Art in the United States," *Country Life* (London), CXIX, January 19, 1956, pp. 102–3.

205. ――――. "Jackson Pollock," *Financial Times* (London), November 25, 1958, p. 13.

206. Sweeney, James Johnson. "Five American Painters," *Harper's Bazaar*, April 1944.

207. Sylvester, David. (Review.) *Nation*, September 9, 1950, p. 232.

208. Taylor, Basil. "Modern American Painting," *Spectator* (London), No. 6656, January 20, 1956, p. 80.

209. Tillim, Sidney. "Jackson Pollock. A Critical Evaluation," *College Art Journal*, XVI, Spring 1957, pp. 242–43.

210. ———. (Reviews.) *Arts*, XXXIII, December 1958, p. 53; XXXVIII, March 1964, pp. 55–59.

211. "Transition," *Newsweek*, XLVIII, 8, August 20, 1956.

212. Tyler, Parker. "Nature and Madness among the Younger Painters," *View* (New York), V, May 1945, pp. 30–31.

213. ———. "Jackson Pollock: The Infinite Labyrinth," *Magazine of Art*, XLIII, March 1950, pp. 92–93.

214. ———. (Review.) *Art News*, LIV, December 1955, p. 53.

215. ———. "Hopper/Pollock. The Loneliness of the Crowd and the Loneliness of the Universe: An Antiphonal," *Art News Annual*, XXVI, 1957, pp. 86–107.

216. ———, *see* No. 12.

217. (Unsigned review.) *The Compass* (New York), December 3, 1950.

218. Valliere, James T. "The El Greco Influence on Jackson Pollock's Early Works," *Art Journal*, XXIV, Fall 1964, pp. 6–9.

218a. ———. "De Kooning on Pollock," an interview, *Partisan Review*, XXXIV, Fall 1967, pp. 603–605.

219. ———. "Daniel T. Miller," *Prov-incetown Review*, No. 7, Fall 1968, pp. 34–42.

220. Wallis, Neville. "Heroes of the Day," *Observer* (London), November 9, 1958.

221. Washburn, Gordon Bailey. "Three Gifts to the Gallery," *Carnegie Magazine*, XXVII, December 1953, pp. 337–38.

222. Whittet, G. S. "London Commentary," *Studio* (London), CLVII, February 1959, p. 58.

223. "The Wild Ones," *Time*, LXVII, February 20, 1956, pp. 70–75.

224. Willing, Victor. "Thoughts after a Car Crash," *Encounter*, VII, October 1956, pp. 66–68.

225. Wolf, Ben. (Reviews.) *Art(s) Digest*, XX, April 15, 1946, p. 16; XXI, January 15, 1947, p. 21.

226. "Words," *Time*, LIII, February 7, 1949, p. 51.

227. Wysuph, C. L. "Behind the Veil," *Art News*, LXIX, October 1970, pp. 52–55, 80.

228. "The Year's Best: 1950," *Art News*, XLIX, January 1951, pp. 42–43, 58–59.

229. "The Year's Best: 1952," *Art News*, LI, January 1953, pp. 42–43.

230. Zinsser, William K. "Far Out on Long Island," *Horizon*, V, 5, May 1963.
 Photographs by Hans Namuth.

EXHIBITION CATALOGUES
(Arranged chronologically)

231. New York, Art of This Century. *Jackson Pollock.* November 9–27, 1943. Pp. 4.

Introduction by James Johnson Sweeney. Reprinted in catalogue of Pollock exhibition at the Arts Club of Chicago, March 5–31, 1945; in *It Is* (New York), No. 4, Autumn 1959, p. 56.

232. New York, Art of This Century. *Jackson Pollock.* January 14–February 1, 1947. Pp. 4.
Introduction by (W.) N. M. Davis.

233. New York, Samuel M. Kootz Gallery. *The Intrasubjectives.* September 14–October 3, 1949.
Essays by Harold Rosenberg and Samuel M. Kootz.

234. Venice, Ala Napoleonica (Museo Correr). *Jackson Pollock.* July 22–August 12–15, 1950. Pp. 8.
Two catalogues printed: the first gives Le Tre Mani as sponsors, contains introductory remarks by Peggy Guggenheim and an essay, " 'Guazzabugli' di Jackson Pollock," by Bruno Alfieri; the second contains only the remarks by Peggy Guggenheim.

235. New York, Betty Parsons Gallery. *Jackson Pollock.* November 26–December 15, 1951. Pp. 18.
Introduction by Alfonso Ossorio. Reprinted (in French) in No. 236; with slight alterations in New York, The Museum of Modern Art, *15 Americans,* April 9–July 27, 1952; in New York, The Museum of Modern Art, *The New American Painting,* May 28–September 8, 1959.

236. Paris, Studio Paul Facchetti. *Jackson Pollock.* March 7–31, 1952. Pp. 8.
Essays by Michel Tapié, "Jackson Pollock avec nous," and Alfonso Ossorio, "Mon Ami Pollock" (*see* No. 235).

237. New York, The Museum of Modern Art. *15 Americans.* April 9–July 27, 1952. 8 works by Pollock.
Essay on Pollock by Alfonso Ossorio (*see* No. 235).

238. Bennington College (Vt.). *A Retrospective Show of the Paintings of Jackson Pollock.* November 17–30, 1952.
Statement by Clement Greenberg.

239. New York, Sidney Janis Gallery. *15 Years of Jackson Pollock.* November 28–December 31, 1955. Pp. 16.

240. New York, The Museum of Modern Art. *Jackson Pollock.* December 19, 1956–February 3, 1957. Pp. 36. (*The Museum of Modern Art Bulletin,* XXIV, No. 2, 1956–57.)
Text by Sam Hunter. Reprinted in English and Portuguese in No. 242; in English and other languages in No. 243.

241. New York, Poindexter Gallery. *The 30's/painting in new york.* 1957.
Edited by Patricia Passloff.

242. New York, The International Council at the Museum of Modern Art. *Pollock* (Representação dos Estados Unidos à IV Bienal do Museu de arte moderna de São Paulo). September 22–December 31, 1957. Pp. 36.
Text by Sam Hunter, in English and Portuguese, adapted from No. 240.

243. New York, The International Council at the Museum of Modern Art. *Jackson Pollock 1912–1956.* March 1, 1958–February 15, 1959.

Translations of text by Sam Hunter, adapted from No. 240, in separate catalogues published in each city: Rome, Galleria Nazionale d'Arte Moderna, March 1–30, 1958; Basel, Kunsthalle, April 19–May 26, 1958; Amsterdam, Stedelijk Museum, June 6–July 7, 1958; Hamburg, Kunstverein, July 19–August 17, 1958 (joint catalogue with Basel Kunsthalle); Berlin, Hochschule für Bildende Künste, September 1–October 1, 1958; London, Whitechapel Art Gallery, November 4–December 14, 1958; Paris, Musée National d'Art Moderne, January 16–February 15, 1959 (shown simultaneously with *The New American Painting;* joint catalogue, *Jackson Pollock et la nouvelle peinture américaine*).

244. New York, The Museum of Modern Art. *The New American Painting.* May 28–September 8, 1959. Pp. 96. 4 works by Pollock.

Exhibition, selected by Dorothy C. Miller, as shown in eight European cities April 1958–March 1959 under the auspices of the International Program of the Museum of Modern Art. Catalogue is a reprint of the one used for the showing at the Tate Gallery, London, February–March 1959, with the addition of color plates and a selection of critical response that appeared in European publications.

245. New York, The Museum of Modern Art (in collaboration with the Baltimore Museum of Art). *New Images of Man,* 1959.

Edited and introduced by Peter Selz. Prefatory note by Paul Tillich. "Jackson Pollock" by Frank O'Hara (see No. 171).

246. London, Marlborough Fine Art Ltd. *Jackson Pollock, Paintings, Drawings, and Watercolors from the Collection of Lee Krasner Pollock.* June 1961. Pp. 64.

Introduction and catalogue notes by Lawrence Alloway. Reprinted in various translations in Nos. 247–249; in *Paletten* (Stockholm), XXII, 1961, pp. 82–85.

247. Düsseldorf, Kunstverein für die Rheinlände und Westfalen. Kunsthalle. *Jackson Pollock.* September 5–October 8, 1961. Pp. 55.

Preface by Karl-Heinz Hering. Introduction and catalogue notes by Lawrence Alloway, German translation of No. 246.

248. Zurich, Kunsthaus. *Jackson Pollock.* October 24–November 29, 1961. Pp. 59.

Preface by Edvard Hüttinger. Introduction and catalogue notes by Lawrence Alloway, German translation of No. 246.

249. Rome, Marlborough Galleria d'Arte. *Jackson Pollock.* October–November 1962. Pp. 12.

Introduction by Lawrence Alloway, Italian translation of No. 246. Same exhibition shown in Milan, Toninelli Arte Moderna, November–December 1962, for which a separate catalogue was published.

250. Stockholm, Moderna Museet. *Jackson Pollock.* February–April 1963. Pp. 34.

Introduction by K. G. Hultén.

251. New York, The Jewish Museum.

black and white, December 12, 1963–February 5, 1964.
Catalogue by Ben Heller. Preface by Alan R. Solomon. Introduction by Ben Heller. "Black or White," by Robert Motherwell.

252. New York, Marlborough-Gerson Gallery. *Jackson Pollock*. January–February 1964. Pp. 64.
Brief introduction by Bryan Robertson, excerpt from No. 12.

253. Harvard University, Fogg Art Museum. *Within the Easel Convention: Sources of Abstract-Expressionism*. May 7–June 7, 1964. Pp. 46. 3 works by Pollock.
Text by Ann Gabhart, Frieda Grayzel, Rosalind Krauss. Analysis of Pollock's works by Ann Gabhart.

254. New York, Art Students League. *American Masters from Eakins to Pollock*. July 7–August 26, 1964, pp. 42–43.
Magic Mirror (1941) is illustrated.

255. London, Tate Gallery. *The Peggy Guggenheim Collection*. December 31, 1964–March 7, 1965. Pp. 99. 11 works by Pollock.
Preface by Herbert Read. Introduction by Peggy Guggenheim. Catalogue notes by Ronald Alley.

256. Philadelphia, Institute of Contemporary Art, University of Pennsylvania. *1943–1953: The Decisive Years*. January 14–March 1, 1965.
Introduction by Samuel Adams Green.
Night Dancer (*green*), 1944, is illustrated.

257. Los Angeles County Museum of Art. *New York School. The First Generation. Paintings of the 1940s and 1950s*. July 16–August 1, 1965. Pp. 232. 8 works by Pollock.
Edited by Maurice Tuchman.

258. College Park, University of Maryland Art Gallery. *Federal Art Patronage 1933 to 1943*. April 6–May 13, 1966. Pp. 60. 2 works by Pollock.
Text by Francis V. O'Connor.

259. American Federation of Arts. *American Masters: Art Students League*. 1967, circulated by A.F.A. Pp. 96–97.
Note on Pollock by Thomas B. Hess.

260. New York, Finch College Museum of Art. *Betty Parsons' Private Collection*. March 13–April 24, 1968.
Acknowledgment by Elayne H. Varian. Text by Eugene Goossen.

261. New York, The Museum of Modern Art. *The Art of the Real/USA 1948–1968*. 1968.
Preface, acknowledgment, and text by Eugene Goossen.

262. New York, Whitney Museum of American Art. *The 1930's: Painting & Sculpture in America*. October 15–December 1, 1968.
Text by William C. Agee.
The Flame, 1937, and *Birth*, 1937, in exhibition, the former illustrated in catalogue.

263. New York, The Solomon R. Guggenheim Museum. *Works from the Peggy Guggenheim Foundation*. 1969. Pp. 146–159.
Introduction by Peggy Guggenheim (Venice, July 1968).

264. New York, Marlborough-Gerson Gallery. *Jackson Pollock: Black and White*. March 1969.
 Introduction by William S. Lieberman. "An Interview with Lee Krasner Pollock," by B. H. Friedman.

265. New York, The Museum of Modern Art. *The New American Painting and Sculpture: The First Generation*. June 18–October 5, 1969.
 Check List of the Exhibition, includes fifteen works by Pollock.

266. New York, The Metropolitan Museum of Art. *New York Painting and Sculpture: 1940–1970*. October 18, 1969–February 1, 1970.
 Foreword by Thomas P. F. Hoving; "New York Painting and Sculpture: 1940–1970," by Henry Geldzahler; "The American Action Painters," by Harold Rosenberg; "The Abstract Sublime," by Robert Rosenblum; "After Abstract Expressionism," by Clement Greenberg; "Arshile Gorky, Surrealism, and the New American Painting," by William Rubin; "Shape as Form: Frank Stella's New Paintings," by Michael Fried.

RELATED MATERIAL
(fiction and non-fiction by authors whose works offer insights into Pollock's ambience)

267. Braider, Donald. *The Palace Guard*. New York: The Viking Press, 1958.

268. Breton, André. *Manifestoes of Surrealism*. Ann Arbor: The University of Michigan Press, 1969.
 Translated from the French by Richard Seaver and Helen R. Lane.

269. Friedman, B. H. *Circles*. New York: Fleet Publishing Corp., 1962.
 Reprinted as *I Need To Love*. New York: Macfadden Books, 1963.

270. Friedman, Sanford. *A Haunted Woman*. New York: E. P. Dutton & Co., 1968.

271. Hayter, Stanley W. *New Ways of Gravure*. New York: Pantheon Books, 1949.

272. Jung, C. G. *The Basic Writings*. New York: The Modern Library, 1959.
 Edited with an Introduction by Violet Staub de Laszlo.

273. ———. *Man and His Symbols*. New York: Doubleday & Co.; London: Aldus Books, Ltd., 1964.
 Includes "Ancient Myths and Modern Man," by Joseph L. Henderson and "Symbolism in the Visual Arts," by Aniela Jaffé, the latter of which refers specifically to Pollock (p. 264).

274. Kaprow, Allan, *Assemblage, Environments & Happenings*. New York: Harry N. Abrams, Inc., 1966.

275. Kerouac, Jack. "The Art of Fiction" (interview by Ted Berrigan), *Paris Review*, XI, 43, Summer 1968. Pp. 60–105.

276. Kirby, Michael. *Happenings*. New York: E. P. Dutton & Co., 1966.

277. Kunitz, Stanley J. (ed.). *Twentieth Century Authors*, First Supplement. New York: The H. W. Wilson Co., 1955.
 Includes autobiographical statement by Clement Greenberg.

278. Matthiessen, Peter. *Race Rock*. New York: Harper & Brothers, 1954.

279. Ponge, Francis. "Prose Sketches," *Art and Literature*, 12, Spring 1967. Pp. 225–252. Translated from the French by Lane Dunlop.

280. Tabak, May Natalie. *But Not For Love*. New York: Horizon Press, 1960.

281. ———. "Small Change," *Kenyon Review*, XXX, 122, 5, 1968, pp. 627–51.

282. Thompson, D'Arcy. *On Growth and Form*, Revised Edition. Cambridge University Press, 1948.

283. Williams, Tennessee. *Dragon Country*. "In the Bar of the Tokyo Hotel." New York: New Directions Publishing Corp., 1969.

FILM

284. *Jackson Pollock*. Produced by Hans Namuth and Paul Falkenberg Music by Morton Feldman. Narration by Jackson Pollock, 1951.

 10 minutes. 16mm. Color. Sound. Distributed by Film Images division of Radim Films, Inc., 17 West 60th Street, New York, N.Y. 10023.

 An earlier black-and-white film of Pollock, without sound, is owned by the producers but not distributed.

PUZZLE

285. *Convergence by Jackson Pollock*. Produced by Springbok Editions division of Hallmark Cards, October 1964. Initially but no longer distributed with leaflet containing photographs and statement by Hans Namuth (substantially what appears in No. 163 above) as well as quotations from Pollock's own statements.

—END—

Index

Other titles of interest

MANY MASKS
A Life of Frank Lloyd Wright
Brendan Gill
544 pp., 300 illus.
80872-2 $17.95

ABOUT ROTHKO
Dore Ashton
241 pp., 38 plates, 8 in color
80704-1 $18.95

ALFRED STIEGLITZ
A Biography
Richard Whelan
688 pp., 28 photos
80794-7 $19.95

ANDY WARHOL
Films and Paintings:
The Factory Years
Peter Gidal
159 pp., 120 illus.
80456-5 $14.95

ART TALK
The Early 80s
Edited by Jeanne Siegel
336 pp., 48 photos
80414-X $14.95

ARTWORDS
Discourse on the 60s and 70s
Jeanne Siegel
247 pp., 42 illus.
80474-3 $13.95

DIALOGUES WITH MARCEL
DUCHAMP
Pierre Cabanne
152 pp., 20 illus.
80303-8 $9.95

EARLY AMERICAN MODERNIST
PAINTING 1910–1935
Abraham A. Davidson
342 pp., 178 illus., 8 in full color
80595-2 $19.95

THE LEGACY OF
MARK ROTHKO
Updated Edition
Lee Seldes
432 pp., 31 photos
80725-4 $15.95

THE MEMOIRS OF
GIORGIO DE CHIRICO
278 pp., 24 illus.
80568-5 $13.95

MY LIFE
Marc Chagall
227 pp., 20 plates
80571-5 $14.95

NIGHT STUDIO
Musa Mayer
320 pp., 93 illus. (11 in color)
80767-X $17.95

PAUL CEZANNE, LETTERS
Edited by John Rewald
470 pp., 52 illus.
80630-4 $15.95

PICASSO ON ART
A Selection of Views
Edited by Dore Ashton
200 pp., 43 illus.
80330-5 $13.95

PICASSO'S MASK
André Malraux
285 pp., 46 illus.
80629-0 $13.95

REVOLUTION OF THE MIND
The Life of André Breton
Mark Polizzotti
784 pp., 48 photos, 1 line drawing
80772-6 $20.95

WARHOL
The Biography
Victor Bockris
570 pp., 53 photos
80795-5 $17.95

THE PERSISTENCE OF MEMORY
A Biography of Dali
Meredith Etherington-Smith
518 pp., 42 illus., 16 in color
80662-2 $19.95

A JOSEPH CORNELL ALBUM
Dore Ashton
256 pp., 107 illus.
80372-0 $22.95

KANDINSKY
Complete Writings on Art
Edited by Kenneth C. Lindsay and
Peter Vergo
960 pp., over 250 illus.
80570-7 $25.95

THE WRITINGS OF
MARCEL DUCHAMP
Edited by Michel Sanouillet
and Elmer Peterson
208 pp., 27 photos
80341-0 $13.95

SURREALISM
Julien Levy
New introd. by Mark Polizzotti
202 pp., 68 illus.
80663-0 $17.95

Available at your bookstore

OR ORDER DIRECTLY FROM

DA CAPO PRESS

1-800-321-0050